URBAN LANDSCAPE DESIGN

Edited by John A. Flannery and Karen M. Smith

teNeues

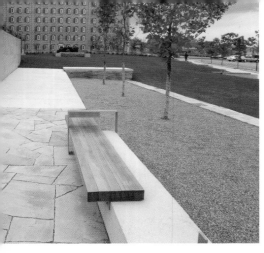
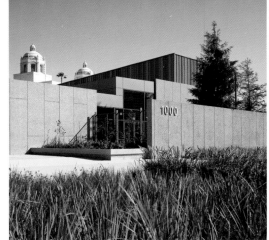
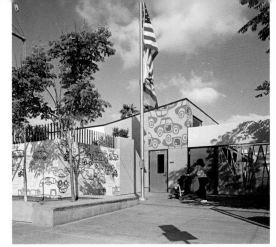

URBAN LANDSCAPE DESIGN

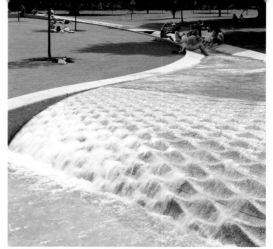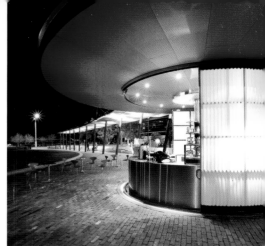

Shores, Quays and Riversides

Boulevards, Streets and Squares

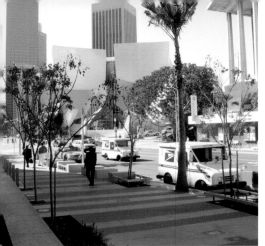 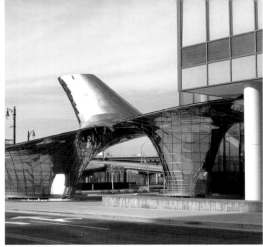

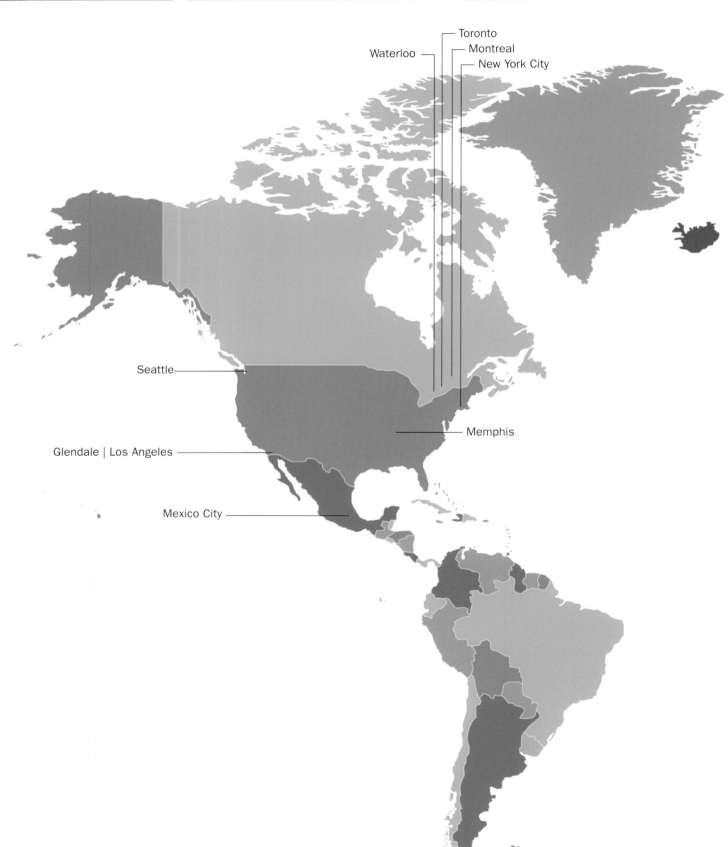

Waterloo

Toronto

Montreal

New York City

Seattle

Memphis

Barcelona

Glendale | Los Angeles

Mexico City

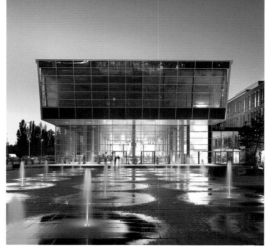
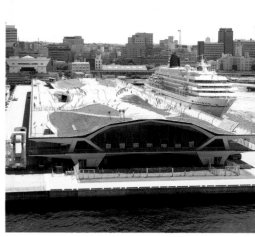

Logrono

Nottingham

London

Bonn

Nordhorn

Munich

Graz

Split

Madrid

Thisted

Shenyang City

Saitama

Yokohama

Dujiangyan City

Taizhou City

Zhongshan City

Sydney

Melbourne

Make No Small Plans ...

Make no small plans for they have no power to stir the blood of man.
Daniel Hudson Burnham (1846–1912), American architect

City dwellers have long held aspirations that the spaces between buildings should be as safe, welcoming and functional as those within the buildings themselves. The transformation of these empty, indefinable territories must also sustain the natural elements of planting and wildlife, thus maintaining the delicate ecological balance between man and the forces of nature.

The projects included in *Urban Landscape Design* seek to illustrate the compound benefits to be won from inspiring landscaping activity in diverse geographical sites. The chapters include examples of how urban wastelands are reclaimed and restored for commercial and artistic pursuits. Polluted derelict shores and quaysides have been transformed into safe havens for recreation and leisure activities. In densely populated China, sterile fields surrounding places of learning have become crop producing land; both ethically sound and aesthetically pleasing as a hybrid landscape solution. European boulevards and streets are newly lined with trees and soft planting in an effort to combat the otherwise stressful experience of commuting and the intrusive effect of transport systems on the city's ambience. In an example of how a project can serve multiple purposes, a bridge linking old and new quarters of a city also functions as a memorial. Blighted industrial areas are shown to have been revitalized by recycling redundant architecture for new social uses, with abandoned manufacturing sites becoming arenas for performance yet maintaining an historical and testimonial value.

With minimal intervention the most congested urban sites are endowed with elements of the most remote landscapes. Rocks, fountains and trees bring the suggestion of mountain, river and forest into the cities of the 21st century. Furthermore, the featured projects reveal how landscape architecture of an organic nature, once set in motion, will continue to grow, age and mature, eventually taking on a life of their own.

Some of the featured projects illustrate how the modern landscape architect can use a barren urban landscape as a blank canvas upon which to create a work claiming artistic merit. Art itself is used to great effect in the landscape. Sculpture, both natural and man-made, creates an environment that might stimulate play or engender a mood of rest within its shadows. Some artists, when afforded the freedom of an outdoor site, are able to cast off the mantle of a gallery's restricted size and create works comparable in scale to those of ancient civilizations.

Many of these sustainable developments demonstrate that in shaping and nurturing the landscape in an intelligent and thoughtful way, mankind will reap benefits far in excess of those initially envisaged.

John A. Flannery

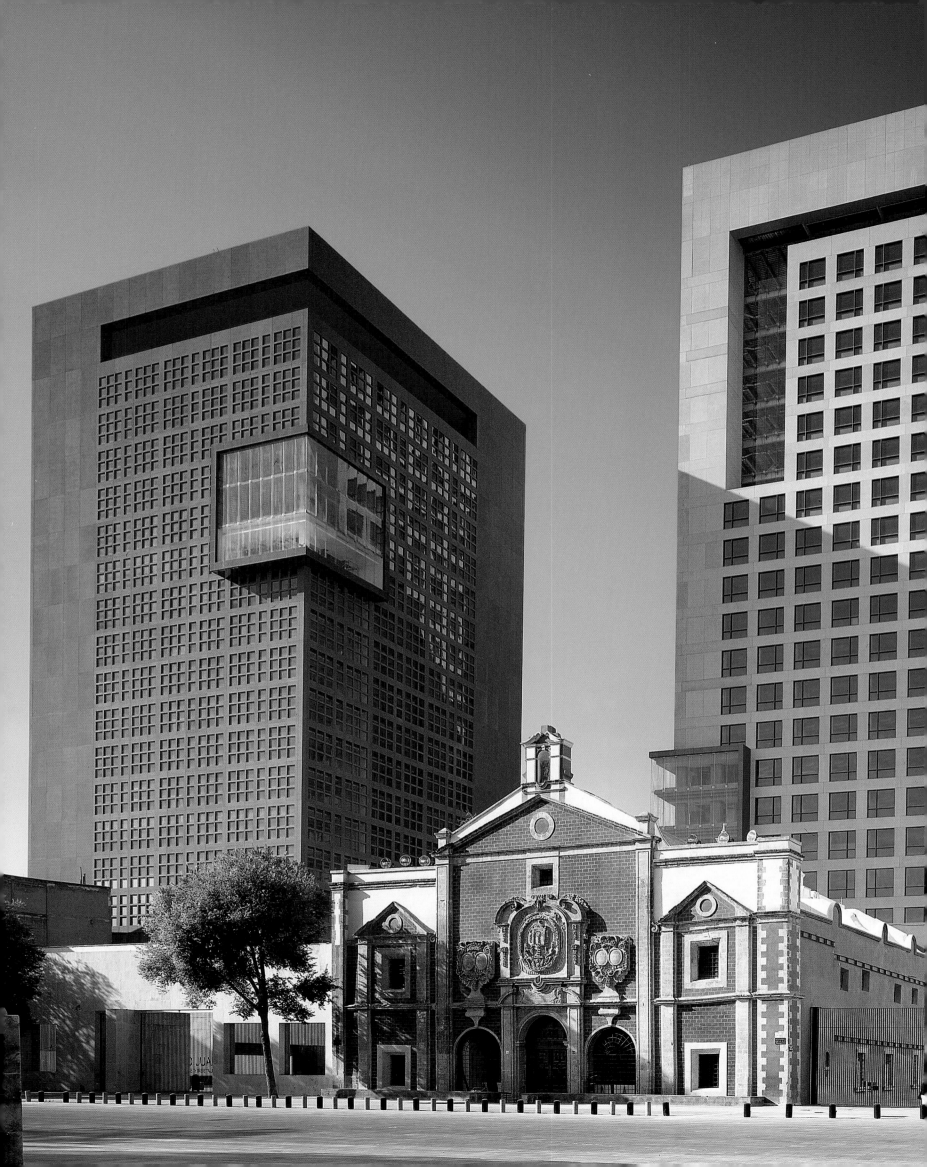

Mach' keine kleinen Pläne ...

Mach' keine kleinen Pläne. Sie haben nicht die Macht, das Blut der Menschen in Wallung zu bringen.
Daniel Hudson Burnham (1846–1912), amerikanischer Architekt

Es gehört zu den ewigen Bedürfnissen von Stadtbewohnern, dass die Räume zwischen den Gebäuden genauso sicher, einladend und funktional sein sollten, wie die Räume innerhalb der Gebäude. Die Umformung dieser leeren, undefinierten Gebiete muss auch natürliche Elemente der Fauna und Flora berücksichtigen und somit die empfindliche ökologische Balance zwischen Mensch und Natur wahren.

Die in *Urban Landscape Design* enthaltenen Projekte zeigen die vielen Vorteile, die inspirierende Landschaftsgestaltung an den unterschiedlichsten geographischen Orten bietet. Die Kapitel umfassen Beispiele der Rückgewinnung und Restaurierung städtischer Einöden für die kommerzielle und künstlerische Nutzung. Verschmutzte Küstenbrachen und Schiffkais werden zu sicheren Häfen für Erholung und Freizeit. Im dicht besiedelten China werden sterile Felder, die Lernorte umgeben, zu Weizen produzierendem Land; ethisch vernünftig und als hybrides Landschaftskonzept ästhetisch ansprechend. Europäische Boulevards und Straßen werden heute mit Bäumen und weiterer Bepflanzung versehen, um den störenden Einfluss des Stadtverkehrs auf das urbane Flair zu mildern. In einem weiteren Beispiel, wie ein Projekt verschiedenen Zwecken dienen kann, wurde eine Brücke, die alte und neue Stadtviertel miteinander verbindet, zugleich als Gedenkstätte eingerichtet. Ebenso wird gezeigt, wie in aufgelassenen Industriegebieten alte Anlagen für neue soziale Zwecke umgenutzt werden, wobei die aufgegebenen Fertigungsstätten zu Arenen für Theatervorstellungen werden, aber ihren historischen und dokumentarischen Wert behalten.

Dank minimaler Eingriffe werden Elemente entfernter Landschaften in begrenzte städtische Grundstücke integriert: Felsen, Fontänen und Bäume erwecken den Eindruck von Bergen, Flüssen und Wäldern in den Städten des 21. Jahrhunderts. Zudem zeigen die vorgestellten Projekte, wie organische Landschaftsgestaltung im Laufe der Zeit wächst, altert und reift und gelegentlich ein Eigenleben entwickelt.

Einige der gezeigten Projekte machen deutlich, wie der moderne Landschaftsarchitekt eine kahle städtische Landschaft wie eine leere Leinwand nutzen kann, auf der er eine Arbeit erschafft, die für sich künstlerische Bedeutung in Anspruch nimmt. Kunstwerke selbst entfalten in der Landschaft große Wirkung. Natürliche und von Menschen gemachte Skulpturen kreieren eine Umgebung, die zum Spielen oder zum ruhigen Verweilen einlädt. Manche Künstler, die in den Genuss kommen, im Freien arbeiten zu können, sind in der Lage, den begrenzten Raum einer Galerie hinter sich zu lassen und Arbeiten zu schaffen, die in ihrer Größe mit denen von altertümlichen Zivilisationen vergleichbar sind.

Viele dieser nachhaltigen Projekte demonstrieren, dass die intelligente und durchdachte Formung und Pflege der Landschaft der Menschheit in viel höherem Maße als ursprünglich angenommen Nutzen bringen kann.

John A. Flannery

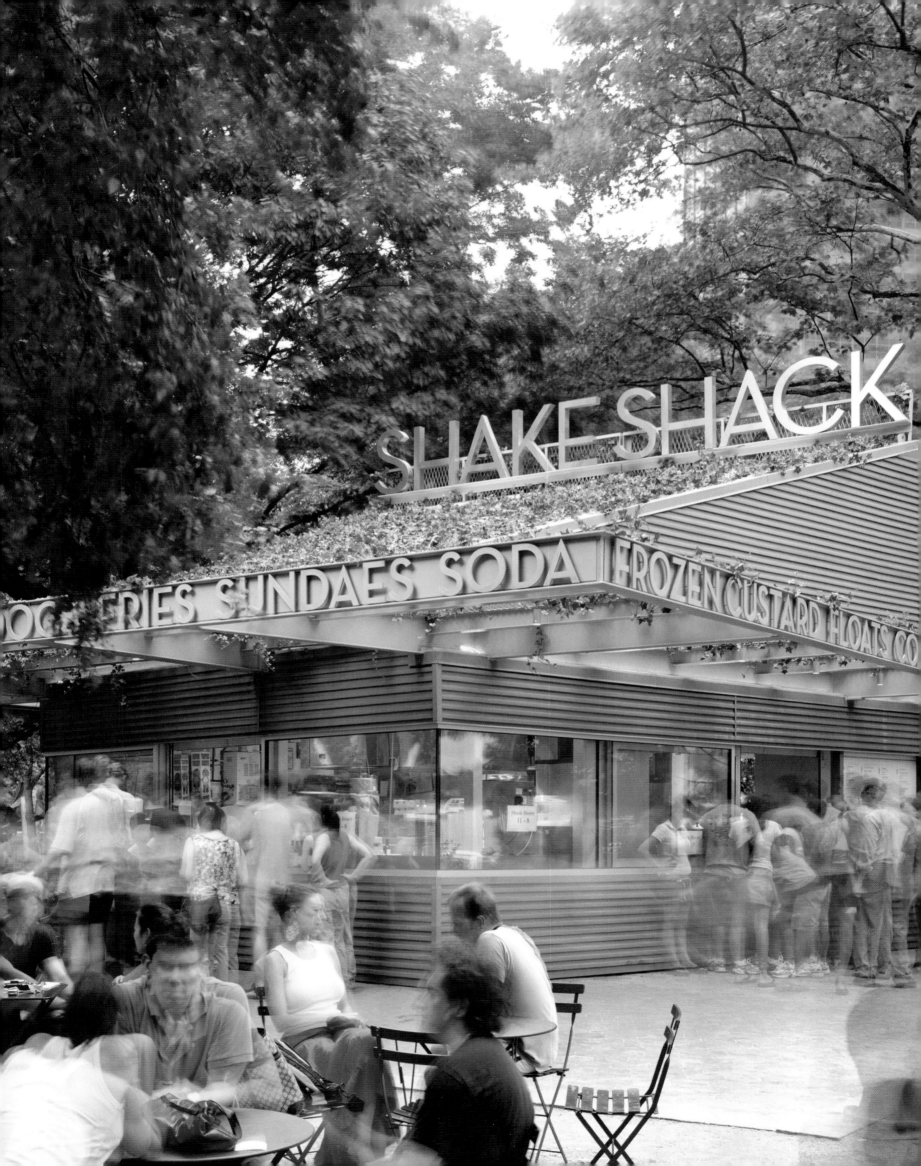

Ne faites pas de petits plans ...

Ne faites pas de petits plans car ils n'ont pas le pouvoir de remuer le sang de l'homme.
Daniel Hudson Burnham (1846–1912), Architecte Américain

Les citadins ont longtemps pensé que les espaces entre les immeubles devaient être des lieux aussi sûrs, accueillants et fonctionnels que les parties intérieures de ces bâtiments. La transformation des territoires vides et indéfinissables doit préserver les éléments naturels liés aussi bien aux plantations qu'à la faune et flore. Elle doit donc maintenir le délicat équilibre écologique entre l'homme et les forces de la nature.

Les projets inclus dans *Urban Landscape Design* cherchent à illustrer tous les bénéfices qu'une activité d'aménagement inspirée peut amener à une grande diversité de sites géographiques. Les chapitres suivants regroupent des exemples montrant comment les terrains vagues urbains sont reconquis et réhabilités dans des buts commerciaux et artistiques. Des rivages pollués à l'abandon ou des bords de quai ont été transformés en havres de paix qui deviennent les lieux parfaits pour se détendre et s'adonner aux loisirs. Dans une Chine densément peuplée, certains terrains stériles entourant des lieux d'apprentissage sont devenus des champs producteurs de récoltes ; pour les deux zones, le fait de privilégier une conception hybride a été à la fois sain d'un point de vue éthique et réussi d'un point de vue esthétique. Les boulevards et rues Européennes sont redéfinis avec des allées d'arbres et des jardins de plantes dans le but de combattre aussi bien l'expérience stressante liée aux déplacements vers le lieu de travail que l'effet envahissant qu'a le système de transport sur l'ambiance des villes. Exemple de la manière qu'a un projet d'avoir plusieurs objectifs, un pont faisant le lien entre les vieux et nouveaux quartiers d'une ville peut aussi faire office de mémorial. Certaines zones urbaines délabrées, dont la reconversion de leurs sites industriels abandonnés en arènes pour spectacles n'a pas pour autant renié leurs valeurs historiques et patrimoniales, sont des exemples qui montrent comment une architecture recyclant le superflu peut revitaliser de tels espaces en leur donnant de nouveaux usages sociaux.

Par le biais d'une intervention minimale, les sites urbains les plus embouteillés peuvent être pourvus d'éléments issus de paysages lointains. En plein cœur des villes du 21ème siècle, la présence de rochers, de fontaines et d'arbres, évoquent une montagne, une rivière ou encore une forêt. Les caractéristiques des projets révèlent, de plus, comment l'architecture paysagiste, en jouant avec la nature organique, continuera, une fois qu'elle est mise en mouvement, à prendre de l'ampleur, à vieillir et à murir, voire éventuellement à vivre sa propre vie.

Certains des projets figurant ici illustrent de quelle manière l'architecture paysagiste moderne peut utiliser un espace urbain aride comme s'il s'agissait d'une toile vide sur laquelle créer un projet au mérite artistique acclamé. L'art lui-même est mis à contribution pour magnifier les paysages. La sculpture, qu'elle soit naturelle ou engendrée par l'homme, crée un environnement qui pourra pourquoi pas stimuler l'envie de s'amuser ou de se détendre à l'abri de son ombre. Certains artistes, lorsqu'il leur est demandé de se confronter à la liberté de création qu'implique un site naturel, se saisissent de cette possibilité pour s'évader des espaces réduits des galeries et produire des œuvres à l'échelle de celles créées il y des siècles par les anciennes civilisations.

Beaucoup de ces développements durables démontrent qu'en façonnant et en faisant éclore le paysage selon une direction réfléchie et sensée, l'humanité récoltera des bienfaits dépassant de loin ceux envisagés au départ.

John A. Flannery

No hacer planes a pequeña escala ...

No hacer planes a pequeña escala ya que no tienen el poder de ilusionar a las personas.
Daniel Hudson Burnham (1846–1912), arquitecto estadounidense

Los habitantes de las ciudades aspiran desde hace mucho tiempo a que los espacios entre los edificios sean tan seguros, acogedores y funcionales como los contenidos por los propios edificios. La transformación de estos territorios vacíos e indefinibles también debe permitir elementos naturales como plantas y animales, manteniendo así el delicado equilibrio biológico entre el hombre y las fuerzas de la naturaleza.

Los proyectos incluidos en *Urban Landscape Design* intentan ilustrar los beneficios múltiples que se obtienen cuando se introduce el paisajismo en emplazamientos geográficos tan distintos. Los distintos capítulos incluyen ejemplos de la reutilización y regeneración de zonas urbanas deprimidas para iniciativas artísticas y comerciales. Litorales y muelles abandonados y contaminados han sido transformados en refugios seguros para actividades recreativas y lúdicas. En la densamente poblada China, los campos baldíos que rodean los lugares de aprendizaje se han convertido en tierras productivas, éticamente válidas y estéticamente agradables como solución híbrida de paisaje. Los bulevares y calles de Europa se flaquean ahora con árboles y plantas en un intento de combatir el estrés de los desplazamientos diarios y el efecto intrusivo de los sistemas de transporte en la atmósfera de la ciudad. Un ejemplo de cómo un mismo proyecto puede servir varios propósitos sería el puente que conecta los barrios viejos y nuevos de una ciudad y que también actúa como monumento conmemorativo. Las zonas industriales en desuso se han visto revitalizadas gracias a la reutilización de edificios abandonados para nuevos usos sociales, como las fábricas en desuso que se utilizan como escenarios para actuaciones, pero manteniendo su valor histórico y testimonial.

Una mínima intervención puede servir para dotar de elementos procedentes de los paisajes más remotos a los sitios urbanos más congestionados. Son las rocas, fuentes y árboles las que ofrecen la sensación de montañas, ríos y bosques en las ciudades del siglo XXI. Es más, los proyectos recogidos muestran cómo continúa creciendo, envejeciendo y madurando la arquitectura de paisajes de naturaleza orgánica, que en algún momento llegará a adquirir vida propia.

Algunos de esos proyectos ilustran bien cómo un moderno arquitecto de paisajes puede utilizar un paisaje urbano estéril cual lienzo en blanco sobre el que crear una obra para la que se reclame mérito artístico. El propio arte se usa en el paisaje con grandes resultados. La escultura, tanto la natural como la realizada por el hombre, crea un entorno que puede estimular la interacción o generar un clima de descanso al cobijo de sus sombras. Algunos artistas, cuando se les concede la libertad de un espacio en el exterior, logran desprenderse de la limitación de tamaño que impone una galería para crear obras comparables en escala con aquellas de las civilizaciones más antiguas.

Muchos de esos desarrollos sostenibles demuestran que la humanidad se beneficiará en mucha mayor medida de la prevista en un inicio si damos forma y alimentamos el paisaje de una forma inteligente y reflexiva.

John A. Flannery

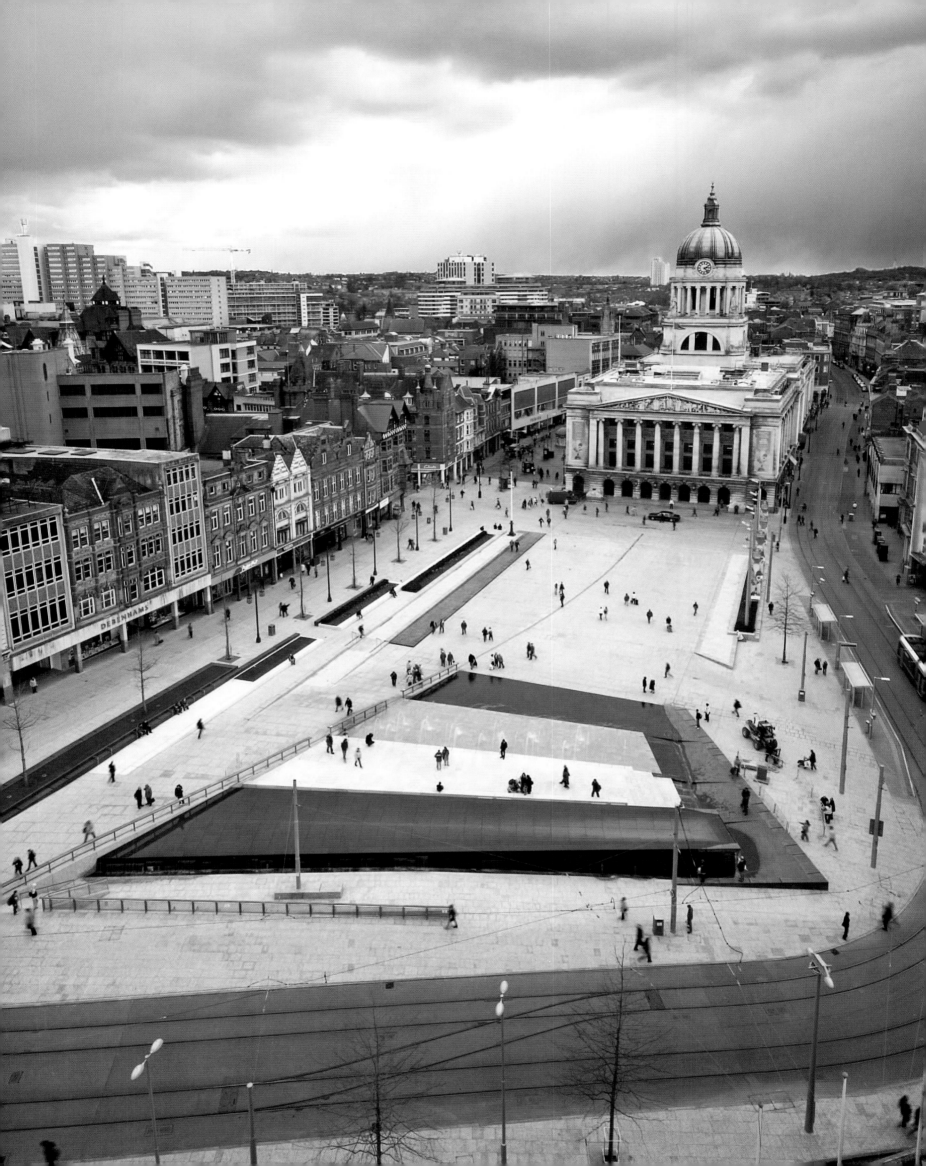

Non fate mai piani di poco conto ...

Non fate mai piani di poco conto; non possiedono la magia che smuove il sangue degli uomini.
Daniel Hudson Burnham (1846–1912), architetto americano

I cittadini da tempo speravano che gli spazi tra gli edifici fossero sicuri, piacevoli e funzionali come gli spazi all'interno degli edifici stessi. La trasformazione di questi territori vuoti e indefiniti dovrebbe essere di sostegno anche a quegli elementi naturali presenti sul territorio come piante e fauna, presevando così il delicato equilibrio biologico tra l'uomo e le forze della natura.

I progetti inclusi nell'*Urban Landscape Design* (piano di progettazione paesaggistica urbana) mirano ad illustrare i benefici che si trarrebbero da degli interventi sul territorio di grande ispirazione naturale nei diversi siti geografici. I capitoli includono esempi in cui aree dismesse cittadine sono state bonificate, restaurate ed infine destinate ad attività artistiche o culturali. Spiagge e baie inquinate e desolate sono state trasformate in paradisi per la ricreazione e l'intrattenimento. Nella popolosissima Cina, campi sterili che circondavano aree scolastiche sono stati trasformati in colture produttive; eticamente corrette ed esteticamente piacevoli, rappresentano la soluzione ibrida perfetta. I viali e le strade di tutt'Europa sono bordati da alberi e piante basse nel tentativo di combattere quello che sarebbe un'estenuante tentativo di mutare il territorio e l'invasività eccessiva dei mezzi di trasporto, tipici di una città. Per riassumere in un esempio come un progetto può servire a diversi scopi, un ponte di collegamento tra i quartieri vecchi e quelli nuovi di una città, funge anche da monumento alla memoria. Aree industriali dismesse sono state riportate alla vita riciclando le parti inutilizzate della vecchia architettura per scopi sociali, trasformando poli industriali in arene artistiche, trattenendone tutto il loro valore storico e culturale.

Con interventi minimi, anche le aree urbane più congestionate possono essere abbellite con elementi di richiamo naturalistico. Rocce, fontane e alberi suggeriscono la presenza di montagne, fiumi e foreste all'interno delle città del XXI secolo. Inoltre, i progetti realizzati rivelano come l'architettura paesaggistica basata sulla natura organica, una volta creata, continua a crescere, maturare, svilupparsi, fino a vivere di vita propria.

Alcuni dei progetti illustrano come l'architettura paesaggistica moderna possa usare un certo paesaggio urbano come una tela bianca su cui creare un lavoro simile ad una vera e propria opera d'arte. La stessa arte è utilizzata per dare enfasi al paesaggio. La scultura, che sia essa naturale o fatta dall'uomo, crea un ambiente che stimola al gioco o al rilassamento alla sua ombra. Alcuni artisti, una volta avuta piena libertà d'azione su un intero spazio, riescono a concepire opere che, seppure in scala, possono eguagliare i capolavori delle civiltà più antiche.

Alcune di queste strutture ecosostenibili dimostrano che plasmare e coltivare il paesaggio in modo saggio e responsabile, darà la possibilità all'uomo di trarre benefici ben maggiori di quelli inizialmente previsti.

John A. Flannery

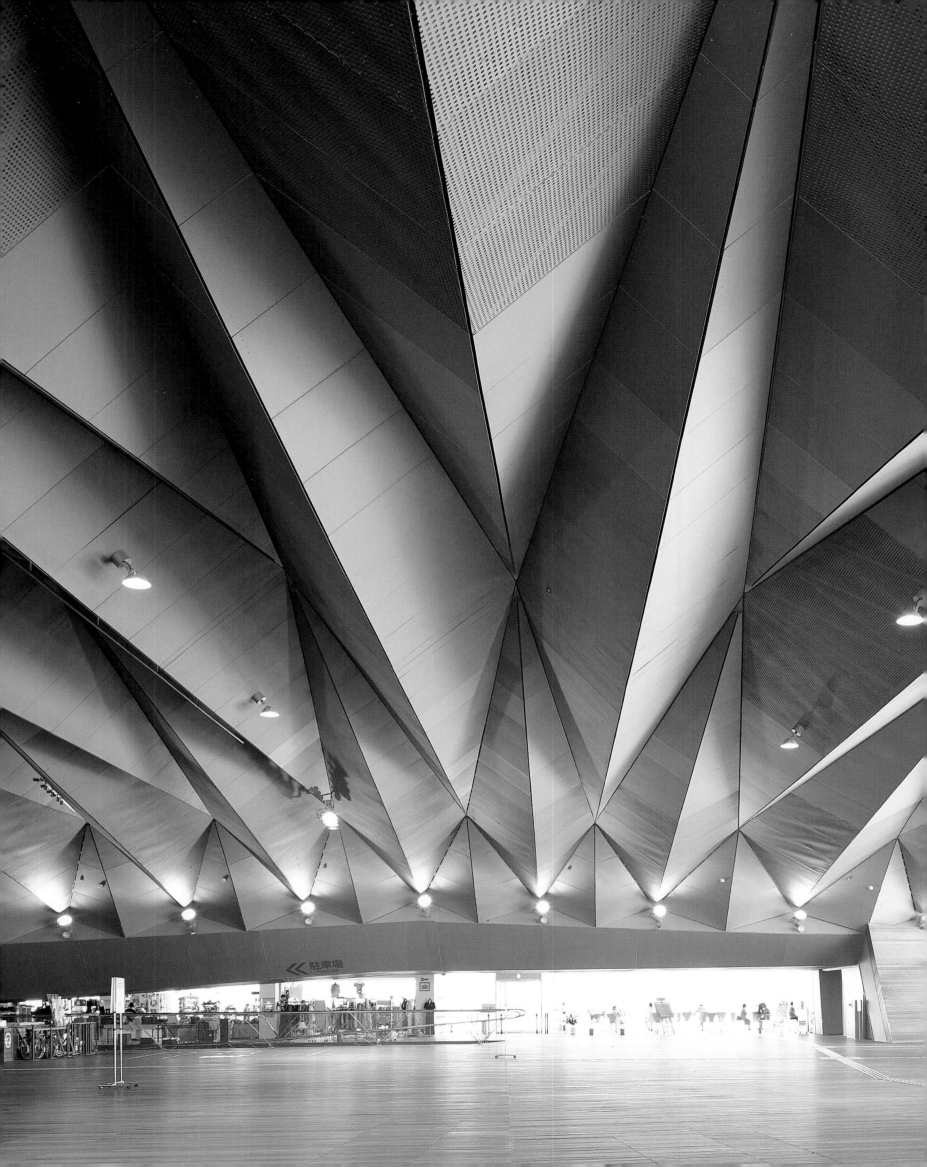

Barrel Warehouse Park

Waterloo, Canada

Barrel Warehouse Park is located near the historic Seagram Distilleries and adjacent to two former barrel warehouses, now converted into condominiums. The design intent of the project was to create a public park reflecting the characteristics of the uptown Waterloo community. A large area of ornamental grasses suggests the fields of grain used in the distilling process while large-scale mechanical artifacts are used as sculptures, redolent of the industrial heritage of the site.

Der Barrel Warehouse Park befindet sich in der Nähe der alten Seagram Spirituosenbrennereien und grenzt an zwei frühere Fasslagerhäuser, die vor kurzem erst zu Eigentumswohnungen umgebaut wurden. Als Gestaltungsidee des Projekts stand die Erstellung eines öffentlichen Parks, der die typischen Eigenschaften des nördlichen Wohnviertel Waterloos reflektieren soll. Ein großer Bereich mit Ziergräsern deutet die für den Destillationsprozess wichtigen Getreidefelder an, während großformatige alte Maschinenteile als Skulpturen dienen und stark an das industrielle Erbe des Orts erinnern.

Barrel Warehouse Park est situé à proximité des Distilleries Seagram et de deux anciens entrepôts de tonneaux, convertis depuis en appartements. L'idée directrice et conceptuelle du projet a été de créer un parc public qui reflète les caractéristiques du quartier résidentiel de la communauté de Waterloo. Une large bande d'herbes ornementales, suggérant les champs de grain utilisés dans le processus de distillation, cohabite avec des objets mécaniques fabriqués à grande échelle et convertis de ce fait en sculptures évoquant l'héritage industriel du site.

Barrel Warehouse Park está situado al lado de la histórica destilería Seagram y junto a dos antiguos almacenes de barriles, ahora reconvertidos en apartamentos. El diseño del proyecto buscaba la creación de un parque público que reflejara las características de la comunidad que habita el centro de Waterloo. Una amplia zona de hierbas ornamentales recuerda los campos de grano utilizados en el proceso de destilación y los grandes artefactos mecánicos que se han dispuesto a modo de esculturas evocan el pasado industrial del lugar.

Il Barrel Warehouse Park è situato vicino alle storiche distillerie Seagram nei pressi dei due ex-depositi di barili, ora convertiti in complessi residenziali. L'intento del progetto era di creare un parco pubblico che riflettesse le caratteristiche della comunità benestante di Waterloo. Un'ampia area di piante ornamentali richiama i campi di grano usati nei processi di distillazione mentre imponenti manufatti meccanici si ergono a mo' di sculture, a porre l'accento sull'eredità industriale del sito.

2001
Janet Rosenberg + Associates
www.jrala.ca

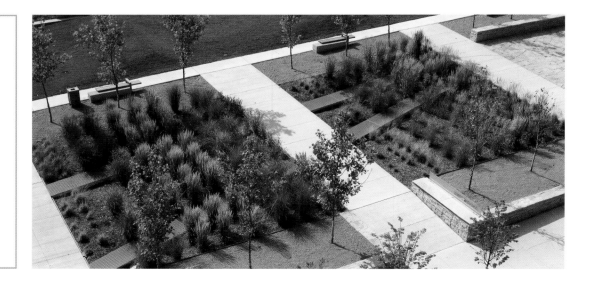

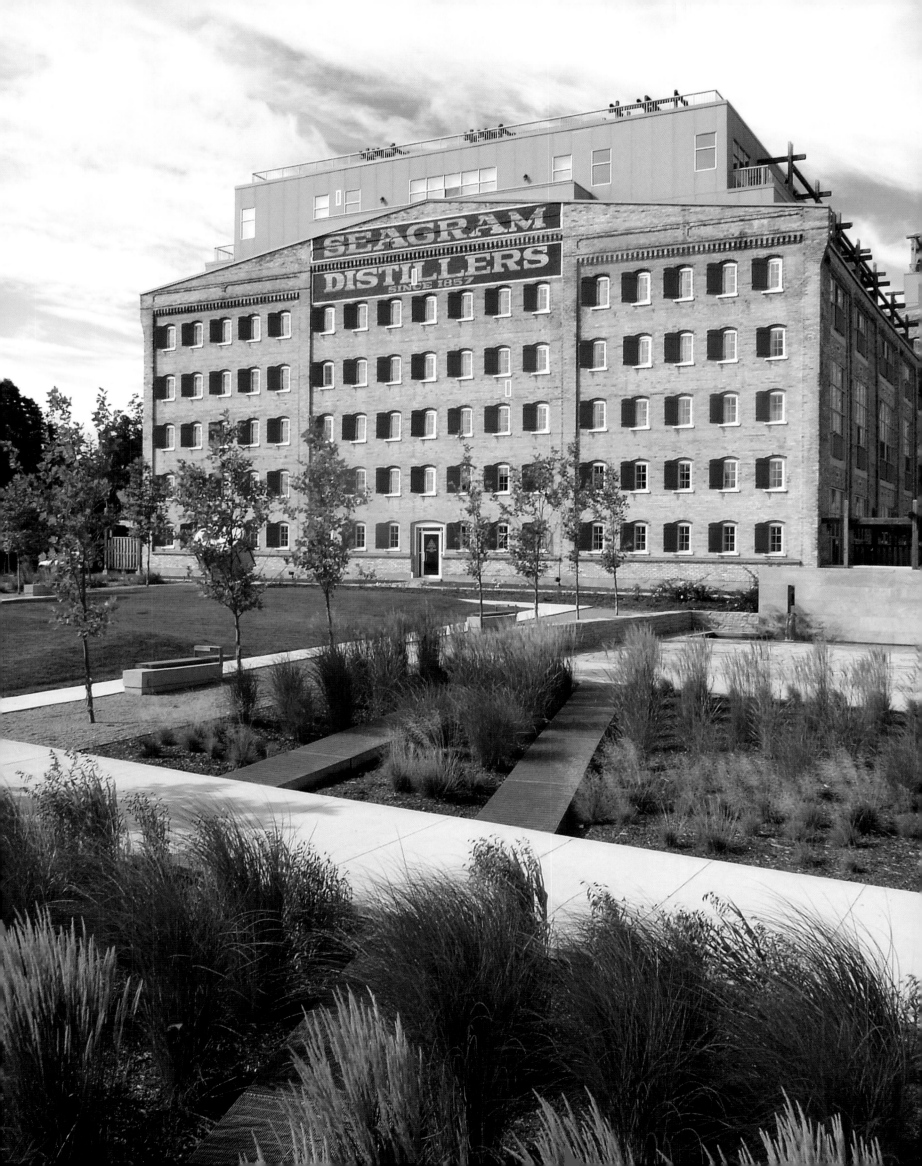

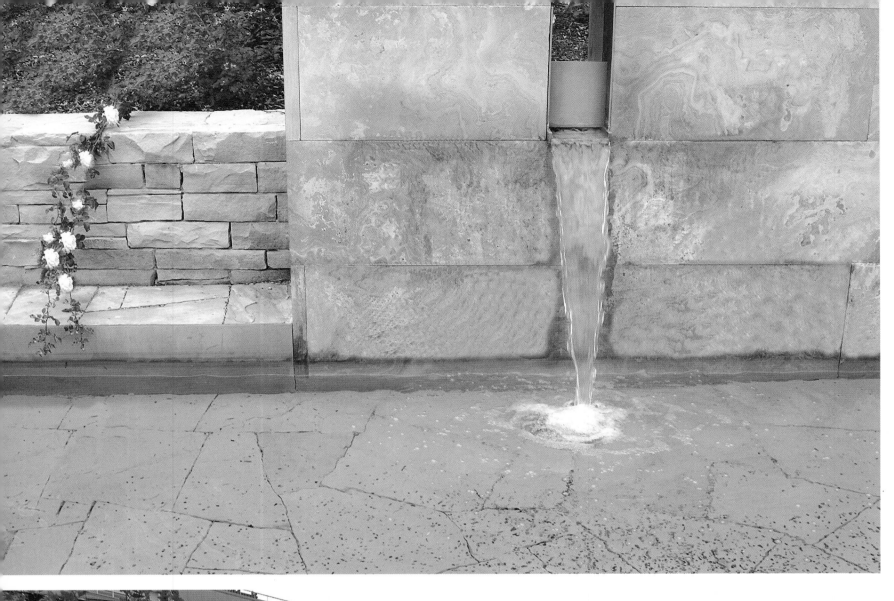

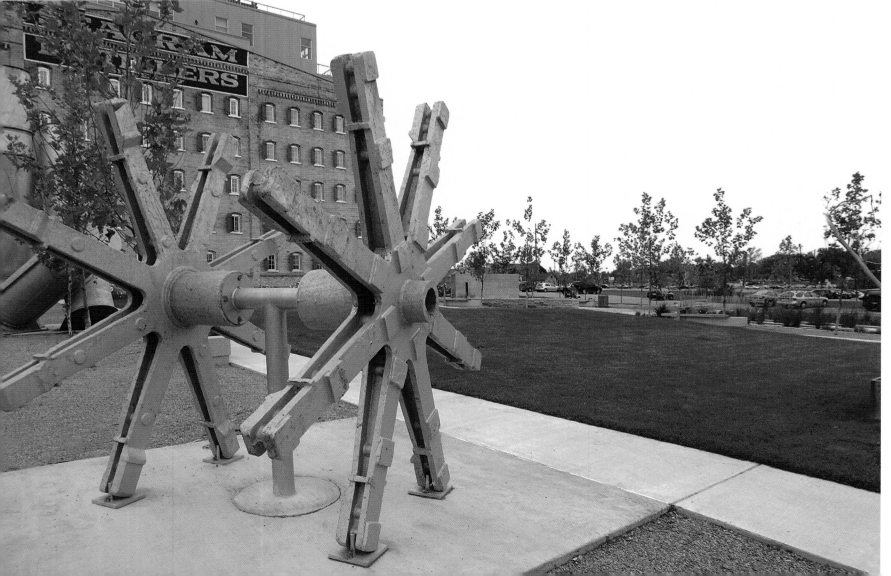

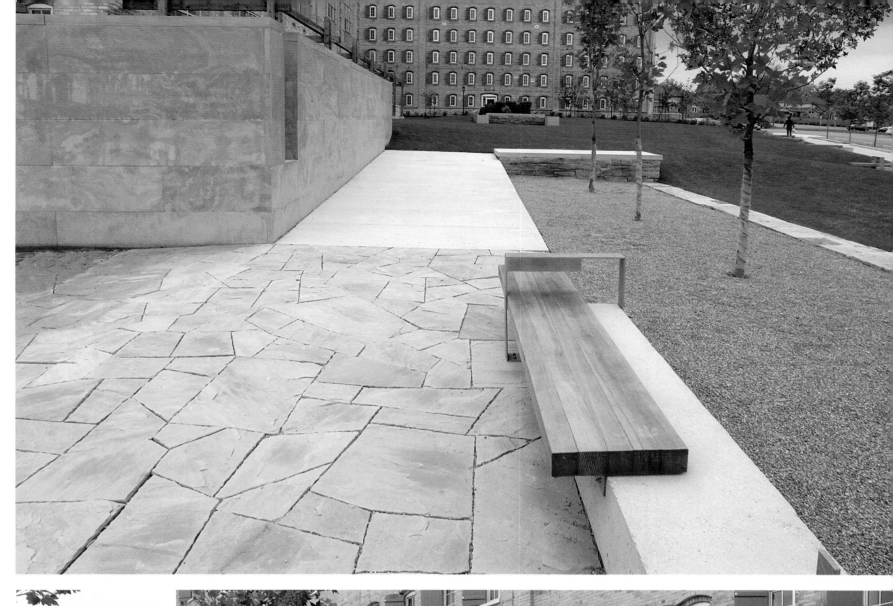
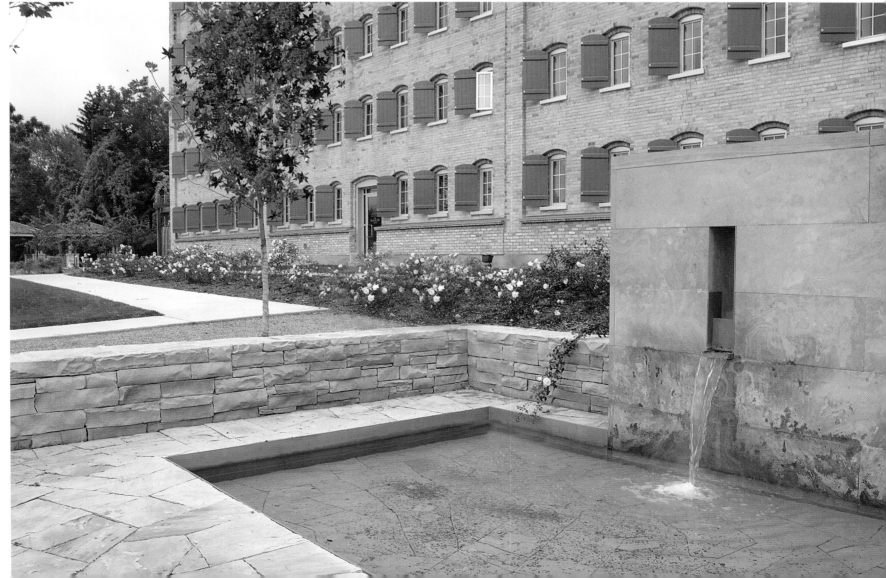

A mixture of traditional and contemporary elements in the design of the park facilitates the transition of the site from industrial to residential use.

Bei der Gestaltung des Parks versinnbildlicht eine Mischung aus traditionellen und zeitgenössischen Elementen den Übergang des Geländes vom Industriegebiet zum Wohngebiet.

Un mélange d'éléments traditionnels et contemporains définit donc le design du parc et facilite la reconversion d'un site au passé industriel en une zone à usage résidentiel.

La mezcla de elementos tradicionales y contemporáneos presentes en el diseño del parque facilita la transición de un uso industrial a otro residencial.

La fusione degli elementi contemporanei a quelli tradizionali utilizzata nel progetto del parco, contribuisce alla transizione del sito da zona industriale ad area residenziale.

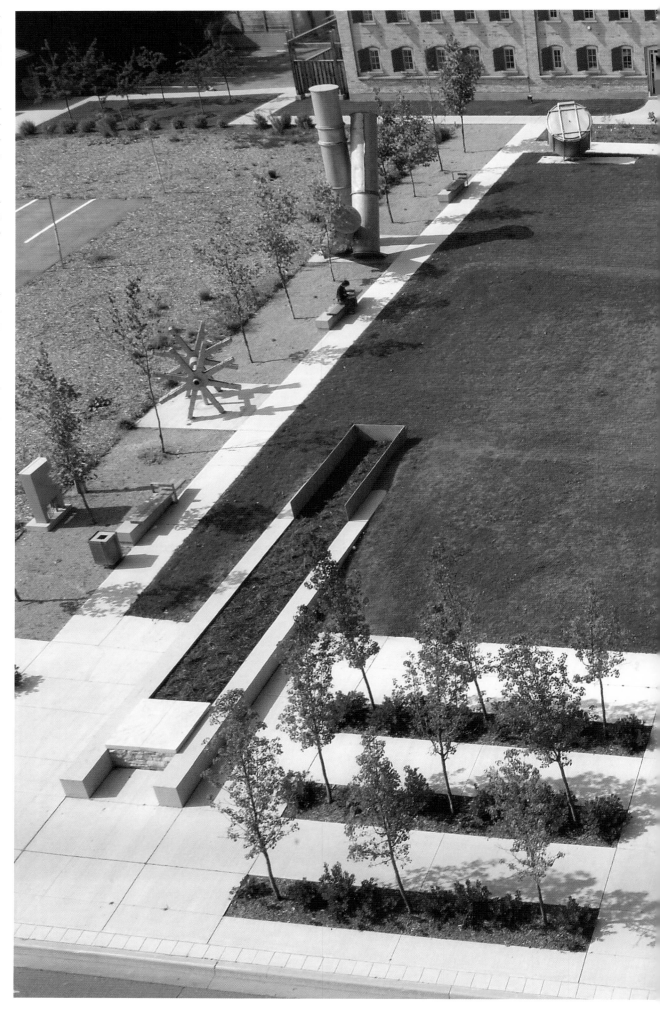

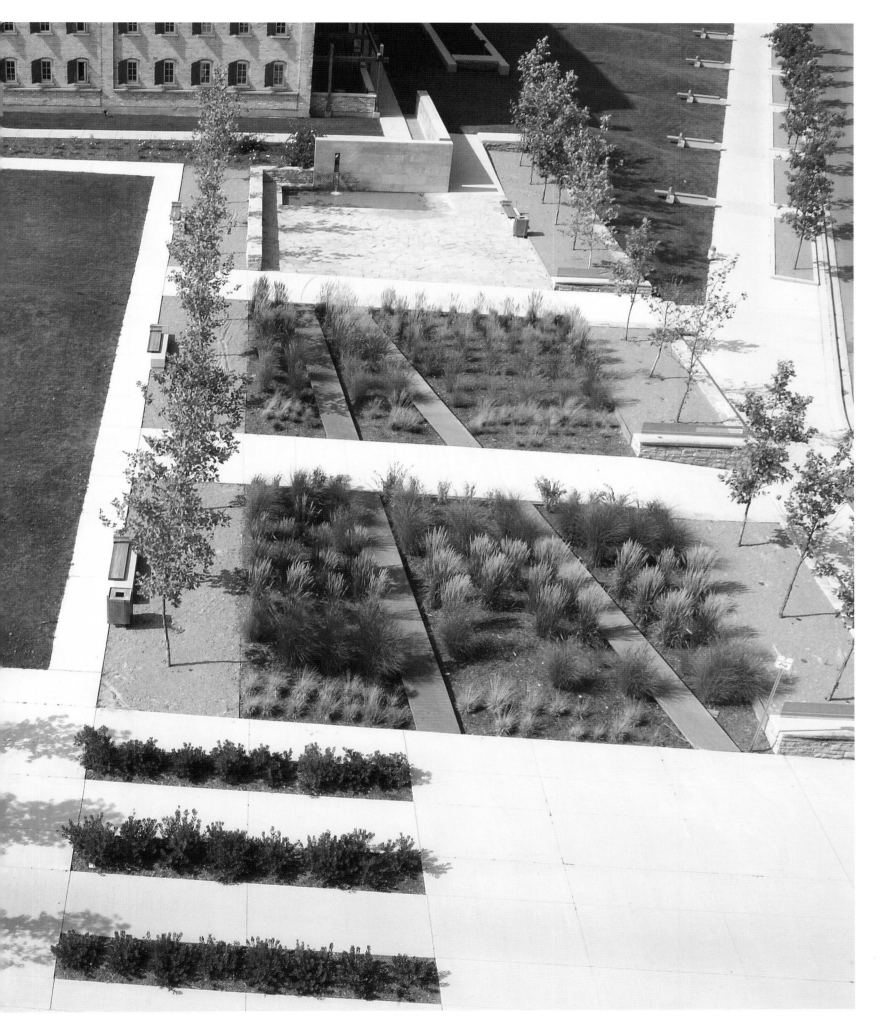

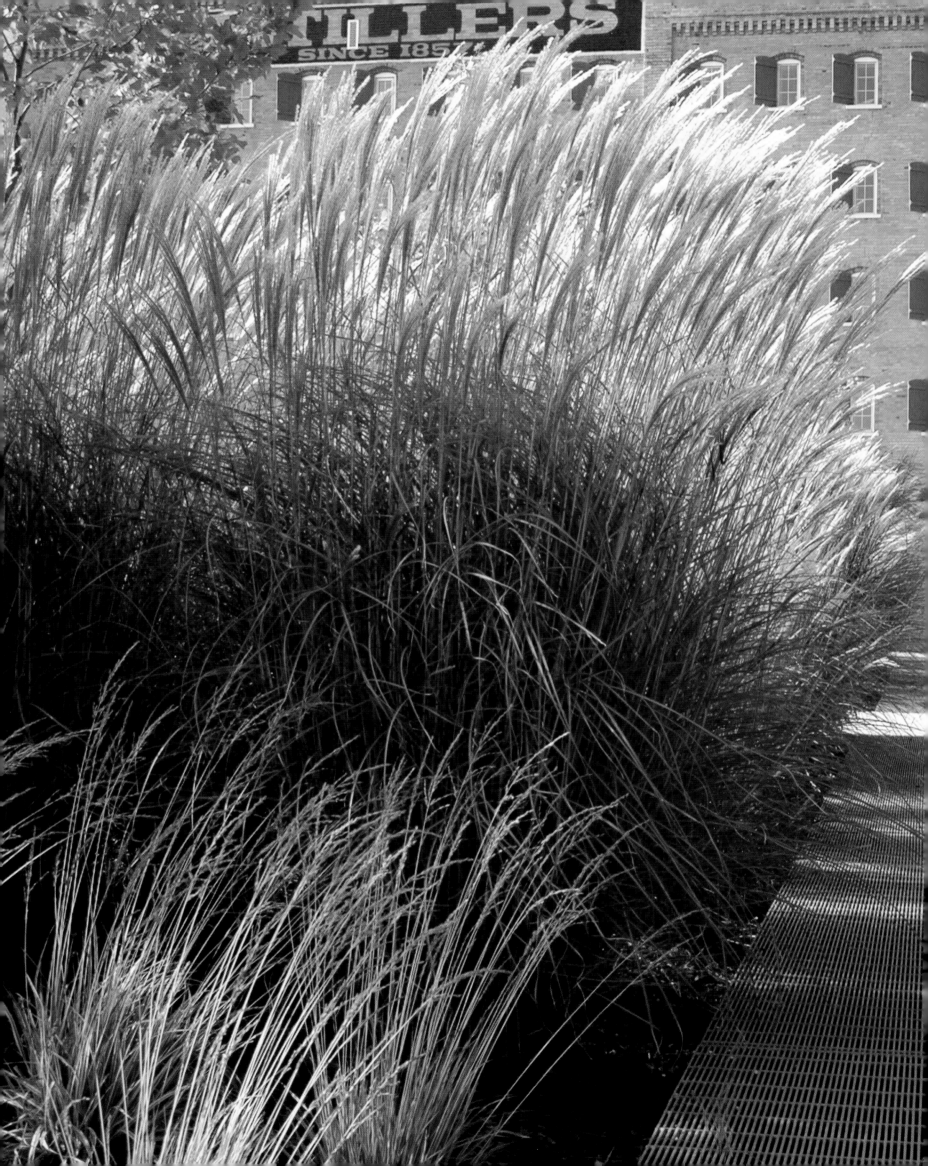

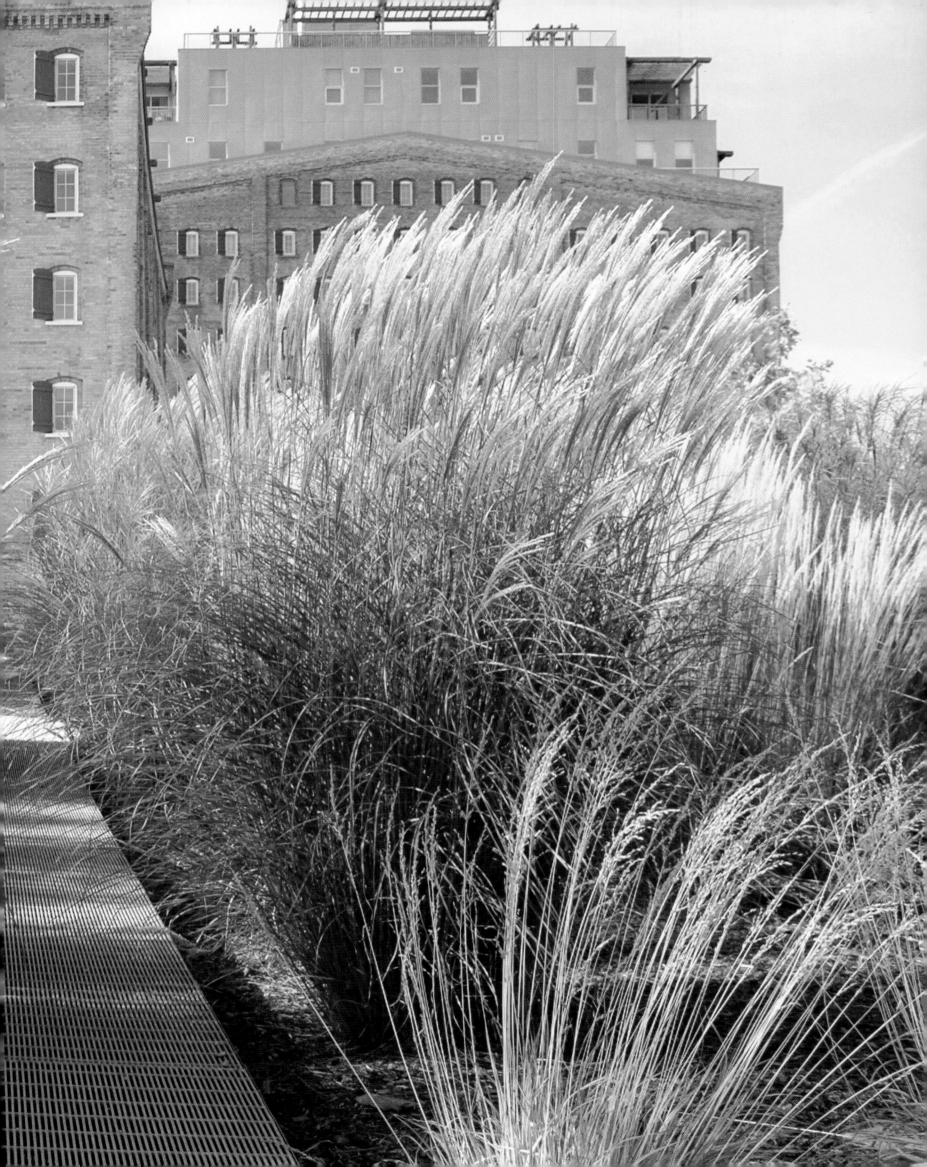

Centro Tecnológico de La Rioja

Logrono, Spain

Located on the outskirts of Logrono, the technology center borders the Iregua River, a tree nursery and a hospital for endangered indigenous animals. The designer's primary objective was to make the building complex an integral part of the landscape in an effort to retain the site's natural beauty. The site will become a part of the metropolitan park system. This will include a major commercial center, a housing development and a water purifying plant to cope with the proposed high density urbanization.

Mit seinem Standort am Stadtrand von Logrono grenzt das Technologiezentrum an den Fluss Iregua, eine Baumschule und ein Krankenhaus für gefährdete heimische Tiere. Die Hauptaufgabe des Gestalters war es, den Gebäudekomplex zu einem integralen Bestandteil der Landschaft zu machen, um die natürliche Schönheit des Ortes zu erhalten. Die Anlage wird ein Teil des städtischen Parksystems mit einem großen Einkaufszentrum, Wohnbebauung und einer Kläranlage werden, um mit der prognostizierten beschleunigten Verstädterung mitzuhalten.

Situé dans la banlieue de Logroño, le centre technologique borde la rivière Iregua, une pépinière et un hôpital pour animaux autochtones en danger. L'objectif principal de l'architecte a été de faire du complexe une part intégrante du paysage et de conserver ainsi la beauté du site naturel. Il est prévu que le ce dernier devienne une partie du complexe de jardin public urbain qui inclura un grand centre commercial, un ensemble immobilier et une usine de purification d'eau et fera ainsi face à une urbanisation à forte densité.

Situado a las afueras de Logroño, el centro tecnológico está situado junto al río Iregua, un vivero de árboles y un centro de recuperación de especies animales protegidas. El principal objetivo del diseñador fue integrar el complejo de edificios en el paisaje, en un esfuerzo por conservar la belleza natural del lugar. Este emplazamiento pasará a formar parte del sistema metropolitano de parques, que incluirá un gran centro comercial, una zona residencial y una planta depuradora de aguas para abastecer la alta densidad de la zona que se piensa urbanizar.

Situato alla periferia di Logrono, il centro tecnologico sorge in prossimità del fiume Iregua, di un vivaio forestale e di una clinica veterinaria per la cura delle specie animali locali. L'obiettivo principale dell'architetto era di fondere il complesso edilizio con il territorio circostante, così da preservare il più possibile la bellezza naturale del luogo. Quest'area diventerà parte del sistema metropoliano di parchi che si comporrà di un centro commerciale principale, di un complesso residenziale e di un impianto per la purificazione dell'acqua creato per far fronte all'enorme richiesta di urbanizzazione.

2007
Foreign Office Architects
www.f-o-a.net

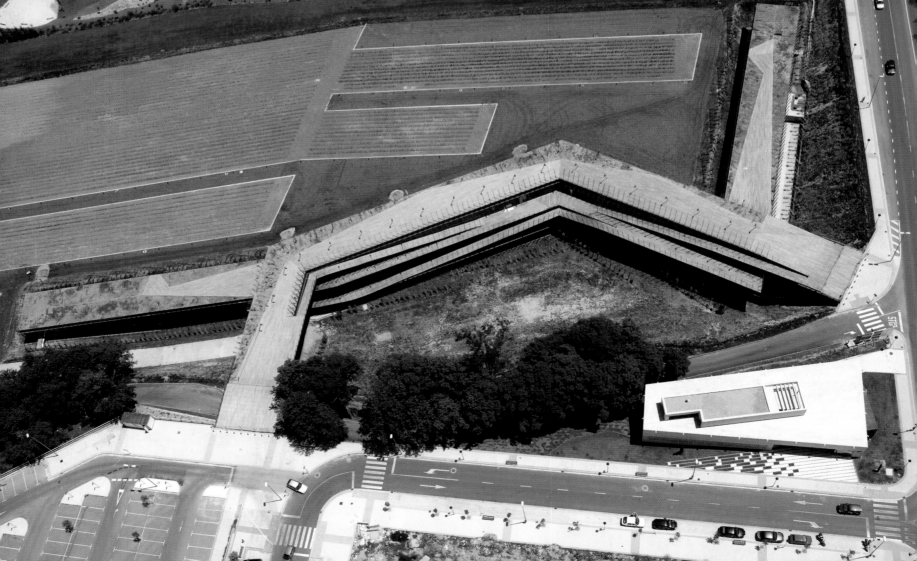

The building's linear structure maximizes the surface contact with the outdoors.

Die lineare Struktur des Gebäudes maximiert den Oberflächenkontakt mit dem Äußeren.

La structure linéaire du bâtiment maximise le contact avec l'extérieur.

La estructura lineal del edificio aprovecha al máximo la superficie de contacto con el exterior.

La struttura lineare del complesso va a massimizzare il contatto tra la superficie e l'esterno.

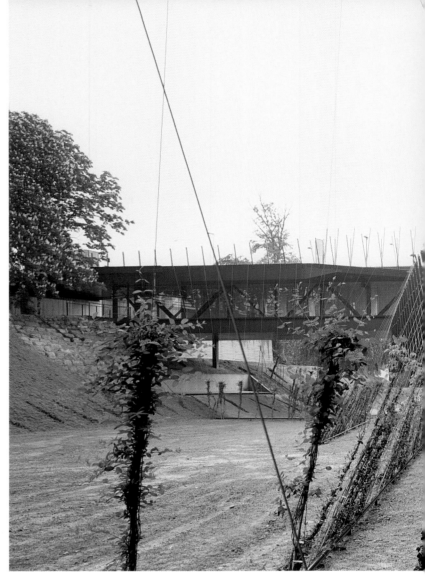

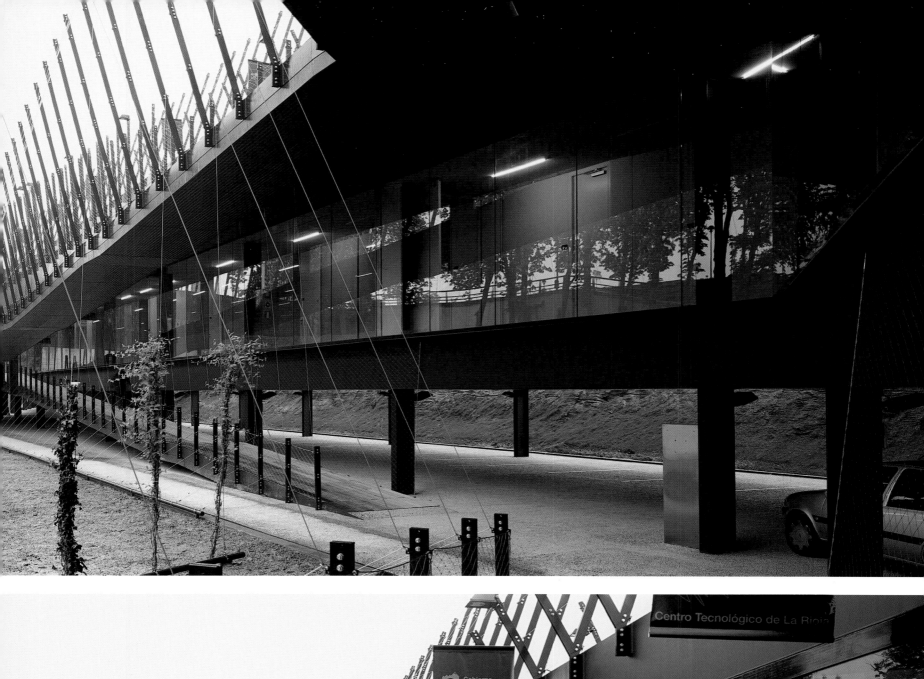
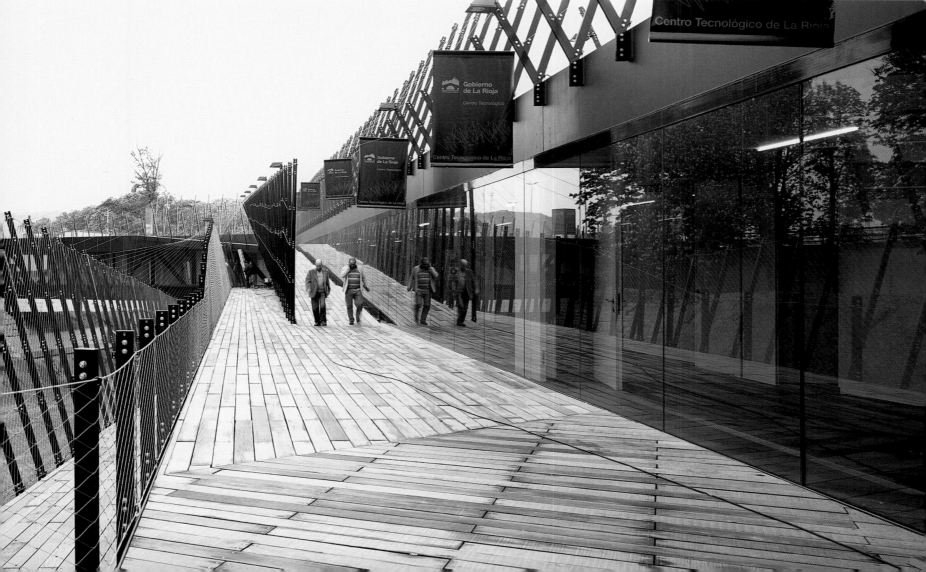

To minimize impact on the landscape the ribbon-shaped structure runs parallel to the topographical cornice that forms the western edge of the site. By surrounding the elms along the Camino de los Lirios the building envelopes the natural slope as an internal garden.

Um die Landschaft möglichst wenig zu beeinträchtigen, verläuft das Gebäude in der Form eines Bandes parallel zu einer topographischen Kante, welche den westlichen Abschluss des Geländes bildet. Durch das Umschließen der Ulmen entlang des Camino de los Lirios umgibt das Gebäude die natürliche Geländesteigung wie einen Innenhof.

Afin de minimiser l'impact sur le paysage, la structure en ruban à la forme de L s'étend en parallèle de la corniche topographique qui forme le recoin ouest du site. Le bâtiment, encerclant les ormes qui se trouvent le long du Camino de los Lirios, semble envelopper la pente naturelle tel un jardin éternel.

Para minimizar el impacto en el paisaje, su estructura lineal corre paralela a la cornisa topográfica que conforma el límite oeste del emplazamiento. Esta ubicación permite al edificio rodear los olmos situados a lo largo del Camino de los Lirios, envolviendo la pendiente natural como un jardín interno.

Per ridurre al massimo l'impatto sul territorio, questa struttura a forma di fiocco rimarrà parallela alla cornice topografica che compone la sommità ovest del sito. L'edificio sembra custodire la roccia naturale in un giardino interno grazie al perimetro di olmi che corre intorno al Camino de los Lirios.

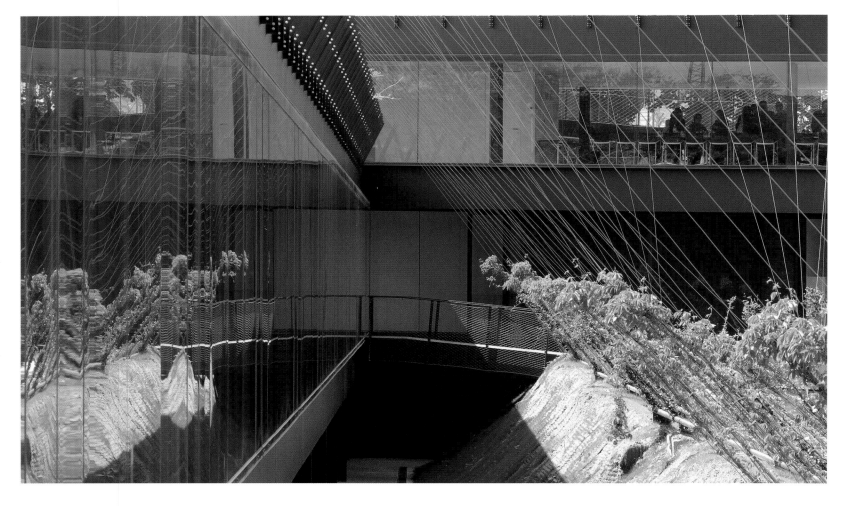

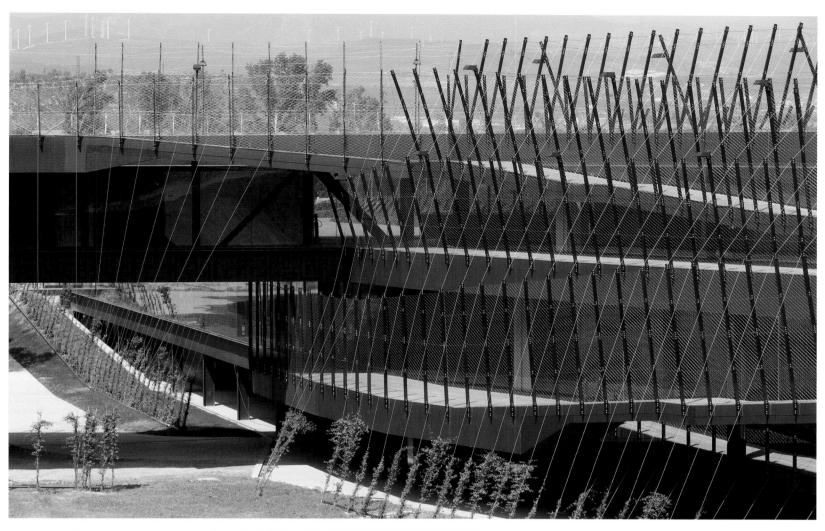

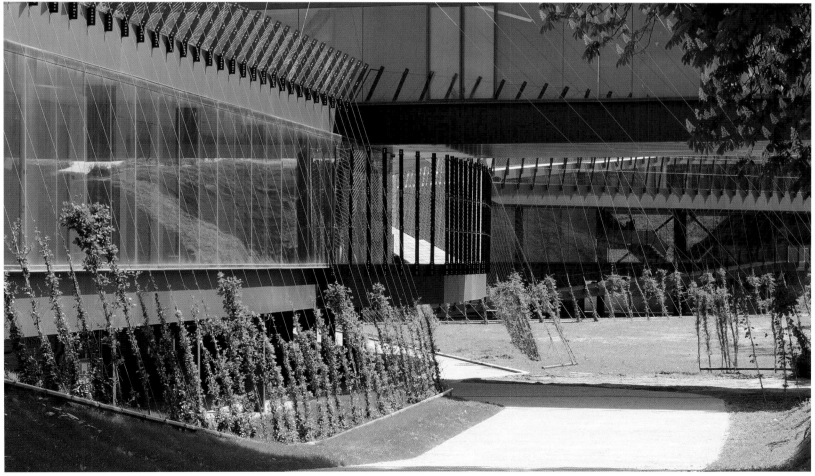

Diana, Princess of Wales Memorial Fountain

London, England

This permanent memorial to the Princess appropriately combined both traditional and contemporary methods of construction. The modeling of the 2,500 square-feet watercourse challenged the expertise of all involved. Diana's life is epitomized in the "Reaching Out—Letting In" concept of the design. The varied features of the oval water fountain include Steps, Rock and Roll, Swoosh, Mountain Stream, Bubbles, Chadder and The Reflective Pool. All are created by the special surface textures carrying the oval of water as it flows around the verdant contours of Hyde Park.

Dieser dauerhafte Gedenkplatz für die Prinzessin vereint in angemessener Art und Weise traditionelle und zeitgenössische Konstruktionsmethoden. Die Gestaltung des 230 Quadratmeter großen Wasserlaufs forderte die Erfahrung aller Beteiligten. Dianas Leben wird durch das Designkonzept „Hinausreichen – Hereinlassen" verkörpert. Die verschiedenen Modi des ovalen Brunnens heißen Stufen, Rock & Roll, Rauschen, Bergbach, Luftblasen, Chadder und Spiegelteich. Sie werden alle durch besondere Oberflächenstrukturen produziert, die das Wasser des Ovals während seines gewundenen Wegs durch die grünen Konturen des Hyde Parks dirigieren.

Ce mémorial permanent dédié à la Princesse a été érigé en combinant de manière appropriée des méthodes de construction traditionnelles et contemporaines. La mise en forme des 230 mètres carrés de cours d'eau a défié les compétences de tous les collaborateurs. La vie de Diana est incarnée dans le concept de « Tendre le bras – Laisser entrer » ayant présidé le projet. Parmi les différentes particularités de la fontaine ovale, on peut retenir la présence d'Échelons, de Torrents de Montagne, de Bouillonnements, d'un Chaddar et d'une Piscine Miroitante. Tous ces éléments ont été créés avec des textures de surface spéciales permettant à l'eau de couler dans l'ovale qui entoure les contours verdoyants d'Hyde Park.

Este monumento conmemorativo de la princesa combina de modo apropiado los métodos tradicionales y contemporáneos de construcción. El modelado de este curso de agua de 230 metros cuadrados constituyó un reto para todos los participantes en el proyecto. La vida de Diana queda muy bien resumida en su concepto de diseño "Tender la mano – Dejar participar". Entre los distintos elementos de la fuente oval se encuentran los Escalones, el Rock and Roll, el Swoosh, el Arroyo de la Montaña, las Burbujas, el Chadder y el Estanque Reflejante. Todos los elementos son producto de las diferentes texturas especiales de la superficie del óvalo de agua durante su curso a lo largo de las suaves pendientes verdes de Hyde Park.

Questo monumento alla memoria della Principessa ha voluto combinare tecniche di costruzione moderne e tradizionali. La plasmatura del corso d'acqua di circa 230 metri quadrati ha messo a dura prova le abilità degli addetti ai lavori. La vita di Lady Diana è simboleggiata con il concetto del "Dare – Ricevere", ben evidente nel progetto. Tra le diverse caratteristiche della fontana ovale, troviamo Gradini, Giochi d'Acqua, Correnti, Ruscelli, Bolle, Chadder e Piscina Riflettente. Tutto ciò ricreato dalla particolare intessitura della superficie che fa scorrere l'acqua in questo percorso ovale nel verdissimo scenario di Hyde Park.

2004
Gustafson Porter Ltd
www.gustafson-porter.com

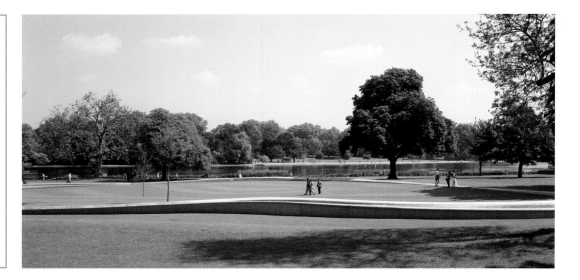

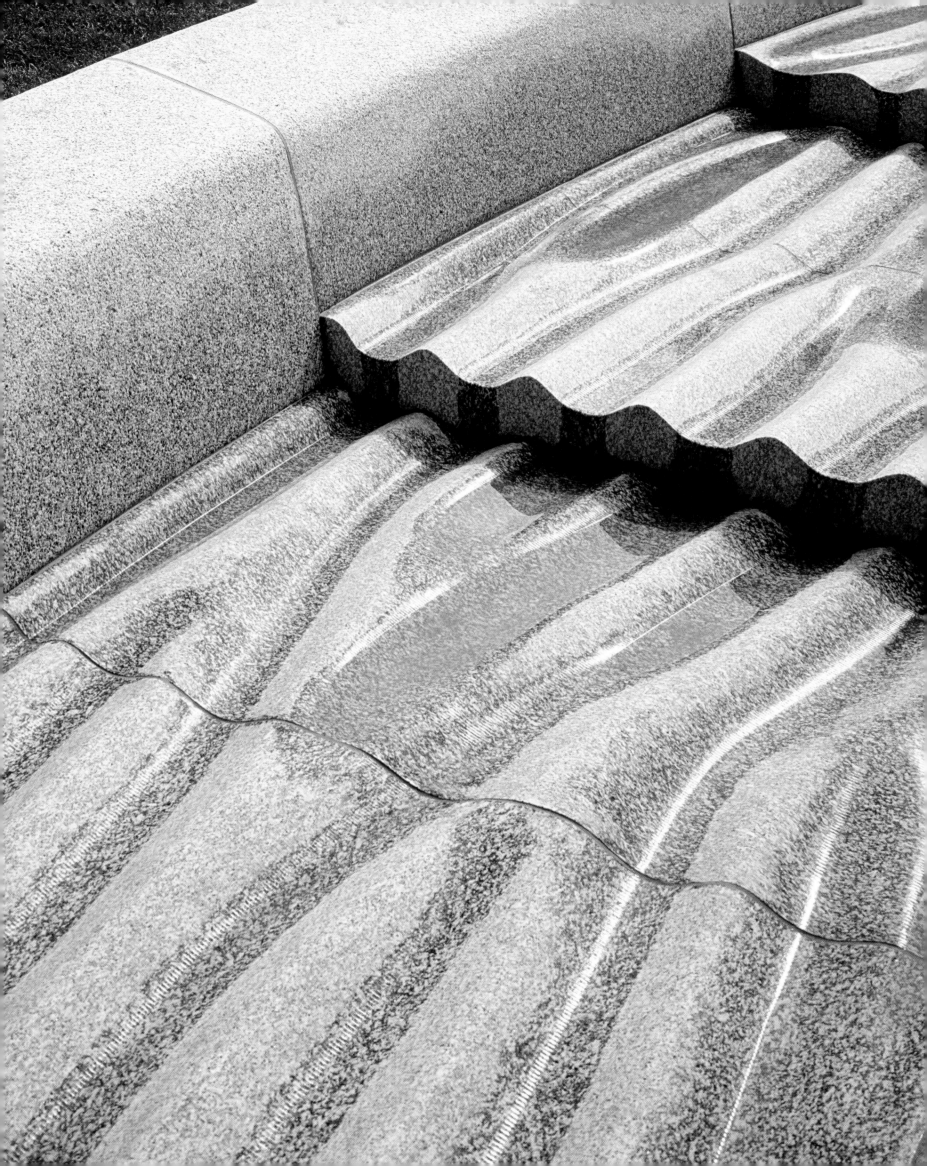

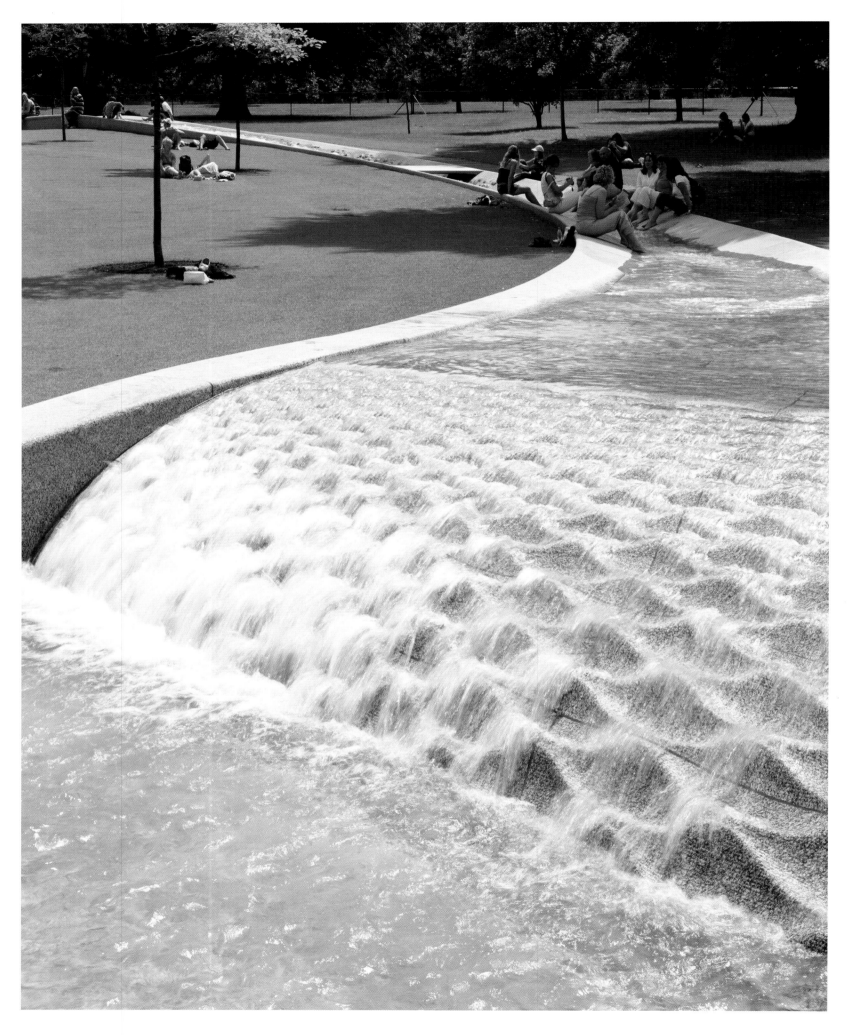

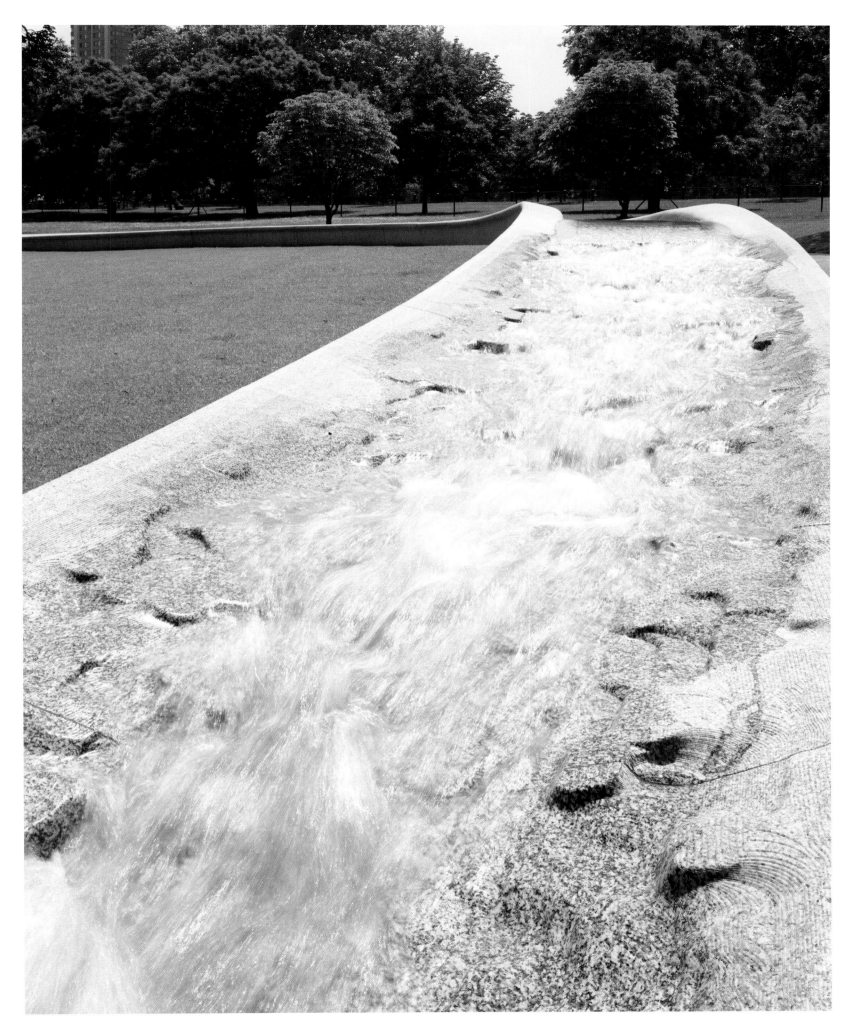

Diana, Princess of Wales Memorial Fountain | London | England **33**

De Lank granite from Cornwall was chosen for its hardwearing and non-porous qualities. Additionally its unique light coloring highlights the sparkling quality of the water on its circulatory course.

De-Lank-Granit aus Cornwall wurde aufgrund seiner widerstandsfähigen und nicht porösen Gestalt ausgewählt. Zusätzlich betont seine besonders helle Farbe die Eigenschaft des Sprudelns des Wassers auf seinem Rundkurs.

Le granit De Lank, originaire des Cornouailles, a été choisi pour ses qualités de résistance et de non-porosité. En outre, sa teinte unique et colorante permet de refléter la brillance de l'eau durant sa course circulaire.

El granito De Lank, de Cornualles, fue elegido por su resistencia y ausencia de porosidad. Además, su singular color claro resalta el movimiento del agua a lo largo de recorrido.

Il granito De Lank della Cornovaglia fu scelto per la sua particolare durezza non porosa, oltre all'unicità del suo colore che risalta la lucentezza dell'acqua che scorre in modo circolare.

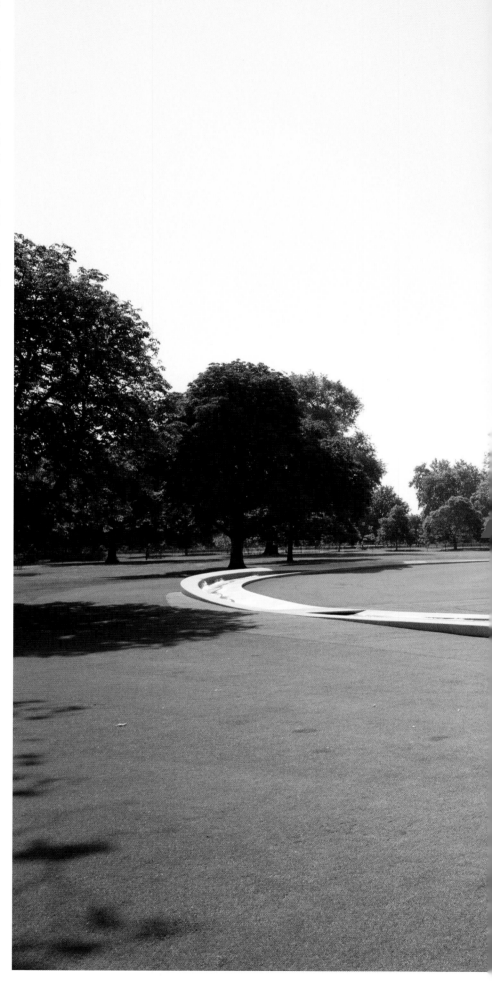

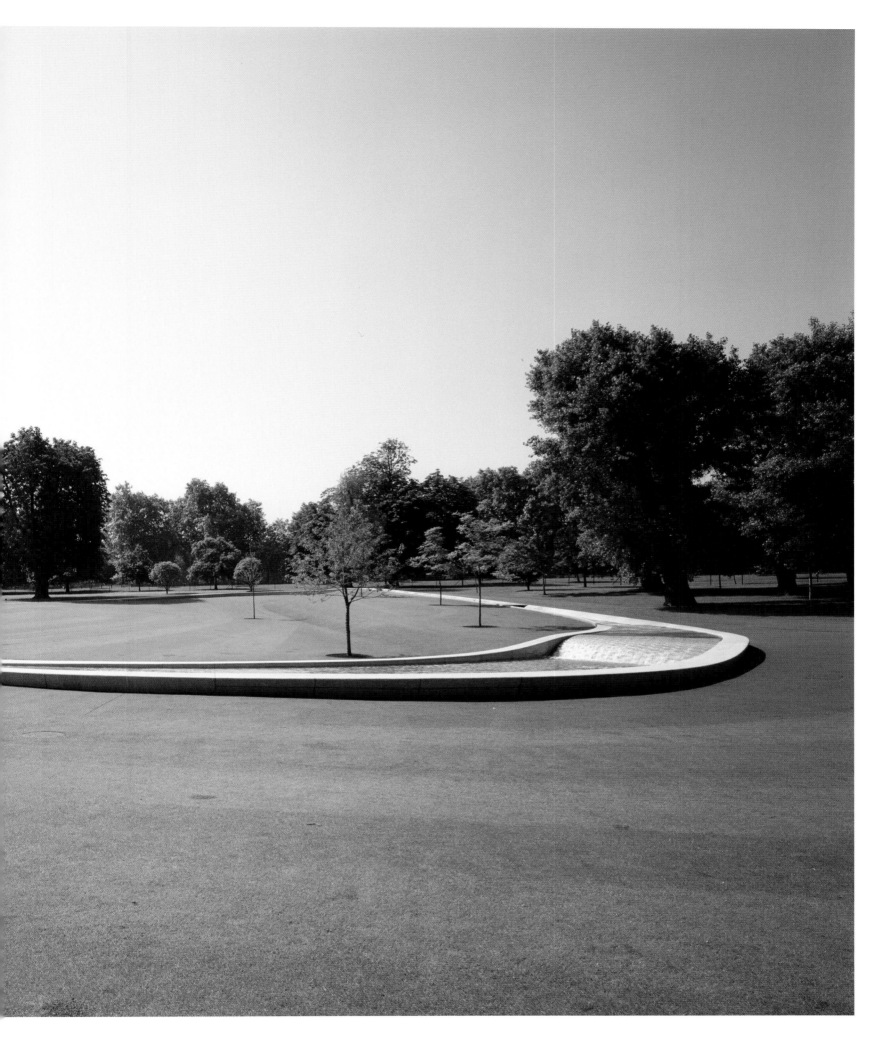

Dujiangyan
Water Culture Plaza
Dujiangyan City, China

The requirements for Dujiangyan were to provide a public open space for both local residents and tourists that relates to the cultural and historical legacy of the city. The legend of Li Bin's pioneering techniques of water management to increase the land's fertility and the surrounding field patterns are reflected in the layout. Important art works including the gold canopy are integrated into the exercise areas. Fountains designed for play, and areas set aside for card games complete the recreational feel of the plaza.

Die Anforderung an Dujiangyan war die Bereitstellung eines öffentlichen Platzes für Einheimische und Touristen, der mit dem kulturellen und historischen Vermächtnis der Stadt in Zusammenhang steht. Li Bins legendäre Pioniertechniken der Wasserbewirtschaftung zur Erhöhung der Fruchtbarkeit des Landes und der umgebenden Felder spiegeln sich in der Gestaltung wider. Wichtige Kunstwerke, wie beispielsweise der goldene Baldachin, sind in die Übungsbereiche integriert. Zum Spielen einladende Fontänen und abgelegene Bereiche für Kartenspiele komplettieren den Erholungscharakter des Platzes.

Le concept utilisé dans le cas de Dujiangyan était de proposer un espace public ouvert aussi bien aux résidents locaux qu'aux touristes qui relate le legs culturel et historique de la ville. La légende des techniques pionnières de Li Bin concernant la gestion de l'eau et ayant permis d'accroitre la fertilité des terres et de redéfinir les modèles de champs environnants, est reflétée dans l'agencement. D'importantes œuvres d'art, dont la voute dorée, sont intégrées dans les zones prévues pour l'exercice. Des fontaines conçues pour s'amuser et des zones de jeux de cartes situées de côté contribuent à l'atmosphère récréative de la place.

En Dujiangyan era necesario proporcionar un espacio público y abierto a los residentes locales y turistas que estuviera relacionado con el legado histórico y cultural de la ciudad. En el diseño se reflejan la leyenda de las técnicas innovadoras de Li Bin en gestión del agua para mejorar la fertilidad del terreno y las formas de los campos circundantes. En las zonas de ejercicios se han integrado importantes obras de arte, incluida la cubierta dorada. Completan el aspecto recreativo de la plaza las fuentes pensadas para el juego y las áreas destinadas a juegos de cartas.

La priorità di Dujiangyan era di fornire uno spazio aperto a residenti e turisti che potesse fare da simbolo al forte legame culturale e storico con la città. Anche le leggendarie tecniche di Li Bin nella gestione dell'acqua per incrementare la fertilità della terra e la disposizione dei campi circostanti, sono stati inclusi nel progetto. Gli importanti interventi artistici, inclusa la cupola dorata, si fondono nell'area esercizio. Le fontane progettate per giochi d'acqua e zone poste un po' in disparte dove poter giocare a carte, completano lo scenario ricreativo della piazza.

2002
Turenscape (Beijing Design Institute)
www.turenscape.com

The golden canopy is an environmental art feature inspired by the rape seed blossom which dominates the surrounding landscape in the warm spring. The canopy also provides shade for festival musicians.

Der goldene Baldachin ist ein Kunstelement des Außenbereichs, das durch die Rapsblüte inspiriert wurde, welche im warmen Frühling die umgebende Landschaft dominiert. Die Überdachung bietet auch den Festivalmusikern Schatten.

La voûte dorée est un exemple d'art environnemental particulier inspiré par les plants de colza en fleurs qui dominent le paysage environnant durant la chaleur du printemps. Elle procure de plus une zone d'ombre pour les musiciens jouant au cours des fêtes.

La cubierta dorada es una pieza de arte medioambiental inspirada en la floración de la colza que domina los paisajes circundantes en la cálida primavera. La cubierta también proporciona sombra a los músicos del festival.

La volta dorata è una scultura ispirata alla colza, vera protagonista del paesaggio locale nelle calde giornate primaverili. La cupola, inoltre, fa da palco riparato per i musicisti del festival.

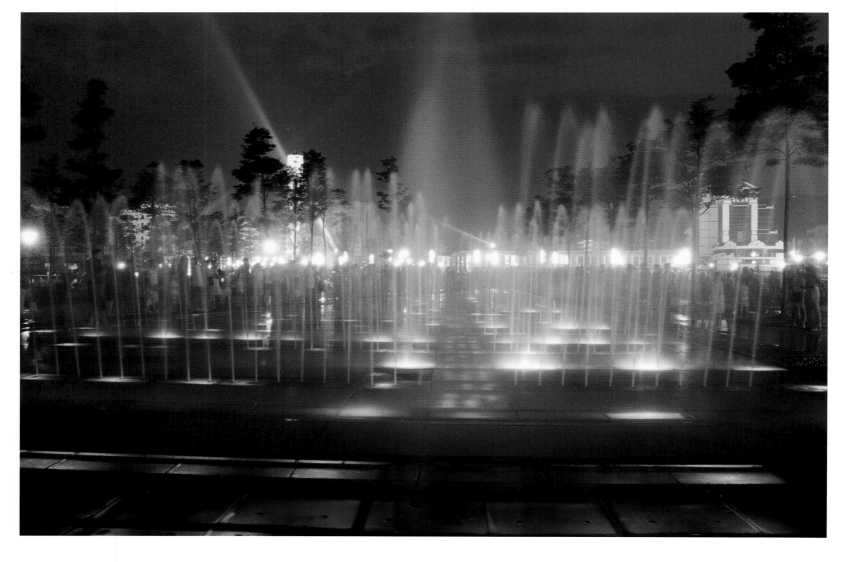

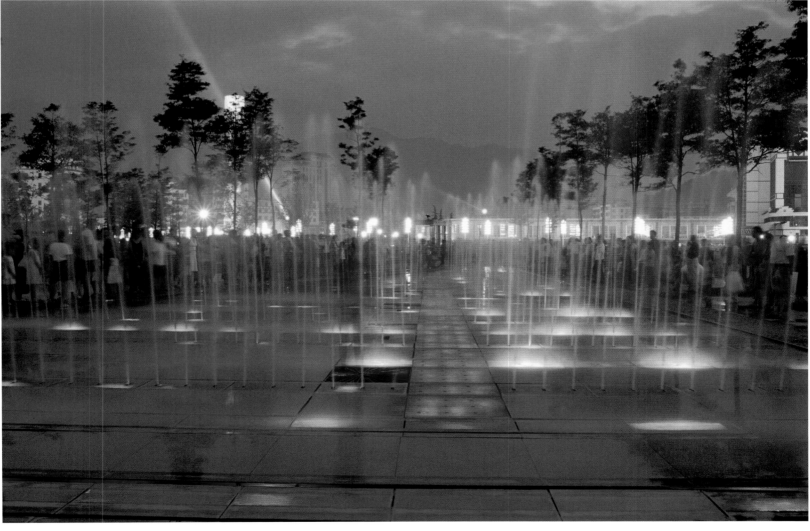

The square's water features are an abstraction of the city's 2,000-year-old weir, which was constructed from bamboo baskets filled with stones.

Die Wasserelemente des Platzes sind ein abstraktes Symbol für die 2.000 Jahre alte Stadtwehr, die aus Bambuskörben konstruiert wurde, die mit Steinen befüllt waren.

Les caractéristiques de la place d'eau reposent sur une abstraction du barrage de la ville qui, vieux de 2.000 ans, fut construit à partir de paniers de bambous remplis de pierres.

Los elementos acuáticos presentes en la plaza son una abstracción de la presa de la ciudad, de 2.000 años de antigüedad y construida a base de cestos de bambú rellenos de piedras.

Gli elementi acquatici della piazza sono un'astrazione dei famosissimi argini di Dujiangyan, vecchi più di 2.000 anni, costruiti con cesti di bambù riempiti poi di pietre.

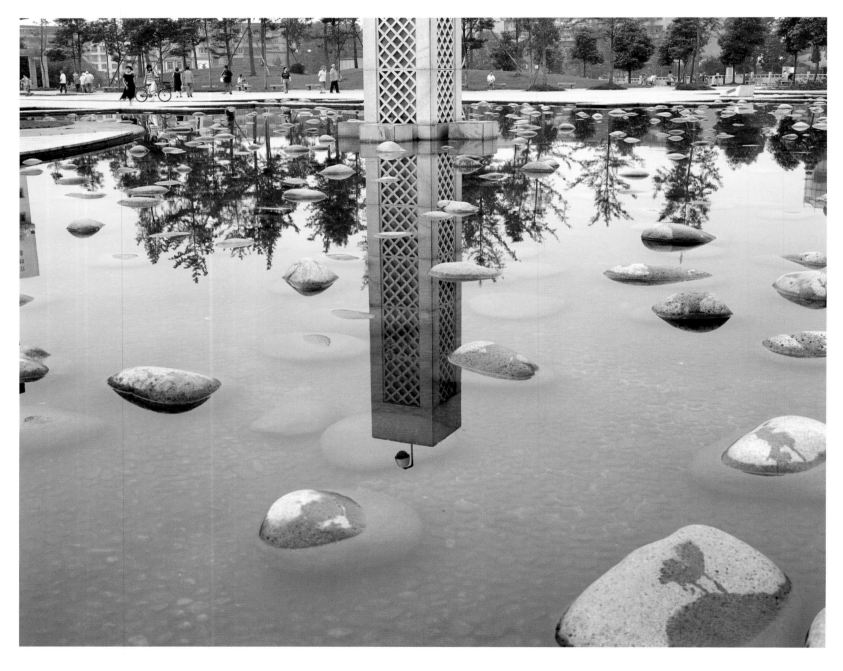

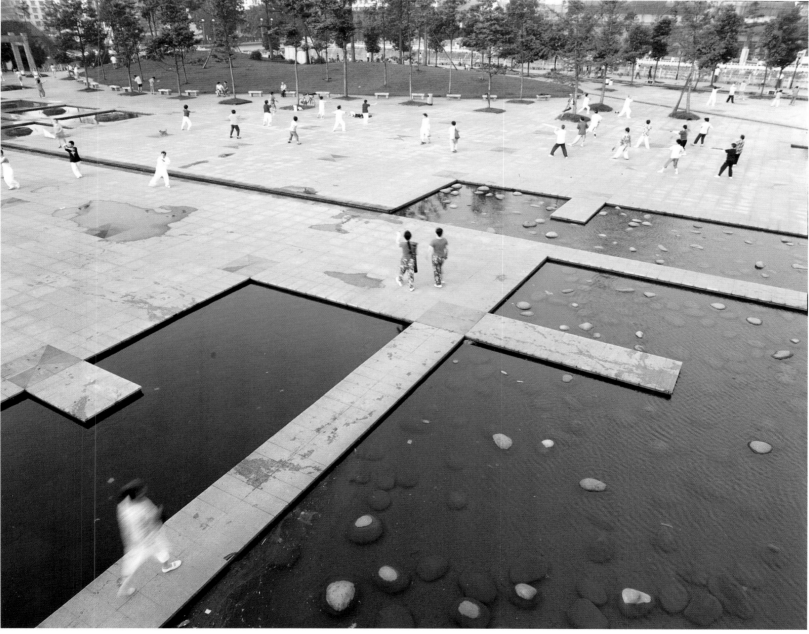

Juárez Complex
Mexico City, Mexico

Juárez complex is located inside the historical center of Mexico City, in front of the Alameda Park. The project's primary objective is to regenerate the historical downtown of Mexico City that was severely damaged by the 1985 earthquake. The complex includes important civic buildings and the main outdoor space of the Plaza Juárez which surrounds the restored temple of Corpus Christi. Within the Plaza is a water mirror containing more than 1,000 red concrete pyramids. Adjacent to Vicente Rojo's fountain can be found the mural called VELOCIDAD by David Alfaro Siqueros (page 46, top).

Der Juárez-Komplex vor dem Alameda Park befindet sich innerhalb des historischen Zentrums von Mexiko Stadt. Die Hauptzielsetzung des Projektes ist die Wiederherstellung der historischen Innenstadt von Mexiko Stadt, die beim Erdbeben 1985 stark zerstört wurde. Der Komplex beinhaltet städtische Gebäude und den wichtigsten Außenbereich der Plaza Juárez, die den restaurierten Corpus-Christi-Tempel umgibt. Innerhalb der Plaza befindet sich ein Bassin, das mehr als 1.000 rote Betonpyramiden enthält. Angrenzend an den Vicente-Rojo-Brunnen finden wir ein großes Wandbild mit Namen VELOCIDAD von David Alfaro Siqueros (Seite 46, oben).

Le complexe de Juárez est situé à l'intérieur du centre historique de Mexico City, en face du Parc de l'Alameda. L'objectif principal de ce projet est de régénérer le centre-ville historique de Mexico City, sévèrement endommagé lors du tremblement de terre de 1985. Des bâtiments publics importants et la Plaza Juárez, entourant le temple restauré du Corpus Christi, constituent le complexe. Le miroir aquatique, contenant plus de 1.000 pyramides en béton rouge, a été installé à l'intérieur de la place. La peinture murale surnommée VELOCIDAD, créée par David Alfaro Siqueros (page 46, en haut), est quant à elle contigüe à la fontaine de Vicente Rojo.

El Complejo de Juárez está situado en el casco histórico de la Ciudad de México, enfrente del parque de Alameda. El principal objetivo del proyecto consiste en regenerar el centro histórico de Ciudad de México, que resultó gravemente dañado por el terremoto de 1985. El complejo incluye importantes edificios públicos y el principal espacio exterior de la plaza Juárez que rodea el templo restaurado del Corpus Christi. En el interior de la plaza se ha situado un espejo de agua que contiene más de 1.000 pirámides de hormigón rojo. Junto a la fuente de Vicente Rojo se encuentra el mural titulado VELOCIDAD, de David Alfaro Siqueros (página 46, parte superior).

Il complesso Juárez si trova nel centro storico di Città del Messico, di fronte all'Alameda Park. L'obiettivo primario del progetto è di rigenerare il centro storico di Città del Messico, gravemente danneggiato dopo il terremoto del 1985. Il complesso include un certo numero di edifici residenziali e uno spazio aperto principale, Plaza Juárez, che circonda il tempio restaurato di Corpus Christi. All'interno della piazza si trova uno specchio d'acqua contenente più di 1.000 piramidi di cemento rosso. Adiacente alla fontana di Vicente Rojo si trova il murale VELOCIDAD di David Alfaro Siqueros (pagina 46, in alto).

2003
Legoretta + Legoretta
www.legorettalegoretta.com

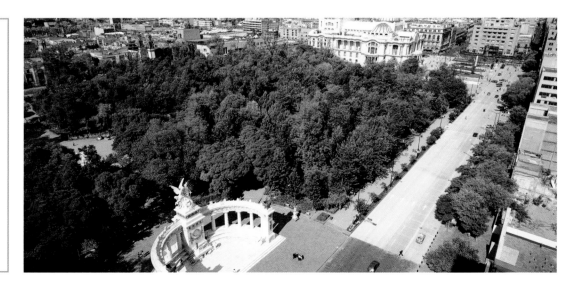

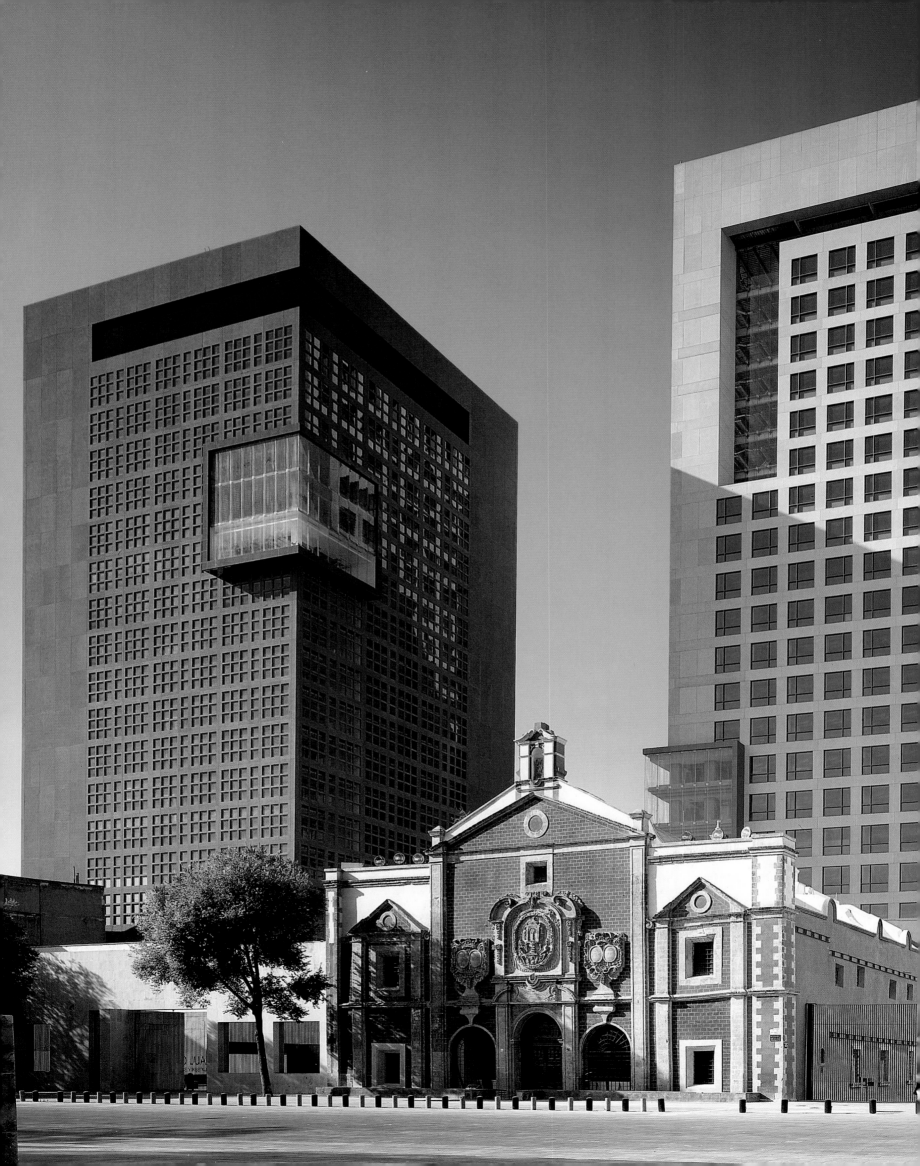

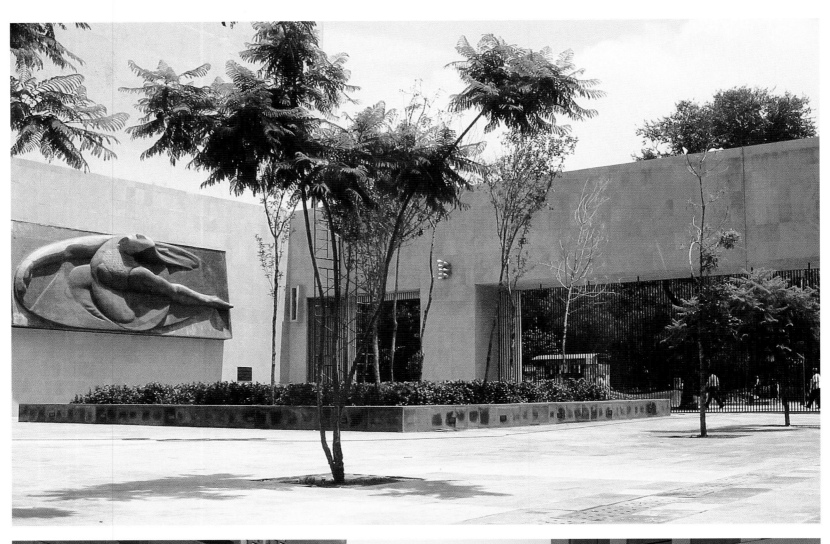

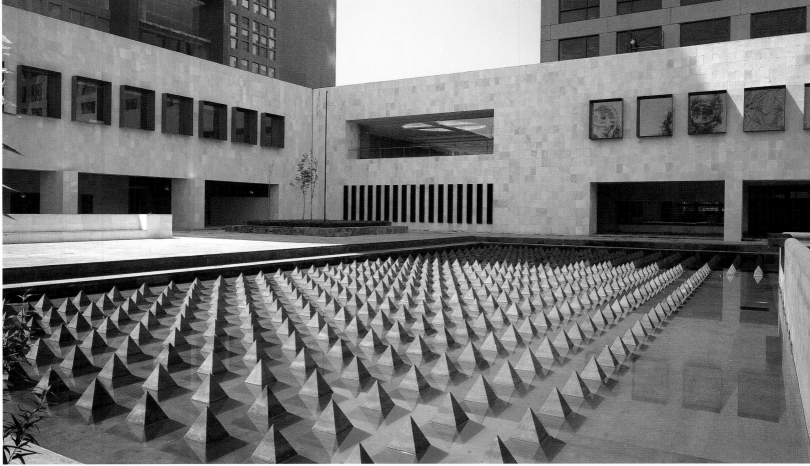

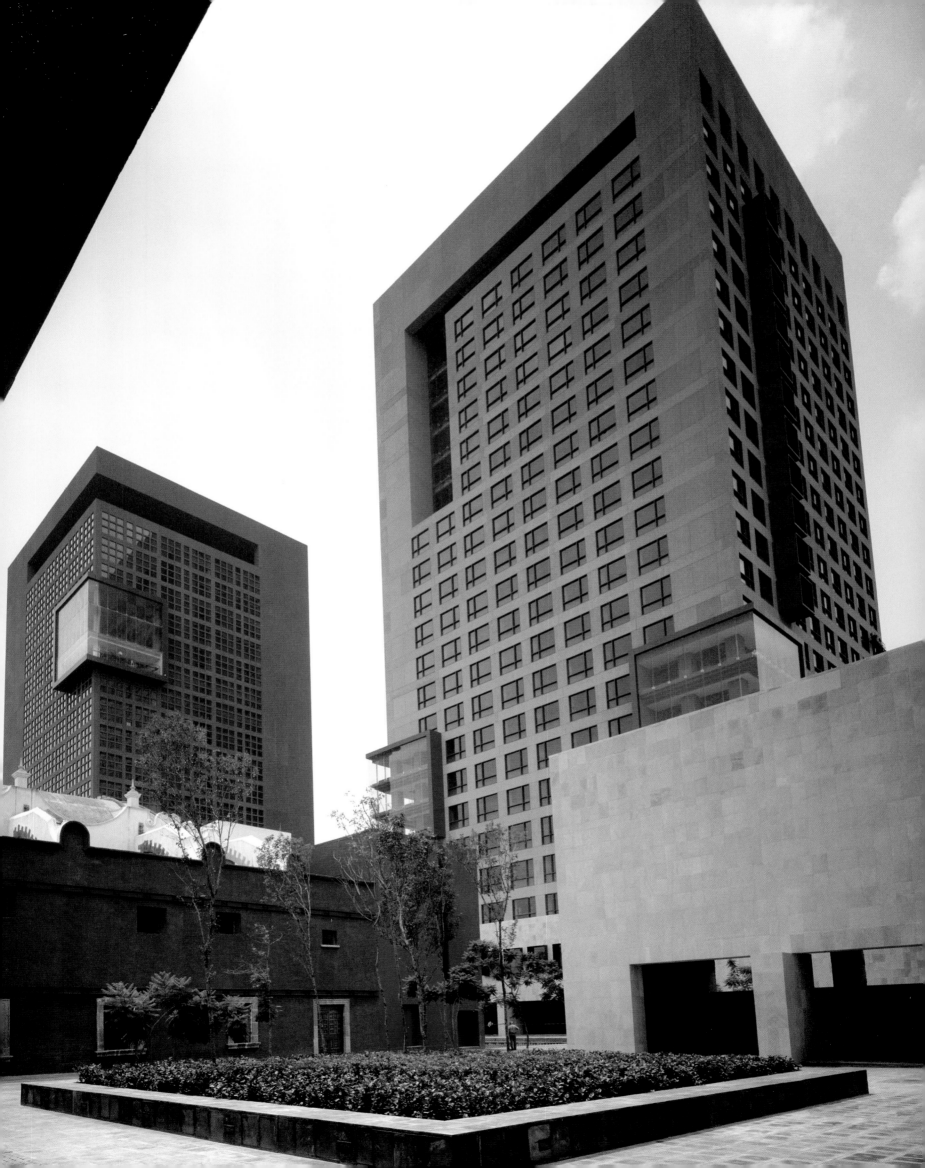

Plaza Juárez provides the pedestrian access to the civic buildings. In its center is the great fountain. This is a collaborative between the architects and the artist Vicente Rojo.

Die Plaza Juárez stellt den Fußgängerzugang zu den städtischen Gebäuden dar. In seinem Zentrum befindet sich ein großer Brunnen. Das Projekt ist eine Zusammenarbeit zwischen den Architekten und dem Künstler Vicente Rojo.

La Place Juárez, dont la grande fontaine occupe le centre, permet au piéton d'accéder aux bâtiments publics. Ce projet est le résultat de la collaboration entre les architectes et l'artiste Vicente Rojo.

La plaza Juárez constituye el principal acceso para los peatones a los edificios públicos. En su centro está la gran fuente. Esta obra es una colaboración entre los arquitectos y el artista Vicente Rojo.

Plaza Juárez serve da accesso pedonale agli edifici residenziali. Al suo centro si trova la grande fontana. Questo progetto ha visto la collaborazione degli architetti con l'artista Vicente Rojo.

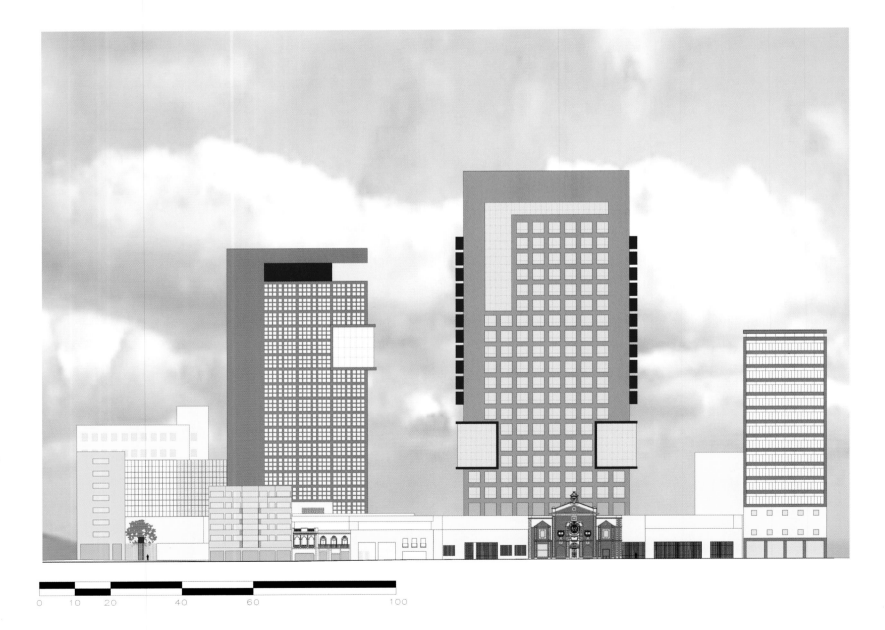

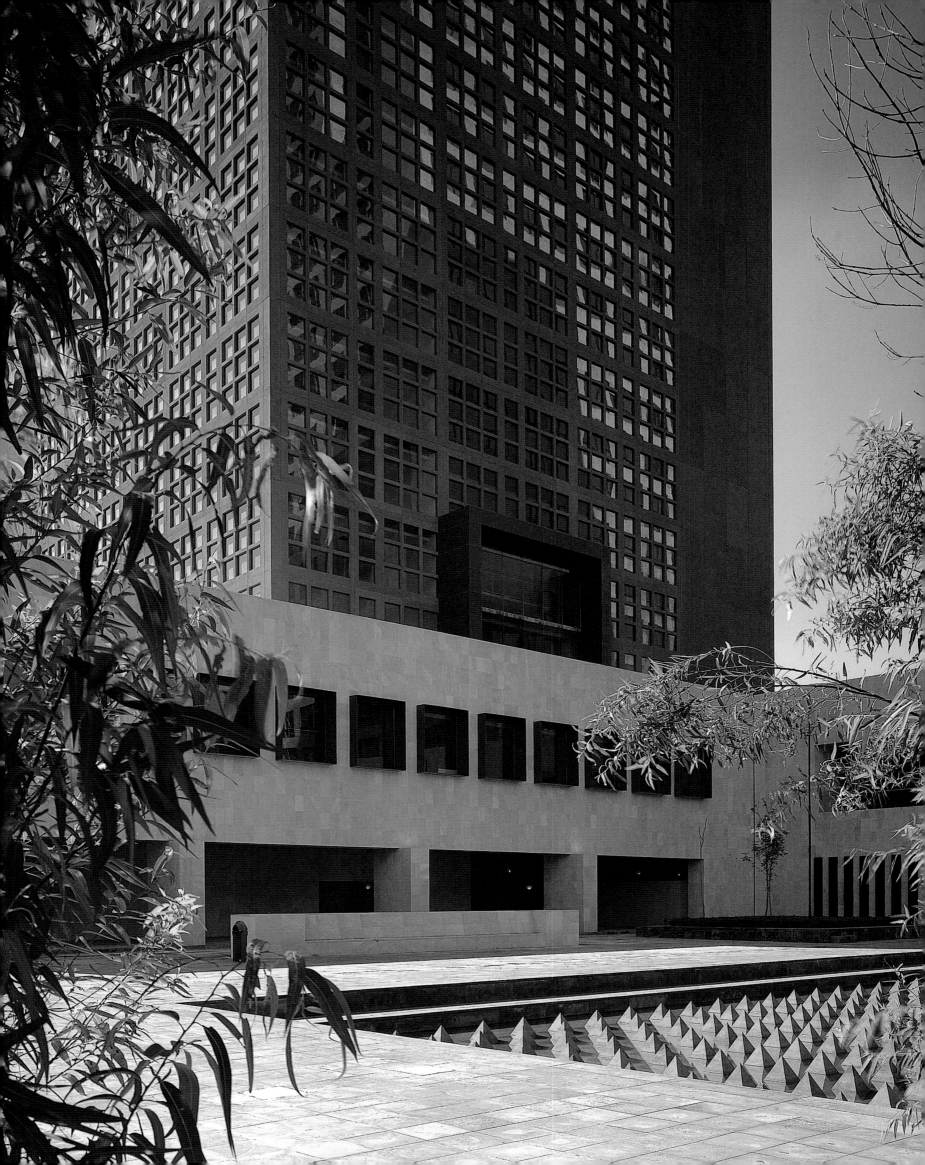

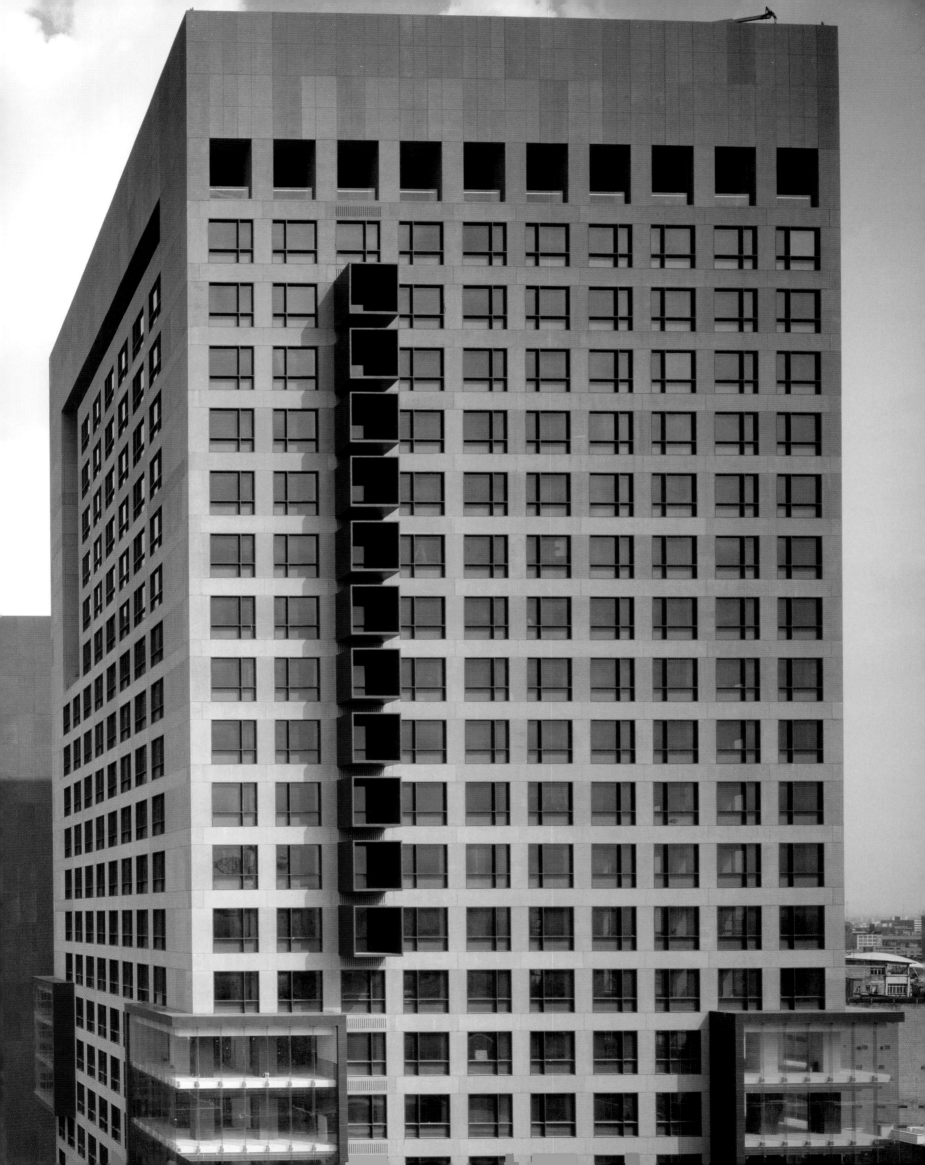

L.A. Design Center

Los Angeles, USA

In 2001, Francisco and Alba Pinedo conceived the idea of creating the L.A. Design Center. This project, which completes the first phase of this new complex, involved the renovation of two rundown warehouses in South Los Angeles. Between the two warehouses a combined motor court and event space provide the social center for the project. The renovated buildings are carefully blended and layered with a textured palette of materials and screens.

Im Jahr 2001 ersannen Francisco und Alba Pinedo die Idee zum Aufbau des L.A. Designzentrums. Dieses Projekt, das die erste Phase eines neuen Komplexes komplettiert, beinhaltet die Renovierung zweier verwahrloster Lagerhäuser im Süden von Los Angeles. Zwischen den zwei Lagerhäusern stellen ein kombinierter Autohof und ein Veranstaltungsplatz das soziale Zentrum des Projekts dar. Den renovierten Gebäuden wurden unterschiedliche Materialien und Verkleidungen vorgeblendet.

En 2001, Francisco et Alba Pinedo ont mis au point l'idée du L.A. Design Center. Ce projet, qui complète la première phase d'un nouveau complexe, a nécessité la rénovation de deux anciens entrepôts de South Los Angeles. C'est entre ces derniers que se trouve le centre social du projet, formé par une allée de garages et un espace dédié à l'organisation d'évènements. Toute une gamme de textures faite de matériaux et d'écrans a été utilisée pour conjuguer harmonieusement les bâtiments rénovés entre eux.

En 2001, Francisco y Alba Pinedo concibieron la idea de la creación del L.A. Design Center. Este proyecto, que culmina la primera fase de este nuevo complejo, implicó la restauración de dos almacenes abandonados de South Los Angeles. Situado entre los dos almacenes, el espacio central para actos o aparcamiento constituye el centro de actividad social del proyecto. Los edificios restaurados mezclan y disponen en capas de forma muy cuidadosa una paleta de materiales y pantallas plena de texturas.

Nel 2001, Francisco e Alba Pinedo hanno progettato la creazione del L.A. Design Center. Il progetto, che completa la prima fase di questo nuovo complesso, ha visto necessari interventi di rinnovamento dei due magazzini dismessi nell'area sud di Los Angeles. Tra i due magazzini, un parco macchine combinato ad un'area eventi agiscono come centro sociale del progetto. Gli edifici rinnovati sono stati sapientemente mescolati e stratificati con un'ampia tavolozza di materiali e pannelli.

2003
John Friedman Alice Kimm Architects
www.jfak.net

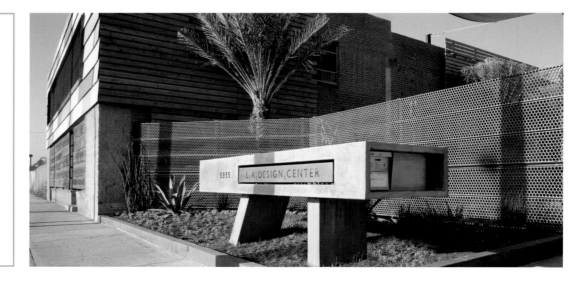

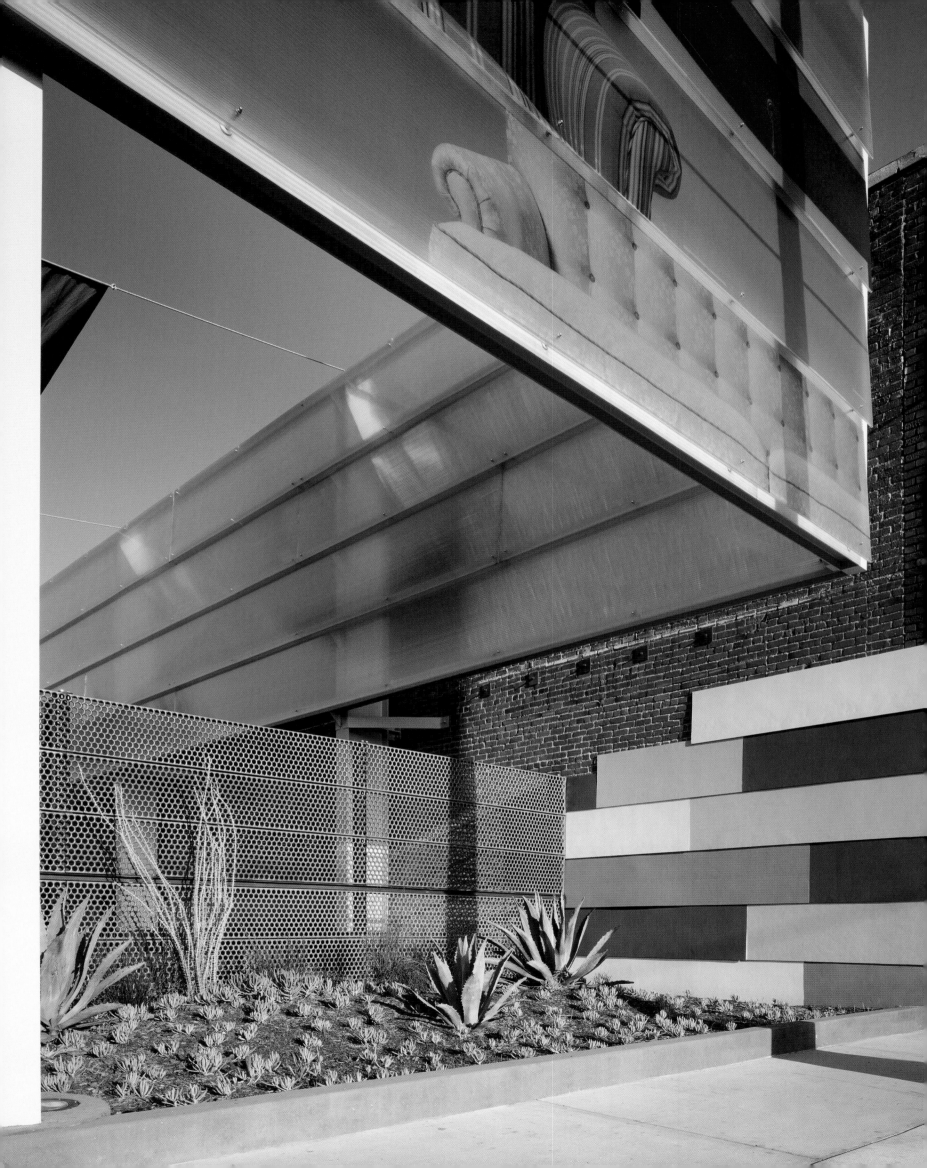

The original character of the site is both preserved and animated by the layered design.

Der originale Charakter des Standorts wird durch die geschichtete Gestaltung sowohl konserviert wie belebt.

Le caractère original du site est à la fois préservé et animé par le design conçu sous forme de couches.

El diseño en capas conserva y resalta el carácter único del lugar.

Il carattere originale del sito è sia preservato che animato da questo progetto stratificato.

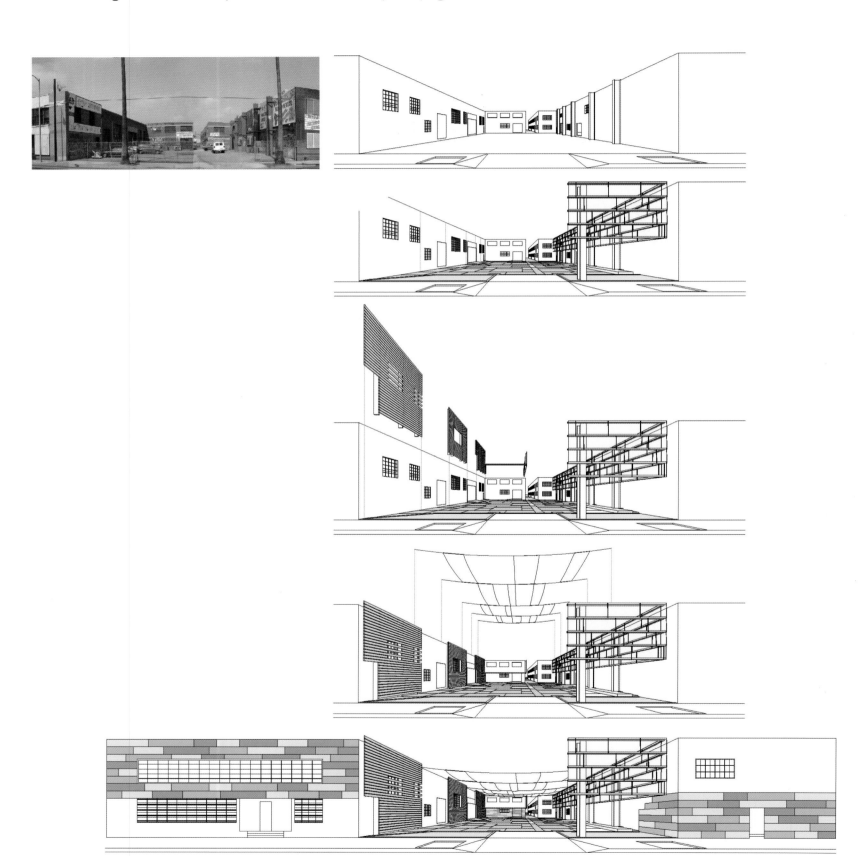

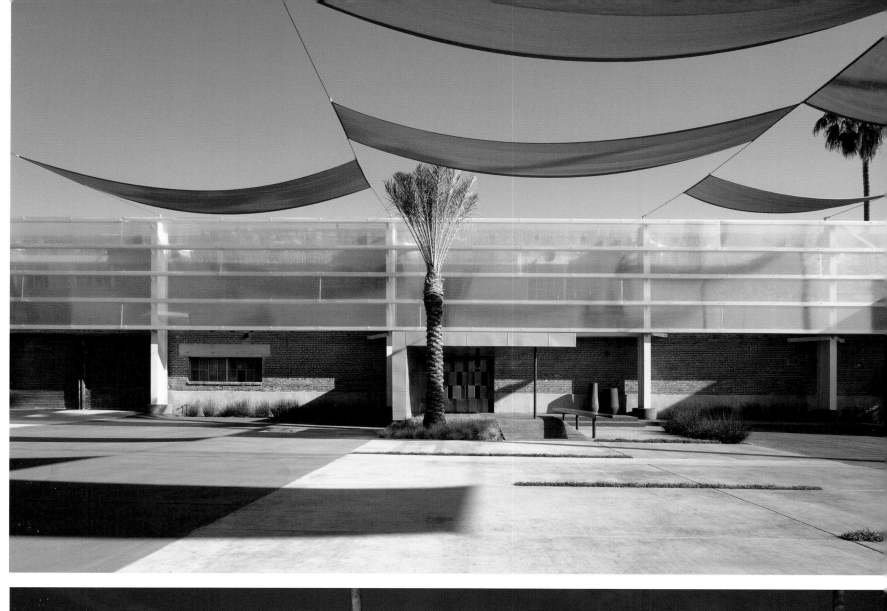

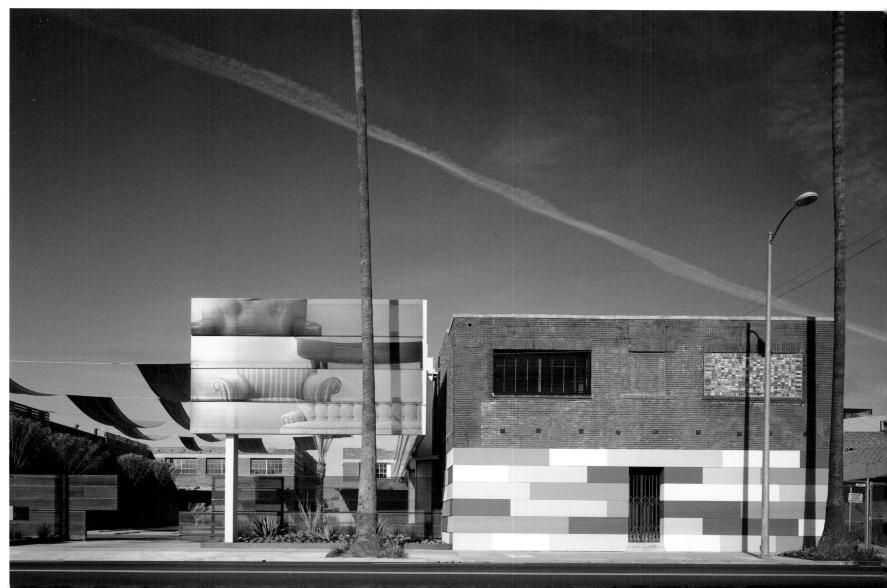

It was essential to produce a strong identity for the project, while equally not creating an unwelcome foreign presence in the neighborhood.

Eine starke Identität für dieses Projekt war notwendig, aber gleichzeitig sollte eine übertriebene Fremdartigkeit zur Umgebung vermieden werden.

La volonté de doter le projet d'une forte identité, sans pour autant que sa présence dépareille dans le voisinage, a été un paramètre essentiel.

Era fundamental aportar una fuerte identidad al proyecto, aunque también era indispensable no dejar una presencia extraña que no fuera bien acogida por los habitantes de la zona.

È stato essenziale dare una forte identità al progetto senza, però, creare un senso di sgradevole corpo estraneo all'interno del quartiere.

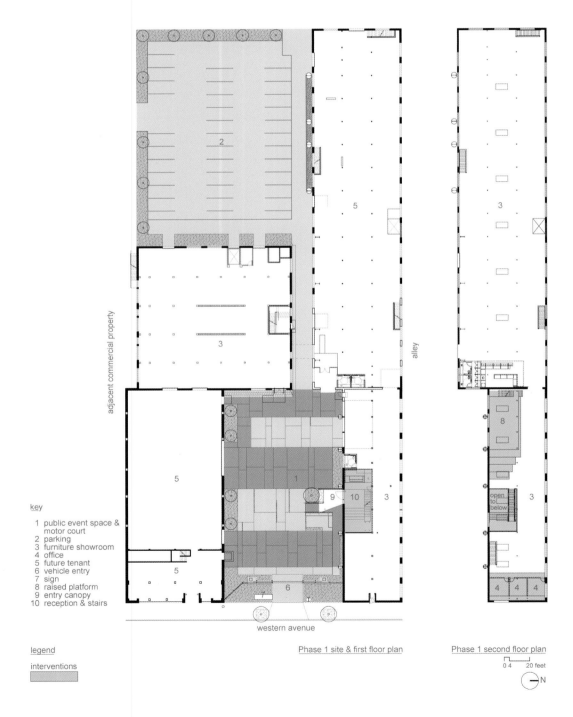

key

1 public event space &
 motor court
2 parking
3 furniture showroom
4 office
5 future tenant
6 vehicle entry
7 sign
8 raised platform
9 entry canopy
10 reception & stairs

western avenue

legend

interventions

Phase 1 site & first floor plan

Phase 1 second floor plan

0 4 20 feet

N

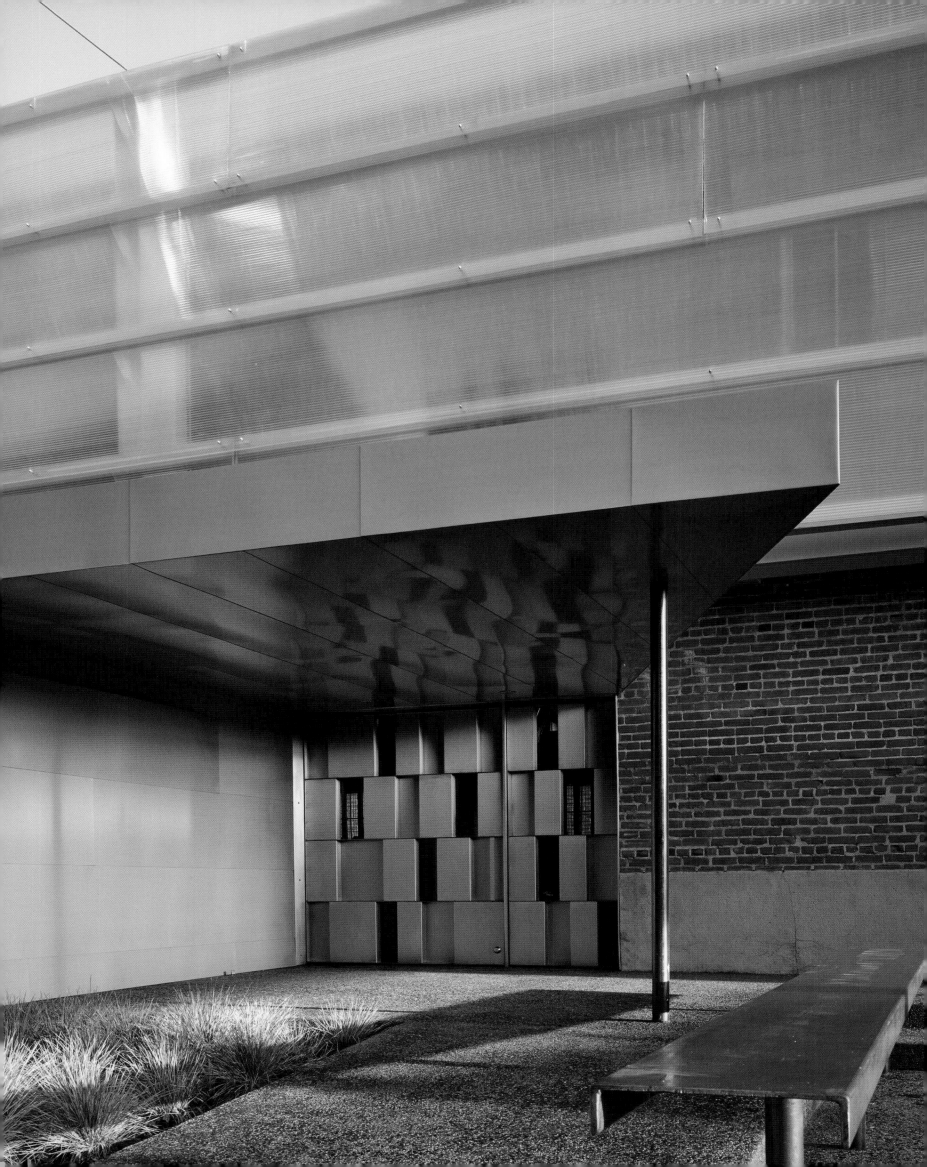

Los Angeles Unified School District Primary Center

Los Angeles, USA

The new school classroom modules of 28 x 48 feet utilize industrial construction materials as a cost-saving measure. Site plans are developed based primarily on security issues and the need for flexible outdoor spaces. The buildings form a secure edge barrier, while landscaped courtyards serve as outdoor classrooms. Although modular in form, each school site has its own bold graphic expression. Connection to the adjoining urbanization is made with the use of murals and planting extending beyond the school's boundaries.

Die Klassenräume der neuen Schule nutzen Module von 8,5 x 14,6 Metern aus industriellen Baumaterialien, um Kosten zu sparen. Bei der Ortswahl standen Sicherheitsfragen und die Notwendigkeit von flexiblen Außenräumen im Vordergrund. Die Gebäude bilden eine sichere Seitenbegrenzung, während landschaftlich gestaltete Höfe als Klassenräume im Freien dienen. Obwohl in Modularbauweise errichtet, hinterlässt jedes Schulgebäude einen eigenständigen optischen Eindruck. Die Verbindung zum angrenzenden Wohngebiet wurde mit Hilfe von Wandmalereien und Anpflanzungen, die über das Schulgelände hinausgreifen, hergestellt.

Les nouveaux modules de salle de classe de 8,5 x 14,6 mètres sont élaborés avec des matériaux de construction industriels afin de minimiser les coûts. Les plans du site sont quant à eux mis au point en se basant essentiellement sur les issues de secours et le caractère essentiel des espaces extérieurs. Les bâtiments forment une barrière close tandis que les cours intérieures aménagées sont utilisées comme des salles de classe à l'air libre. Bien que modulaire dans sa forme, chaque école témoigne d'une expression graphique audacieuse. La connexion avec l'urbanisation voisine est faite grâce aux peintures murales et aux plantations s'étendant au-delà des limites des écoles.

Los nuevos módulos de clases de 8,5 x 14,6 metros emplean materiales industriales de construcción como modo de ahorrar costes. En el desarrollo de los planos se ha dado prioridad fundamentalmente a las cuestiones de seguridad y a la necesidad de obtener unos espacios exteriores flexibles. Los edificios forman una barrera de protección y los nuevos patios sirven de aulas en el exterior. Aunque tengan un fuerte componente modular, cada sección de la escuela cuenta con distintas convenciones gráficas. La conexión con el espacio circundante se lleva a cabo mediante murales y plantas que se extienden más allá de los límites de la escuela.

Per la nuova scuola sono stati utilizzati dei moduli di 8,5 x 14,6 metri uniti a materiali per la costruzione industriale, al fine di limitare i costi. Le piante del sito sono state basate innanzitutto sulla sicurezza e su spazi esterni flessibili. Gli edifici formano una barriera sicura mentre il cortile di richiamo paesaggistico servirà per le classi esterne. Nonostante appaia in forma modulare, ogni area della scuola conserva una propria identità grafica. Una connessione alla crescente urbanizzazione è stata possibile grazie a murali e piantumazioni che si estendono oltre le pertinenze scolastiche.

2003
Rios Clementi Hale Studios
www.rchstudios.com/

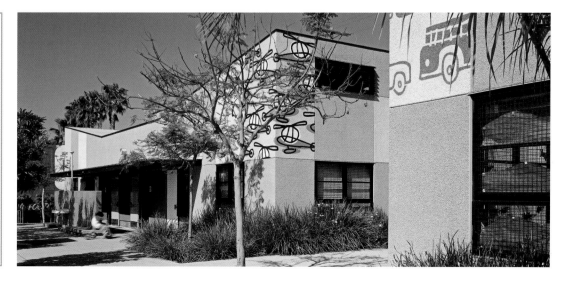

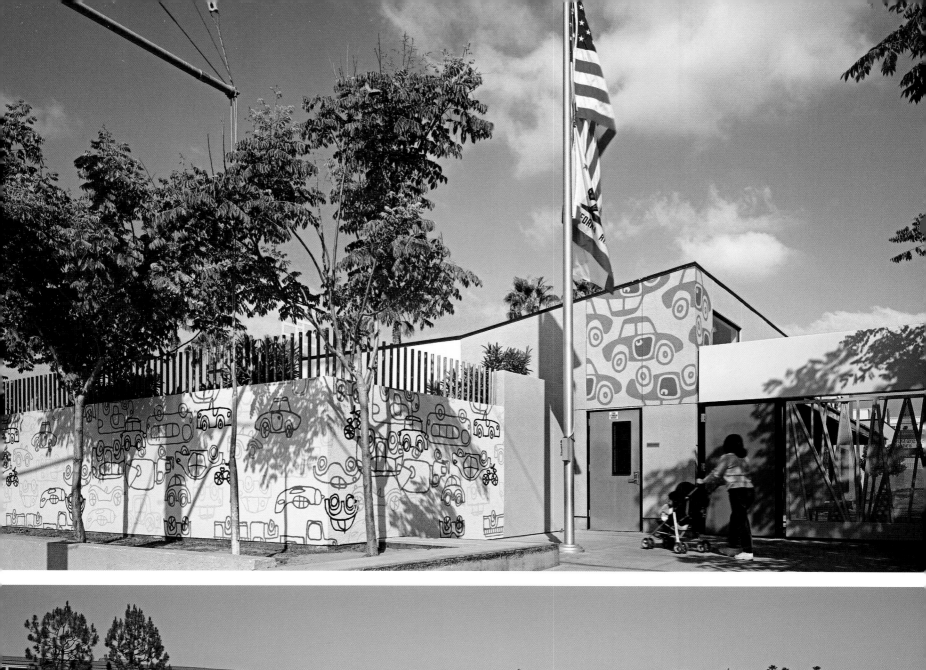

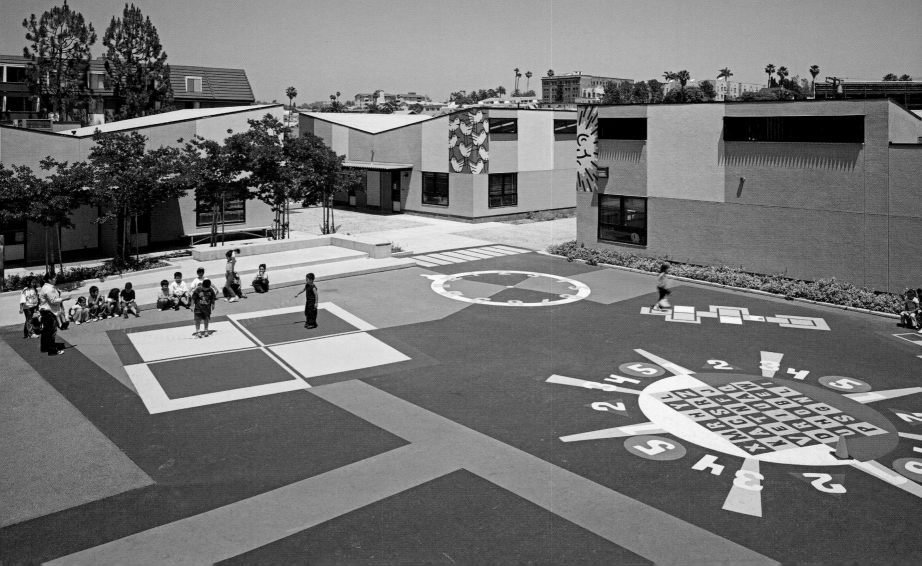

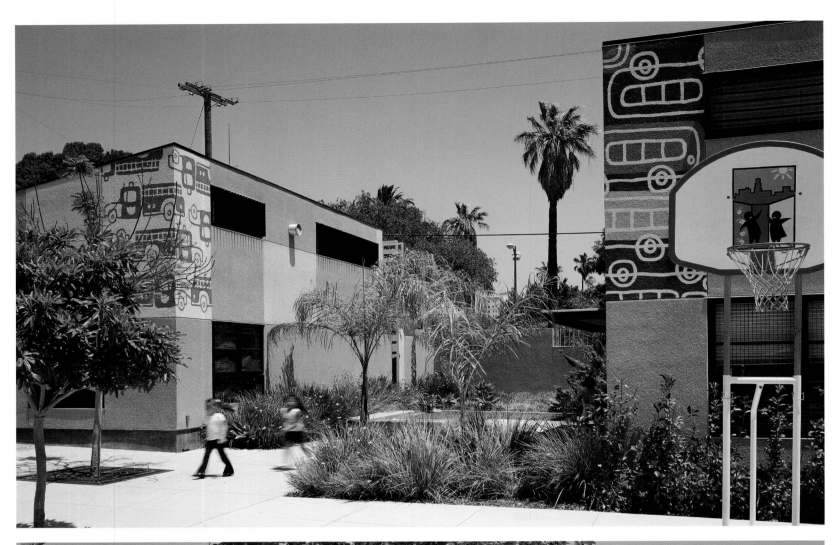

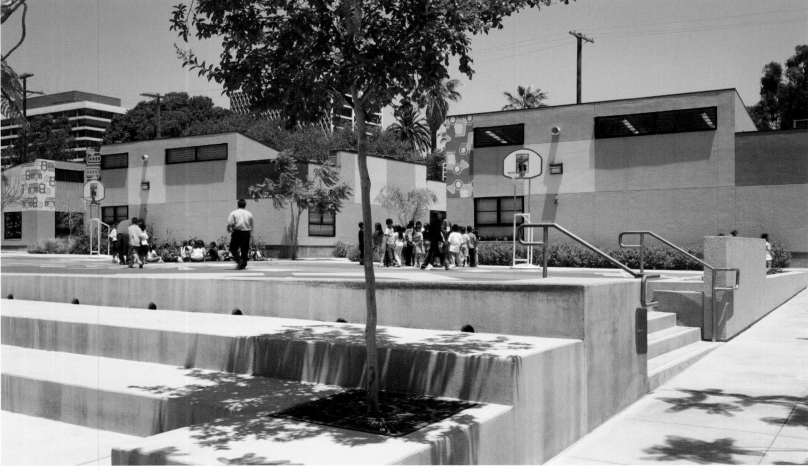

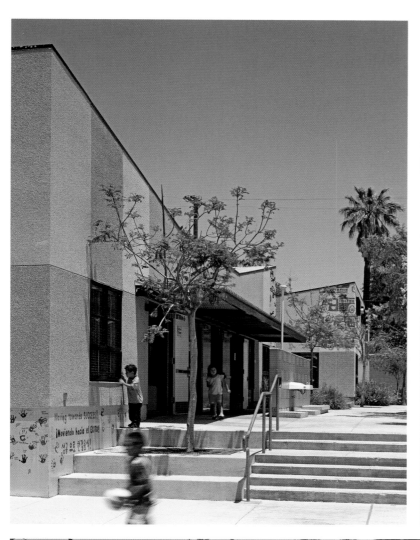

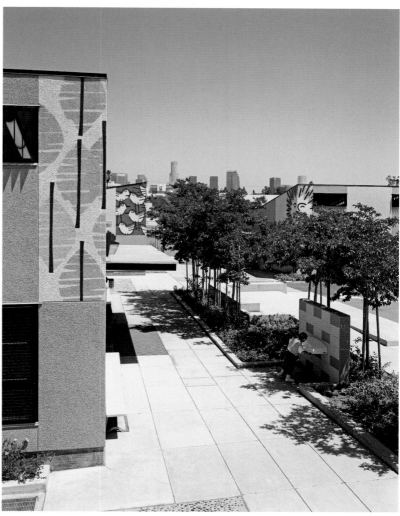

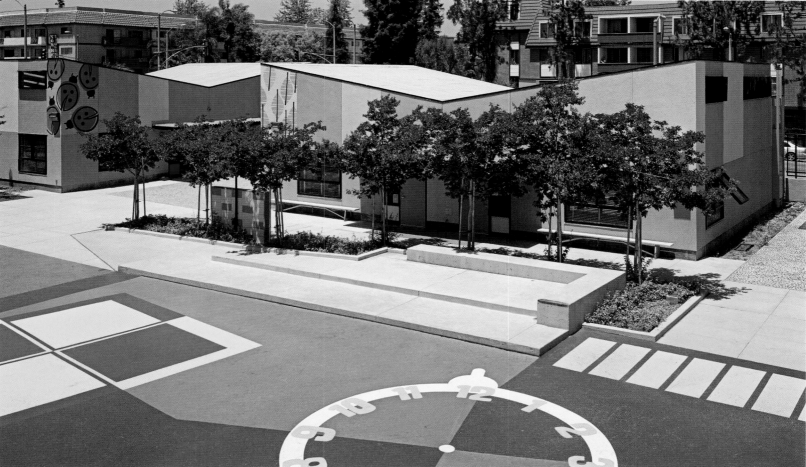

Madison Square Park
Food Kiosk and Café
Shake Shack

New York City, USA

The design inspiration for the Shake Shack is taken from its immediate surroundings. This popular café is located in the historic park with its prolific vegetation and is overlooked by Daniel Hudson Burnham's iconic triangular Flatiron Building. A vine-covered trellis canopy and inclined roof seamlessly blend the Shack into the surrounding tree foliage. The glazing between counter and ceiling level allows views of the park through the building thus merging the structure with the garden. Off-site pre-fabrication minimized construction impact on the sensitive site.

Die Designanregung für den Shake Shack ist von seiner direkten Umgebung abgeleitet. Das populäre Café befindet sich im historischen Park mit seiner fruchtbaren Vegetation und wird von Daniel Hudson Burnhams dreieckigem Flatiron Building überragt, das als Architekturikone bekannt ist. Ein mit Wein bewachsenes Gittervordach und ein geneigtes Hausdach integrieren den Shake Shack in das umgebende Blattwerk der Bäume. Die großzügige Verglasung erlaubt Aussichten auf den Park durch das Haus hindurch und verbindet so das Bauwerk mit dem Garten. Externe Vorfertigung minimierte den Bauaufwand in der sensiblen Umgebung.

Le design du Shake Shack est inspiré par son environnement immédiat. Le populaire café se trouve en effet au milieu de la riche végétation du parc historique. Il est dominé par la forme triangulaire et iconique du Flatiron Building conçu par Daniel Hudson Burnham. Une treille couverte de vignes et un toit incliné et intégré se marient entre eux et procure au Shack un feuillage ambiant. Le vitrage séparant le bar et le niveau du plafond permet d'avoir une vue du parc et de faire fusionner la structure avec le jardin. La préfabrication du site a tenu à minimiser l'impact de la construction sur un espace sensible.

El diseño del Shake Shack se inspira en su entorno inmediato. Este popular café se encuentra en el histórico parque de frondosa vegetación y está presidido por la icónica forma triangular del Flatiron Building de Daniel Hudson Burnham. El tejado inclinado y la enredadera que repta por él integran sin aparente esfuerzo el Shack con el arbolado que lo rodea. Los cristales colocados entre el mostrador y el nivel del tejado permiten ver el parque a través del edificio, lográndose así fusionar su estructura con el jardín. El empleo de elementos prefabricados minimizó el impacto sobre un lugar tan delicado.

Ad ispirare il progetto dello Shake Shack è stata l'area ad esso circostante. Questo famoso bar si trova all'interno dello storico parco ed è circondato da una ricca vegetazione e sormontato dal possente Flatiron Building, l'edificio triangolare ad opera di Daniel Hudson Burnham. La pergola a volta ricoperta di rampicanti e il tetto inclinato sembrano quasi inglobare lo Shack nel fogliame. Le vetrate tra il bancone e il soffitto offrono una meravigliosa vista sul parco, facendo fondere la struttura con il giardino. Una prefabbricazione esterna al sito ha permesso una sensibile riduzione dell'impatto costruttivo nell'area.

2004
SITE
www.SITEenvirodesign.com

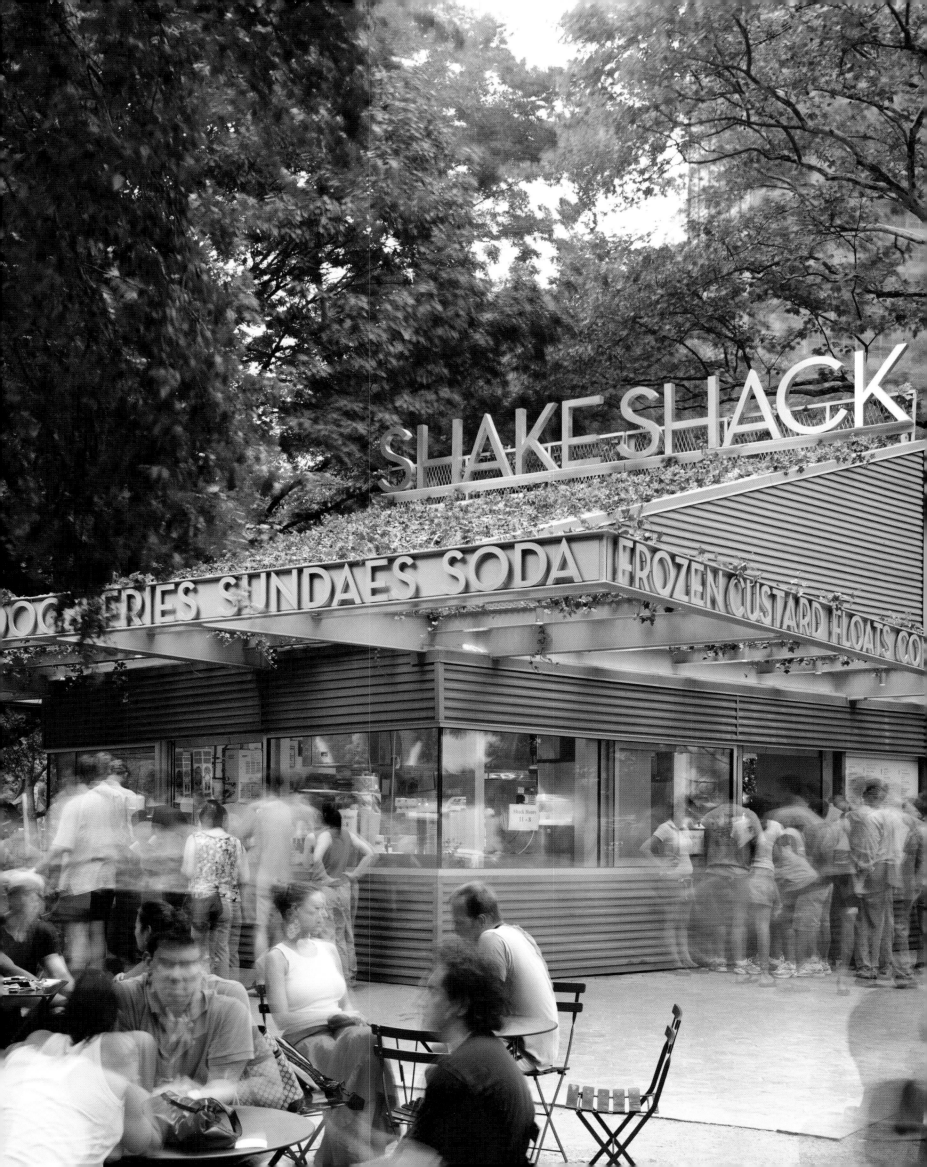

The Shake Shack provides a festive beacon within the park; hot dogs, milk shakes and burger stands have long been associated with American pop culture.

Der Shake Shack stellt einen Höhepunkt des Parks dar; Hot Dogs, Milchshakes und Burgerbuden werden seit langem mit der amerikanischen Popkultur assoziiert.

Le Shake Shack est un point de repère festif situé à l'intérieur du parc. Proposant ses hot dogs, milk shakes et hamburgers, il revendique les icônes de la culture pop Américaine.

El Shake Shack proporciona un referente festivo al parque; los puestos de perritos calientes, batidos y hamburguesas se han asociado desde hace mucho tiempo con la cultura pop estadounidense.

Lo Shake Shack dona un'atmosfera festiva all'interno del parco; stand di hot dog, frullati e hamburger sono stati associati per molto tempo alla cultura pop americana.

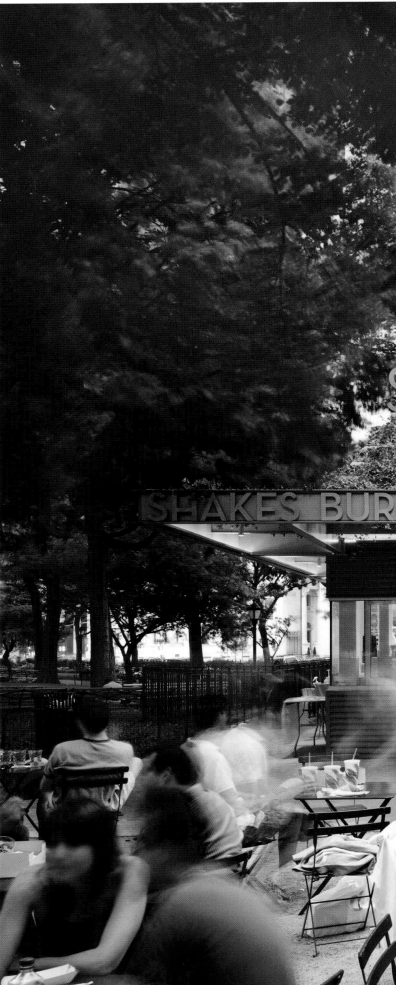

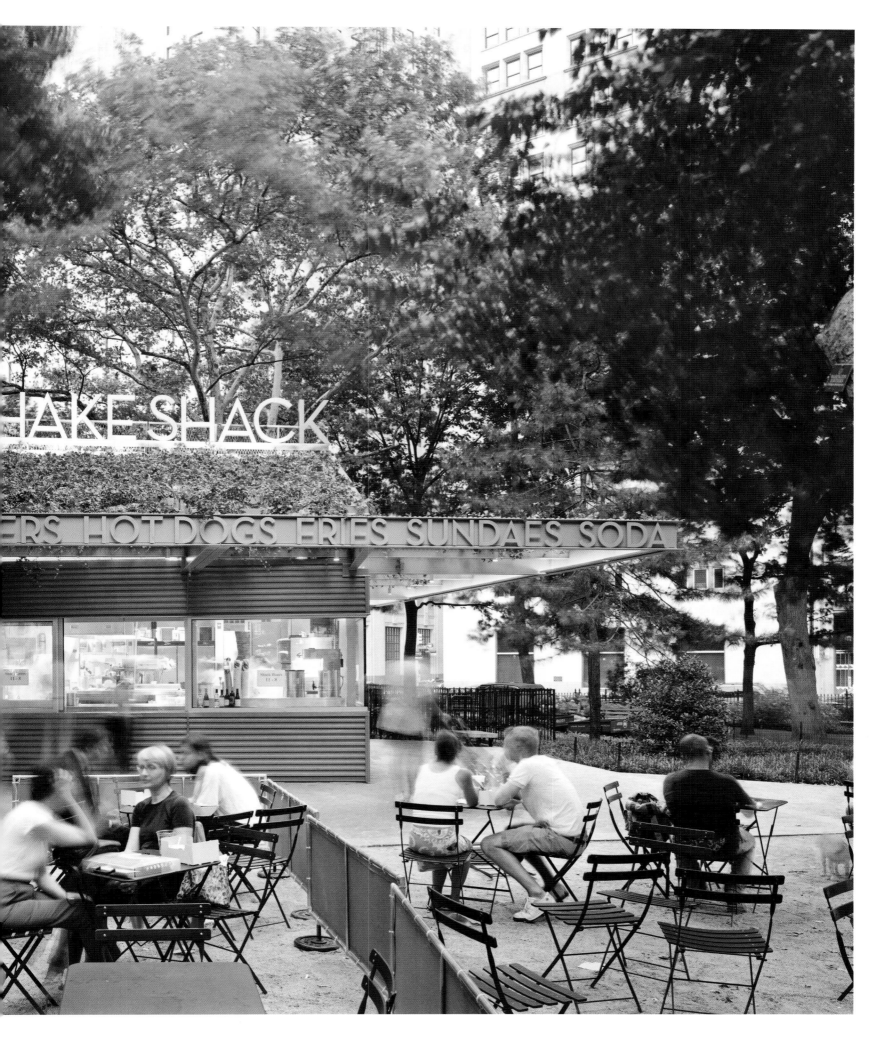

Munich Airport
Munich, Germany

In a striking stylization of the Bavarian landscape, the roof of the 6,400 space car park facility pays homage to the neighboring hills of Freising and Erding. Passengers arriving by commuter trains reach the new terminal via the Munich Airport Center (MAC), a building complex with offices, shops and restaurants by Chicago architects Murphy/Jahn with Rainer Schmidt and the Californian landscape architect Peter Walker. The plaza is covered with an arched roof structure 130 feet above the ground, giving the external plaza the character of an indoor space.

In einer bemerkenswerten Stilisierung der bayrischen Landschaft huldigt das Dach der 6.400 Plätze großen Parkplatzanlage den angrenzenden Hügeln von Freising und Erding. Die mit den Pendlerzügen ankommenden Passagiere erreichen das neue Terminal über das Munich Airport Center (MAC), einen Gebäudekomplex mit Büros, Läden und Restaurants der Chicagoer Architekten Murphy/Jahn mit Rainer Schmidt sowie des kalifornischen Landschaftsarchitekten Peter Walker. Der Platz ist von einer 40 Meter hohen bogenförmigen Dachstruktur überwölbt, durch die der Außenplatz den Charakter eines Innenraums erhält.

Fruit d'une stylisation frappante du paysage Bavarois, le toit du parking pouvant accueillir 6.400 voitures rend hommage aux collines voisines de Freising et Erding. Les passagers arrivant par les trains de liaison atteignent le nouveau terminal par le biais du Munich Airport Center (MAC), un complexe de bâtiments comprenant bureaux, magasins et restaurants conçu par les architectes de Chicago Murphy/Jahn avec Rainer Schmidt et l'architecte-paysagiste californien Peter Walker. La place extérieure est couverte d'un toit à la structure cintrée de 40 mètres surplombant le sol, ce qui lui donne le caractère d'un espace intérieur.

Producto de una poderosa estilización del paisaje bávaro, el tejado de este aparcamiento con capacidad para 6.400 plazas rinde homenaje a las cercanas colinas de Freising y Erding. Los pasajeros que llegan en tren entran en la nueva terminal a través del Munich Airport Center (MAC), un complejo de edificios con oficinas, tiendas y restaurantes de los arquitectos de Chicago Murphy/Jahn con Rainer Schmidt y el arquitecto de paisajes californiano, Peter Walker. La plaza está cubierta por una estructura provista de un tejado arqueado que se eleva 40 metros por encima del suelo, lo que otorga a esta plaza exterior una cualidad de espacio interior.

In un'imponente stilizzazione dello scenario bavarese, il tetto con un parcheggio che può ospitare fino a 6.400 auto, rende omaggio alle vicine colline di Freising e Erding. I passeggeri in arrivo da passaggi ferroviari raggiungono il nuovo terminale passando per il Munich Airport Center (MAC), un complesso di uffici, negozi e ristoranti ad opera dagli architetti di Chicago Murphy/Jahn e Rainer Schmidt insieme all'architetto paesaggistico californiano Peter Walker. La piazza è ricoperta da un soffitto a volta di 40 metri di altezza, dando alla piazza le caratteristiche di uno spazio coperto.

2003
Rainer Schmidt Landscape Architects
Munich, Berlin, Bernburg, Istanbul
www.rainerschmidt.com

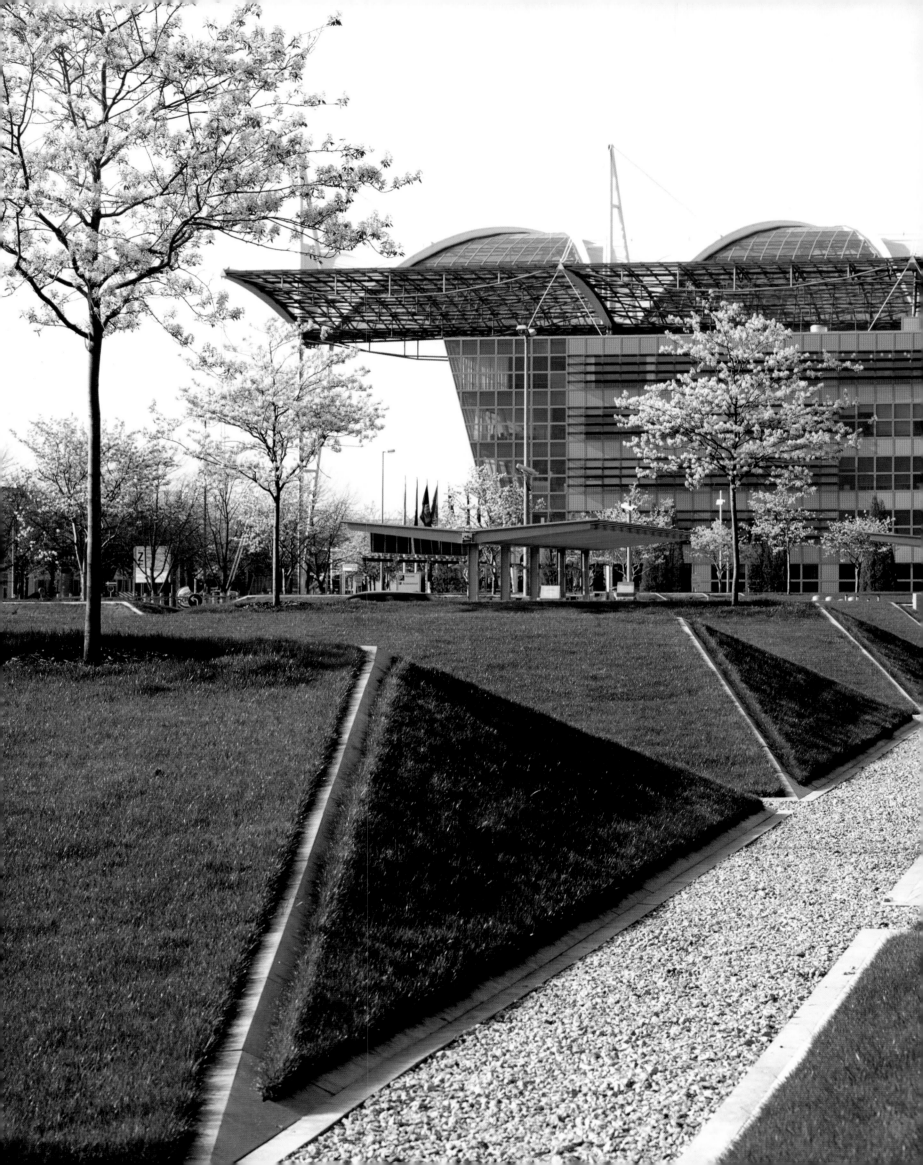

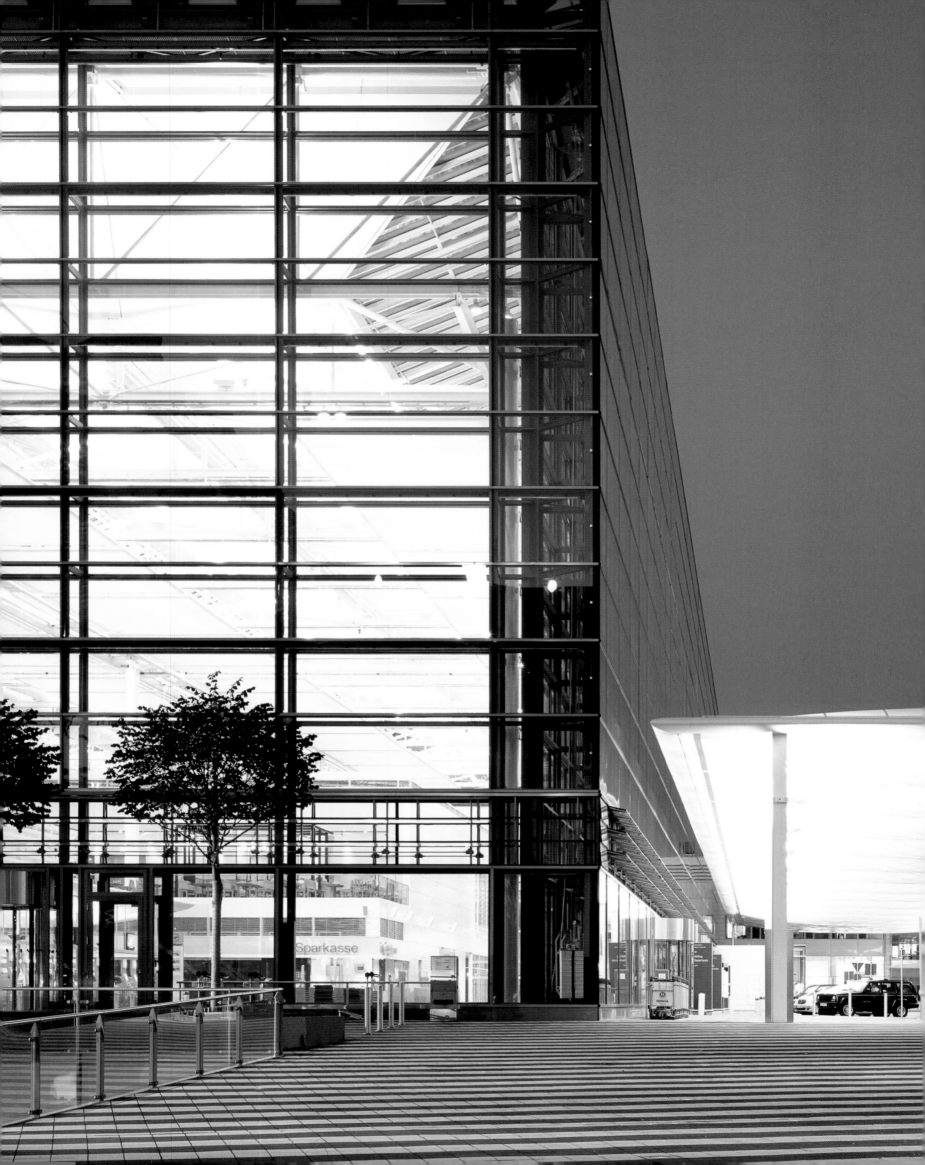

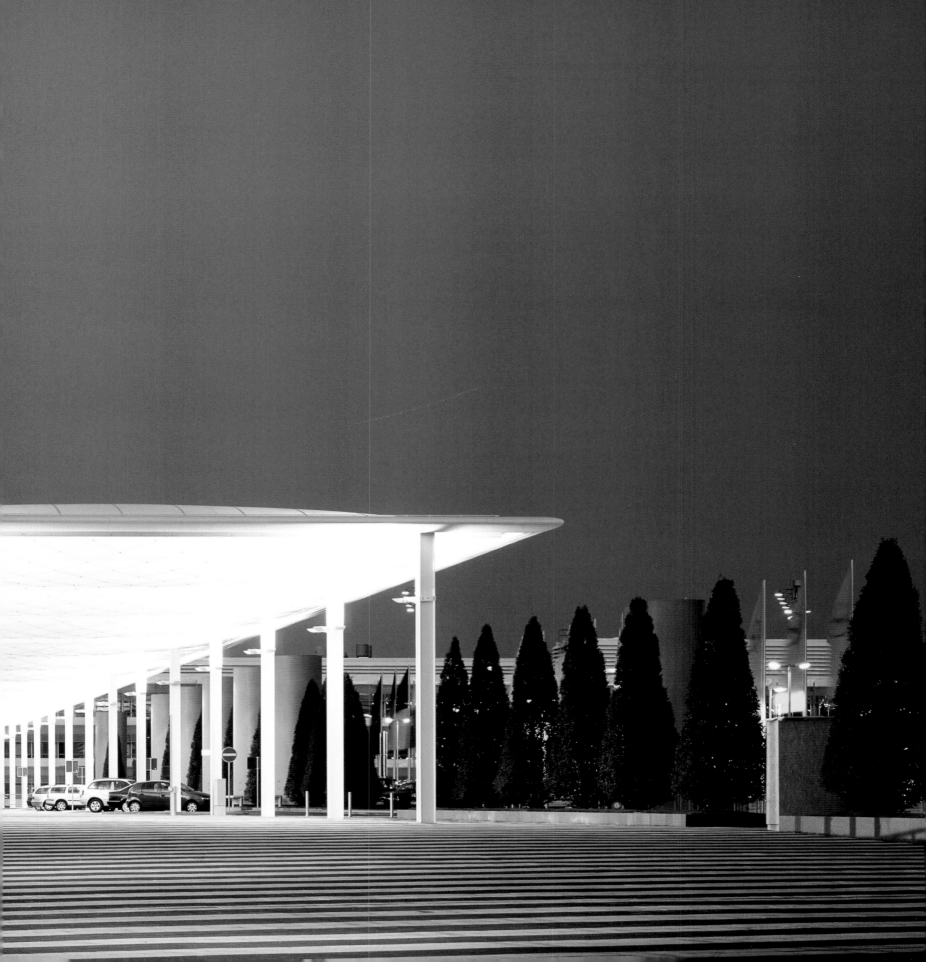

By breaking away from the purely functional aspects of airport architecture, the open space design merges the indoor with the outdoor.

Durch Aufgabe der rein funktionellen Aspekte der Flughafenarchitektur verbindet die Gestaltung offener Räume Innen- und Außenbereiche miteinander.

En échappant aux aspects purement fonctionnels liés à l'architecture de l'aéroport, la conception de l'espace ouvert fait ainsi fusionner l'intérieur et l'extérieur.

Merced a este distanciamiento de los aspectos más puramente funcionales de la arquitectura aeroportuaria, el diseño de los espacios abiertos fusiona el interior con el exterior.

Rompendo dai classici schemi tipici della progettazione aeroportuale, per lo più fondati sulla funzionalità, il design a spazio aperto fonde la parte interna con quella esterna.

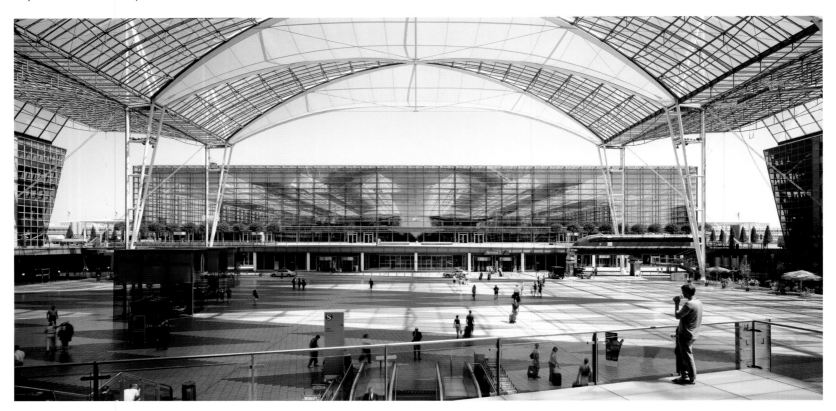

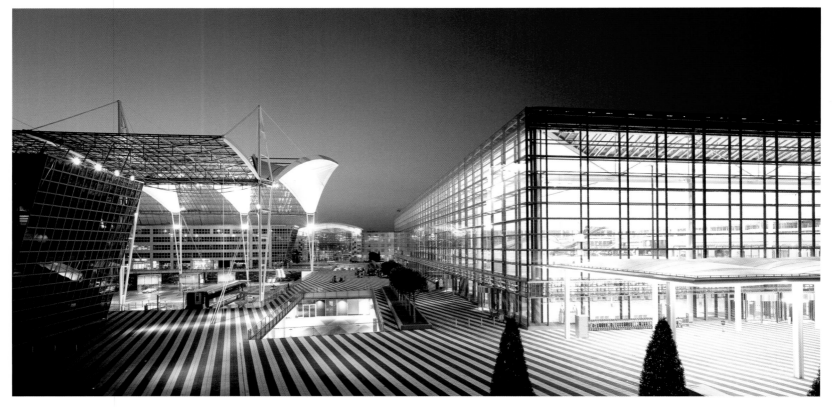

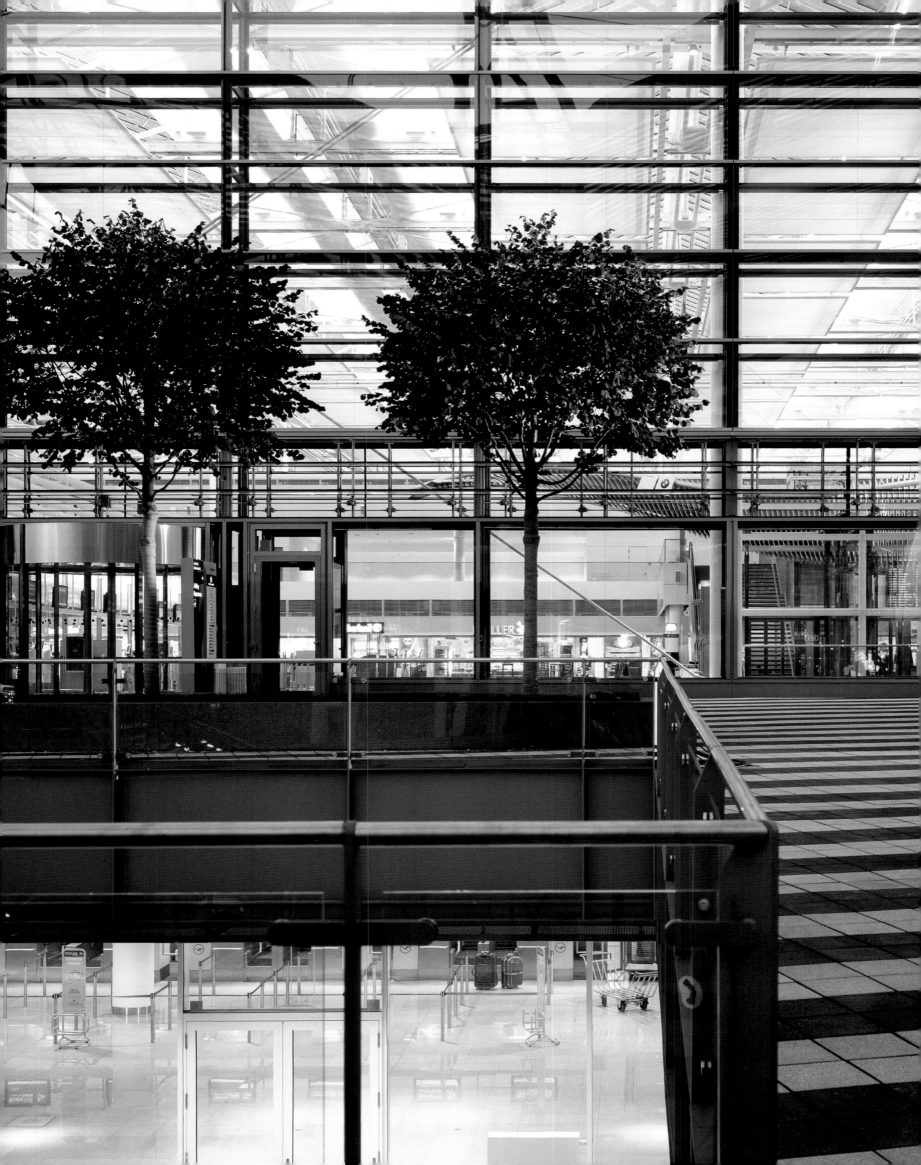

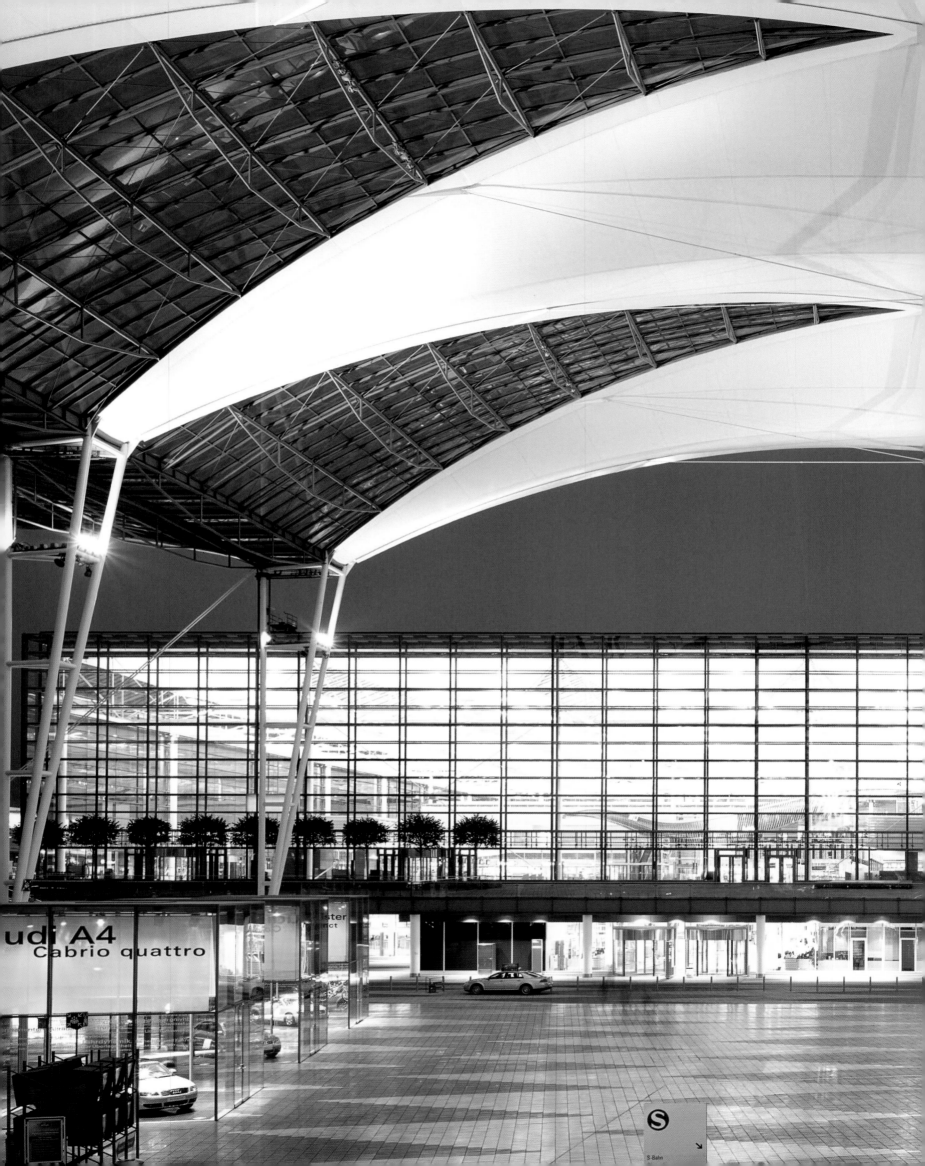

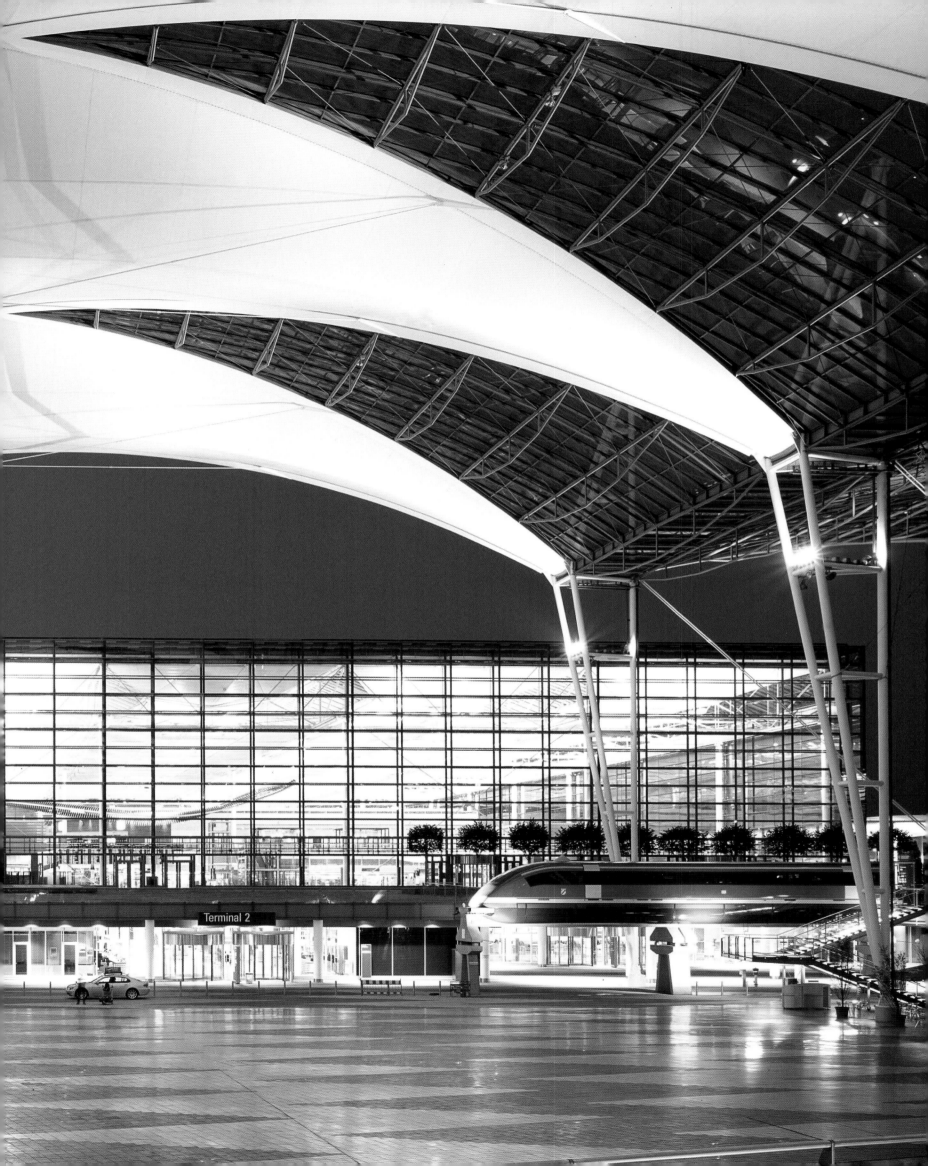

Parkcity Munich

Munich, Germany

This city park is characterized by the attention to detail found in the themed gardens. Deliberately avoiding a segregation of green areas, streets and offices, the city park provides a sequence of trees, pavilions and open lawns. Here, the white steel pergola serves as a trellis for climbing plants. Their shade creates an additional play of light on the stone platform that seems to float on a sea of lawn. Rocks, boulders, meadows and prism structures are symbolic of the landscape between Munich and the Alps.

Der Stadtpark ist charakterisiert durch die Detailgenauigkeit, die in den Themengärten zum Ausdruck kommt. Absichtlich die Trennung grüner Bereiche von Straßen und Büros vermeidend bietet der Stadtpark Baumreihen, Pavillons und offene Rasenflächen. Hier dient die weiße Stahlpergola als Rankgitter für Kletterpflanzen. Ihre Schatten produzieren ein zusätzliches Lichtspiel auf der Steinplattform, die auf einem See von Grünflächen zu fließen scheint. Felsen, Gesteinsbrocken, Wiesen und Prismenstrukturen stehen symbolisch für die Landschaft zwischen München und den Alpen.

Le parc de la ville se caractérise par ses jardins à thème où tous les détails ont été pris en compte. Conçu pour éviter de séparer les zones vertes des rues et bureaux, le parc de la ville fait se succéder des parties boisées, des pavillons et des pelouses ouvertes. Ici, les pergolas en acier blanc servent de treilles pour les plantes grimpantes. Leur ombrage crée un jeu additionnel de lumière sur la plate-forme en pierre qui semble alors flotter sur une mer d'herbe. Pierres, rochers, prairies et structures en prisme sont les éléments qui symbolisent les paysages séparant Munich des Alpes.

Este parque urbano se caracteriza por la atención al detalle que se puede observar en los jardines temáticos. El parque ofrece una secuencia de árboles, pabellones y praderas de césped, evitando de forma deliberada una separación entre zonas verdes, calles y oficinas. La pérgola de acero blanco sirve de enrejado para las plantas trepadoras. Su sombra crea un juego adicional de luces sobre la plataforma de piedra que parece flotar sobre un mar de césped. Las rocas, cantos, prados y estructuras prismáticas simbolizan el paisaje entre Munich y los Alpes.

Questo parco cittadino vanta una particolare attenzione ai dettagli nei giardini a tema. Nel tentativo non casuale di mescolare aree verdi a strade e uffici, il parco offre una sequenza di alberi, padiglioni e giardini. Qui, il pergolato in acciaio bianco fa da spalliera alle piante rampicanti. La loro ombra aiuta a creare ulteriori giochi di luce sulla piattaforma di pietra che sembra galleggiare in un mare di prato. Rocce, massi, grandi prati e strutture prismatiche simboleggiano il paesaggio tra Monaco e le Alpi.

1994
Rainer Schmidt Landscape Architects
Munich, Berlin, Bernburg, Istanbul
www.rainerschmidt.com

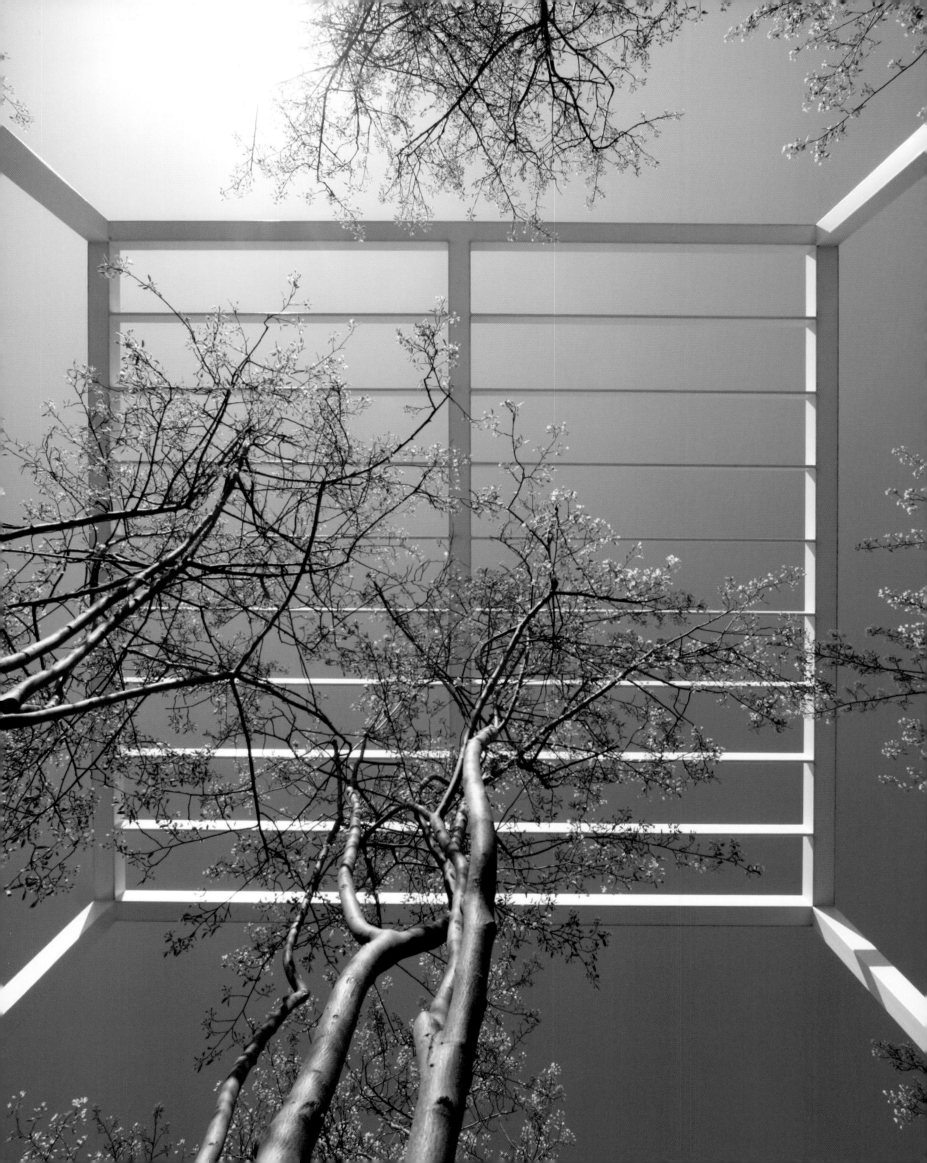

The design concept of the park is it's allusion to the nearby Alps for the people who live and work in the area.

Das Gestaltungskonzept des Parks ist eine Anspielung auf die nahe gelegenen Alpen für Menschen, die in der Umgebung leben und arbeiten.

Le projet conceptuel du parc se base sur l'idée d'évoquer les Alpes voisines aux personnes vivant et travaillant dans cette partie de la ville.

El concepto de diseño del parque es una referencia a los cercanos Alpes destinada a las personas que viven y trabajan en la zona.

L'idea alla base del progetto del parco è di dare l'illusione alle persone che vivono e lavorano nell'area, di un paesaggio del tutto simile alle vicine Alpi.

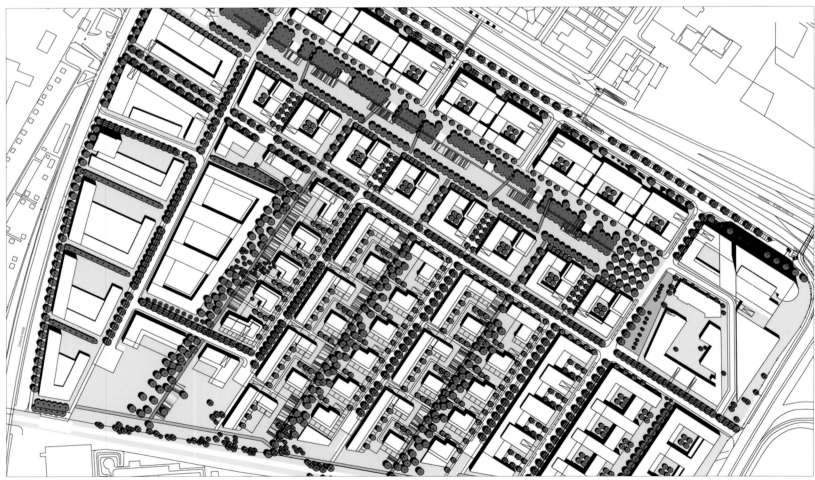

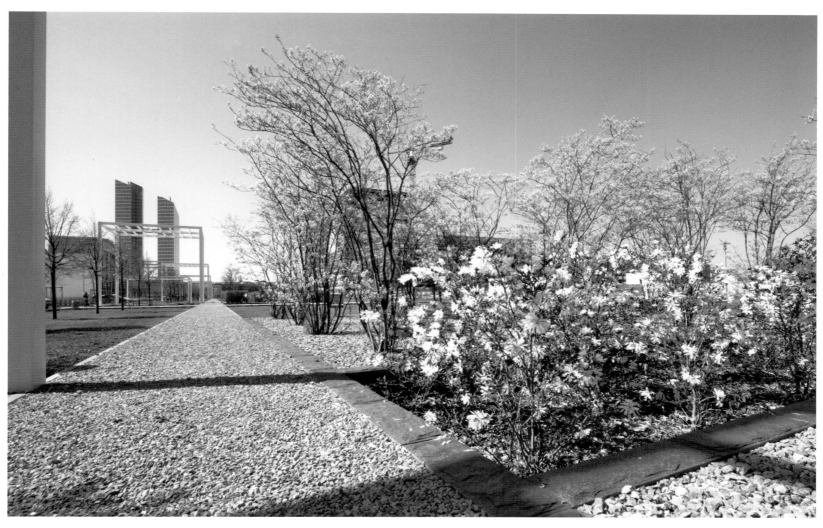

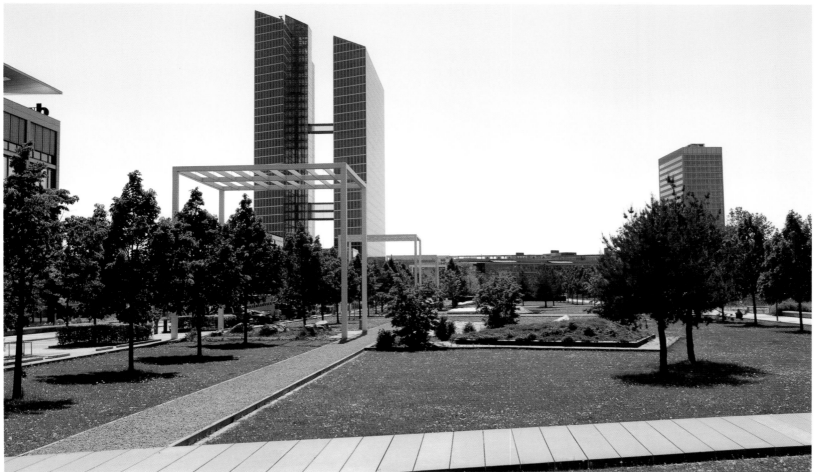

Royal Botanical Gardens

Madrid, Spain

The last available plot in Madrid's Royal Botanical Gardens was located in an elevated position between the Villanueva Pavilion and the street of Alfonso XII. The sloping plot was primarily established to accommodate a permanent exhibition of bonsai under the guidance of María Theresa Tellería. A gradual procession of hedgerows was conceived to define exhibition space and provide shade where required. The project is surrounded by eucalyptus to the northwest and a row of limes parallel to the royal street.

Das letzte verfügbare Grundstück der Königlichen Botanischen Gärten von Madrid befand sich in einer erhobenen Position zwischen dem Villanueva Pavillon und der Straße Alfonso XII. Das leicht geneigte Grundstück wurde hauptsächlich zur Aufnahme einer permanenten Bonsai Ausstellung unter der Aufsicht von María Theresa Tellería genutzt. Eine abgestufte Serie von Hecken wurde zur Definition des Ausstellungsraums angelegt und spendet, wenn nötig, Schatten. Das Projekt ist im Nordwesten von Eukalyptus- und einer Reihe von Limettenbäumen parallel zur königlichen Straße umgeben.

Le dernier terrain disponible dans les Jardins Botaniques Royaux de Madrid était situé sur une position en hauteur entre le Pavillon de Villanueva et la rue d'Alphonse XII. À l'origine, cette surface inclinée était utilisée pour héberger une exposition permanente de bonsaï supervisée par María Theresa Tellería. Une succession graduelle de haies a été conçue afin de délimiter l'espace d'exposition et fournir des zones d'ombre aux endroits en nécessitant. Le projet est entouré d'un eucalyptus au nord-ouest et d'une rangée de citronniers parallèle au chemin royal.

El último rincón de terreno disponible en el Real Jardín Botánico de Madrid estaba situado en una posición elevada entre el pabellón de Villanueva y la calle Alfonso XII. La zona en talud se remodeló en un inicio para albergar una exposición permanente de bonsáis bajo la dirección de María Teresa Tellería. Para definir el espacio expositivo y proporcionar sombra cuando fuera necesario se dispuso una fila de seto vivo. El proyecto está rodeado por eucaliptos al noroeste y una hilera de tilos paralelos a la calle real.

L'ultimo appezzamento disponibile all'interno dei Giardini Botanici Reali di Madrid si trovava in una posizione elevata tra il Padiglione Villanueva e la via Alfonso XII. Questo sito in pendenza era solito ospitare l'esibizione permanente di bonsai, curata da María Theresa Tellería. Un avanzamento graduale di bordure era stato progettato per definire lo spazio da dedicare all'esibizione e per fornire ombra quando richiesto. L'area è circondata da alberi di eucalipto a nord-ovest mentre una fila di limette corre parallela alla strada reale.

2005
Fernando Caruncho & Associados, S.L.
www.fernandocaruncho.com

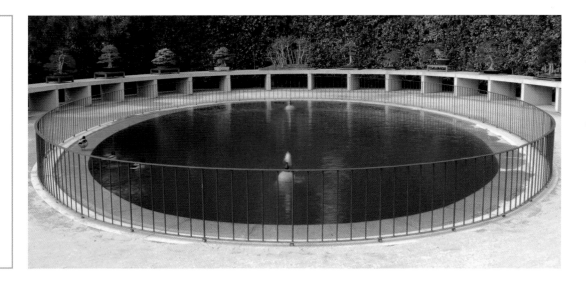

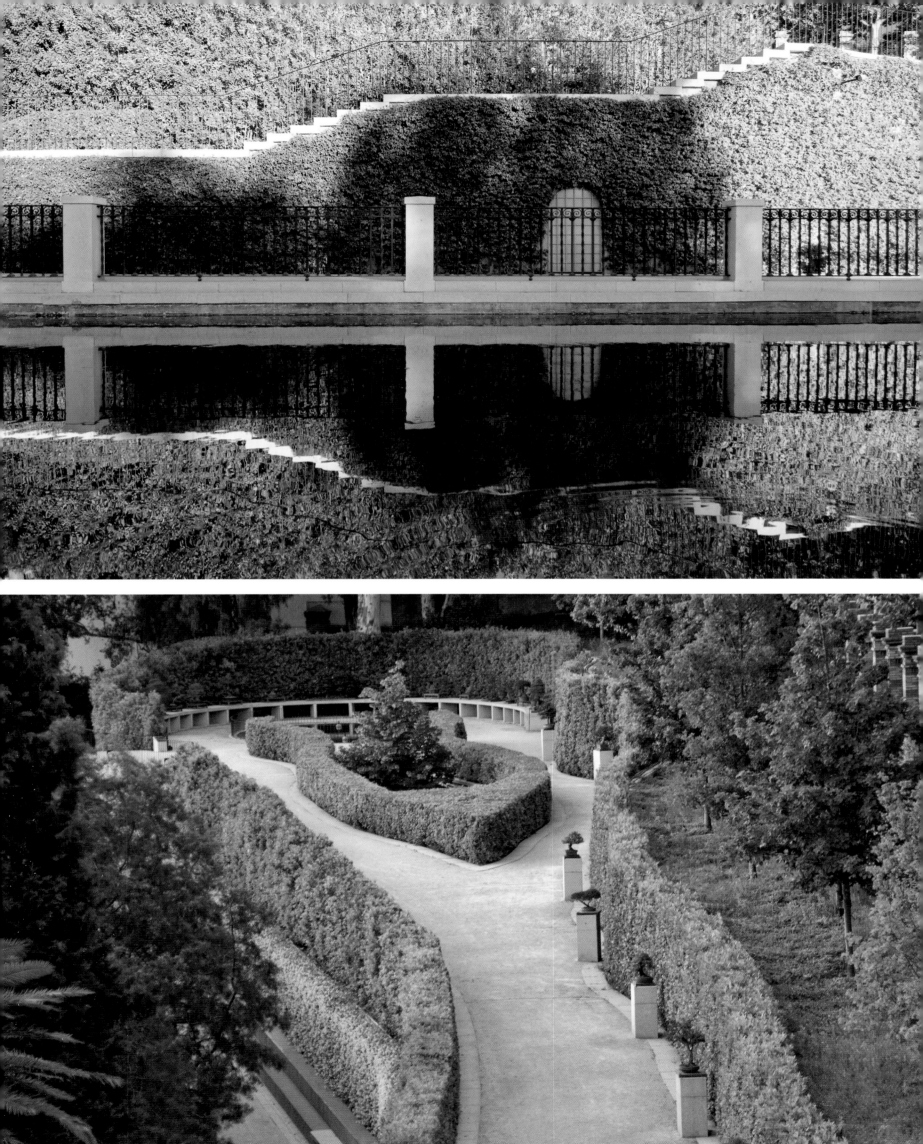

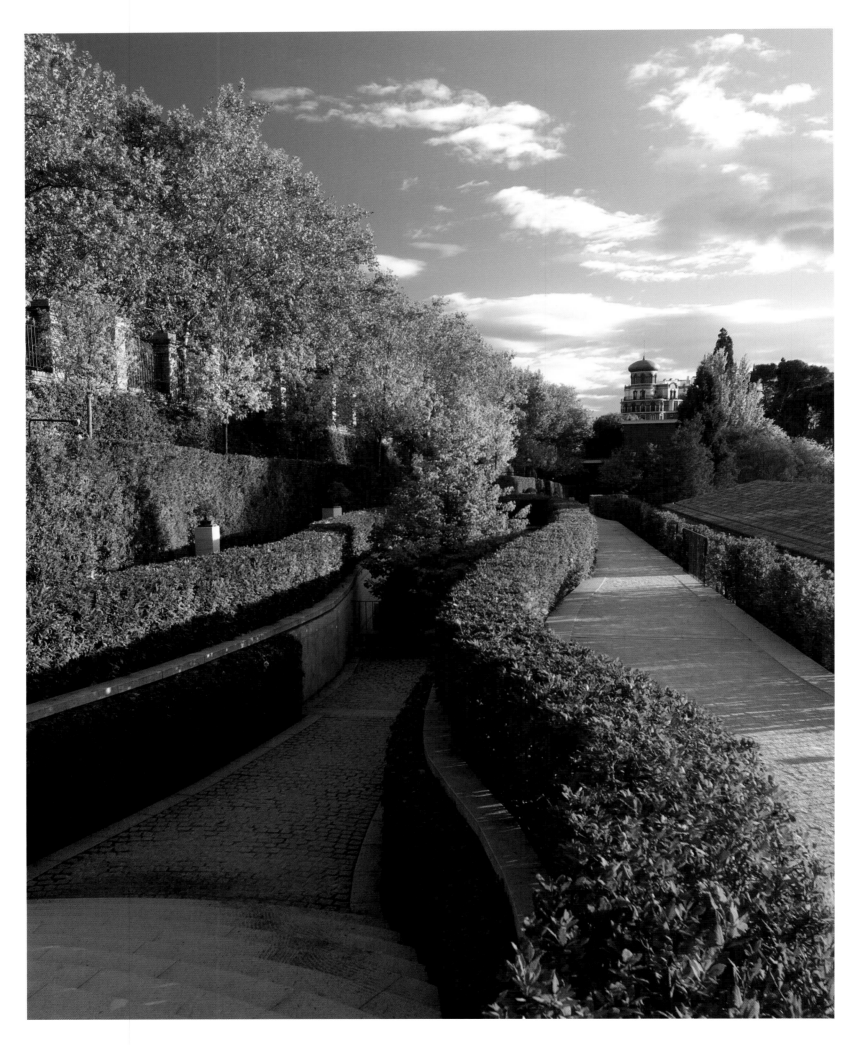

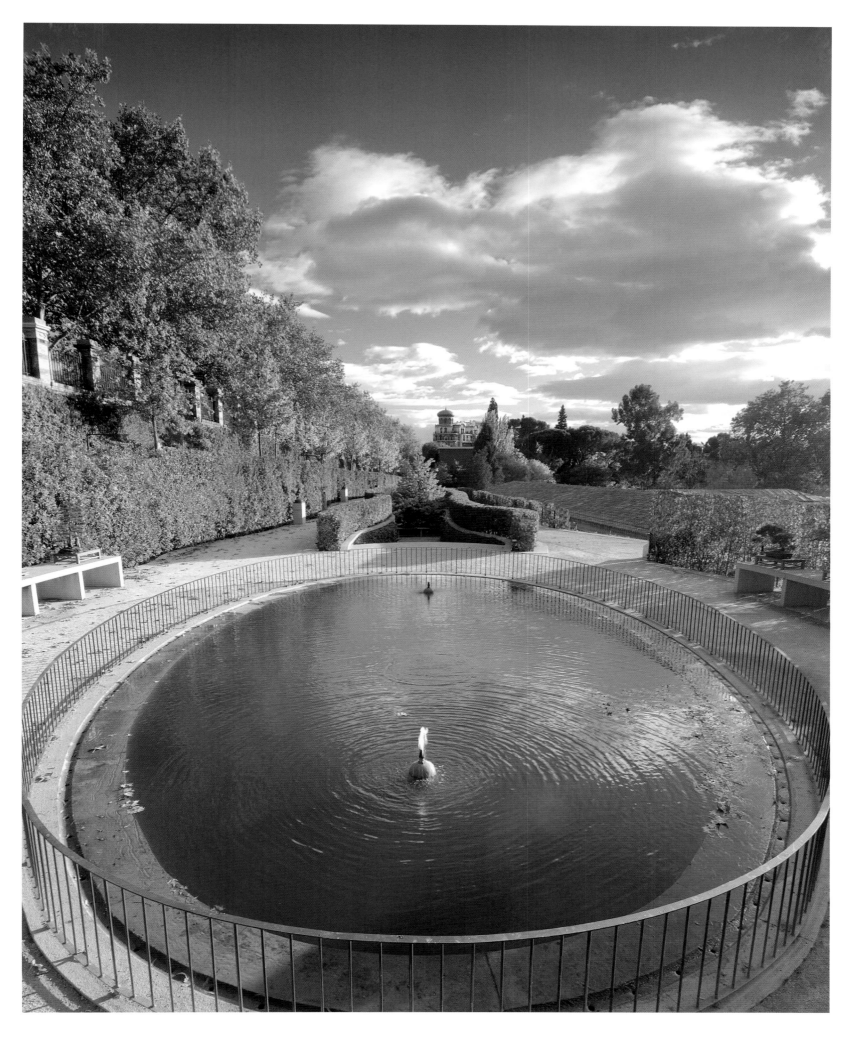

This 21st-century garden was designed to harmonize with and evolve from gardens established in three previous centuries. The architectural infrastructure for the scheme was provided by Pablo Carvajal.

Dieser Garten des 21. Jahrhunderts wurde so gestaltet, dass er mit Gärten aus den drei vorhergehenden Jahrhunderten harmoniert und eine Weiterentwicklung darstellt. Die architektonische Infrastruktur für das Schema wurde durch Pablo Carvajal zur Verfügung gestellt.

Ce jardin du 21ème siècle a été élaboré dans le but de se fondre harmonieusement dans les jardins créés au cours des trois siècles précédents et de s'y développer. L'infrastructure architecturale du projet a été proposée par Pablo Carvajal.

Este jardín del siglo XXI ha sido diseñado para lograr un resultado armónico y desarrollar los jardines dispuestos en los tres siglos anteriores. La infraestructura arquitectónica del proyecto estuvo a cargo de Pablo Carvajal.

Questo giardino del XXI secolo fu ideato per dare armonia e per risaltare dai giardini costituiti tre secoli prima. L'infrastruttura architettonica dello schema è stata curata da Pablo Carvajal.

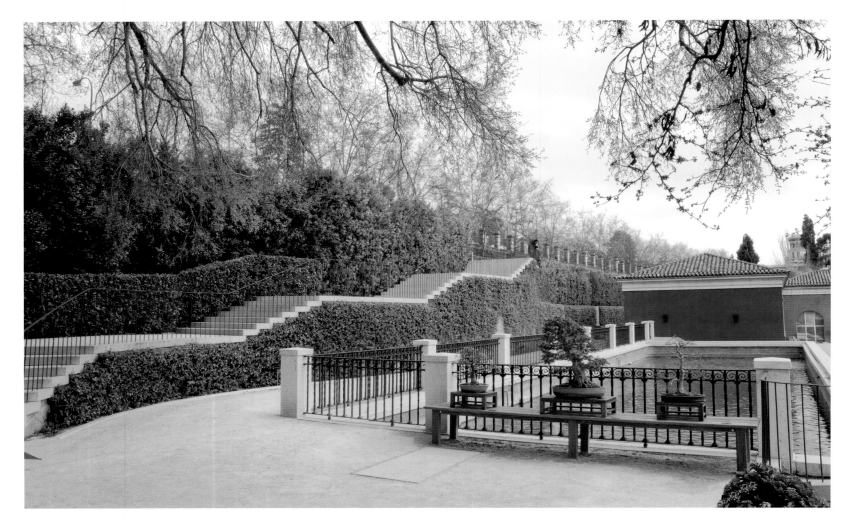

The most significant bonsai pieces are exhibited on the largest surface known as the Ellipse Area.

Die bedeutendsten Bonsaiexemplare werden auf der größten der Flächen, bekannt als die Ellipse, ausgestellt.

Les bonsaïs les plus significatifs sont exposés dans la plus grande surface, connue comme l'Ellipse.

Los bonsáis de mayor valor se exhiben en una zona de gran tamaño conocida como Zona Elíptica.

I principali esemplari di bonsai del sito sono esibiti sulla superficie più grande, conosciuta anche come Area Ellittica.

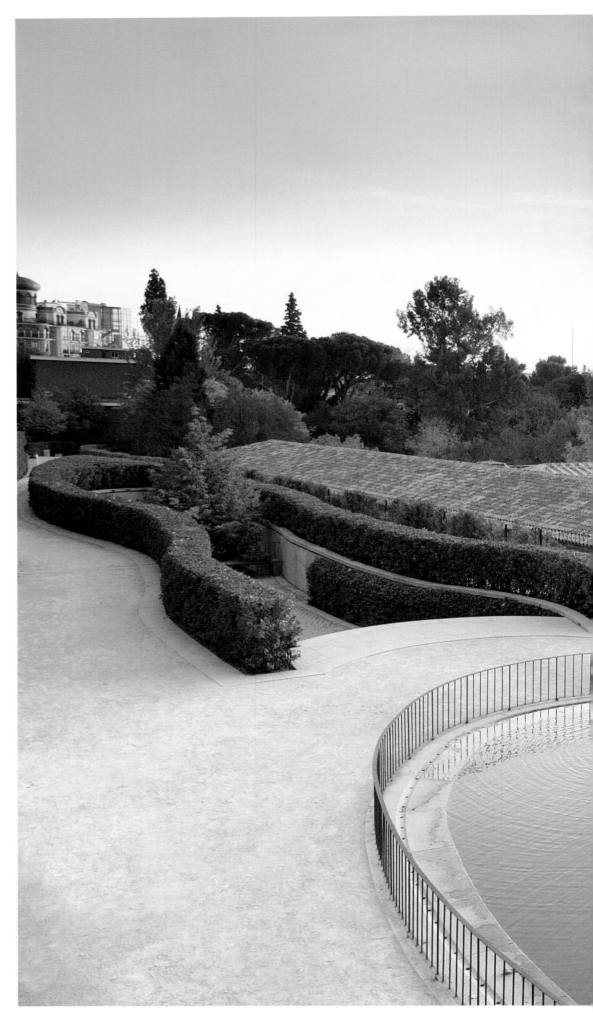

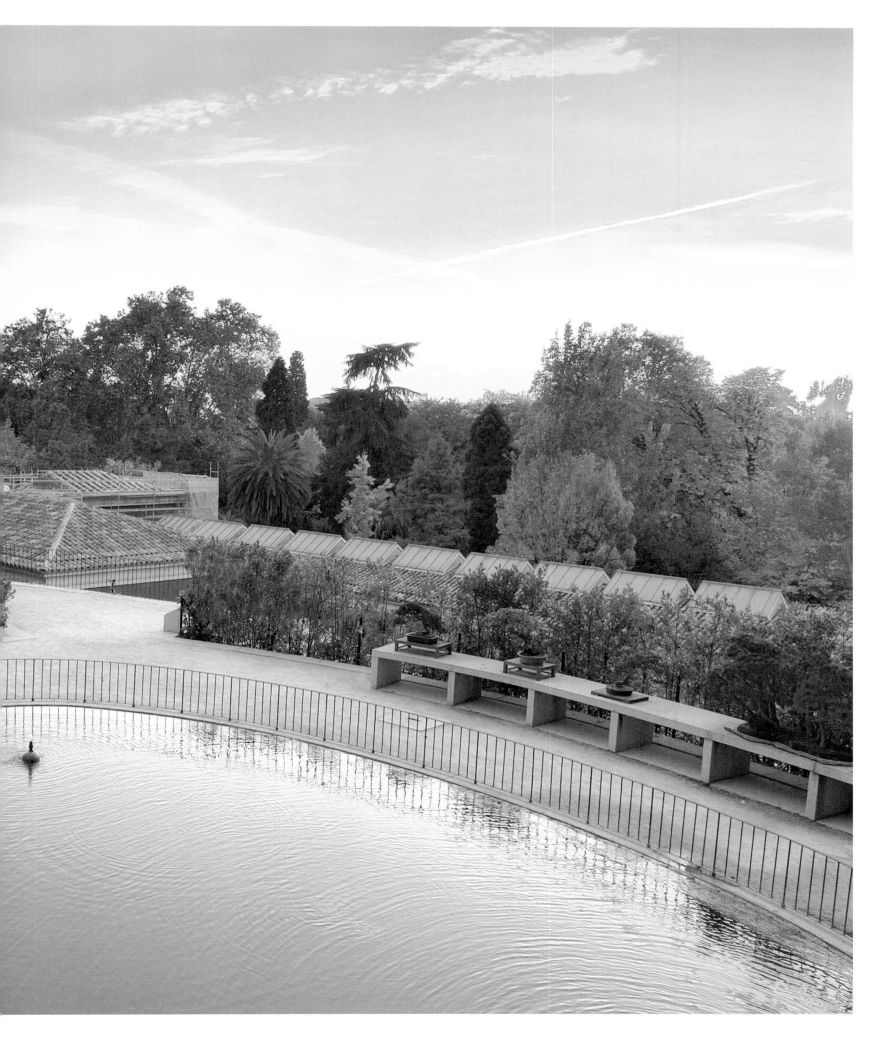

Shenyang Architectural University Campus

Shenyang City, China

China's overwhelming urbanization inevitably impacts upon its arable lands. The concept of Shenyang campus was to use rice as a way of keeping the land productive and also fulfilling its role as an environment for learning. The productive aspect of the landscape draws both students and faculty into the dialog of sustainable development and food production. Golden Rice became a university icon and could raise awareness of new hybrid landscape solutions. The designer also demonstrates how productive agricultural land can become useable space.

Chinas überwältigende Verstädterung hat unvermeidliche Auswirkungen auf sein Ackerland. Das Konzept des Shenyang Campus war es, Reis anzubauen und gleichzeitig seine Rolle als Lernumgebung zu erfüllen. Der Produktionsaspekt der Landschaft zieht Studenten und auch Lehrpersonal in einen Dialog nachhaltiger Entwicklung und Nahrungsmittelproduktion. Golden Rice wurde zu einem universitären Symbol und könnte ein neues Bewusstsein für neue hybride Landschaftsgestaltungen wecken. Der Designer zeigt auch, wie produktives Agrarland zu nutzbarem Raum werden kann.

L'irrésistible urbanisation de la Chine a eu inévitablement un impact sur les terres arables. Le concept du campus de Shenyang est basé sur l'utilisation du riz comme moyen de préserver la productivité de la terre et de mettre en avant le rôle que cette plante joue dans la meilleure connaissance de l'environnement. L'aspect productif du paysage a engagé les étudiants et l'université à établir un dialogue sur le développement durable et la production alimentaire. Le Riz Doré est ainsi devenu l'icône de l'université, et sa culture pourrait aider à accroître les savoirs en termes de solutions paysagères hybrides. Le concepteur démontre aussi comment les terres dédiées à l'agriculture productive peuvent devenir des espaces disponibles pour d'autres usages.

El arrollador proceso de urbanización de China está afectando de forma inevitable a sus tierras cultivables. El concepto del campus de Shenyang era utilizar el arroz como una forma de mantener la producción de la tierra al tiempo que se respetaba su papel de entorno de aprendizaje. El aspecto productivo del paisaje involucra tanto a alumnos como a profesores en el diálogo entre desarrollo sostenible y producción de alimentos. El Golden Rice se convirtió en un icono de la universidad y podía mejorar el conocimiento de las nuevas soluciones de paisaje híbridas. El diseñador también demuestra cómo puede convertirse un terreno agrícola productivo en un espacio útil.

L'imponente urbanizzazione della Cina ha un impatto inevitabile sui terreni coltivabili. Il concetto alla base dello Shenyang campus era di utilizzare il riso come risorsa per mantenere la terra produttiva e di svolgere la sua funzione di luogo d'apprendimento. L'aspetto produttivo del paesaggio porta sia gli studenti che la facoltà al dialogo sullo sviluppo sostenibile e la produzione di cibo. Il Riso Dorato è diventato un'icona dell'università e potrebbe attirare l'attenzione sulla questione delle soluzioni paesaggistiche ibride. L'architetto ha anche dimostrato come un terreno agricolo produttivo può diventare spazio utilizzabile.

2003
Turenscape (Beijing Design Institute)
www.turenscape.com

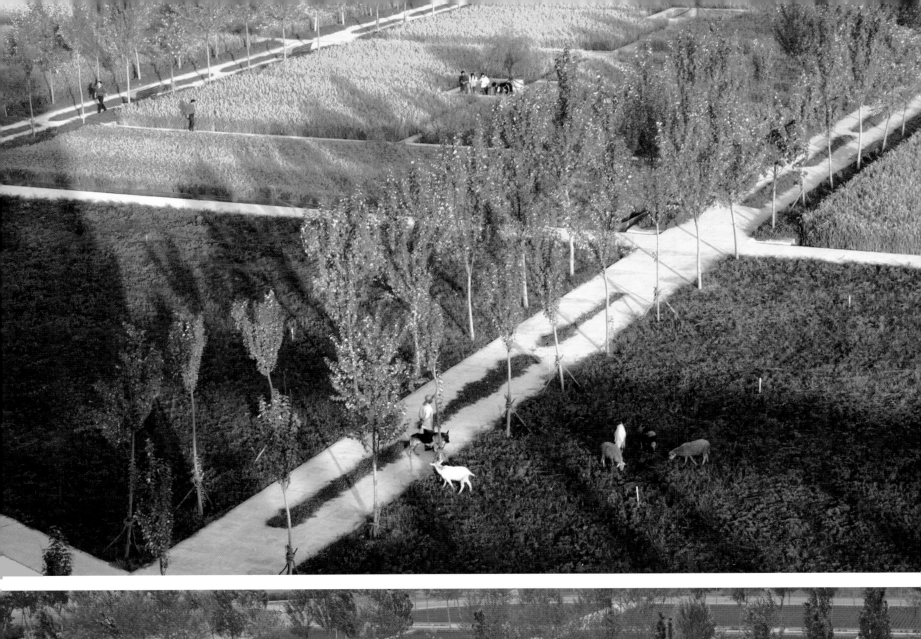
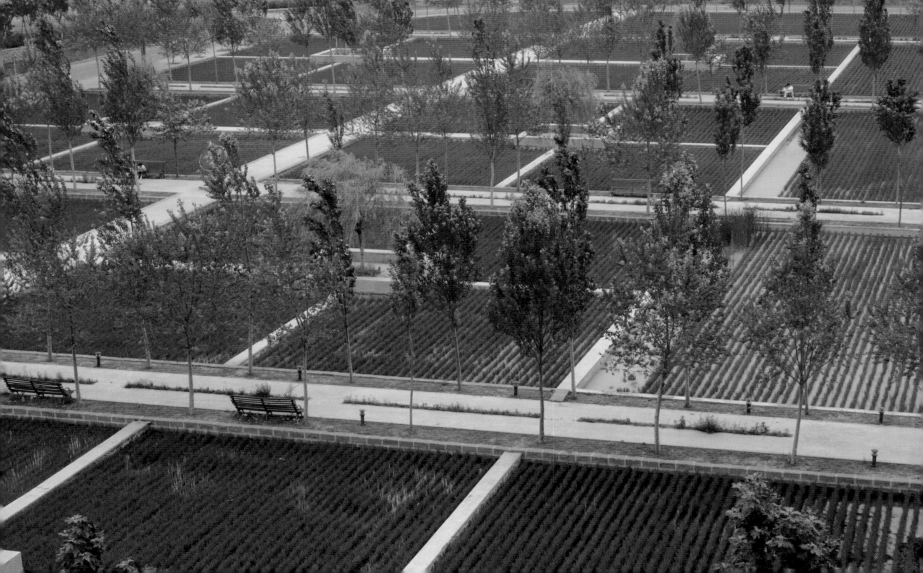

Native popular trees are used for shading, and the path is designed for potential mechanical use as well as for daily pedestrian use, with the planting band in the center. Sheep are raised in the field.

Heimische Baumarten spenden Schatten, der Weg ist für potentielle Nutzung durch Fahrzeuge und Fußgänger angelegt und ist in der Mitte bepflanzt. Im Feld werden Schafe großgezogen.

Les populations d'arbres autochtones sont utilisées pour créer des zones d'ombre et l'allée, comportant une bande de plantations, est conçue à la fois pour des usages mécaniques potentiels et pour le plaisir des piétons qui s'y promènent quotidiennement. Des moutons sont élevés dans le champ.

Se utilizaron árboles autóctonos y conocidos para dar sombra y los caminos se diseñaron de forma que los pudieran utilizar medios mecánicos y peatones, dejando una zona para plantas en su centro. En los campos también se cuidan ovejas.

Alberi locali sono usati per fornire ombra mentre il sentiero è stato studiato per un potenziale uso meccanico oltre che per un più comune uso pedonale, con un'area per le piante nel centro. Le pecore vengono allevate nel campo.

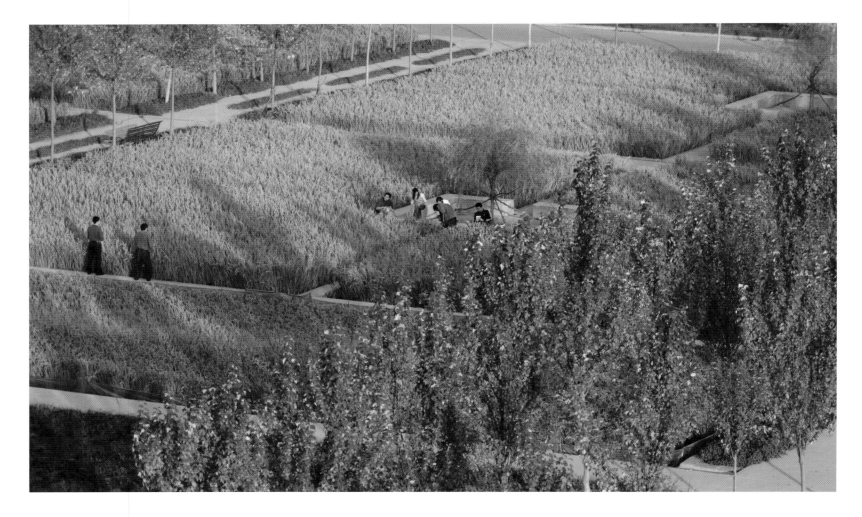

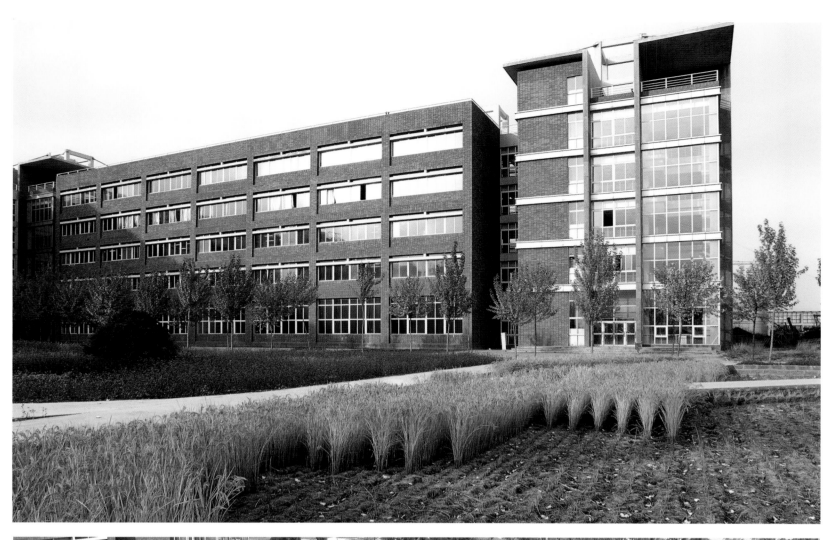

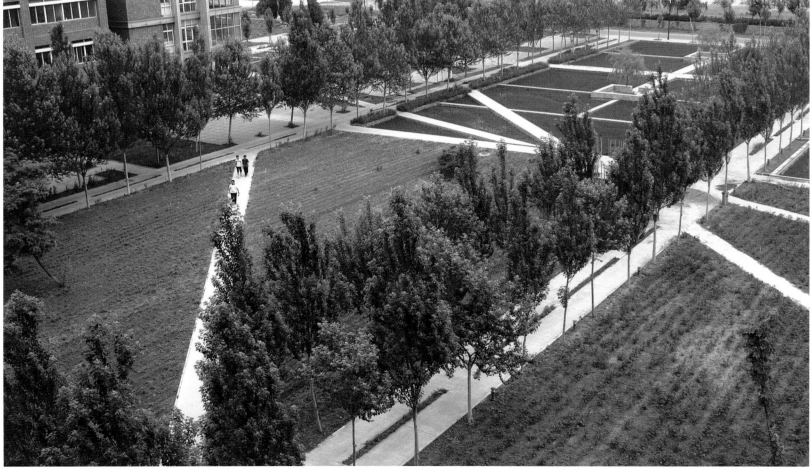

T-Mobile City

Bonn, Germany

The challenge of T-Mobile City was to create an urban open space connecting a total of 42 acres of modern offices, training facilities and an event hall. T-Mobile 1 and 2 are joined by the main plaza to provide a common forecourt and event space which is linked to the adjacent public streets. Deeper into the complex of buildings are inner courtyards, green areas, patios, walkways and mirror pools. The water surfaces reflect the glass facades of the buildings creating the effect of additional light and space.

Die Herausforderung der T-Mobile City war es, einen offenen städtischen Platz zu schaffen, der insgesamt 170.000 Quadratmeter moderner Büros, Schulungsgebäude und eine Veranstaltungshalle miteinander verbindet. T-Mobile 1 und 2 sind durch den Hauptplatz miteinander verbunden, um einen gemeinsamen Vorplatz und Veranstaltungsraum zur Verfügung zu stellen, der mit den angrenzenden öffentlichen Straßen verbunden ist. Tiefer in dem Gelände befinden sich Innenhöfe, grüne Bereiche, Patios, Fußgängerwege und Spiegelteiche. Die Wasseroberfläche reflektiert die Glasfassade der Gebäude und erzeugt einen Effekt von zusätzlichem Licht und Raum.

Le défi de T-Mobile City était de créer un espace urbain ouvert permettant de connecter les 170.000 mètres carrés composés de bureaux modernes, de lieux d'apprentissage et d'un hall dédié à l'organisation d'évènements. T-Mobile 1 et 2 sont raccordés entre eux par la place principale et fournissent un parvis commun et un lieu d'évènements unis aux rues adjacentes. En entrant davantage dans le complexe formé par les bâtiments, on trouve des cours intérieures, des zones vertes, des patios, des allées et des bassins réfléchissants. Les surfaces d'eau reflètent les façades vitrées des bâtiments, ce qui crée l'effet d'une lumière supplémentaire et donne l'impression de plus d'espace.

El reto en T-Mobile City era crear un espacio urbano abierto que conectara un total de 170.000 metros cuadrados de modernas oficinas, instalaciones de formación y un salón de actos. T-Mobile 1 y 2 están unidos por la plaza principal, que actúa de patio común y de espacio para actos, y que está unida a las calles adyacentes. En el interior del complejo de edificios se pueden encontrar patios interiores, zonas verdes, pasajes y estanques. La superficie del agua refleja las fachadas de cristal de los edificios creando un efecto de luz y espacio.

La sfida della T-Mobile City era di sviluppare uno spazio pubblico aperto che collegasse una superficie di 170.000 metri quadrati di uffici dallo stile moderno, piste d'allenamento e un centro eventi. T-Mobile 1 e 2 sono uniti tra loro dalla piazza centrale per creare un'area comune e uno spazio per gli eventi dotato di accesso alle strade adiacenti. Guardando più da vicino il complesso scopriamo cortili, aree verdi, un patio, marciapiedi e specchi d'acqua. Le superfici acquatiche riflettono le facciate di vetro degli edifici creando un altro sensazionale effetto di luce e spazio.

2004
RMP Stephan Lenzen Landschaftsarchitekten
www.RMP-Landschaftsarchitekten.de

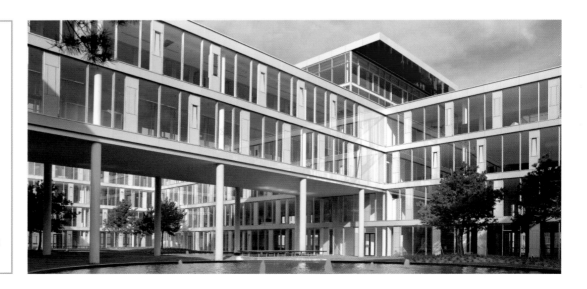

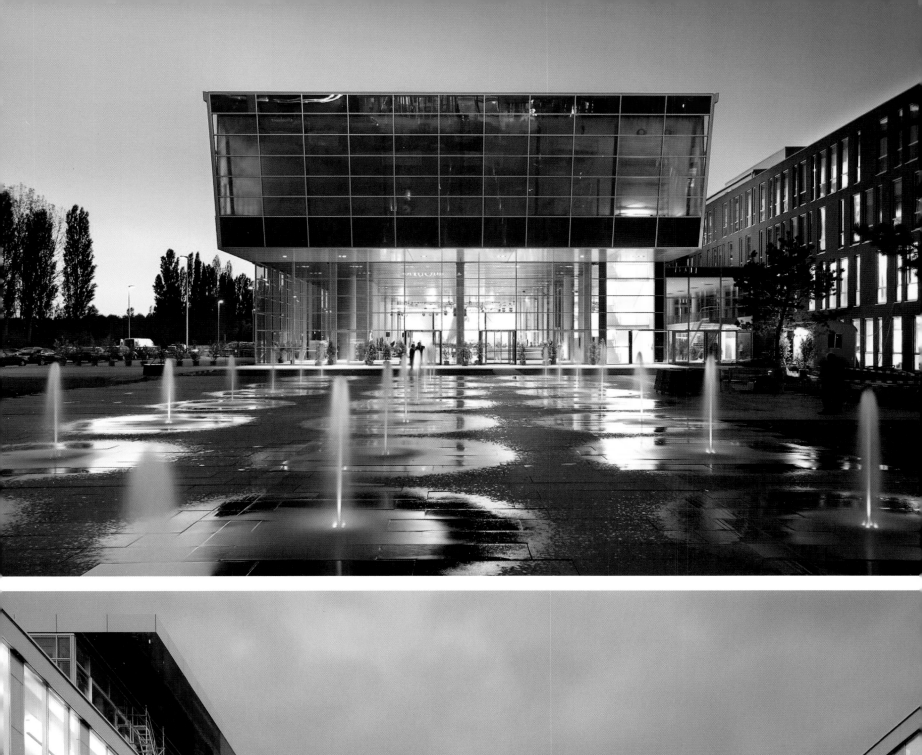
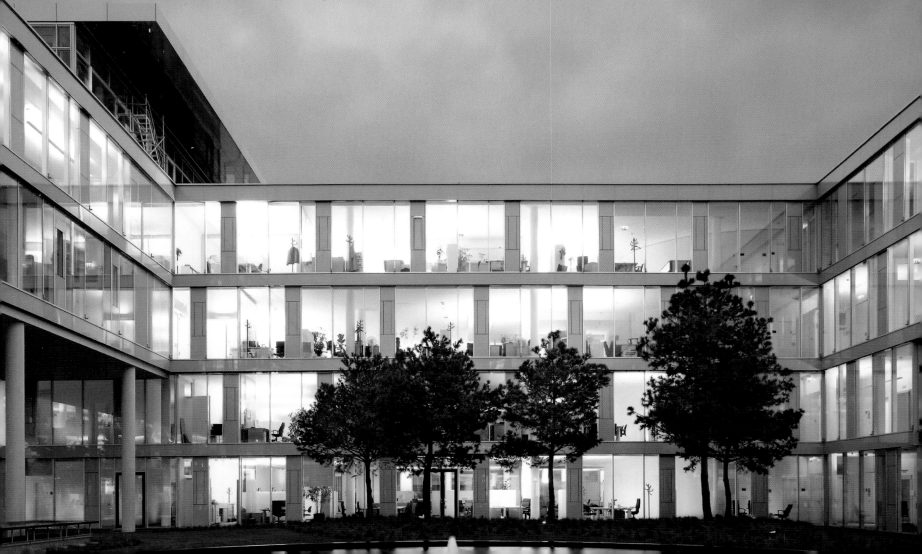

The functionality of the space is evident with seating, bike parks and thoroughfares. Tree planting and mowed lawns further enhances the workplace of over 5,000 employees.

Die Funktionalität des Raums gewinnt durch Sitzgelegenheiten, Fahrradabstellbereiche und Durchgänge. Baumpflanzungen und gemähter Rasen werten diesen Arbeitsplatz von mehr als 5.000 Angestellten weiter auf.

La fonctionnalité de ce lieu de travail où accourent chaque jour près de 5.000 employés et qui comprend des zones pour s'assoir, des parkings pour bicyclettes et des voies publiques, est évidente. Des plantations d'arbres et des pelouses tondues en rehaussent l'esthétique.

La funcionalidad del espacio es evidente, como se puede ver en los asientos, zonas para abarcar bicicletas y calles. Los árboles plantados y el césped bien cuidado brindan mayor calidad a este lugar de trabajo que acoge a más de 5.000 empleados.

Lo scopo funzionale dello spazio è evidente dal numero di panchine, parchi biciclette e stradine. Alberi e prati curati migliorano questo ambiente di lavoro di oltre 5.000 impiegati.

 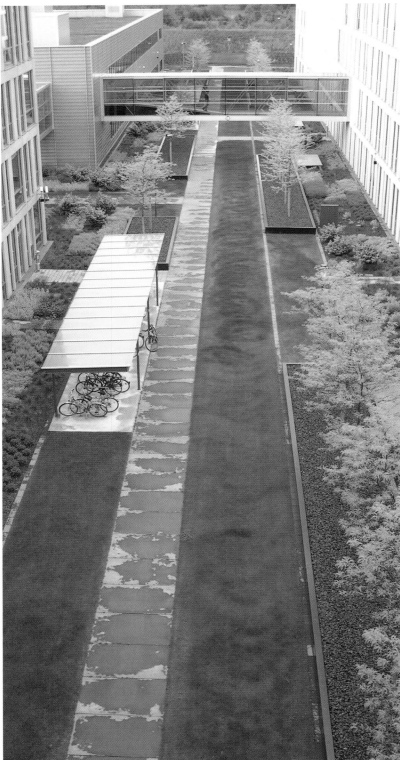

Embedded within the water pools are islands of vegetation accessed by stepping stones. Additionally, each yard area is provided with a large wooden patio.

In die Wasserteiche eingebettet befinden sich Inseln mit Vegetation, die über Trittsteine erreicht werden können. Zusätzlich ist in jedem Hofbereich ein großer hölzerner Patio vorhanden.

Des îles de végétation, accessibles grâce à des pierres de gué, sont intégrées à l'intérieur des bassins. Chaque zone jardinée comporte de plus un grand patio fait en bois.

Dentro de los estanques de agua se han dispuesto islas de vegetación a las que se puede acceder por medio de piedras. Además, cada una de las zonas cuenta con un gran patio de madera.

Ad arricchire i laghetti ci sono piccole isole di vegetazione a cui si può arrivare attraverso delle rocce immerse nell'acqua. Inoltre, ciascuna zona dispone di un patio in legno.

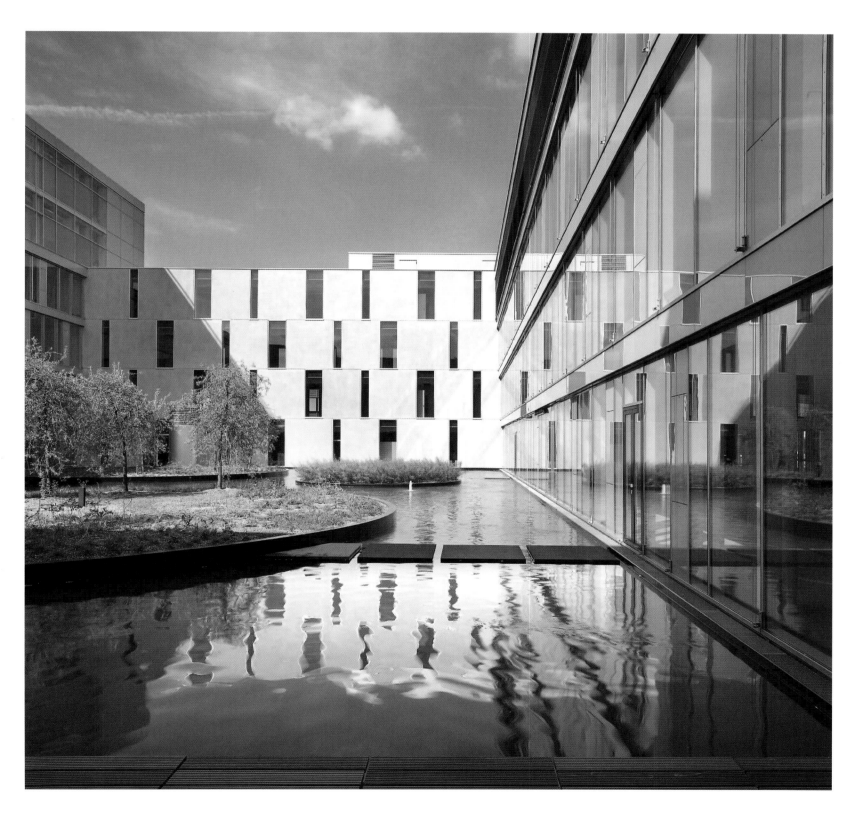

The California Endowment

Los Angeles, USA

The California Endowment offices are situated in a 16,000-square-feet garden courtyard. Influences include California's historic Mission Courtyards and the Japanese gardens of nearby Little Tokyo. There is continuity between indoor and outdoor spaces via retractable glass walls. A medicinal herb garden symbolizes the company's commitment to health education and provides a meditative area for employees and visitors. California's diverse ecosystems are evoked in the prolific planting, with the iconic large redwood trees juxtaposed against the sites' urban industrial backdrop.

Die Büros des California Endowment befinden sich in einem 1.500 Quadratmeter großen begrünten Hof. Beeinflusst wurde die Anlage durch historische kalifornische Missionshöfe und die nahen japanischen Gärten von Little Tokyo. Innen- und Außenbereiche verschmelzen mittels verschiebbarer Glaswände. Ein medizinischer Kräutergarten symbolisiert das Interesse der Gesellschaft an der Gesundheitserziehung und stellt einen meditativen Bereich für Angestellte und Besucher zur Verfügung. Fruchtbare Anpflanzungen erinnern an die unterschiedlichen Ökosysteme Kaliforniens; charakteristische Mammutbäume kontrastieren die städtisch-industrielle Umgebung.

Les bureaux de la fondation California Endowment sont situés dans une cour intérieure jardinée de 1.500 mètres carrés. Les influences prises en compte lors de la conception du projet vont des Cours faisant partie des missions Espagnoles de Californie aux Jardins japonais situés proches du district de Little Tokyo. Un mur de verre escamotable permet de créer une continuité qui unit les espaces intérieurs et extérieurs. Un jardin d'herbes médicinales symbolise les engagements de la fondation envers l'éducation à la santé et crée une zone propice à la méditation des employés et visiteurs. La diversité des écosystèmes de Californie est évoquée par le biais d'une riche plantation où dominent de majestueux séquoias qui forment une toile de fond se démarquant des sites industriels et urbains environnants.

Las oficinas del California Endowment están situadas en un patio ajardinado de 1.500 metros cuadrados. Entre sus influencias se encuentran los patios de las antiguas misiones de California y los jardines japoneses del cercano Little Tokyo. Hay una clara continuidad entre los espacios interiores y exteriores a través de sus muros de cristal replegables. Un jardín de hierbas medicinales simboliza el compromiso de la empresa con la educación sanitaria y proporciona un área de meditación para los empleados y visitantes. La abundante vegetación, como las inmensas secuoyas situadas contra el telón urbano industrial del lugar, evoca los diferentes ecosistemas de California.

Il complesso di uffici California Endowment è situato all'interno di un giardino di 1.500 metri quadrati. Tra le influenze del progetto troviamo gli storici Mission Courtyards californiani e i giardini giapponesi della vicina Little Tokyo. C'è una continuità tra gli spazi interni ed esterni frutto delle pareti di vetro retrattili. Il giardino di erbe officinali simboleggia l'impegno della compagnia verso l'educazione alla salute, fungendo anche da area meditativa per impiegati e visitatori. I diversi ecosistemi della California sono evocati dalla fitta piantumazione, con le imponenti sequoie giustapposte ad icona allo stampo urbano industriale del sito.

2006
Rios Clementi Hale Studios
www.rchstudios.com

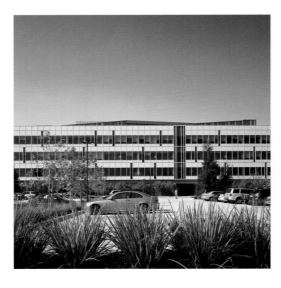
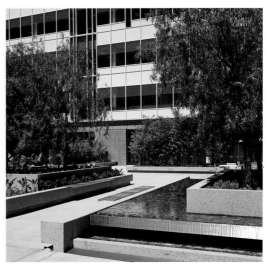

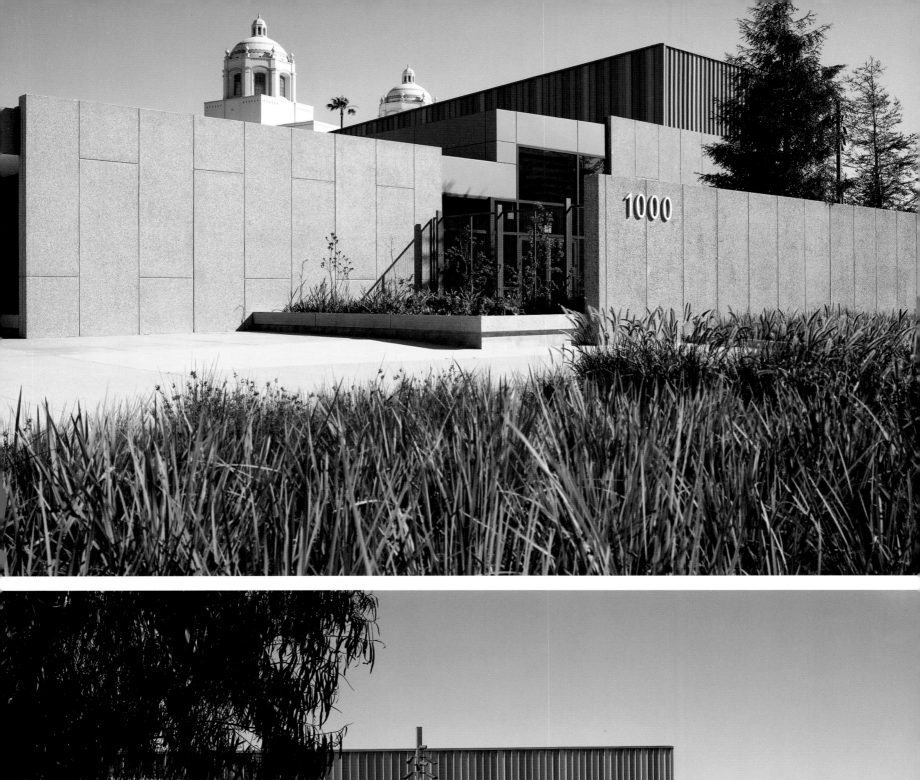
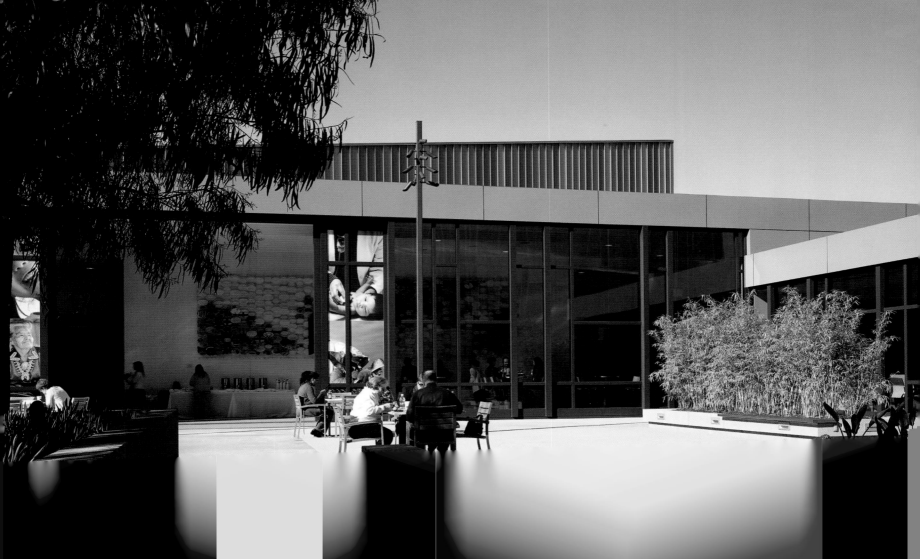

The riparian trees allude to the nearby L.A. River and the defunct Zanja Madre irrigation ditch that once served Pueblo de Los Angeles.

Die Uferbäume weisen auf den nahegelegenen L.A. River hin und den nicht mehr bestehenden Zanja-Madre-Bewässerungsgraben, der einmal dem Pueblo de Los Angeles diente.

Les arbres lacustres font quant à eux allusion à la L.A. River située à proximité et au défunt aqueduc de la Zanja Madre qui était autrefois utilisé pour desservir en eau le Pueblo de Los Angeles.

Los árboles ribereños aluden al cercano río Los Ángeles y a la desaparecida acequia de irrigación Zanja Madre, que en su día abastecía el Pueblo de Los Ángeles.

Gli alberi rivieraschi rimandano al vicino L.A. River e al vecchio canale d'irrigazione Zanja Madre che un tempo serviva il Pueblo de Los Angeles.

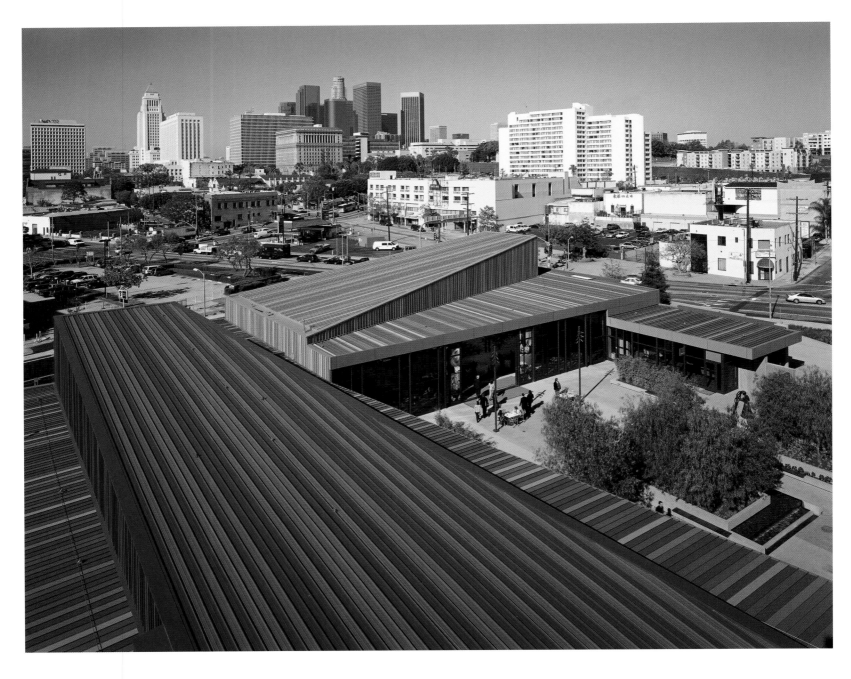

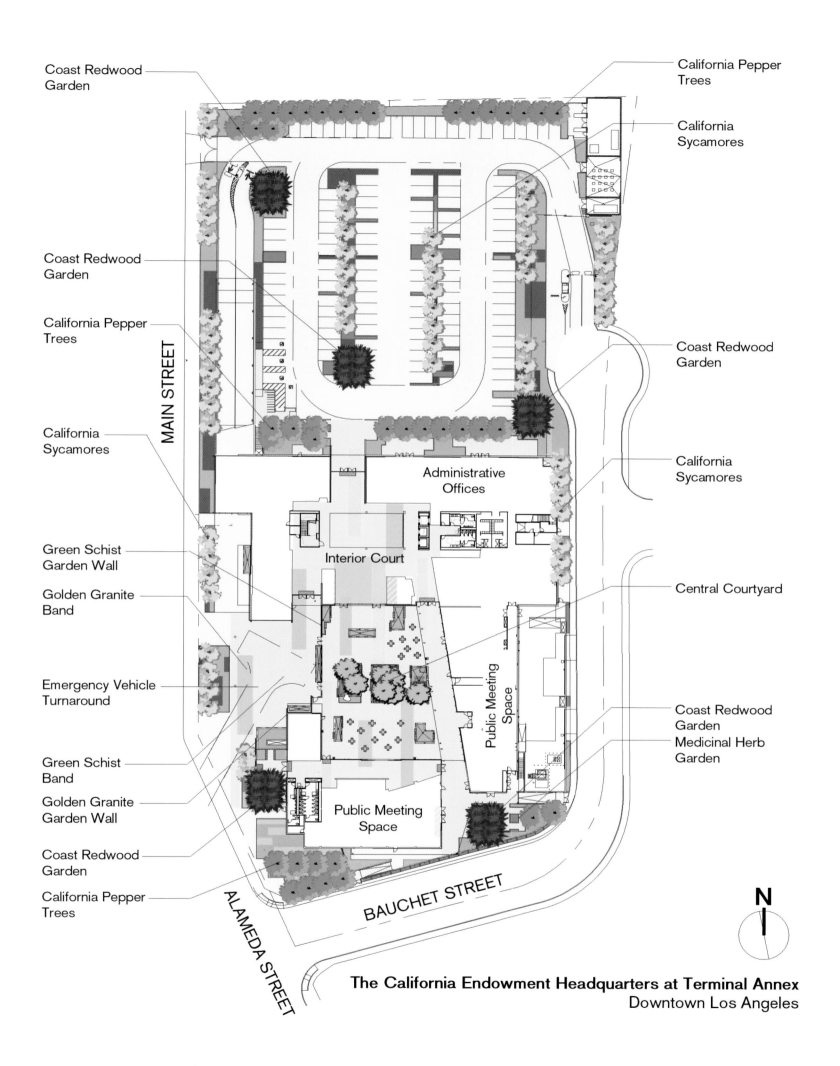

Coast Redwood Garden

Coast Redwood Garden

California Pepper Trees

California Sycamores

Green Schist Garden Wall

Golden Granite Band

Emergency Vehicle Turnaround

Green Schist Band

Golden Granite Garden Wall

Coast Redwood Garden

California Pepper Trees

California Pepper Trees

California Sycamores

Coast Redwood Garden

California Sycamores

Central Courtyard

Coast Redwood Garden

Medicinal Herb Garden

MAIN STREET

ALAMEDA STREET

BAUCHET STREET

Administrative Offices

Interior Court

Public Meeting Space

Public Meeting Space

N

The California Endowment Headquarters at Terminal Annex
Downtown Los Angeles

The Museum of Modern Art
Saitama, Japan

The museum is located in the center of a park making use of the historically important rows of trees that are prominent in the landscape. A height restriction of 50 feet required that the museum's permanent collection is displayed at basement level. The corner lattice walls of the museum enclose a spacious garden in front of the main entrance. This transitional space is a modern interpretation of the ancient inner garden traditionally located in front of a Japanese tea ceremony house.

Das Museum befindet sich im Zentrum eines Parks, der hauptsächlich aus den historisch bedeutenden Baumreihen besteht, die die Landschaft dominieren. Eine Höhenbeschränkung auf 15 Meter erforderte, dass die permanente Sammlung des Museums auf Kellerhöhe gezeigt wird. Die Gitterwände an der Ecke des Museums umgeben einen großzügigen Garten vor dem Haupteingang. Dieser Übergangsplatz ist eine moderne Interpretation eines alten Innengartens, der sich traditionell direkt vor dem japanischen Haus für Teezeremonien befindet.

Le musée est situé au centre d'un parc qui utilise des rangées d'arbres dont la proéminence dans les paysages de la région leur a conféré une importance historique. Une limitation de la hauteur à 15 mètres a obligé à répartir la collection permanente du musée dans le sous-sol. Les murs en treillis des angles du musée encerclent un jardin spacieux situé en face de l'entrée principale. Cet espace de transition est une interprétation moderne des anciens jardins d'intérieur se trouvant traditionnellement en face des maisons de cérémonie de thé Japonaises.

El museo está situado en el centro de un parque y utiliza las hileras de históricos árboles que destacan en el paisaje. Debido al límite de altura de 15 metros, la colección permanente del museo debió exponerse en el sótano. Los muros de celosía del museo guardan un espacioso jardín situado frente a la entrada principal. Este espacio de transición es una interpretación moderna del antiguo jardín interior tradicionalmente emplazado frente a las casas de té japonesas.

Il museo è situato al centro di un parco in cui sfoggiano lunghe file di alberi storici che si stagliano sull'orizzonte. Un divieto che impedisce alle costruzioni di superare i 15 metri d'altezza ha costretto ad esporre questa mostra permanente al piano interrato. Le pareti angolari a traliccio del museo racchiudono un ampio giardino posto di fronte all'ingresso principale. Quest'area di passaggio è una moderna interpretazione di un antico giardino interno un tempo situato di fronte alla casa della cerimonia giapponese del tè.

1982
Kisho Kurokawa architect and associates
www.kisho.co.jp

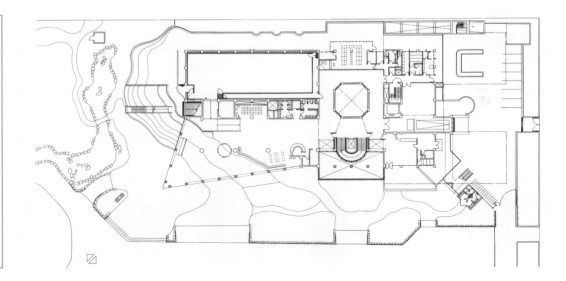

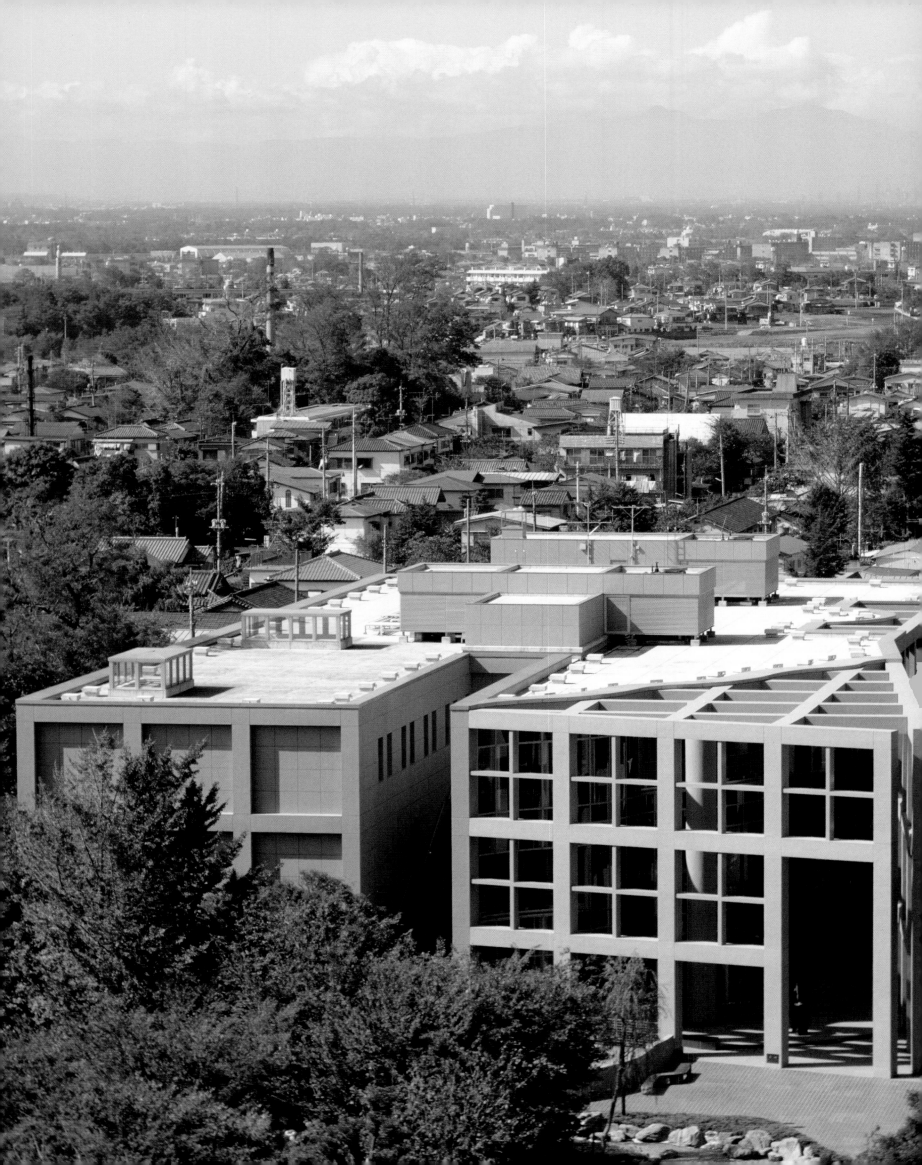

The exterior lattice columns are the point in the design where architecture and nature are joined.

Das äußere Fachwerkgestell ist der Punkt in der Gestaltung, wo Architektur und Natur aufeinandertreffen.

Les colonnes en treillis extérieures représentent la partie du projet où l'architecture et la nature se rejoignent.

Las columnas de celosía exteriores son el punto del diseño donde se encuentran la arquitectura y la naturaleza.

Le colonne esterne in traliccio rappresentano il punto del progetto in cui architettura e natura si fondono.

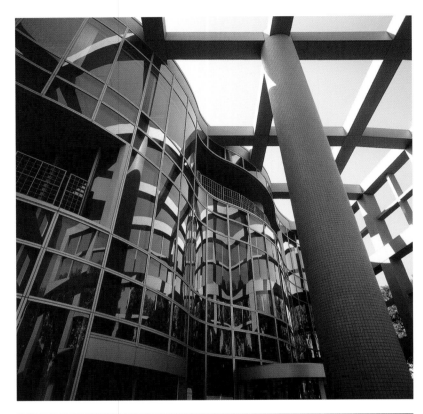
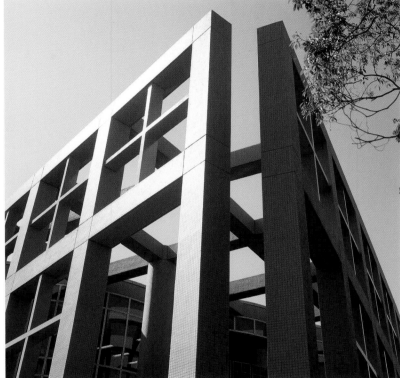
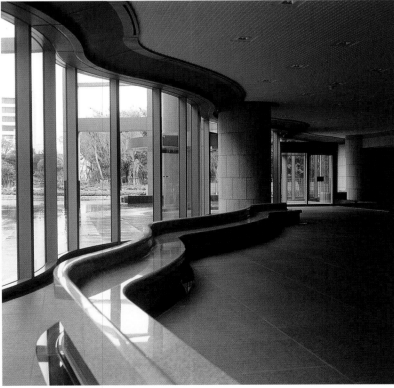
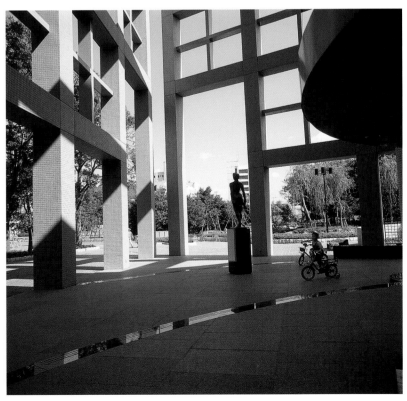

A dramatic sculpture by Yonekichi Tanaka has been installed into the building's facade to complete the design.

Eine dramatische Skulptur von Yonekichi Tanaka wurde in die Gebäudefassade integriert, um das Design zu vollenden.

Une spectaculaire sculpture de Yonekichi Tanaka a été installée dans la façade du bâtiment pour compléter le design.

En la fachada del edificio se ha instalado una dramática escultura de Yonekichi Tanaka para completar el edificio.

Un'emozionante scultura ad opera di Yonekichi Tanaka è stata posta sulla facciata dell'edificio per completarne il design.

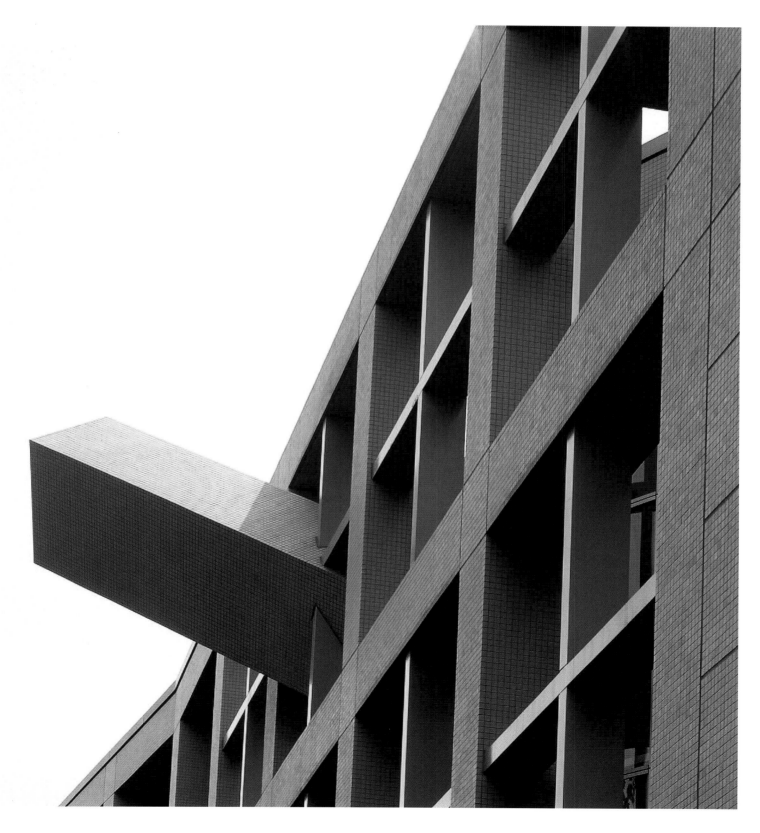

West 8th Street Subway Station Facade

New York City, USA

The unique character of New York's Coney Island became further enhanced by the completion of the West 8th Street Station renovation. As part of the Arts for Transit program, the station's facade features a sculptural architecture that has become an attraction in its own right. Taking inspiration from an ocean wave, the facade's main function is to form a windshield for the stairways and platforms. Where the facade bulges and breaks open it creates views across to the Atlantic Ocean itself.

Der einmalige Charakter von New Yorks Coney Island wurde durch die Vollendung der Renovierung der West 8th Street Station weiter aufgewertet. Als Teil des „Kunst im Verkehr"-Programms erhielt die Stationsfassade eine bildhauerische Architektur, die selber eine Attraktion geworden ist. Inspiriert von der Form einer Ozeanwelle, ist die Hauptaufgabe der Fassade, einen Windschutz für Treppen und Bahnsteige zu bilden. Durch Wölbungen und Brüche in der Fassade entstehen Ausblicke über den Atlantischen Ozean.

Le caractère unique de Coney Island, New-York, a été grandement amélioré avec la fin des travaux de rénovation de West 8th Street Station. Faisant partie du programme Arts for Transit, la façade de la gare est ornementée d'une architecture sculpturale devenue une attraction en tant que telle. Puisant son inspiration dans les vagues de l'océan, la principale fonction de la façade est de former un écran pour les escaliers et les quais. À l'endroit où la façade ressort, il est possible de jouir d'une vue plongeante sur l'Océan Atlantique.

El carácter distintivo de Coney Island, Nueva York, quedó más patente tras la finalización de la reforma de la West 8th Street Station. Como parte del programa Arts for Transit, la fachada de la estación luce una arquitectura escultural que se ha convertido en una atracción en sí misma. Inspirada en la forma de una ola, la principal función de la fachada es resguardar los andenes y escaleras de la acción del viento. Cuando la fachada se abre y abomba, permite ver directamente el propio océano Atlántico.

Il carattere unico di Coney Island, New York, è stato ulteriormente valorizzato dalla completata ristrutturazione della West 8th Street Station. In quanto parte del programma Arts for Transit, la facciata della stazione incorpora forme di architettura scultoria che la trasforma in una vera e propria attrazione. Ispirata ad un'onda dell'oceano, la funzione primaria della facciata è di proteggere le scale e le piattaforme dal vento. Nel punto in cui la facciata si tuffa in avanti per poi aprirsi, si possono godere emozionanti vedute dell'Oceano Atlantico.

2006
Acconci Studios
www.acconci.com

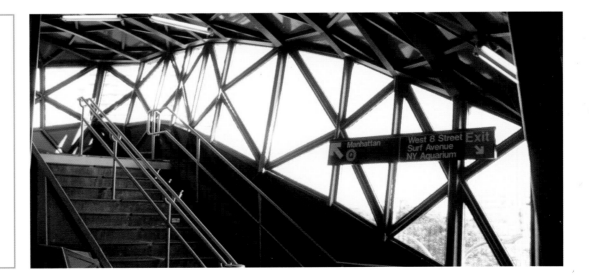

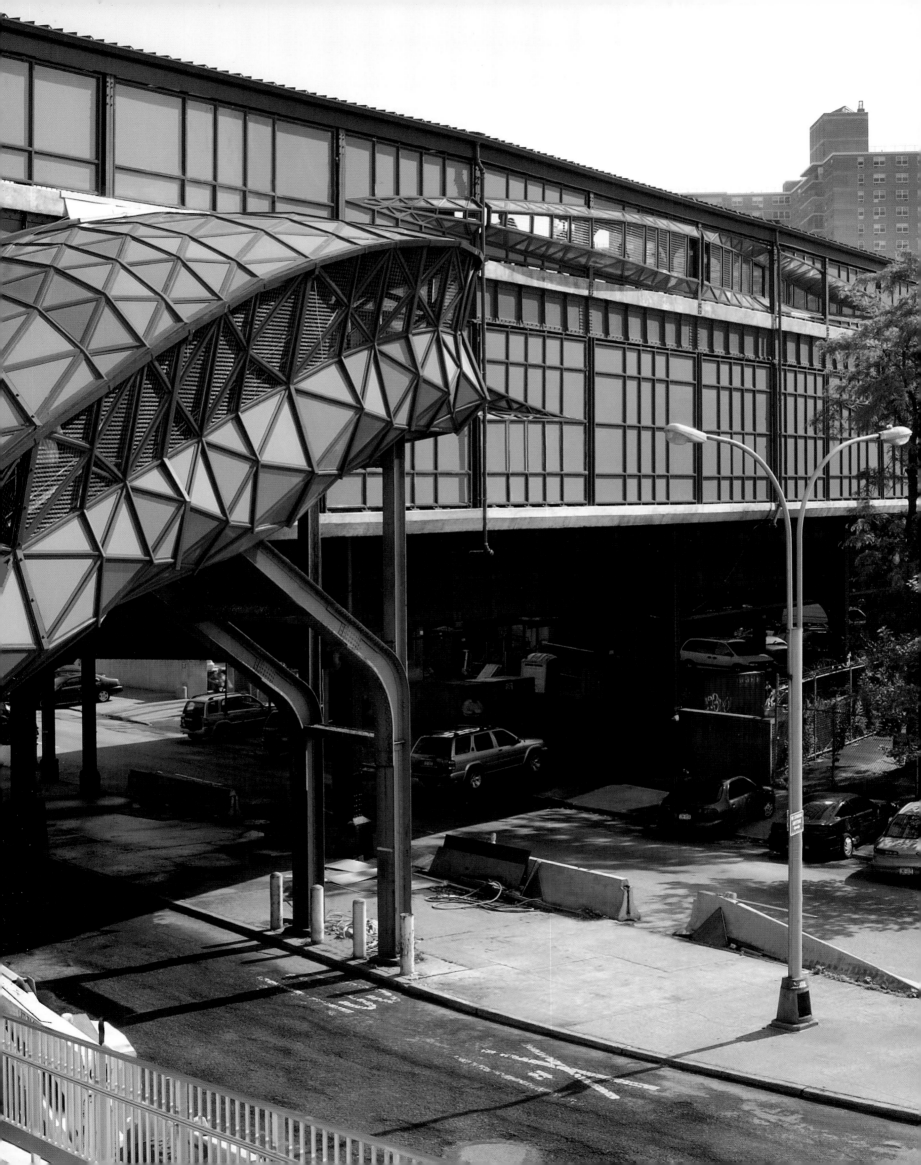

Spanning 640 feet across Surf Avenue, the new structure's rolling, curving steel frame is redolent of the adjacent Coney Island roller coaster park. Therefore, the commuting experience is lifted from the mundane and becomes part of the whole Coney Island experience.

Der gekrümmte Stahlrahmen der neuen Konstruktion, die auf einer Länge von 195 Metern die Surf Avenue überspannt, erinnert stark an den angrenzenden Achterbahnpark von Coney Island. Dadurch hebt sich auch die Erfahrung des Berufsverkehrs aus dem Alltäglichen und wird Teil der gesamten Coney-Island-Erfahrung.

S'étendant sur 195 mètres à travers la Surf Avenue, la nouvelle structure du châssis roulant et courbé évoque le parc à montagnes russes adjacent à Coney Island. Se rendre au travail s'accompagne alors d'une élévation au-dessus du quotidien terrestre, ce qui permet de se sentir comme intégré dans l'ensemble de Coney Island.

El marco de acero de la nueva estructura ondulante y curva, que ocupa 195 metros a lo largo de Surf Avenue, recuerda la montaña rusa del cercano parque de atracciones, con lo que la experiencia de los viajeros se eleva de lo mundano y pasa a formar parte de la experiencia integral de Coney Island.

Estendendosi per 195 metri lungo Surf Avenue, la struttura in acciaio della costruzione si piega e si curva, come ad imitare le montagne russe nel vicino parco di Coney Island. Ecco come anche una semplice stazione può diventare parte integrante dell'emozionante esperienza di Coney Island.

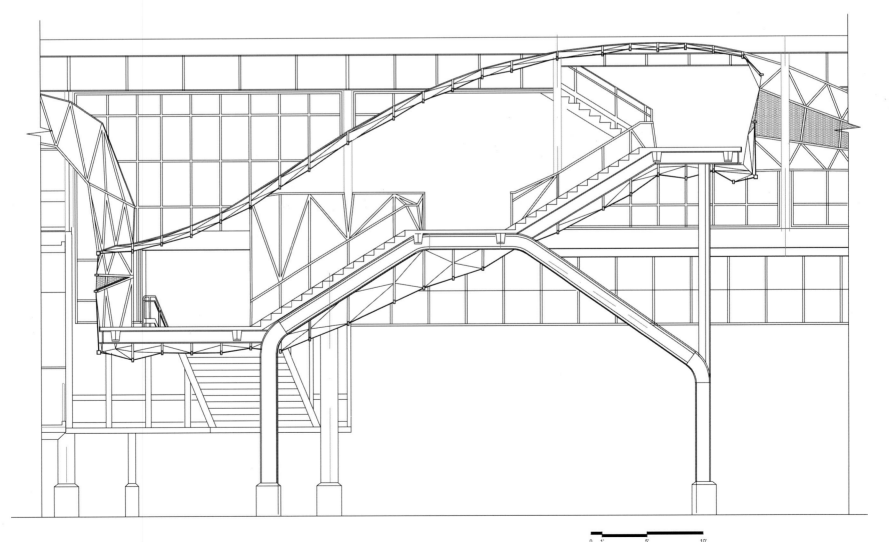

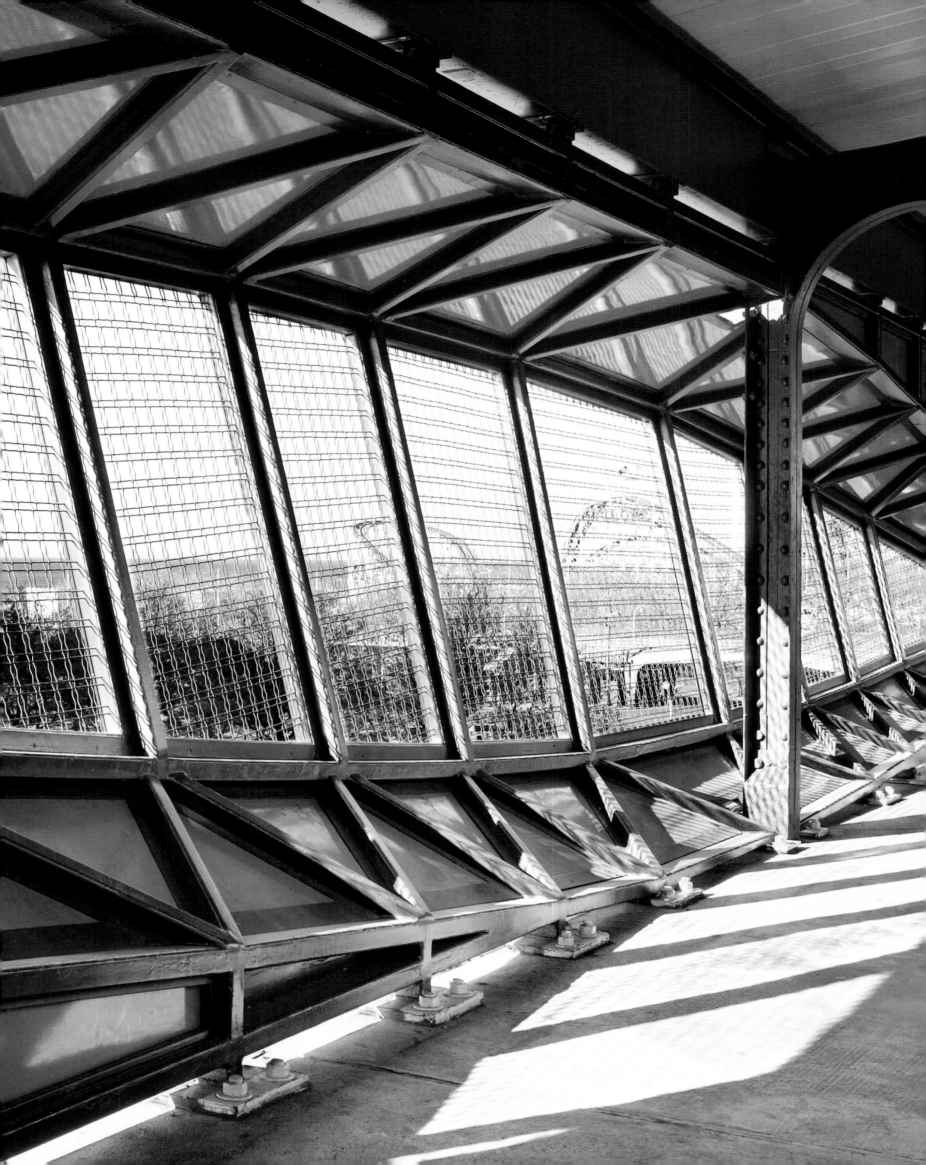

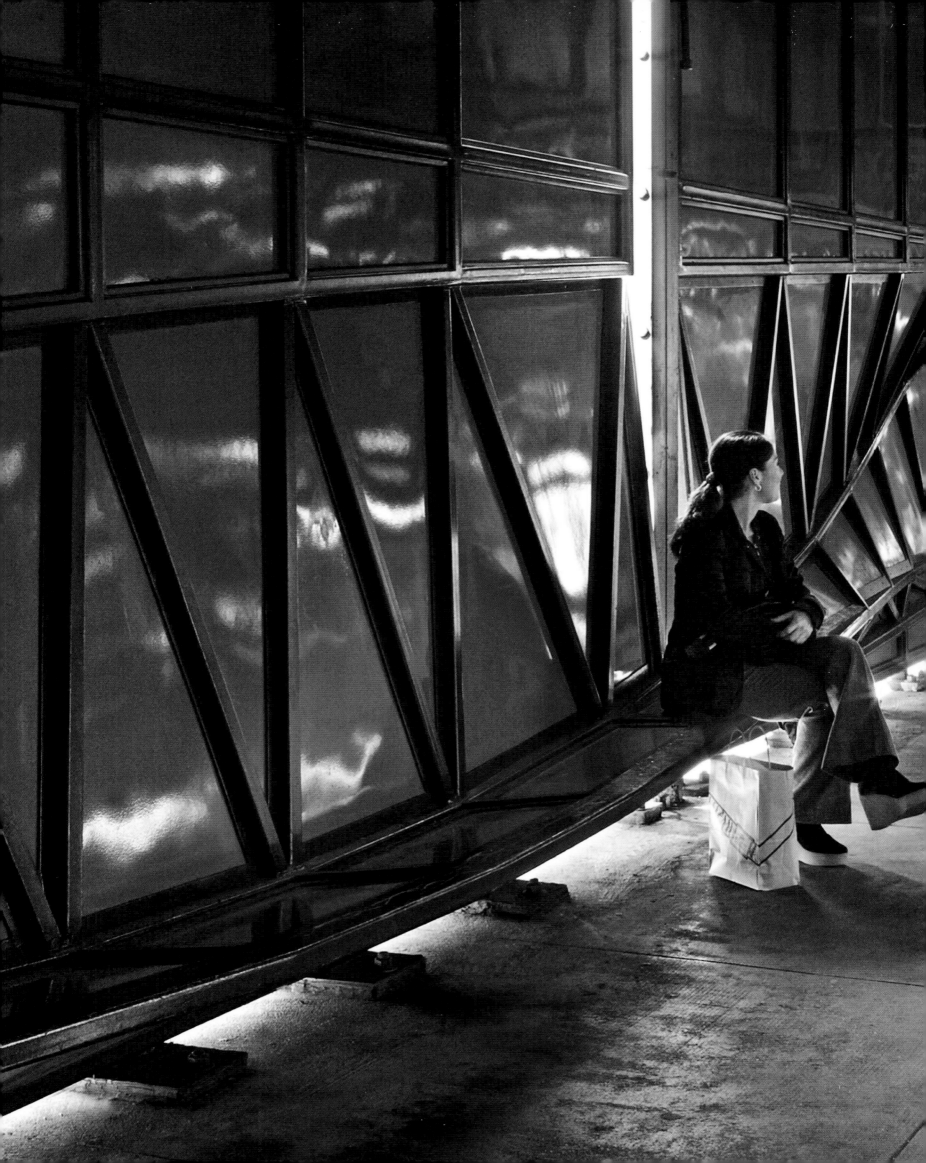

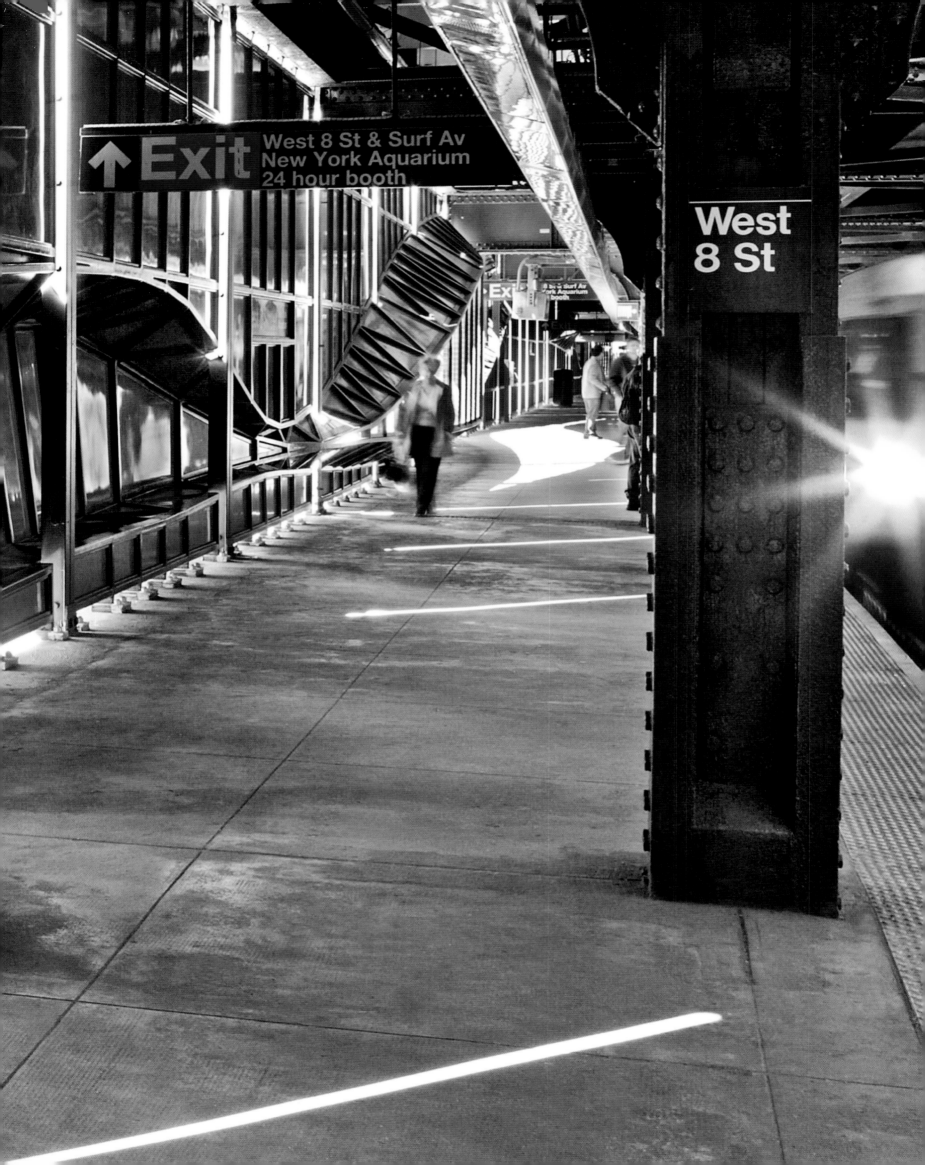

Biotech Research Campus

Seattle, USA

Biotech Research Campus is made up of 1.3 million square feet of laboratories and offices housing up to 2,500 employees. The buildings sit in a 29-acre site enjoying open views of city, shoreline and mountains. The diverse landscaping scheme includes large wild flower meadows and medicinal herb gardens, adding diverse color to the environment. Bamboo planting and sawn rock adds drama and height to the courtyard areas. Wide open green spaces complete this immense scheme sweeping down to the waterfront to provide views of Mount Rainier.

Der Biotech Forschungscampus besteht aus 120.000 Quadratmetern mit Laboren und Büros, die bis zu 2.500 Angestellte beherbergen. Die Gebäude befinden sich auf einem 12 Hektar großen Gelände, das weite Ausblicke auf die Stadt, Küstenlinie und die Berge bietet. Das vielfältige Landschaftsbild besteht aus großen Wiesen mit Wildblumen und medizinischen Kräutergärten, die der Umgebung verschiedenste Farben hinzufügen. Angepflanzter Bambus und geschnittene Felsblöcke verleihen den Hofbereichen Dramatik und Höhe. Ausufernde grüne Bereiche vervollständigen dieses gewaltige Projekt, führen zur Küstenlinie herab und bieten Ausblicke auf den Mount Rainier.

Le Biotech Research Campus s'étend sur 120.000 mètres carrés de laboratoires et bureaux hébergeant jusqu'à 2.500 employés. Le bâtiment occupe un site de 12 hectares idéal pour avoir des vues dégagées sur la ville, la côte et les montagnes. La combinaison de paysage inclut de vastes prairies de fleurs sauvages et des jardins d'herbes médicinales, ce qui donne à l'environnement toute une variation de couleurs. Des plantations de bambou et des roches apparentes donnent à la fois un côté spectaculaire et une sensation d'altitude aux zones réservées aux cours. Des espaces verts, vastes et ouverts, complètent cet immense projet descendant vers le front de mer en offrant une vue du Mont Rainier.

El Biotech Research Campus cuenta con 120.000 metros cuadrados de laboratorios y oficinas que pueden albergar hasta 2.500 empleados. Los edificios ocupan una superficie de 12 hectáreas y disfrutan de una vista franca de la ciudad, la zona costera y las montañas. El trabajo de paisajismo realizado incluye elementos tan diferentes como grandes praderas de hierbas salvajes y jardines de hierbas medicinales, que dotan al entorno de múltiples colores. Las plantaciones de bambú y los cortes de las rocas añaden dramatismo y altura a las zonas de patios. Completan este inmenso proyecto amplios espacios verdes abiertos que se prolongan hasta el frente marítimo y que ofrecen una excelente vista del monte Rainier.

Il Biotech Research Campus si estende su una superficie di 120.000 metri quadrati adibiti a laboratori e uffici che ospitano circa 2.500 impiegati. Gli edifici sorgono su un sito di 12 ettari da cui si può godere di una bellissima vista della città, della costa e delle montagne. All'interno di questo paesaggio variegato troviamo anche grandi prati di fiori selvatici e giardini di erbe officinali, che donano una tonalità sempre diversa all'ambiente. Le piantagioni di bambù e le rocce levigate danno invece un fascino davvero unico e un senso di altitudine alle aree intorno al campo. Ampi spazi verdi completano questo immenso schema che si estende fino alla costa, da cui si può godere di una splendida vista sul Mount Rainier.

2004
Murase Associates
www.murase.com

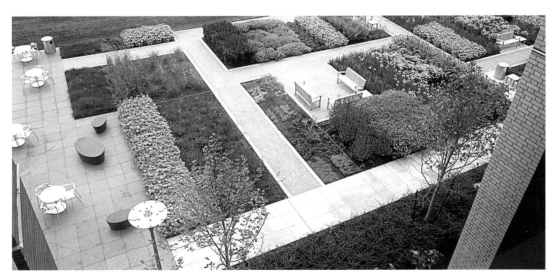

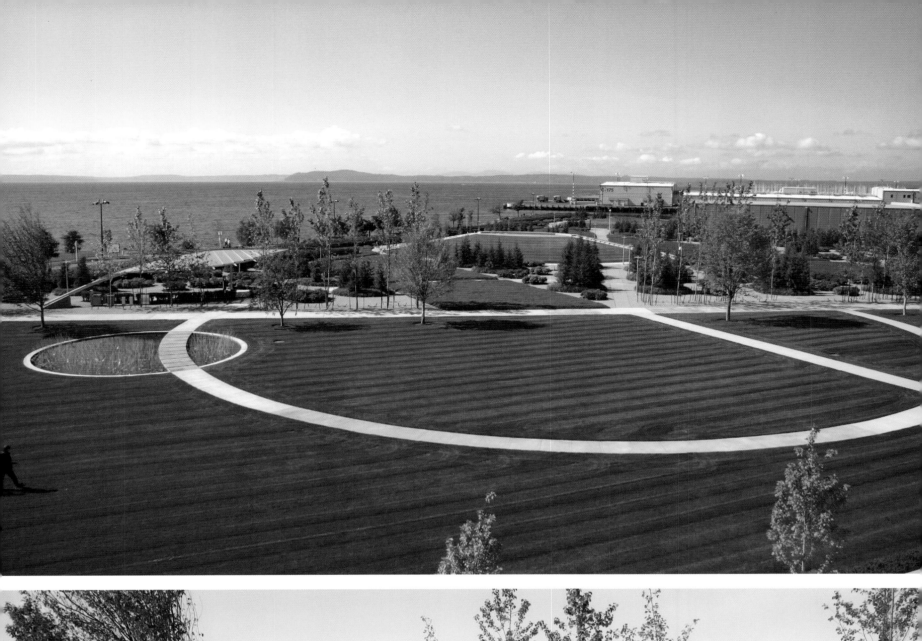

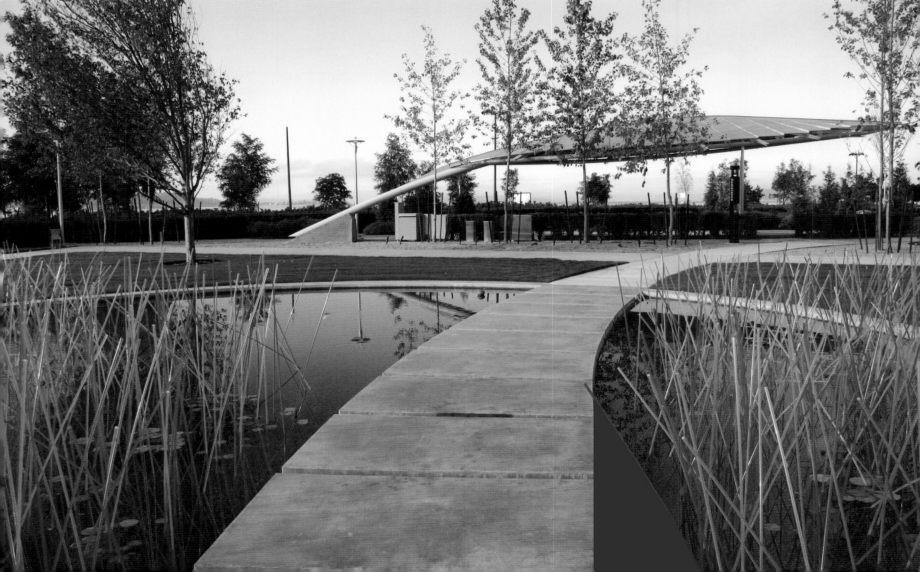

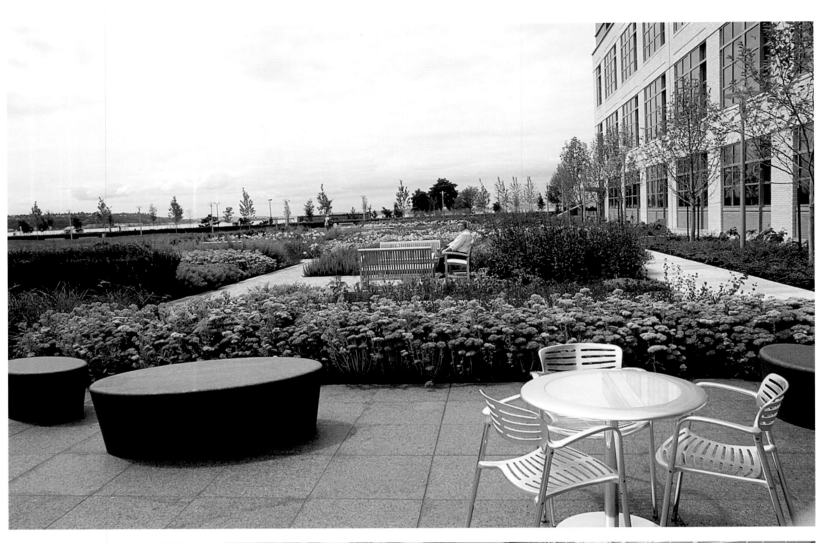

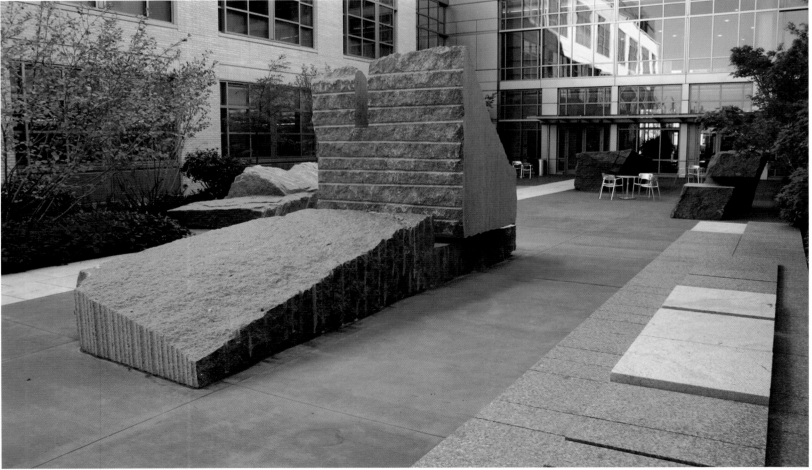

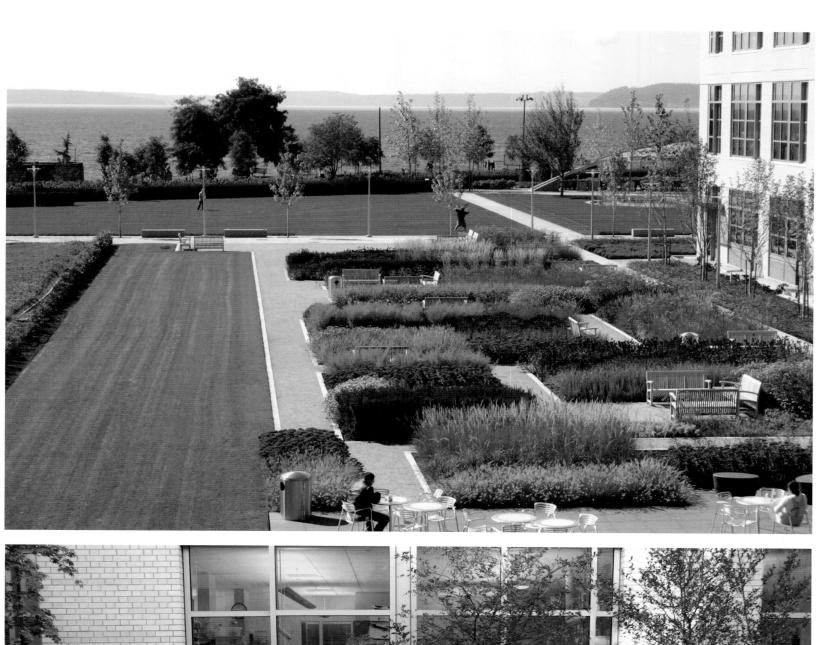

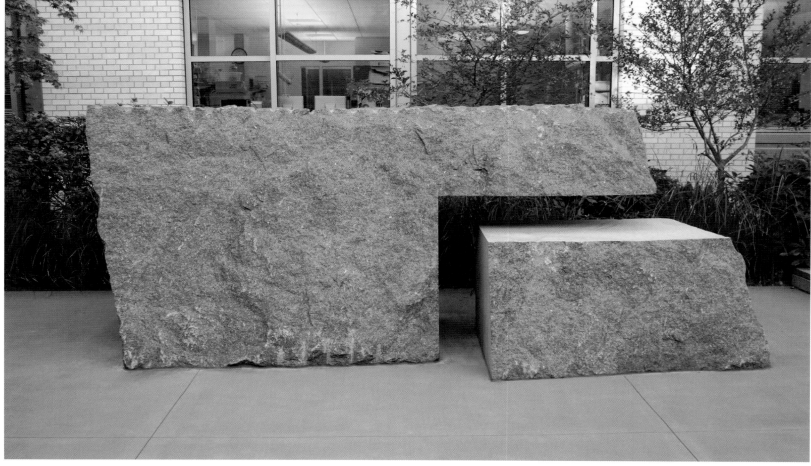

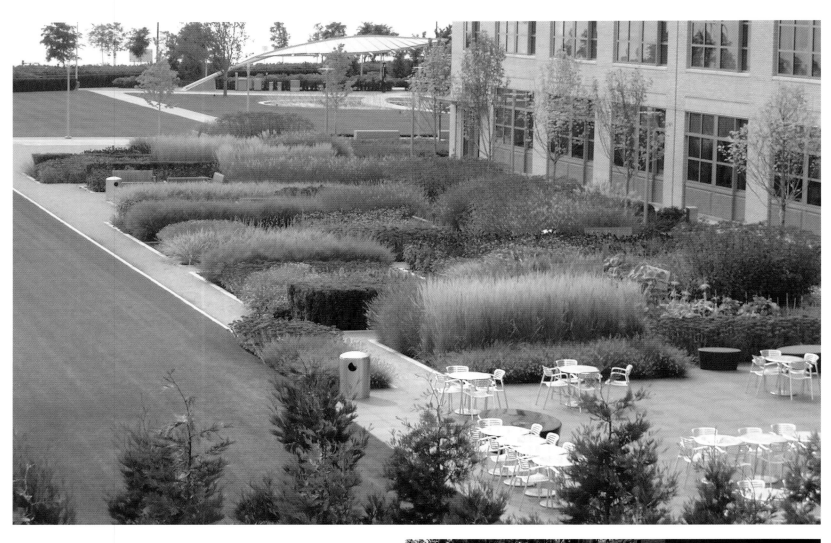

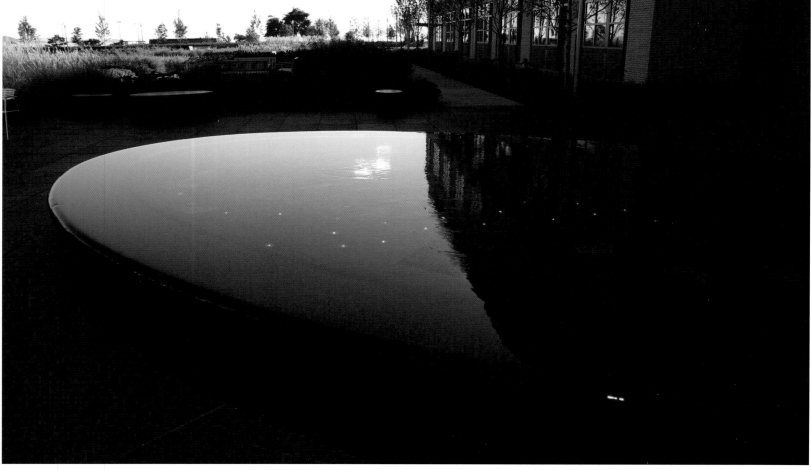

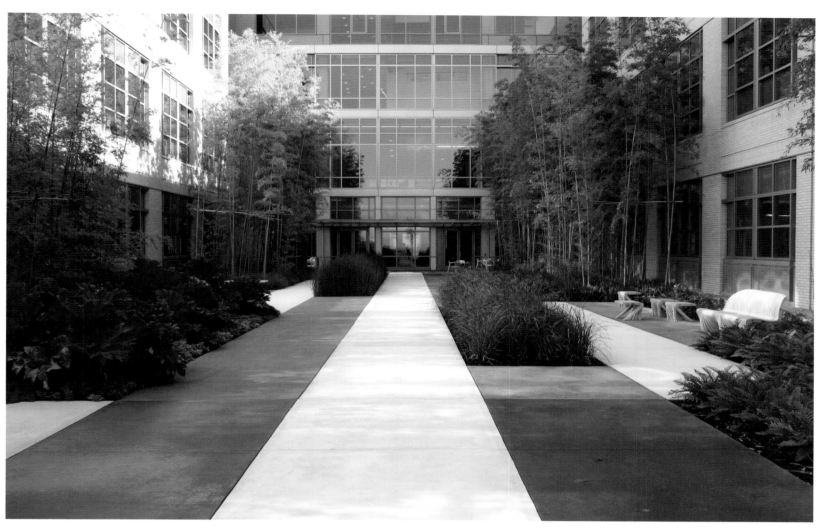

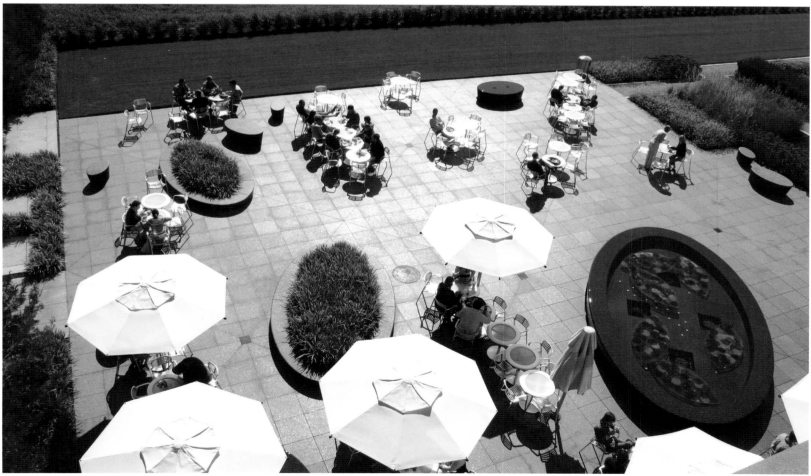

The addition of the dining terrace provides a welcoming outdoor facility for both employees and visitors to use during rest periods throughout the working day.

Die Hinzufügung der Speiseterrasse stellt eine einladende Einrichtung unter freiem Himmel für die Angestellten und Gäste dar, zur Nutzung für die Erholungspausen während des Arbeitstags.

La présence d'une terrasse pour dîner représente un équipement extérieur accueillant pour la plupart des employés et visiteurs qui se rendent ici durant les périodes de repos des journées de travail.

La terraza que se ha instalado en el exterior constituye un agradable punto de descanso durante la jornada laboral tanto para los empleados como para los visitantes.

L'aggiunta della terrazza attrezzata per i pasti costituisce una comodità sia per gli impiegati che per i visitatori che potranno utilizzarla nei momenti di pausa della giornata lavorativa.

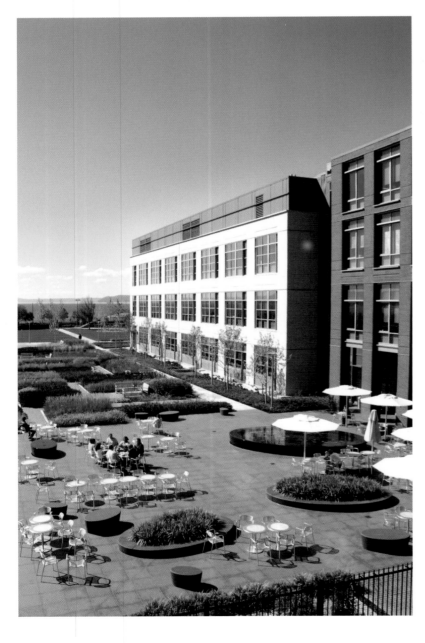 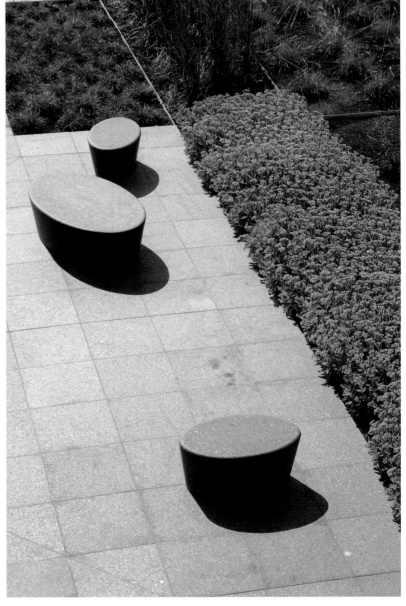

The landscaping scheme was designed to reflect and enhance the inherent natural beauty of this very large waterfront site.

Das Landschaftsschema wurde gestaltet, um die innewohnende Schönheit dieses Standorts mit sehr großer Küstenlinie wiederzugeben und aufzuwerten.

Le projet paysager a été conçu pour refléter et accroître la beauté naturelle de cet ample site de front de mer.

El diseño paisajístico intenta reflejar y potenciar la belleza natural de este inmenso espacio situado al borde del mar.

La progettazione degli esterni è stata ideata per riflettere e dare risalto alla bellezza naturale di questo splendido spazio lungo la costa.

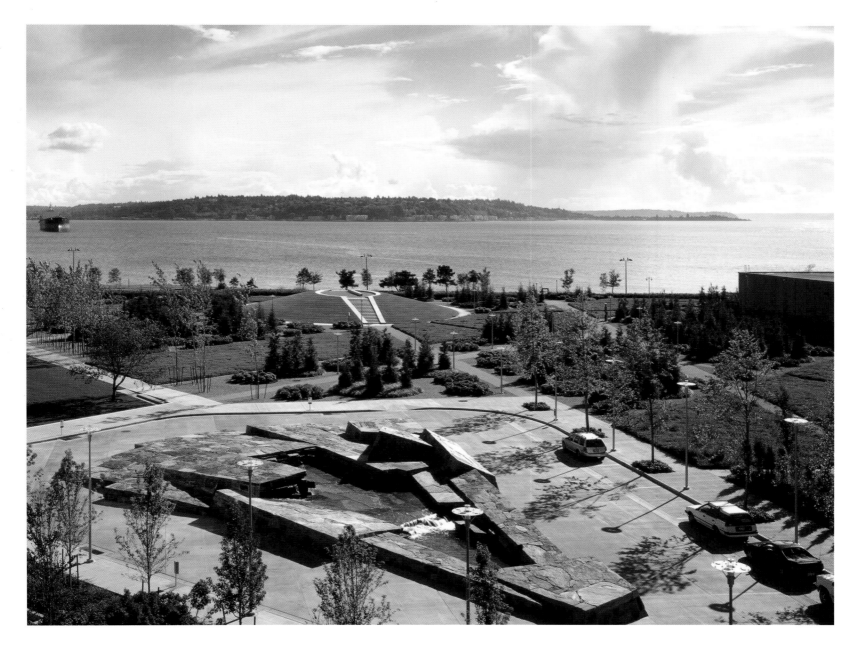

HtO Urban Beach

Toronto, Canada

HtO was designed with the intent of connecting Toronto's downtown to the water front of Lake Ontario. Situated on the remnants of an industrial site, contaminated soils were left undisturbed through the use of capping. The formation of green dunes planted with willow trees and silver maples lead the city's populace to an expanse of sand shaded by tall yellow umbrellas. The water's edge is delineated by a wooden boardwalk. Toronto's water front is now an inviting public space that is flexible, unique and functional.

HtO wurde mit der Zielsetzung gebaut, Torontos Innenstadt mit dem Ufer des Ontariosees zu verbinden. Auf den Überresten eines Industriestandorts erbaut, wurde hier der verunreinigte Boden unter Deckschichten belassen. Die Formation grüner Dünen, die mit Weidenbäumen und Silberahorn bepflanzt ist, leitet die Bevölkerung der Stadt zu einer Sandfläche, die durch große gelbe Sonnenschirme beschattet wird. Der direkte Uferbereich wird durch einen hölzernen Promenadensteg nachgezeichnet. Torontos Uferpromenade ist nun ein einladender öffentlicher Platz, der flexibel ist, einmalig und funktionell.

HtO a été conçu dans le but de connecter le centre-ville de Toronto aux rives du Lac Ontario. Le fait d'être situé sur les restes d'un site industriel a obligé à traiter et à réhabiliter les sols contaminés. Les dunes vertes où cohabitent désormais des saules et des érables argentés amènent les habitants de la ville vers une étendue de sable abritée par de grands parasols jaunes. La formation d'eau est délimitée par un trottoir en planches de bois. Le front d'eau de Toronto est de ce fait un espace public accueillant dont la caractéristique est d'être flexible, unique et fonctionnel.

HtO ha sido diseñado para conectar el centro de Toronto con la zona ribereña del lago Ontario. Situado sobre los restos de una zona industrial, no fue necesario alterar el suelo contaminado gracias al uso de capas superpuestas. La formación de dunas verdes jalonada de sauces y arces plateados da paso a un arenal al que dan sombra sus altas sombrillas amarillas. La orilla está delimitada por un paseo marítimo de suelo de madera. El frente marítimo de Toronto es ahora un acogedor espacio público que es flexible, único y funcional.

L'HtO fu progettato con l'intento di collegare il centro di Toronto alla costa del lago Ontario. Situato sui resti di un sito industriale, il suolo contaminato non venne rimosso durante la ricopertura. La formazione di dune verdi, piantumate a salici piangenti e aceri argentati, accompagnano lo spettatore alla distesa di sabbia ombreggiata da alti ombrelloni gialli. Sul lungolago si delinea una passerella in legno. Il fronte lago di Toronto è ora un invitante spazio pubblico, flessibile, unico e funzionale.

2007
Claude Cormier Architectes Paysagistes
www.claudecormier.com

Janet Rosenberg + Associates
www.jrala.ca

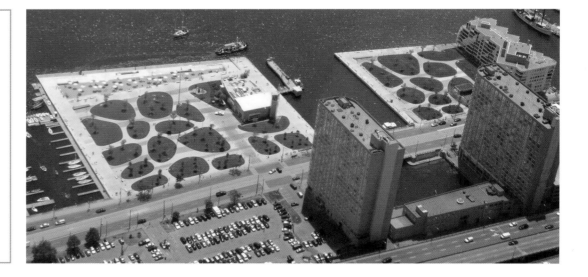

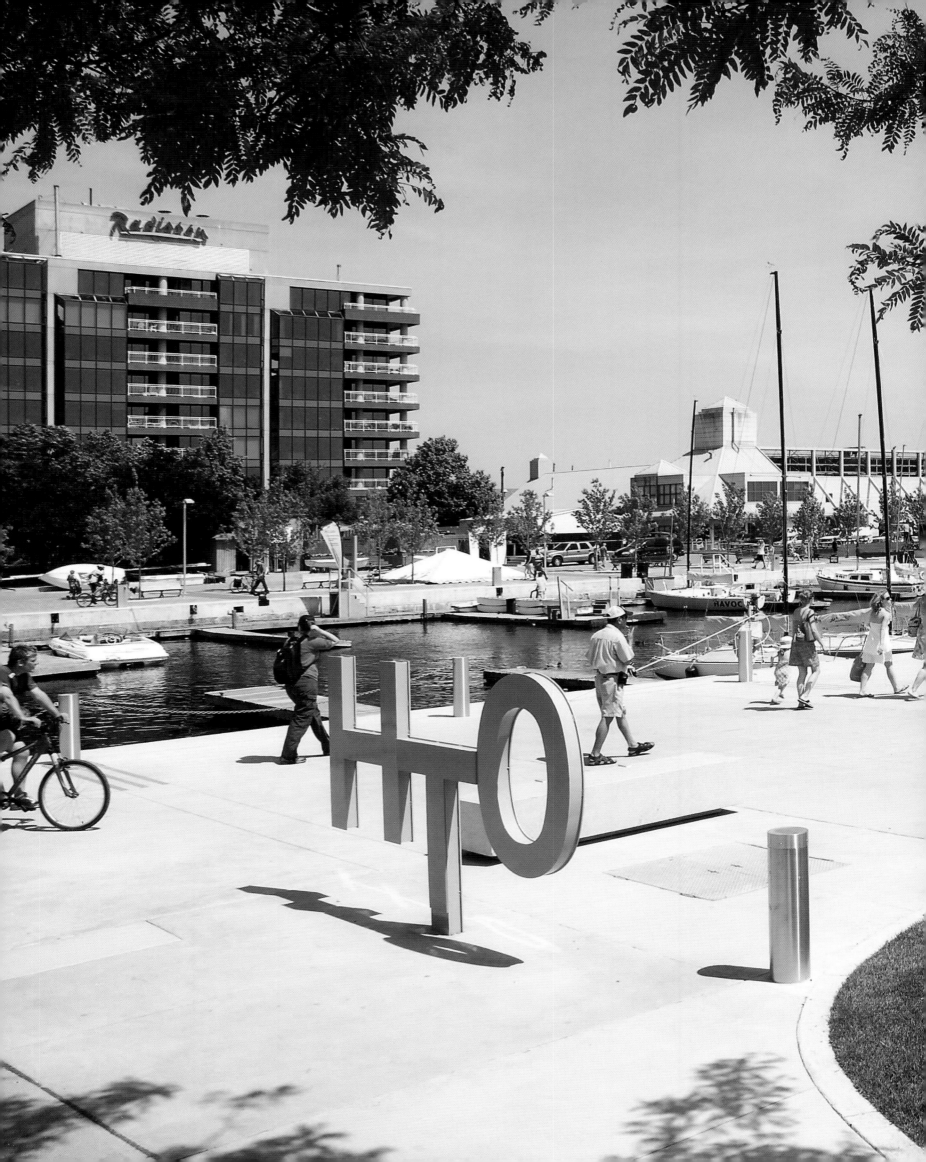

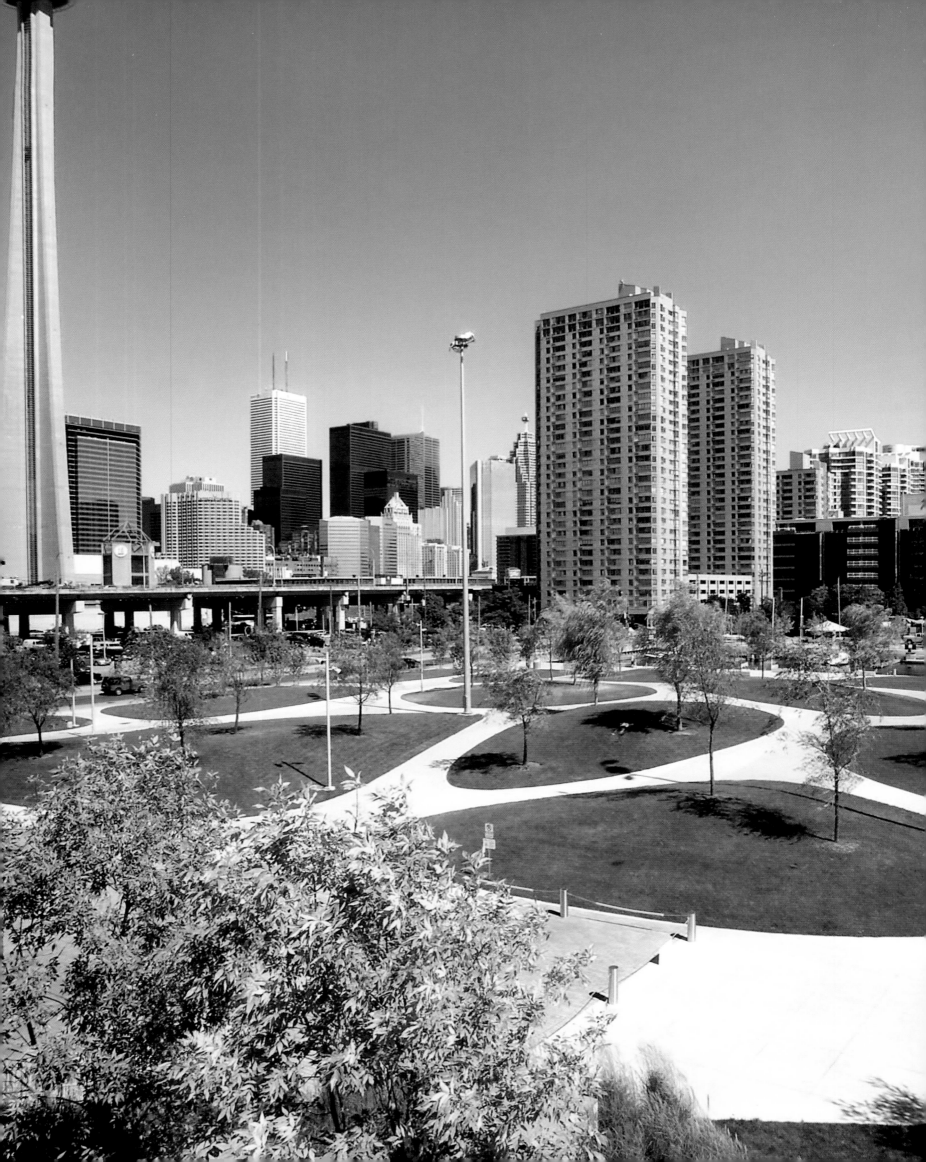

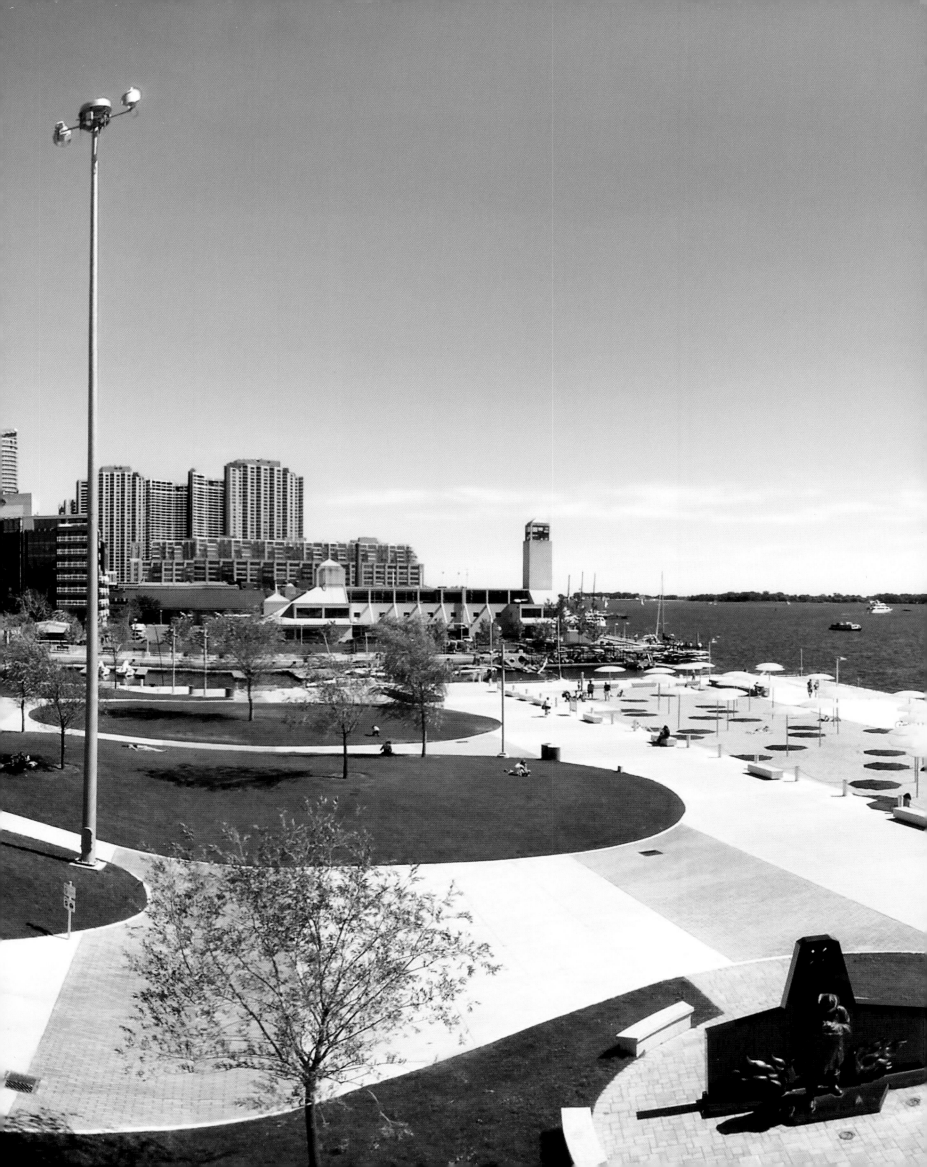

The design of HtO as an urban beach was inspired by a painting by Georges Seurat called "A Sunday Afternoon on the Island of La Grande Jatte."

Die Gestaltung von HtO als ein städtischer Strand wurde durch ein Gemälde von Georges Seurat inspiriert: „Ein Sonntagnachmittag auf der Insel La Grande Jatte".

La conception d'HtO comme plage urbaine a été inspirée par un tableau de Georges Seurat intitulé « Un dimanche après-midi à l'Île de la Grande Jatte ».

El diseño de HtO como playa urbana se ha inspirado en el cuadro de Georges Seurat titulado "Tarde de domingo en la isla de la Grande Jatte".

L'idea di trasformare l'HtO in spiaggia urbana trae ispirazione da un quadro di Georges Seurat chiamato "Una Domenica Pomeriggio all'Isola della Grande Jatte".

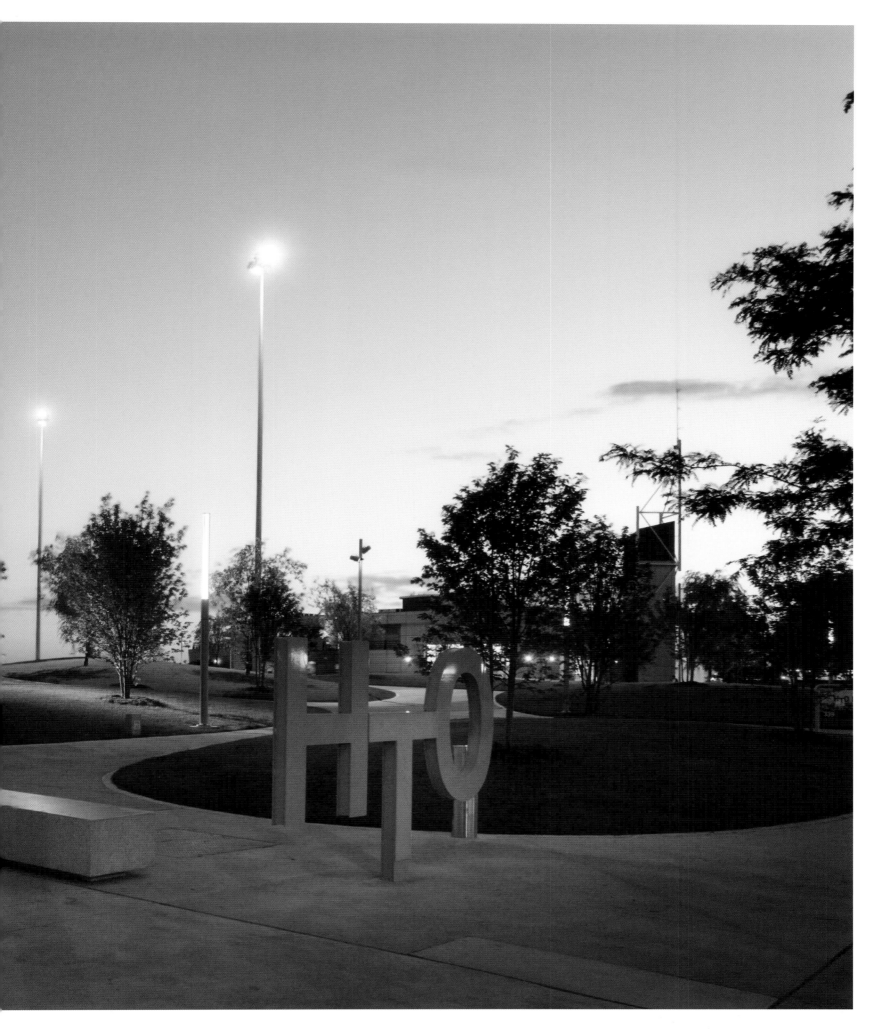

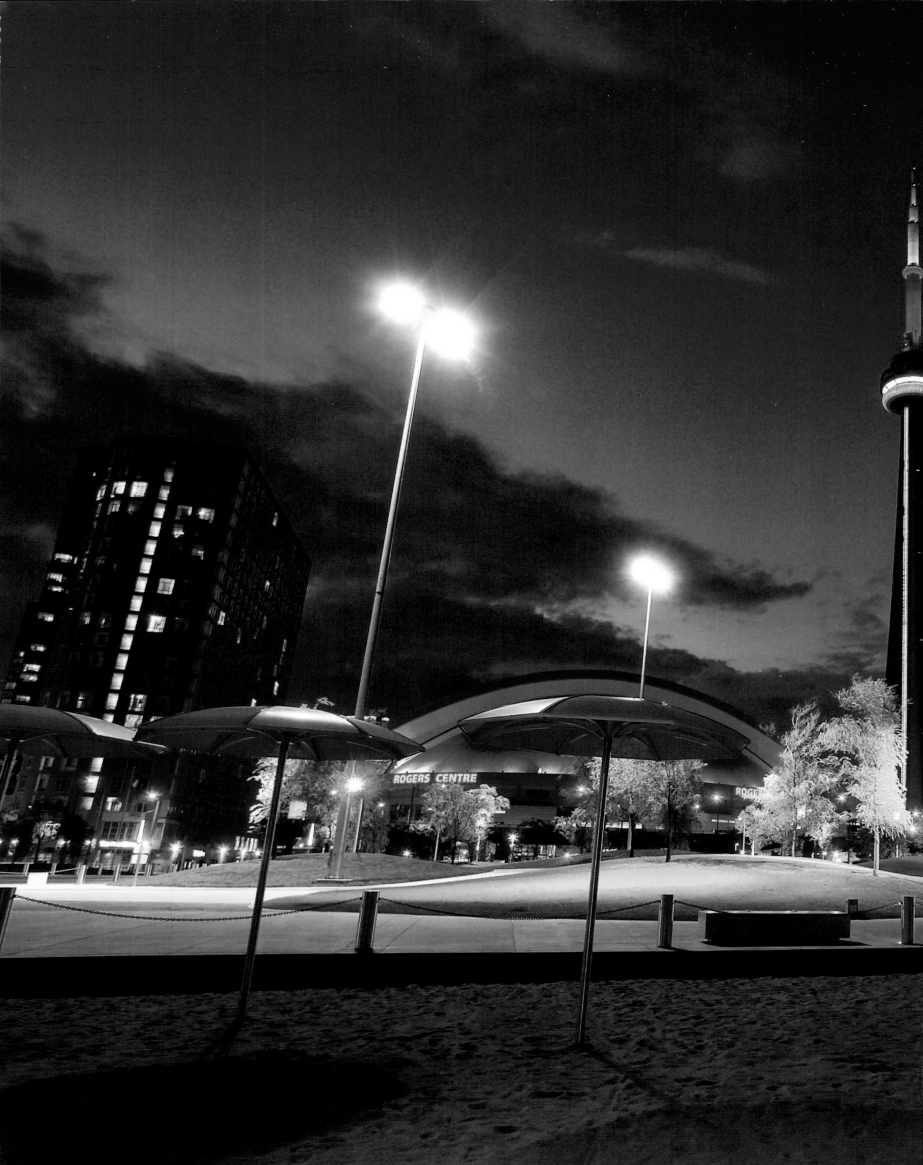

Mur Island

Graz, Austria

Based on an original idea by Graz-born Robert Punkenhoffer, Mur Island was designed by New York artist Vito Acconci on the occasion of Graz becoming the 2003 European Capital of Culture. The island primarily provides a river crossing and a vantage point from which to view the river bank wildlife and the city. The outdoor bowl-shaped space, can function both as a public plaza and an area for performance. Whereas the dome shape section is a fully functioning restaurant. A playground can be found in the area where the bowl morphs into the dome.

Basierend auf einer Idee des in Graz geborenen Robert Punkenhoffer, wurde die Insel Mur durch den New Yorker Künstler Vito Acconci gestaltet, als Graz im Jahre 2003 europäische Kulturhauptstadt wurde. Die Insel stellt hauptsächlich einen Flussübergang und einen Aussichtspunkt dar, von dem die Tierwelt des Flussufers und die Stadt zu sehen sind. Der Außenbereich in der Form einer Halbkugel kann sowohl als öffentlicher Platz als auch als Veranstaltungsfläche genutzt werden, wohingegen der Kuppelbereich ein vollwertiges Restaurant enthält. Ein Spielplatz befindet sich dort, wo die Halbkugel in den Kuppelbereich übergeht.

Basé sur une idée originale de Robert Punkenhoffer, originaire de Graz, l'île Mur a été conçu par l'artiste new-yorkais Vito Acconci à l'occasion de la désignation de Graz comme Capitale Européenne de la Culture 2003. L'île sert principalement de passage pour traverser la rivière et de poste d'observation à partir duquel on peut à la fois observer la faune et la flore vivant sur ses berges et admirer la ville. L'espace extérieur en forme de cuvette peut être utilisé aussi bien comme place publique que comme lieu de spectacle, tandis que la section en forme de dôme héberge un restaurant. Un terrain de jeu se situe à l'endroit où la cuvette se convertit en dôme.

Basada en una idea original del artista nacido en Graz, Robert Punkenhoffer, la isla Mur fue diseñada por el artista neoyorquino Vito Acconci con motivo de la capitalidad europea de la cultura que ostentó Graz en 2003. La isla constituye ante todo una zona de paso del río y un punto privilegiado para observar la ciudad y la fauna de las orillas del río. El espacio exterior en forma de cuenco puede servir de plaza pública y de espacio para actuaciones, mientras que la zona con forma de cúpula es un restaurante totalmente operativo. En la zona donde el cuenco se funde con la cúpula se puede encontrar un área de juegos.

Basata sull'idea originale del graziano Robert Punkenhoffer, l'isola Mur fu progettata dall'artista newyorkese Vito Acconci in occasione dell'elezione di Graz a Capitale Europea della Cultura nel 2003. L'attrazione principale dell'isola consiste in un fiume e in un punto d'osservazione da dove ammirare la natura attorno alla banchina e la città. Lo spazio esterno a forma sferica può avere funzione sia di piazza pubblica che di palcoscenico. Mentre la sezione a forma di cupola è un ristorante. Un parco giochi si trova dove la sfera si trasforma in cupola.

2003
Acconci Studios
www.acconci.com

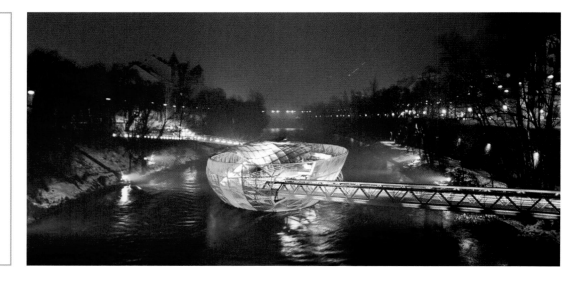

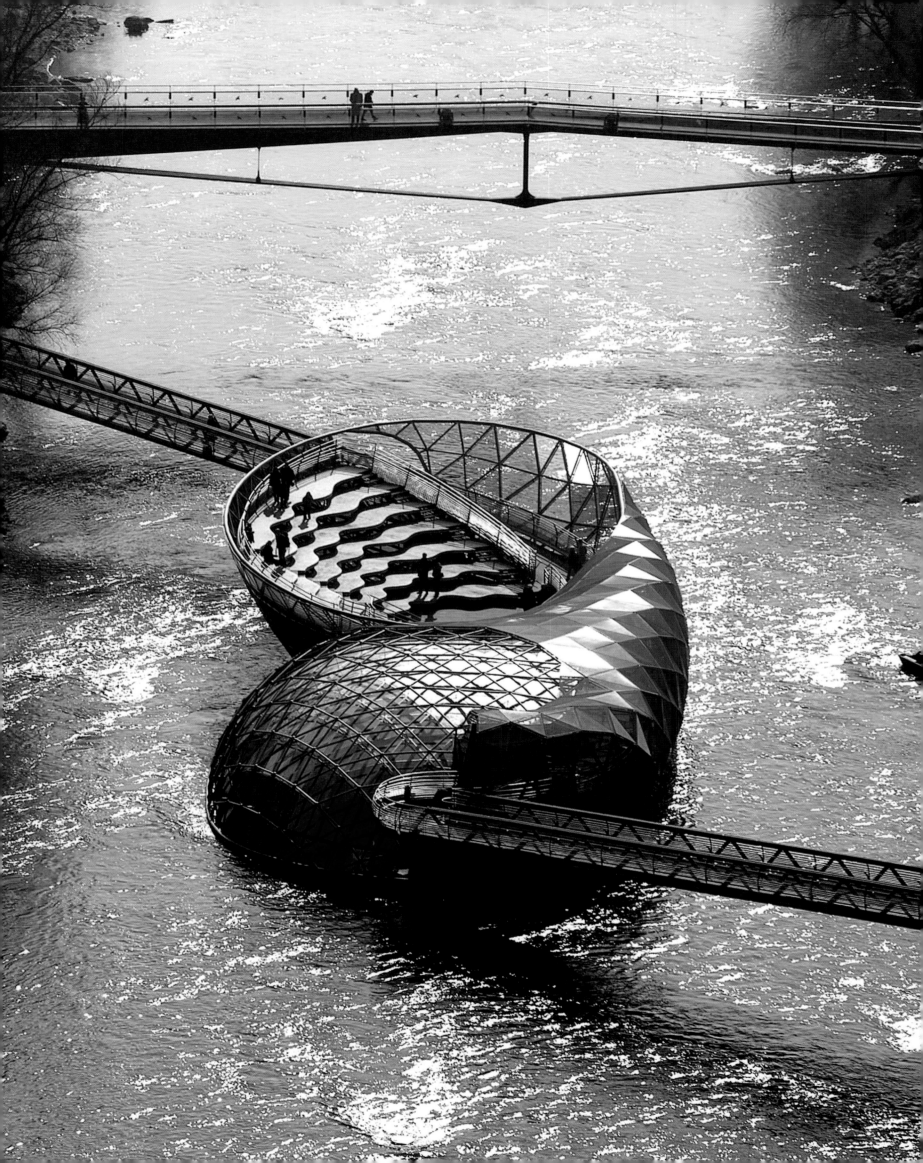

Parque de los Auditorios
Barcelona, Spain

The south-east coastal park was planned as part of the cultural infrastructure of Barcelona. The park provides open air auditoria and event space. Additionally, sport and leisure activities such as running, walking, cycling and skateboarding are encouraged by the provision of a network of paths and activity zones. Wind protection enables vegetation to find adequate growing conditions in the park as well as controlling light, shade and sight lines. The sand dune profile is evident as the model for the site's stabilization.

Der südöstliche Küstenpark wurde als Teil der kulturellen Infrastruktur von Barcelona geplant. Der Park stellt Freiluft-Auditorien und Platz für Veranstaltungen zur Verfügung. Zusätzlich werden Sport- und Freizeitaktivitäten wie Joggen, Wandern, Radfahren und Skateboardfahren durch das Bereitstellen eines Netzwerks von Pfaden und Aktivitätszonen gefördert. Die Vegetation findet im Park optimale Wachstumsbedingungen durch Windschutzvorrichtungen, die zudem Licht, Schatten und Sichtlinien steuern. Das Sanddünenprofil diente zur Stabilisierung der Anlage.

Le parc côtier du sud-est a été conçu comme une partie de l'infrastructure culturelle de Barcelone. Il est composé d'un auditorium à l'air libre et d'un espace dédié à l'organisation d'évènements. Les sports et loisirs tels que la course à pied, la promenade, le cyclisme et la pratique du skateboard sont en outre encouragés par la disposition d'un réseau de sentiers et de chemins et par l'utilisation de surfaces spécifique aux activités. L'endroit, protégé du vent, favorise les conditions adéquates pour la croissance de la végétation. Ce paramètre permet aussi de contrôler la lumière, les zones d'ombre et les angles de vue. La silhouette de la dune de sable met en avant le modèle de stabilisation du site.

El parque literal del sureste es producto de la planificación de la infraestructura cultural de Barcelona. El parque proporciona un auditorio y espacio para actos al aire libre. Además, la red de caminos y zonas para actividades que se han dispuesto fomenta las actividades lúdicas y deportivas, como hacer ejercicio, andar, pasear en bicicleta o skate. La protección frente al viento permite el adecuado crecimiento de la vegetación del parque, así como regular la luz, sombra y líneas visuales. El perfil de dunas de arena se muestra como el modelo para la estabilización del lugar.

Il parco che sorge sulla costa dell'area a sud-est di Barcellona era stato pensato per diventare una parte integrante dell'infrastruttura culturale della città. Il parco offre uno spazio aperto che funge da auditorium o per ospitare eventi pubblici. Inoltre, attività sportive o ricreative come la corsa, passeggiate, ciclismo e skateboard sono incoraggiate attraverso una rete di sentieri e aree apposite. La protezione dal vento permette alla vegetazione di trovare le condizioni ottimali di crescita nel parco, così come il controllo della luce, dell'ombra e dell'osservazione. La funzione della duna di sabbia è senza ombra di dubbio quella di dare stabilità al luogo.

2005
Foreign Office Architects
www.f-o-a.net

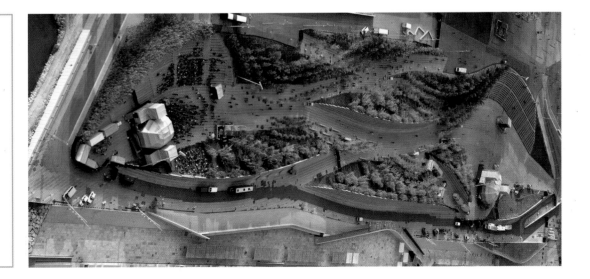

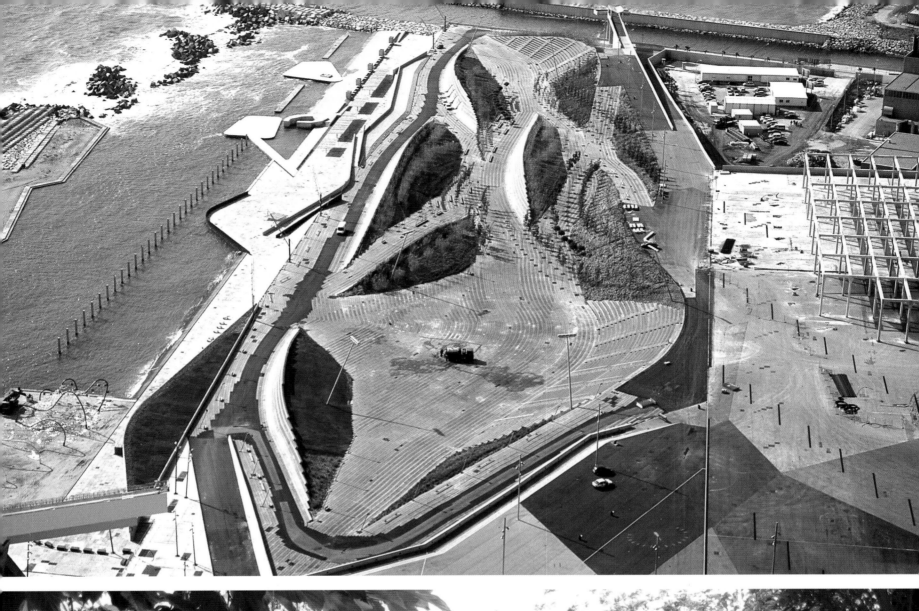

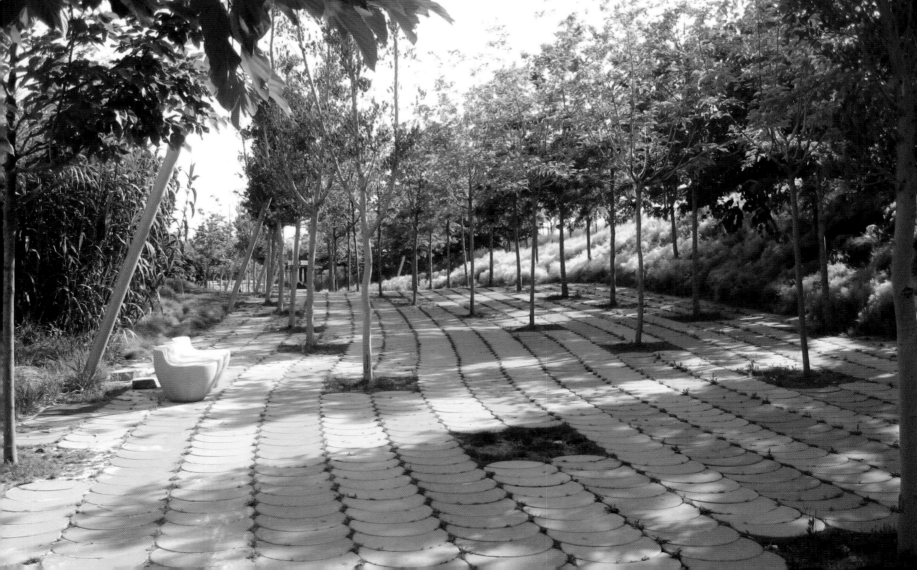

Riva Split Waterfront

Split, Croatia

The ancient city of Split stands on the Croatian Mediterranean shore. Its waterfront, the Riva, has historical links back to the Roman Empire. The challenge for designers 3LHD was to use the modular Roman form of the Diocletian Palace to shape and expand the Riva. The newly integrated surfacing provides the platform for promenades, performances, religious processions, festivals and celebrations. The steel and concrete urban elements of street furniture, lighting and sun shades, combined with varied planting complete the social space to the waterfront restaurants.

Die alte Stadt Split liegt an der kroatischen Mittelmeerküste. Ihre Küstenlinie, die Riva, besitzt historische Verbindungen bis zurück ins römische Imperium. Die Aufgabe für die Designer 3LHD war es, die modulare römische Form des Palastes des Diokletian zur Formung und Ausweitung der Riva zu nutzen. Die neuen Oberflächen stellen Plattformen für Promenaden, Vorführungen, religiöse Umzüge, Festivals und Veranstaltungen bereit. Elemente aus Stahl und Beton wie Straßenmöbel und Lampen und schattenspendende Baldachine, kombiniert mit unterschiedlicher Bepflanzung, komplettieren den öffentlichen Bereich bis zu den Restaurants an der Küstenlinie.

L'ancienne ville de Split s'étend sur la côte Méditerranéenne de la Croatie. Son front de mer, la Riva, a préservé les systèmes de liaisons hérités de l'Empire Romain. Le défi pour les concepteurs de 3LHD a été d'utiliser la conception modulaire Romaine, magnifiée par le Palais de Dioclétien, pour mettre en forme et étendre la Riva. Le revêtement nouvellement intégré forme des plates-formes utilisées pour les promenades, représentations, processions religieuses, festivals et célébrations. Les éléments urbains en acier et béton du mobilier de rue, les jeux d'ombre et de lumière du soleil et les plantations diverses sont combinés entre eux pour former un espace social se déroulant jusqu'aux restaurants de front de mer.

La antigua ciudad de Split se encuentra en la costa mediterránea de Croacia. Su frente marítimo, la Riva, tiene vínculos históricos con el imperio romano. El reto al que se enfrentaban los diseñadores 3LHD era utilizar las formas modulares del palacio de Diocleciano para dar forma y ampliar la Riva. La nueva superficie integrada proporciona un escenario para paseos, actuaciones, procesiones religiosas, festivales y celebraciones. Los elementos de acero y hormigón del mobiliario urbano, iluminación y cubiertas solares se combinan con la diferente vegetación para completar el espacio cívico hasta los restaurantes del frente marítimo

L'antica città di Spalato è situata sulla costa croata del Mediterraneo. La storia della Riva, il suo litorale, risale all'Impero Romano. La sfida per gli architetti 3LHD era di fare uso della forma modulare romana del Palazzo Diocleziano ed espandere la Riva. L'installazione di nuove superfici integrate sono utili alla piattaforma per passeggiate, esibizioni, processioni religiose, festival e celebrazioni. Gli elementi d'arredo urbano in cemento e acciaio, come anche l'illuminazione e i parasole, vengono combinati a zone verdi piantumate per completare lo spazio pubblico di fronte ai ristoranti sul lungomare.

2007
3LHD
www.3lhd.com

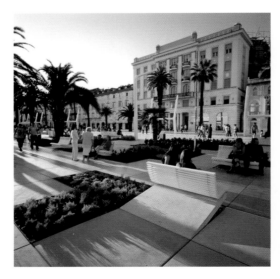
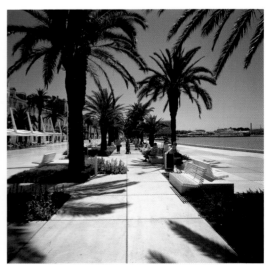

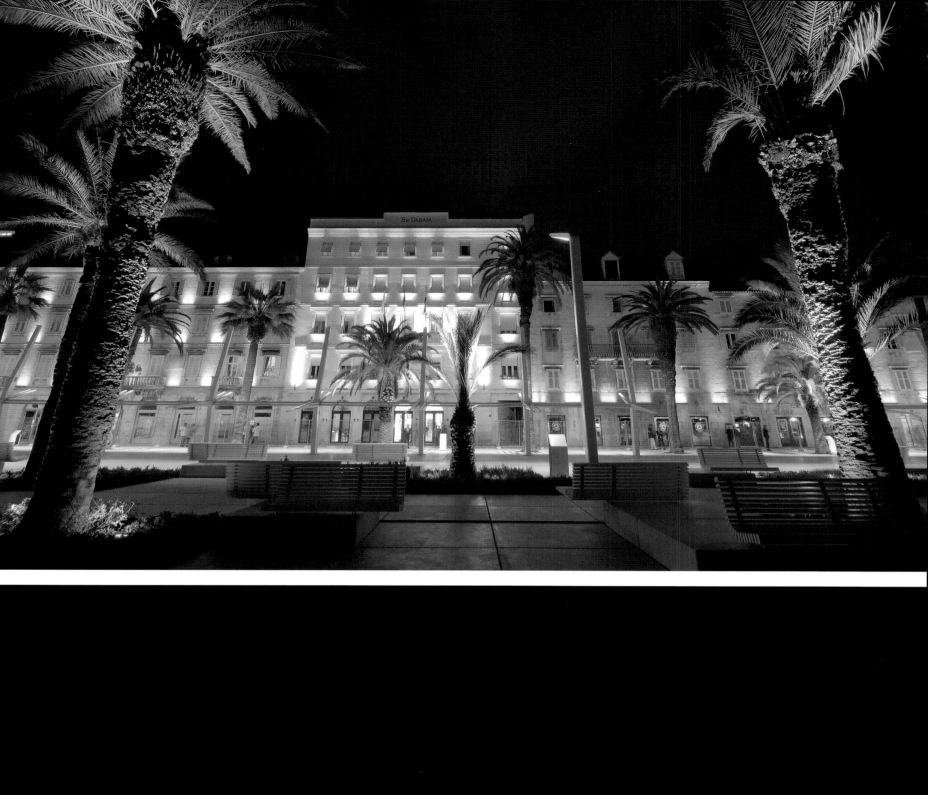
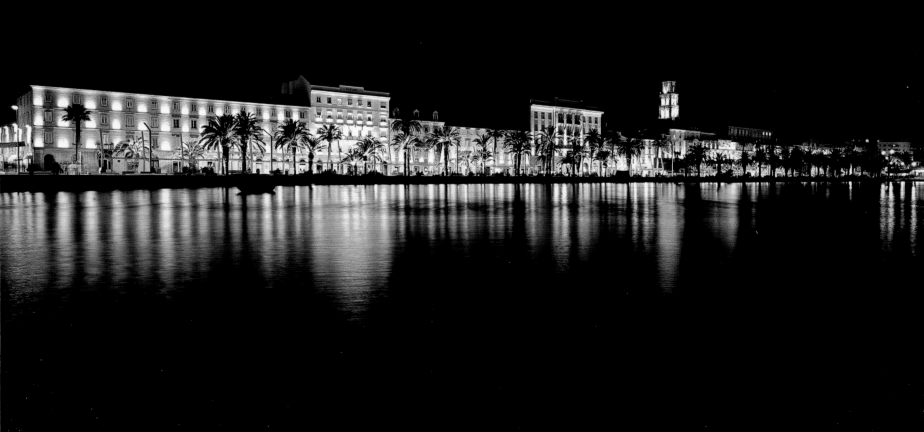

Canopies providing protection from the hot Mediterranean sun cast a nautical shadow over the promenade. Informal seating is redolent of the waves lapping the waterfront.

Einzelne Überdachungen bieten Schutz vor den heißen Strahlen der Mittelmeersonne und neigen ihren nautisch anmutenden Schatten auf die Promenade. Dort erinnern die ungewöhnlichen Sitzgelegenheiten an die Wellen, die die Hafenmauern umspülen.

Offrant une protection face au chaud soleil Méditerranéen, des feuillages plongent la promenade sous une ombre nautique. Un espace informel pour s'assoir évoque le clapotis des vagues.

Las cubiertas ofrecen protección del fuerte sol mediterráneo y proyectan sombras de sabor náutico sobre el paseo. Los bancos distribuidos por el paseo recuerdan las olas que baten el frente marítimo.

Le volte che proteggono dal caldo sole mediterraneo stendono un velo d'ombra sulla passeggiata marina. Gli informali posti a sedere sono un richiamo alla onde che lambiscono il lungomare.

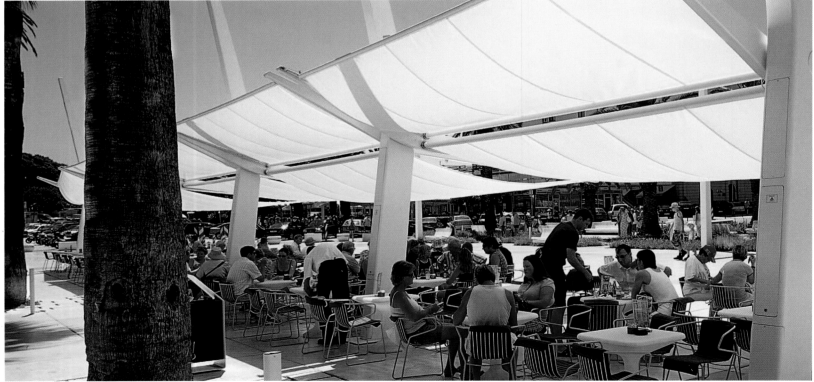

The new concrete paving slabs are cut and laid to the Roman measurement of paces as a reference to the site's heritage.

Die neuen Betongehwegplatten wurden nach römischen Stufenmaßen zurechtgeschnitten und verlegt, um einen Hinweis auf das kulturelle Erbe des Ortes zu geben.

Afin de rendre hommage à l'héritage du site, les nouvelles dalles de pavé en béton sont taillées et disposées selon les mesures correspondantes au pas Romain.

Las nuevas losas de hormigón han sido cortadas y dispuestas utilizando la medida de pasos romanos, como referencia al pasado del lugar.

Le nuove lastre di cemento della pavimentazione sono state tagliate e posate secondo lo stile Romano, in riferimento all'eredità storica del sito.

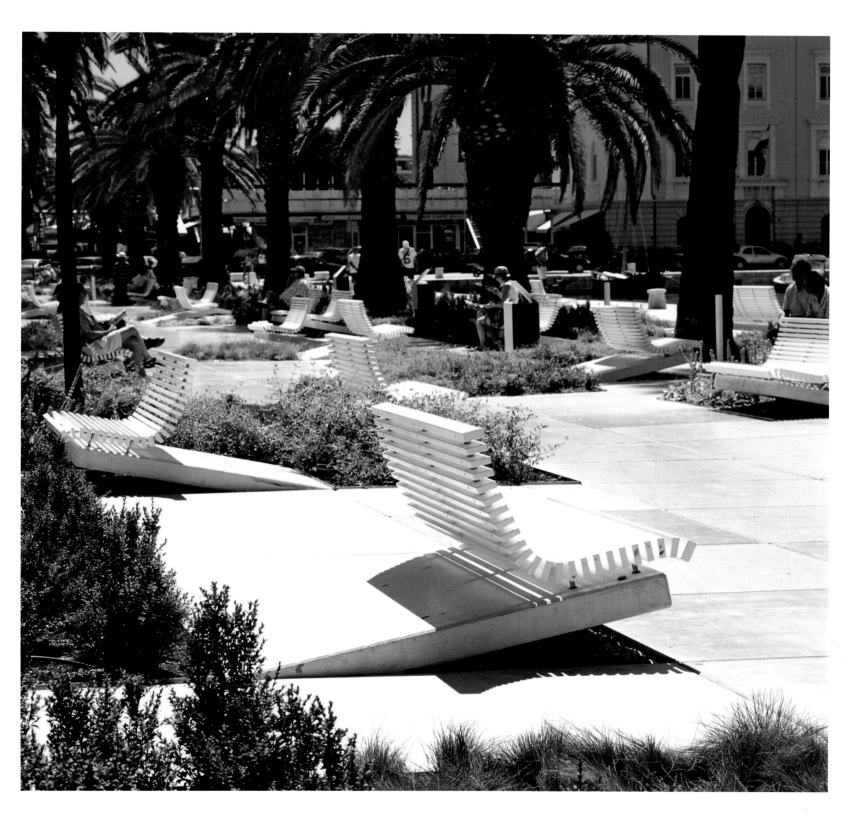

Mature palm trees punctuate the Riva bringing a calming ambience to the busy scheme.

Ausgewachsene Palmenbäume bestimmen die Riva und bringen eine beruhigende Atmosphäre in die geschäftige Szenerie.

Des palmiers adultes ponctuent l'effervescente promenade de la Riva, lui donnant une touche de quiétude.

El paseo está flanqueado por unas altas palmeras que proporcionan una sensación de calma a un entorno con tanto ajetreo.

Grandi palme punteggiano la Riva dando a questo quadro spumeggiante, un'atmosfera di grande quiete.

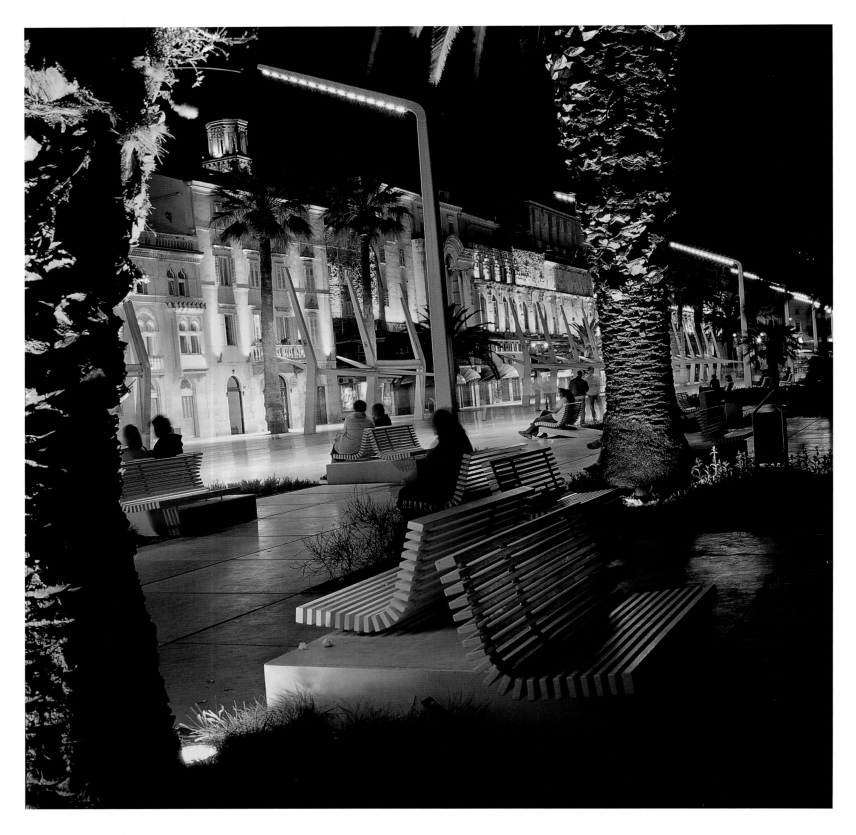

LED lamps illuminate the site encouraging full use Riva's facilities beyond the hours of daylight.

LED-Lampen illuminieren die Anlage und machen die Einrichtungen an der Riva auch in den Nachtstunden nutzbar.

Des lampes de type LED illuminent les installations du site, ce qui invite à en profiter une fois la nuit tombée.

La luz de diodos de las lámparas permite el uso de la Riva más allá de las horas diurnas.

Lampade a LED illuminano la zona incoraggiando il pieno utilizzo delle attrezzature della Riva anche la sera.

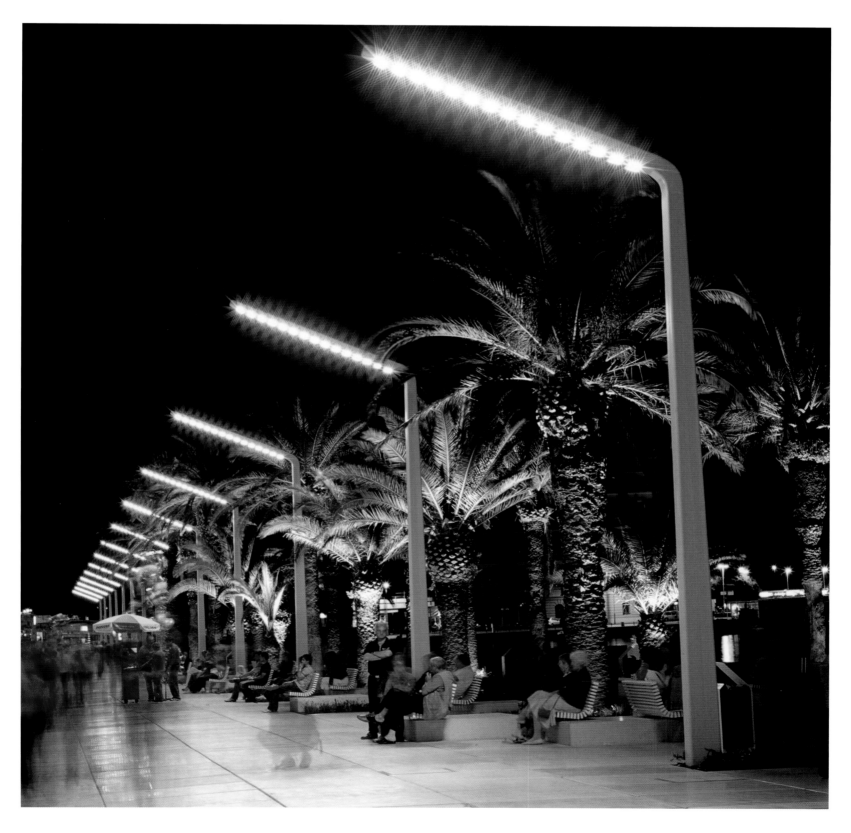

The Floating Gardens
Yongning River Park
Taizhou City, China

Yongning River Park is an ecology-based flood and storm water control system for Taizhou City. The design sets the standard for China's rivers as a viable alternative to concrete damming and canalisation. The functioning park allows flooding, serves wildlife and is accessible to the local population and tourists. The first layer is restored riparian wetlands along the flood plain. The second layer is the floating garden for humanity. This is a designed park of tree groves, paths, and a matrix of story boxes.

Der Park am Yongning Fluss ist ein ökologisches Kontrollsystem für Flut- und Sturmwasser in der Stadt Taizhou. Seine Gestaltung definiert Standards für Chinas Flüsse als brauchbare Alternative zu Betondämmen und Kanalisation. Der funktionsfähige Park erlaubt die Flutung, nützt wildlebenden Tieren und ist der einheimischen Bevölkerung und Touristen zugänglich. Die erste Schicht besteht aus wiederhergestellten Uferfeuchtgebieten längs des Überschwemmungsgebiets. Die zweite Schicht ist der Fließende Garten der Menschlichkeit. Er ist ein gestalteter Park aus Baumgruppen und Wegen sowie einem System aus Infokästen.

Le Yongning River Park est basé sur un système d'inondation et de contrôle des eaux pluviales conçu de manière écologique pour la ville de Taizhou. La conception a pris en compte les standards appliqués pour les fleuves chinois comme s'agissant d'une alternative viable au bétonnage des inondations et canalisations. Le fonctionnement du parc, se basant sur l'inondation, fait du site un lieu écologique de grande valeur pour la faune et la flore. Le parc est de plus accessible aux populations locales et aux touristes. La première partie est formée de zones humides lacustres s'étendant le long de la plaine inondée. La seconde se compose du jardin flottant pour l'humanité. Il s'agit d'un parc élaboré autour de bosquets d'arbres, de sentiers et d'une matrice de boites à histoire.

Yongning River Park es un sistema ecológico de control del agua de lluvia y de las inundaciones de la ciudad de Taizhou. El diseño fija un estándar para los ríos de China como alternativa al represamiento y canalización a base de hormigón. El funcionamiento del parque permite las inundaciones, sirve de refugio a la fauna y es de fácil acceso para la población local y turistas. La primera zona es un humedal ribereño restaurado a lo largo de la llanura de inundación. La segunda zona es un jardín flotante para la humanidad, que es un parque artificial de arboledas, sendas y una serie de cajas de historias.

Yongning River Park è un sistema ecologico per il controllo di inondazioni e tempeste a Taizhou City. Per la Cina, questo progetto rappresenta una valida alternativa alle dighe in cemento e alla canalizzazione dei fiumi. Il funzionamento del parco permette allagamenti, serve alla fauna ed è accessibile alla popolazione locale e ai turisti. Il primo strato è costituito da terre umide rivierasche poste lungo la golena. Il secondo strato è un giardino galleggiante per la popolazione, un parco progettato con alberi di mangrovie, sentieri e una serie di costruzioni galleggianti che raccontano una storia.

2004
Turenscape (Beijing Design Institute)
www.turenscape.com

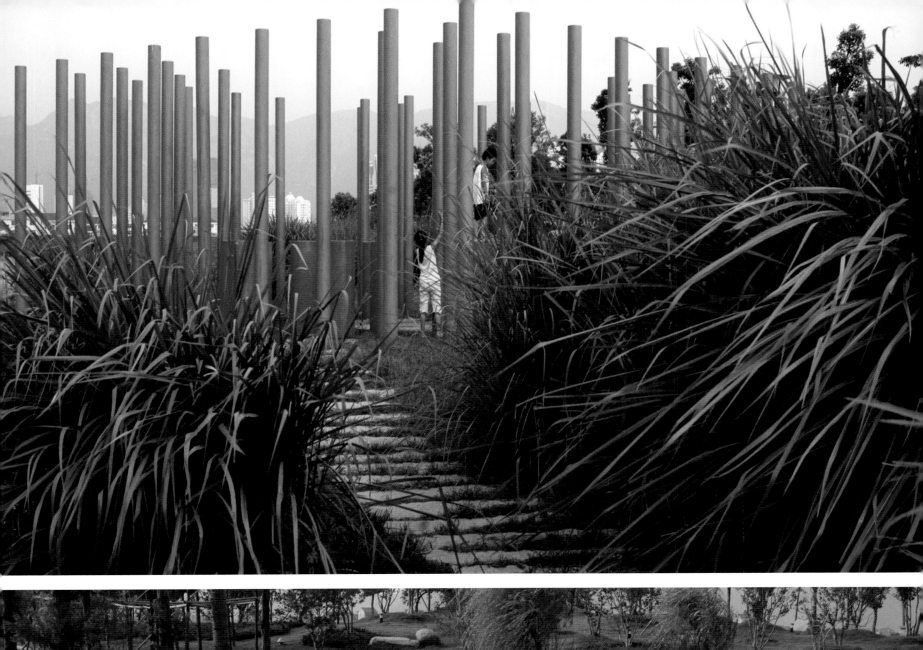
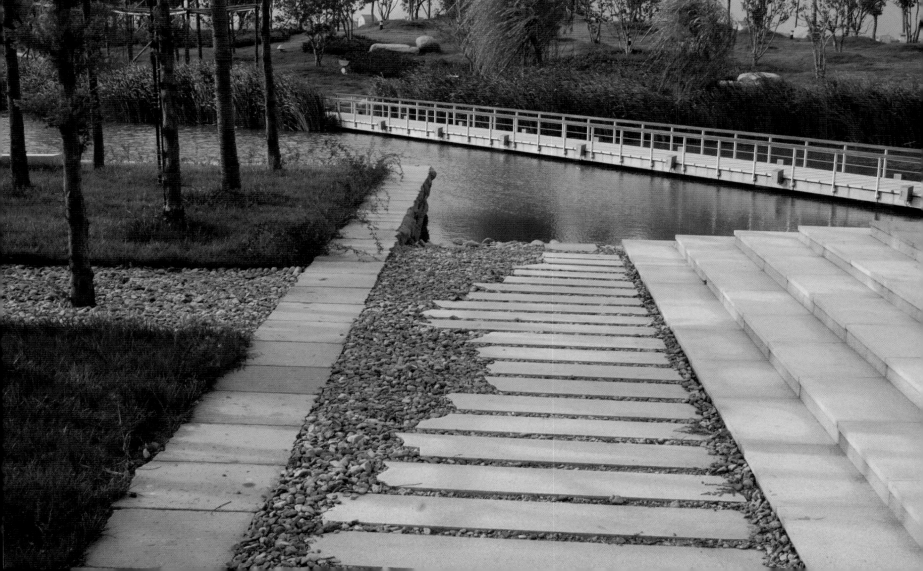

The man-made wetland lake parallel to the riverbank copes with the monsoon season flooding. During the dry season the outer wetland is still submerged from retained water and fresh water from the upper reach of the river.

Der künstliche See mit Feuchtgebieten parallel zum Flussufer ist an die saisonalen Überflutungen durch den Monsun angepasst. Während der trockenen Jahreszeit sind die äußeren Feuchtgebiete noch von zurückgehaltenem und frischem Wasser vom Oberlauf des Flusses überschwemmt.

Le lac artificiel de la zone humide parallèle à la berge est conçu pour faire face aux inondations liées à la saison de la mousson. Durant la saison sèche, l'eau retenue et l'eau douce venues de la partie supérieure de la rivière continuent à submerger la zone humide extérieure.

El humedal artificial corre paralelo a la ribera del río y en la temporada de los monzones se inunda. Durante la estación seca, el humedal externo sigue sumergido bajo el agua retenida y el agua dulce del tramo superior del río.

Il lago artificiale parallelo alla banchina del fiume serve a fronteggiare gli allagamenti della stagione monsonica. Durante la stagione secca, le paludi esterne sono sommerse dalle acque trattenute e dalle acque fresche provenienti dalle zone più alte del fiume.

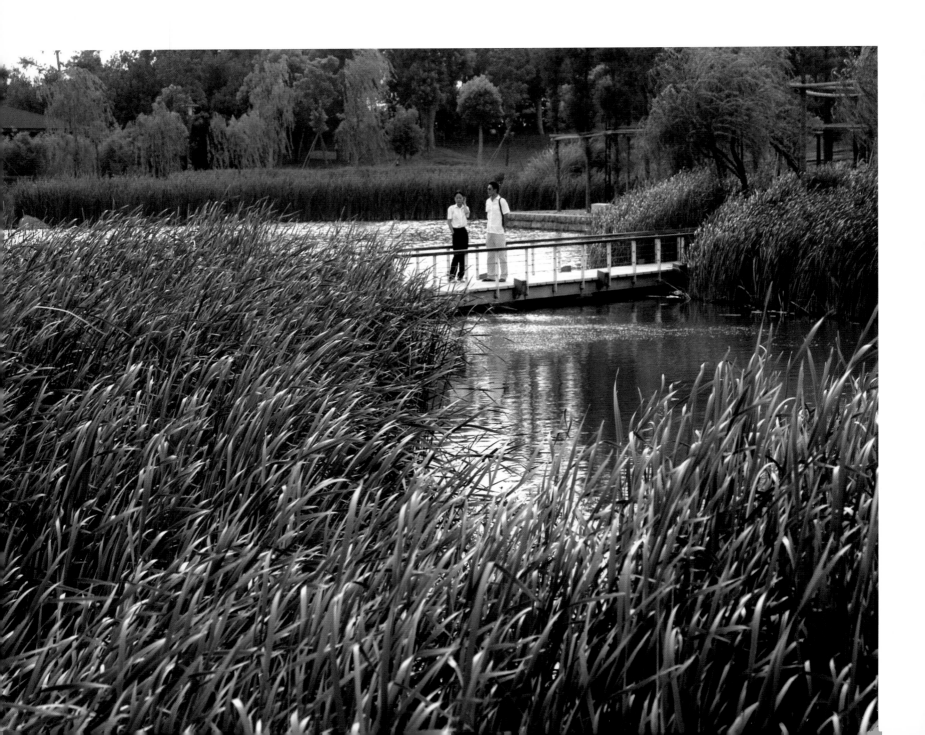

The river bank was consolidated with indigenous grasses creating an attractive setting for visitors and encouraging wildlife to repopulate their native habitats.

Das Flussufer wurde mit heimischem Gras befestigt, das eine attraktive Umgebung für Besucher schafft und wildlebenden Tieren ermöglicht, in ihre natürlichen Lebensräume zurückzukehren.

La rive de la rivière a été consolidée avec des herbes autochtones, ce qui crée un ensemble attrayant pour les visiteurs et encourage la faune et la flore à repeupler leur habitat naturel.

La ribera se consolidó con hierbas autóctonas, que crean un entorno agradable para los visitantes y ayudan a que la fauna repueble sus hábitats naturales.

La banchina del fiume fu consolidata con piante erbacee locali in modo da creare un quadro attraente agli occhi dei visitatori e per incoraggiare la fauna a ripopolare gli habitat originali.

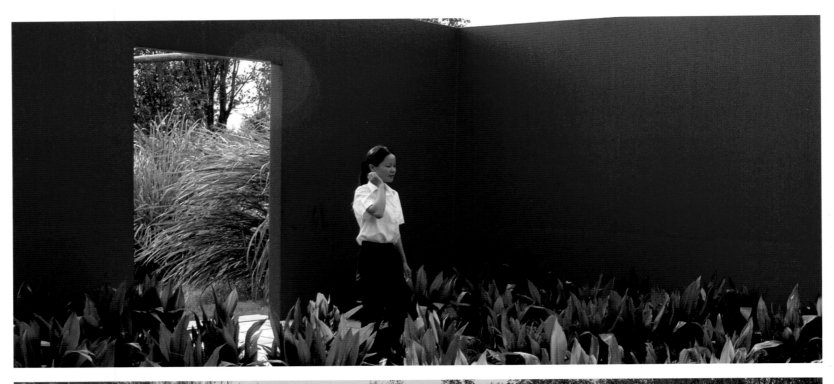

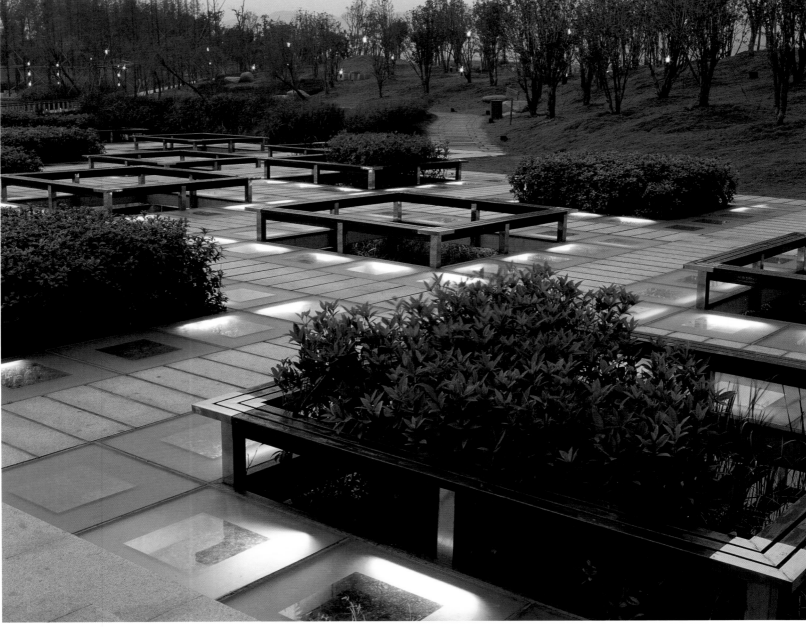

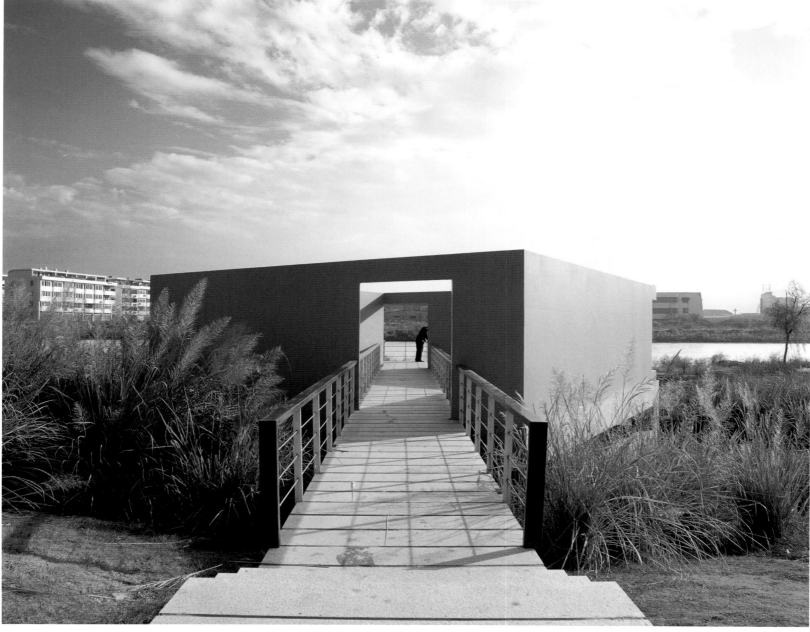

The Floating Gardens – Yongning River Park | Taizhou City | China **139**

Thisted Harbor Plaza

Thisted, Denmark

Following an initiative to improve urban spaces, Thisted harbor was identified as having potential for development. With both tourism and cultural events in mind, a new harbor plaza was designed with the tourist information center as the heart of the development. The plaza provides areas for quiet contemplation of the sea, while being the setting-out point for boat excursions around Limfjorden Bay. The plaza's atmosphere is enhanced by the central water element and creates a perfect setting for small-scale concerts.

Einer Initiative folgend, die städtischen Freiräume zu erweitern, wurde der Hafen von Thisted als potentieller Entwicklungsraum identifiziert. Unter Berücksichtigung von Tourismus und kulturellen Veranstaltungen wurde ein neuer Hafenplatz mit dem Tourismusinformationszentrum als Herz der Entwicklungsarbeit gestaltet. Der Platz bietet Bereiche für die stille Betrachtung der See, während er der Startpunkt für Bootsausflüge rund um die Limfjorden Bucht ist. Die Atmosphäre des Platzes wird durch das zentrale Wasserelement erweitert und schafft eine perfekte Szenerie für kleinere Konzerte.

S'inscrivant dans une initiative visant à améliorer les espaces urbains, le port de Thisted a été identifié et retenu pour son potentiel de développement. La nouvelle place portuaire a été conçue, en collaboration avec l'office du tourisme, pour devenir le cœur névralgique d'une zone en développement. De ce fait, elle devait pouvoir accueillir des évènements touristiques ou culturels. Pourvue de zones permettant de contempler tranquillement la mer, elle est le point d'embarquement choisi par les bateaux proposant des excursions autour de la baie de Limfjorden. L'atmosphère de la place est magnifiée par l'élément aquatique central qui crée un cadre parfait pour accueillir des formations musicales de petite taille.

El puerto de Thisted fue seleccionado por su potencial de desarrollo en el curso de un proyecto para mejorar los espacios urbanos. El centro de información turística constituye el corazón del diseño de la nueva plaza del puerto, ya que se ha pensado siempre en el turismo y en los actos culturales. La plaza ofrece zonas para la pacífica contemplación del mar, a la vez que constituye el punto de salida para las excursiones en barco por la bahía de Limfjorden. El elemento acuático situado en el centro de la plaza mejora su atmósfera y crea un escenario perfecto para pequeños conciertos.

A seguito di un piano di rinnovamento degli spazi urbani, il porto di Thisted è stato scelto come area di potenziale potenziamento. Pensata per ospitare eventi culturali e turistici, nella nuova piazza del porto spicca il centro d'informazioni turistiche, vero e proprio cuore del progetto. La piazza include aree da cui è possibile godersi la vista del mare in tutta tranquillità, rimanendo al tempo stesso un vitale centro di partenza per escursioni in barca attorno alla Limfjorden Bay. L'atmosfera della piazza è amplificata dall'elemento centrale costituito dall'acqua, che ne fa uno sfondo perfetto per piccoli concerti.

2005
Birk Nielsen
Landskabsarkitekter
www.birknielsen.dk

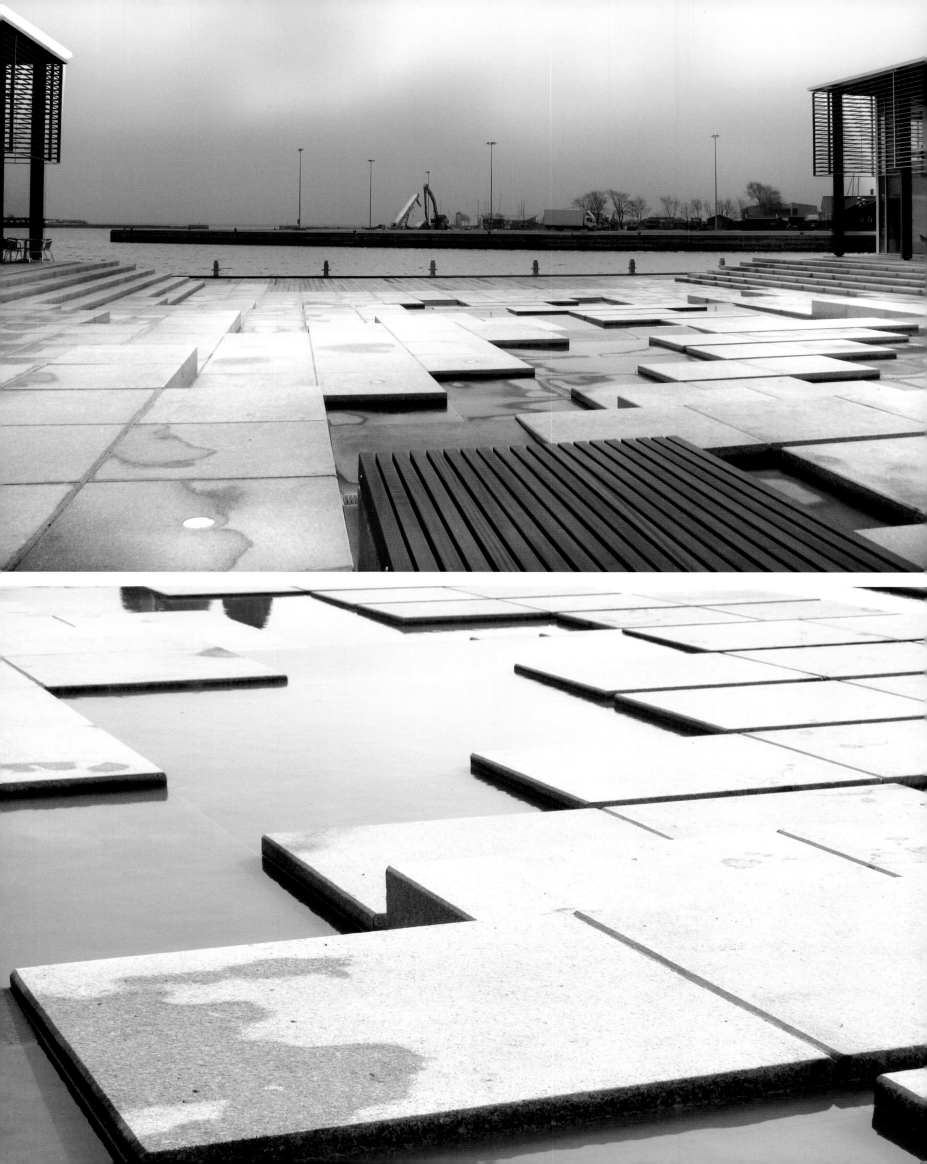

Yokohama International Port Terminal

Yokohama, Japan

The design concept of Ni-wa-minato alludes to a relationship between garden and harbor. The terminal's surface layer is a public open space complimentary to Yamashita Park. As such, the urban landscape is integrated with Yokohama Bay. The varying demands for space within the terminal between domestic and international carriers can be accommodated by using mobile or collapsible barriers. Segmented structural design has been avoided in favor of the flexibility and lightness of structural layers. This system has proved resistant to earthquake damage.

Das Designkonzept von Ni-wa-minato spielt auf die Beziehung zwischen Garten und Hafen an. Die äußere Oberfläche des Terminals ist ein offener öffentlicher Raum und ein Komplementär zum Yamashita Park. Als solche ist die städtische Landschaft in die Yokohama Bay integriert. Den veränderlichen Platzanforderungen im Terminal zwischen inländischen und internationalen Transportunternehmen wird mit mobilen oder faltbaren Trennwänden Rechnung getragen. Segmentierte strukturelle Gestaltung wurde zu Gunsten von Flexibilität und Leichtigkeit der tragenden Elemente vermieden. Dieses System hat seine Widerstandskraft gegen Schäden durch Erdbeben bewiesen.

Le concept fondateur du design de Ni-wa-minato fait allusion à la relation entre le jardin et le port. La surface du terminal est un espace public ouvert complémentaire au Yamashita Park. De cette manière, le paysage urbain est intégré à la Yokohama Bay. Il est possible de répondre aux diverses exigences des compagnies nationales et internationales en ce qui concerne l'espace à l'intérieur du terminal grâce à des barrières mobiles ou pliantes. La conception structurelle segmentée a été mise de côté en faveur de la flexibilité et de la discrétion des couches structurelles. Ce système a fait preuve de sa résistance face aux dégâts causés par les tremblements de terre.

El concepto de diseño de Ni-wa-minato está relacionado con la relación existente entre el jardín y el puerto. La capa superficial de la terminal es un espacio público abierto complementario del Yamashita Park. Como tal, el paisaje urbano se integra con la bahía de Yokohama. Las distintas demandas de espacio de las líneas nacionales e internacionales dentro de la terminal se pueden encauzar mediante el uso de barreras móviles o plegables. Se ha huido de un diseño estructural por segmentos para beneficiarse de la flexibilidad y ligereza de las capas estructurales. Este sistema ha demostrado su resistencia a los efectos de los terremotos.

Il concetto dietro al progetto del Ni-wa-minato era di alludere allo stretto rapporto tra giardino e porto. La superficie del terminale è uno spazio pubblico complementare allo Yamashita Park. In questo modo, il paesaggio urbano è integrato alla Yokohama Bay. Le diverse richieste di spazio all'interno del terminal, tra compagnie nazionali e internazionali, possono essere risolte utilizzando barriere mobili o pieghevoli. Si è cercato di evitare l'utilizzo di progetti strutturali segmentati per favorire una struttura più flessibile e luminosa. Tale sistema ha superato l'idoneità ai rischi di terremoto.

2002
Foreign Office Architects
www.f-o-a.net

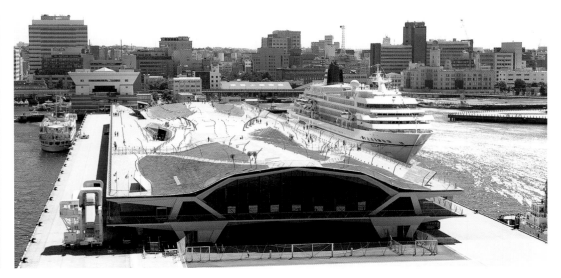

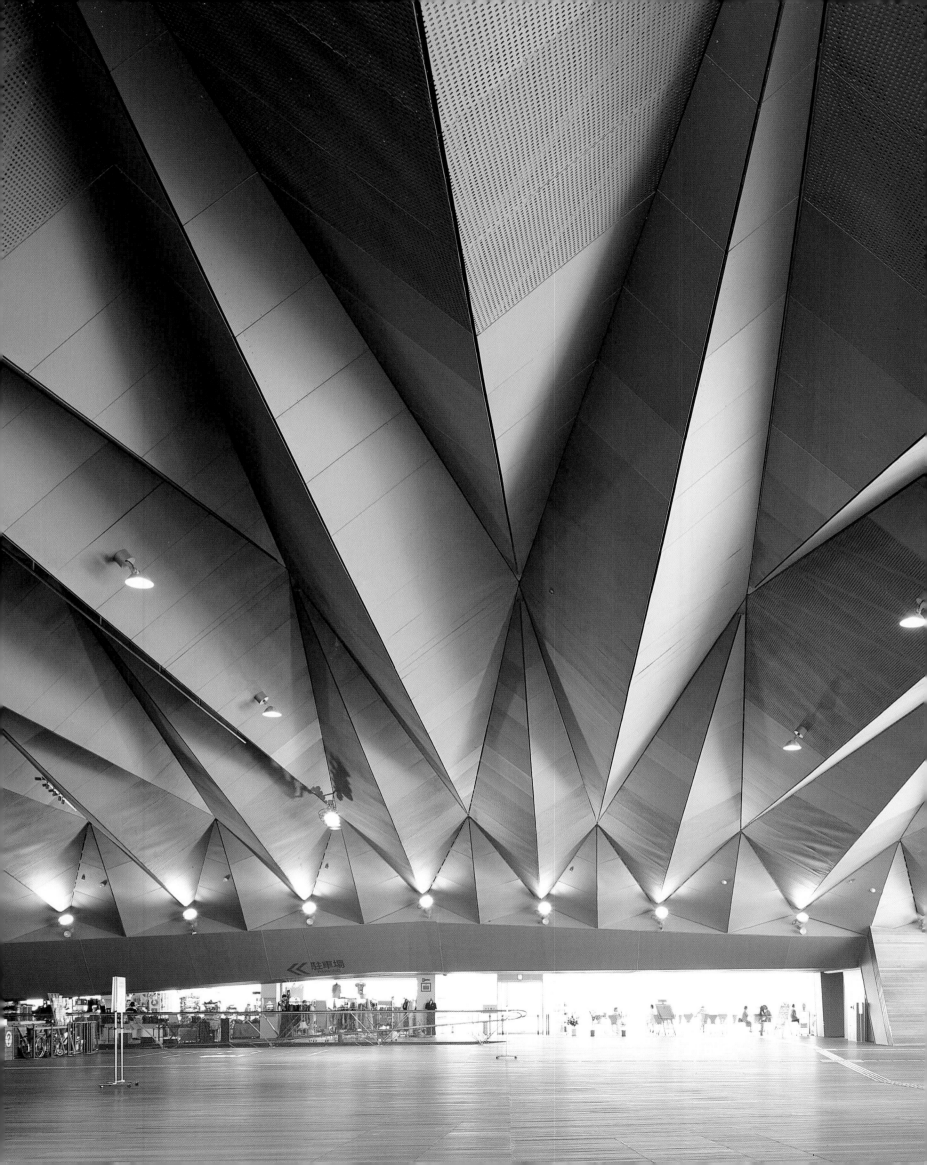

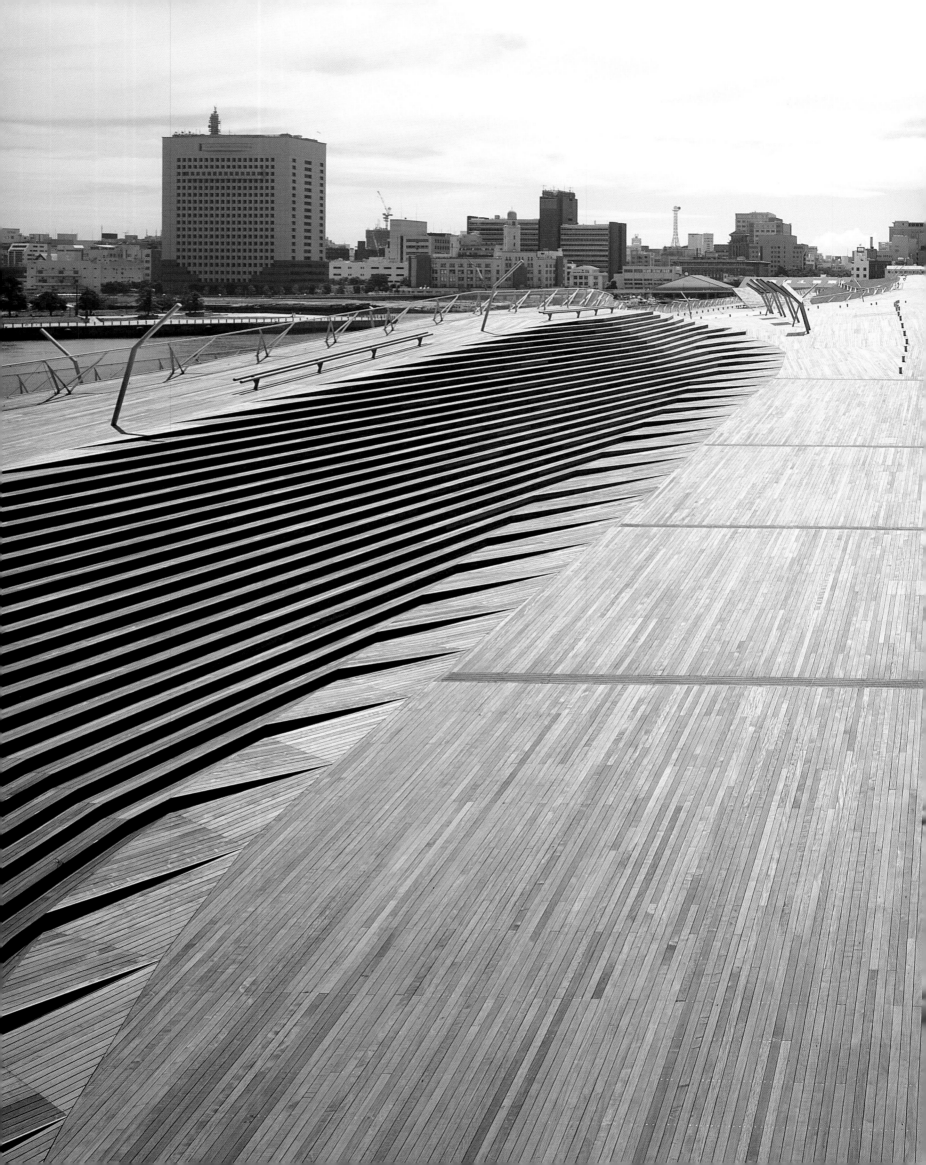

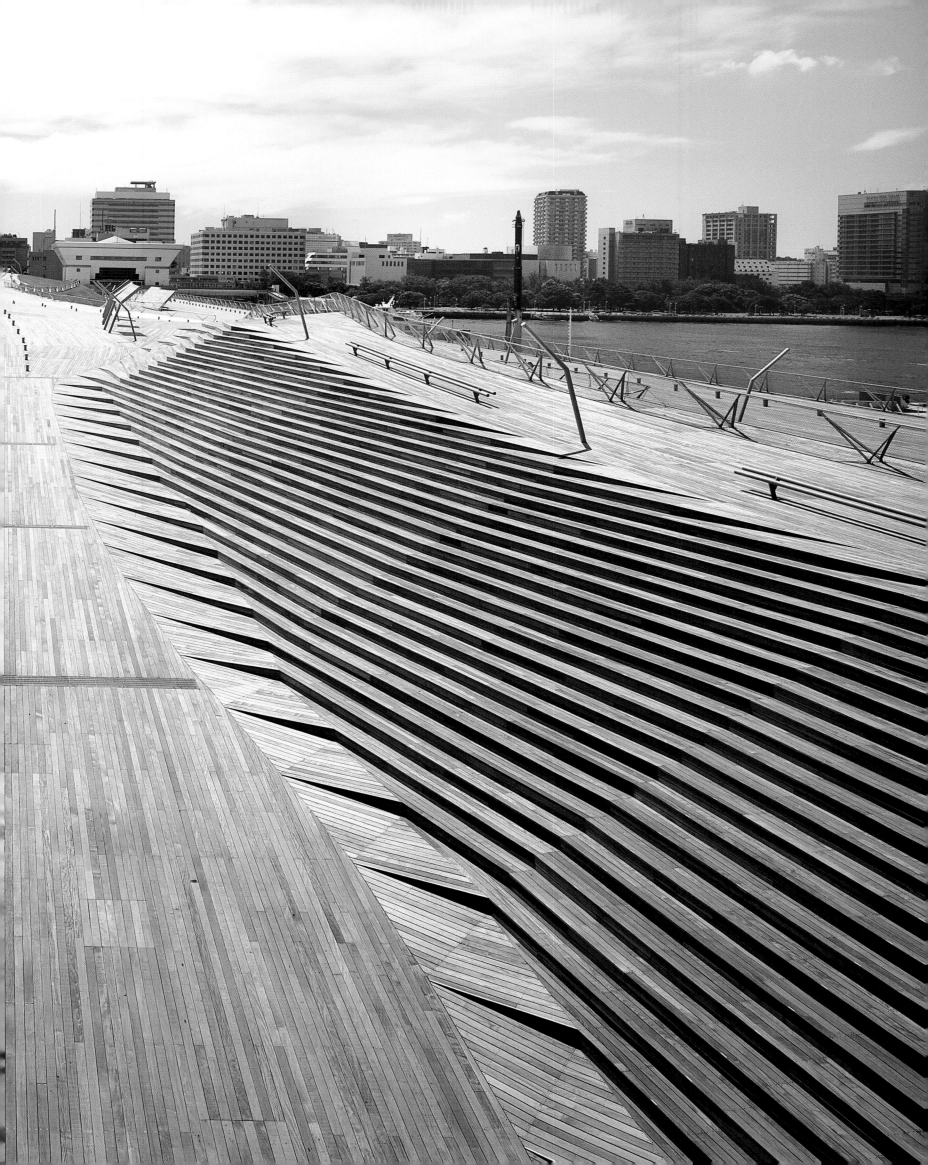

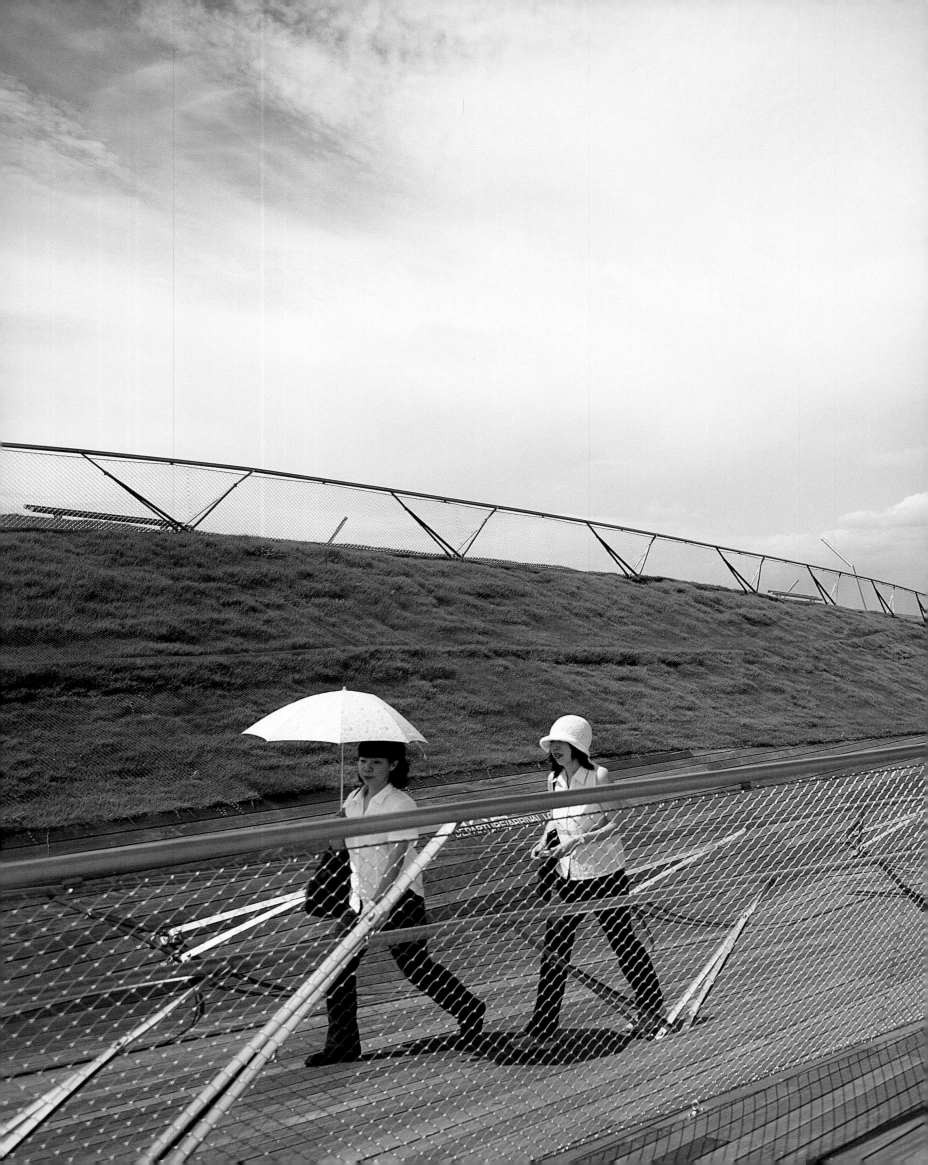

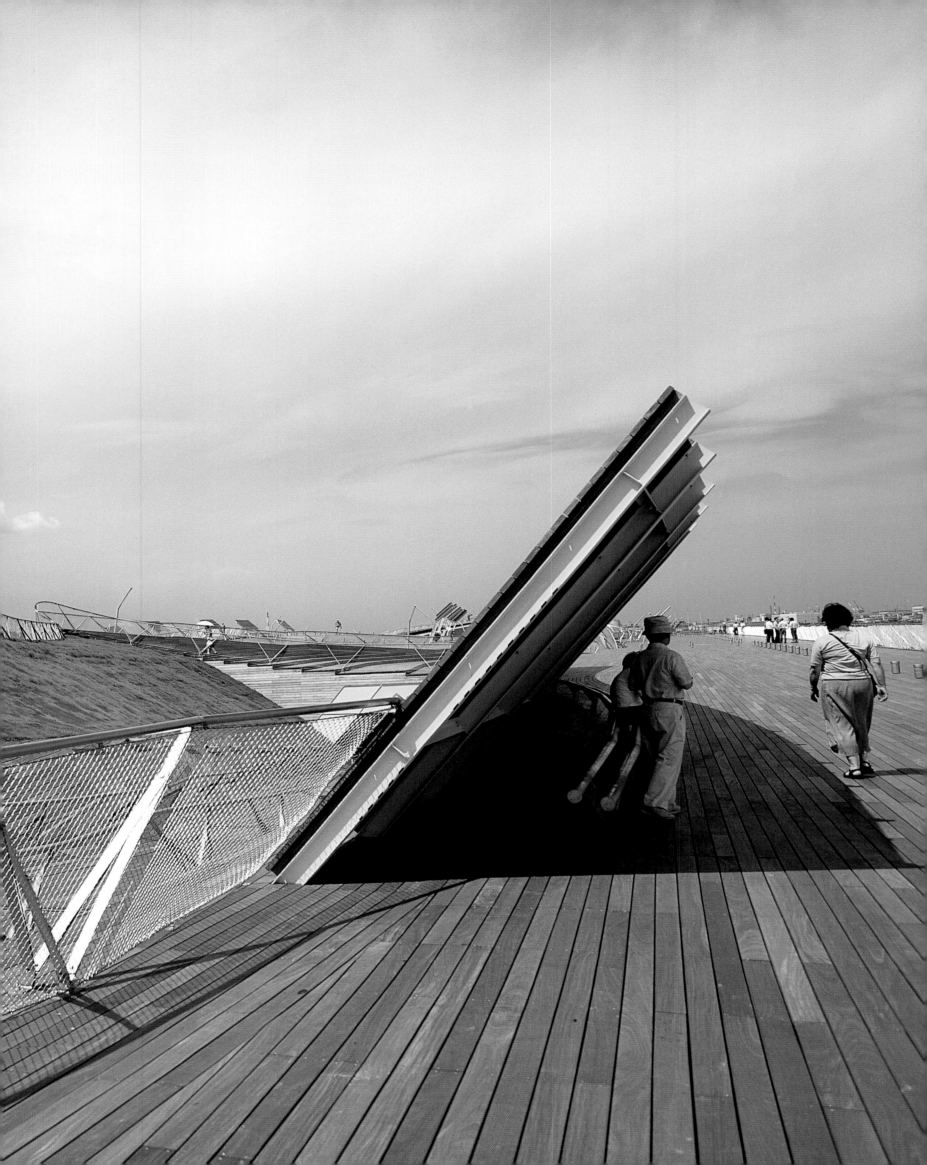

The origami-like folds and creases of the structure create functional routes through the building and also provide an integral structural strength. An one-way circulation system (a series of loops) manage the required traffic flow.

Die dem Origami ähnelnden Knicke und Falten schaffen funktionelle Wege durch das Gebäude ebenso wie wesentliche strukturelle Verstärkungen. Ein einfachgerichtetes Zirkulationssystem (eine Serie von Schleifen) bewerkstelligt den verlangten Verkehrsfluss.

La structure s'apparente à un origami se pliant et se dépliant, ce qui permet de délimiter des itinéraires fonctionnels à travers le bâtiment et fournit de plus une force structurelle intégrale. Un système de circulation à une voie (une série de boucles) permet de gérer le flot de circulation exigé.

Los pliegues y arrugas de la estructura, propios del origami, crean unas rutas funcionales por todo el edificio y también proporcionan una resistencia estructural integral. Un sistema de circulación unidireccional (una serie de bucles) dirige el flujo de tráfico necesario.

La struttura, come un origami, si piega e ri ripiega creando vie molto funzionali che attraversano l'edificio e forniscono anche ulteriore forza alla struttura. Un sistema di circolazione rotatoria (ad anelli) gestice il traffico.

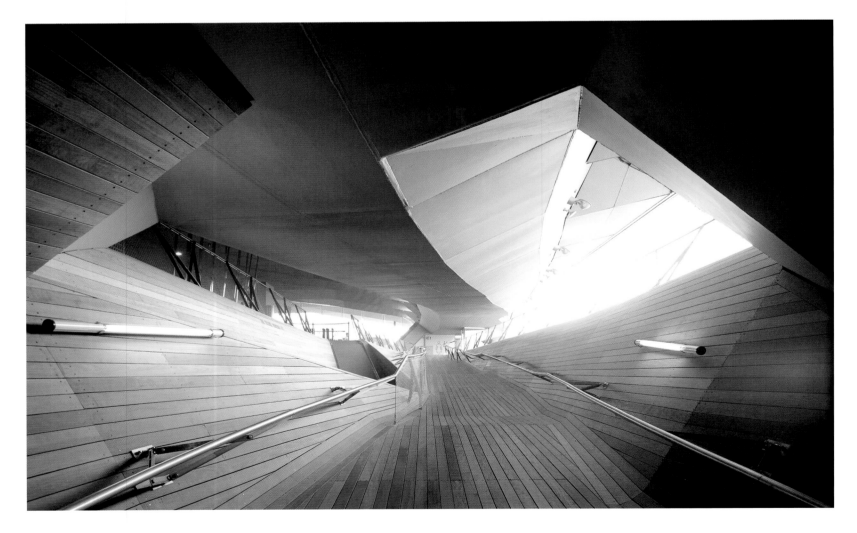

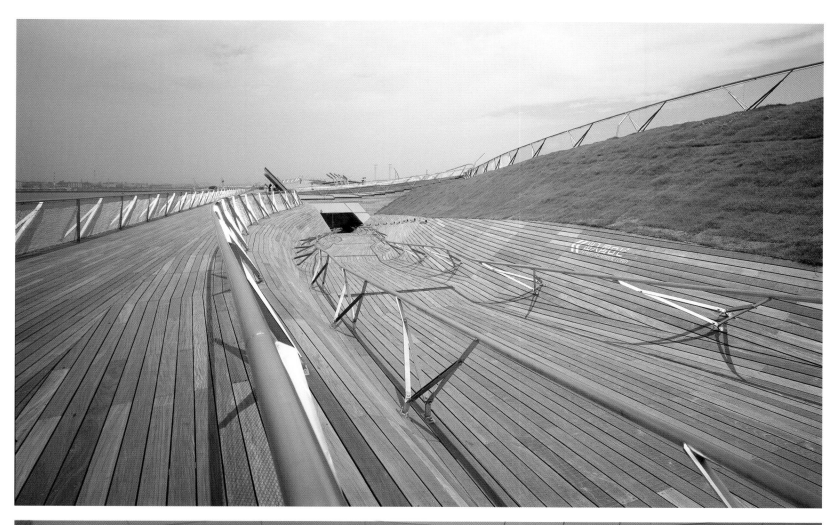

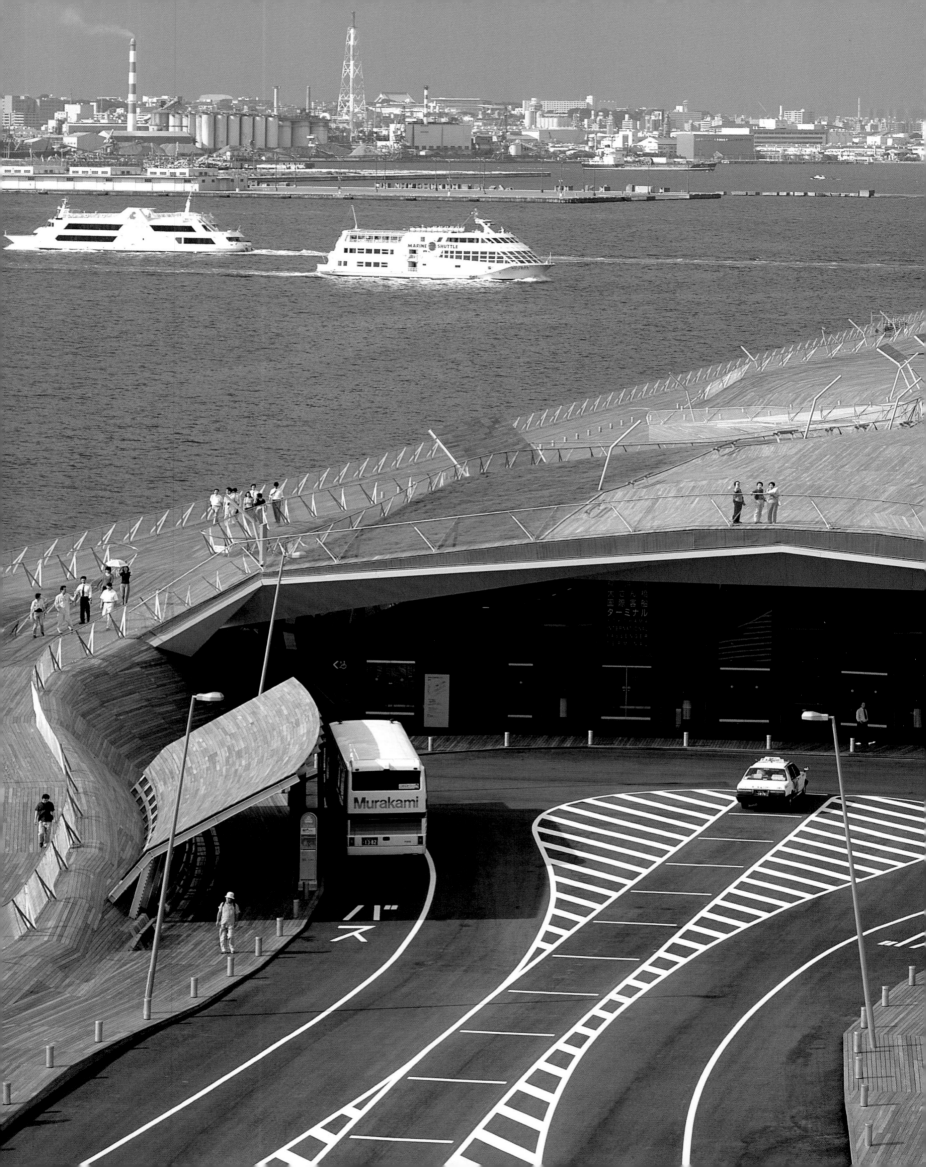

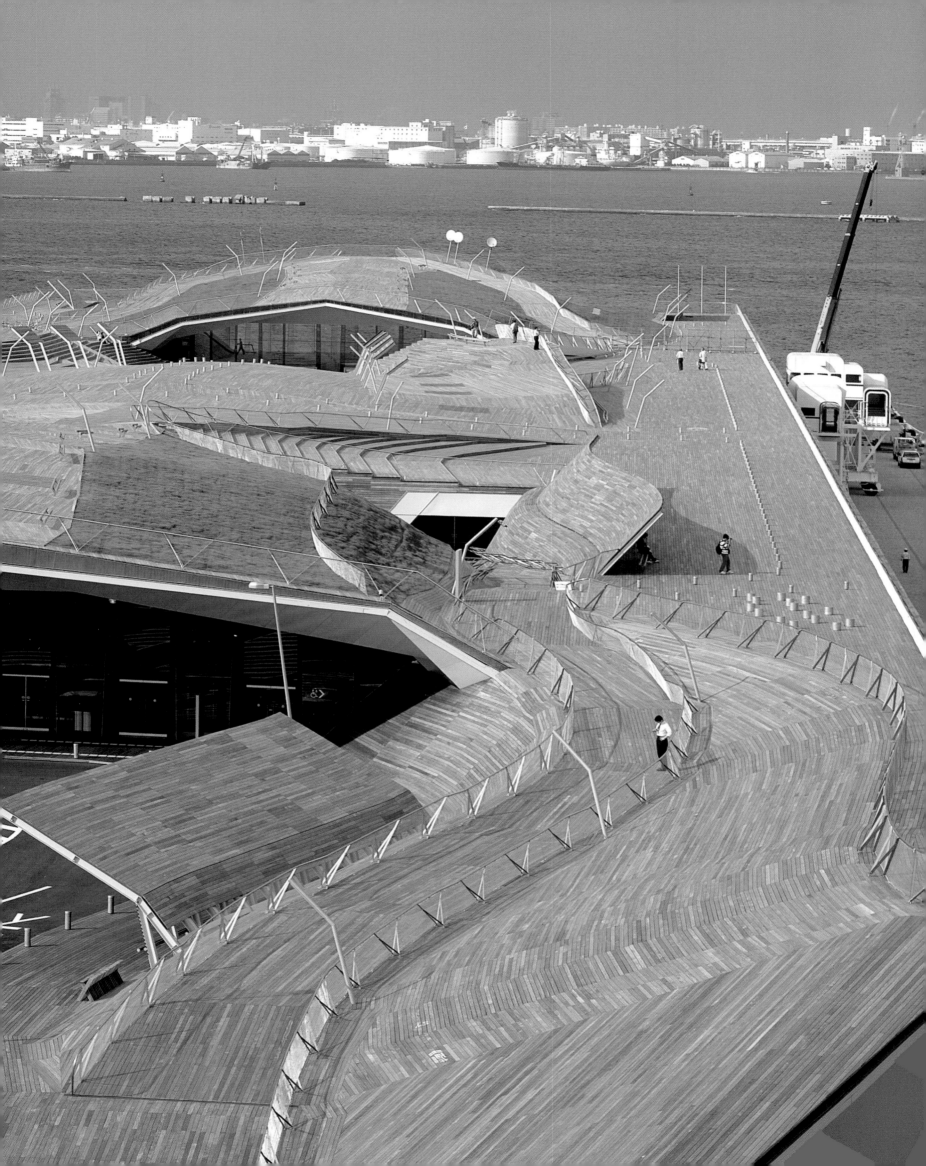

Zhongshan Shipyard Park

Zhongshan City, China

Zhongshan's derelict 1950s shipyard is now restored as a public park with remnants of the dock machinery artistically preserved as a reminder of the industrial heritage of the site. New networks of bridges cope with fluctuating water levels within the Qijiang river estuary. The site's old banyan trees and native salt marsh weeds are preserved within the design. The park is linked to the urban fabric of the city by a network of paths dotted with tea houses constructed from the yard's redundant architecture.

Zhongshans verfallene Werft aus den Fünfzigerjahren wurde nun als öffentlicher Park restauriert, mit künstlerisch konservierten Überbleibseln der Hafenmaschinen als Erinnerung an das industrielle Erbe des Geländes. Neue Netzwerke von Brücken meistern die schwankenden Wasserpegel innerhalb der Flussmündung des Qijiang. Die alten Banyanbäume und natürliche Gräser der Salzsümpfe am Standort wurden als Gestaltungselemente erhalten. Der Park ist durch ein Netzwerk von Pfaden mit dem städtischen Wegesystem verbunden. Das Gelände ist mit Teehäusern gesprenkelt, die aus ungenutzten Architekturelementen gebaut wurden.

La réhabilitation en parc public du chantier naval délabré de Zhongshan, datant des années 50, a tenu à garder les vestiges de la machinerie des docks et à les mettre en valeur de manière artistique. Ceci permet aujourd'hui de se remémorer le passé industriel du site. De nouveaux réseaux de ponts font face aux niveaux fluctuants des eaux à l'intérieur de l'estuaire de la rivière Qijiang. Les vieux banians du site et les herbes aquatiques des marais salants ont été préservés et intégrés à l'intérieur du design. Le parc est relié au tissu social de la ville grâce à un réseau de sentiers parsemés de maisons à thé construites à partir des éléments superflus issus de l'architecture des dépôts.

El astillero abandonado de la década de los cincuentas de Zhongshan ha sido reacondicionado ahora como parque público y se ha dado un contenido artístico a los restos que quedan de la maquinaria del muelle, como un recordatorio del pasado industrial del lugar. Nuevas redes de puentes se encargan del nivel cambiante del agua en el interior del estuario del río Qijiang. El diseño permite la conservación de los viejos banianos y la vegetación autóctona de las marismas. El parque está unido al tejido urbano de la ciudad mediante una red de caminos salpicados de casas de té construidas con materiales procedentes del viejo astillero.

Il vecchio cantiere navale degli anni '50 di Zhongshan è stato di recente restaurato e trasformato in un parco pubblico, pur non dimenticando il passato dell'area, ricordato dalla presenza sul sito di macchinari industriali originali. Una nuova rete di ponti fa fronte all'instabilità dei livelli dell'acqua dell'estuario del fiume Qijiang. I vecchi alberi di ficus e le native alghe marine sono preservati dal progetto. Il parco è collegato al tessuto urbano da una rete di sentieri disseminati di case da tè, costruite in armonia con l'architettura originale del sito.

2001
Turenscape (Beijing Design Institute)
www.turenscape.com

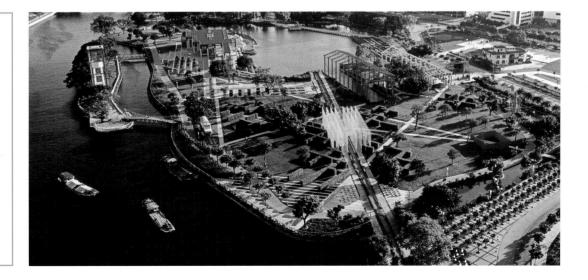

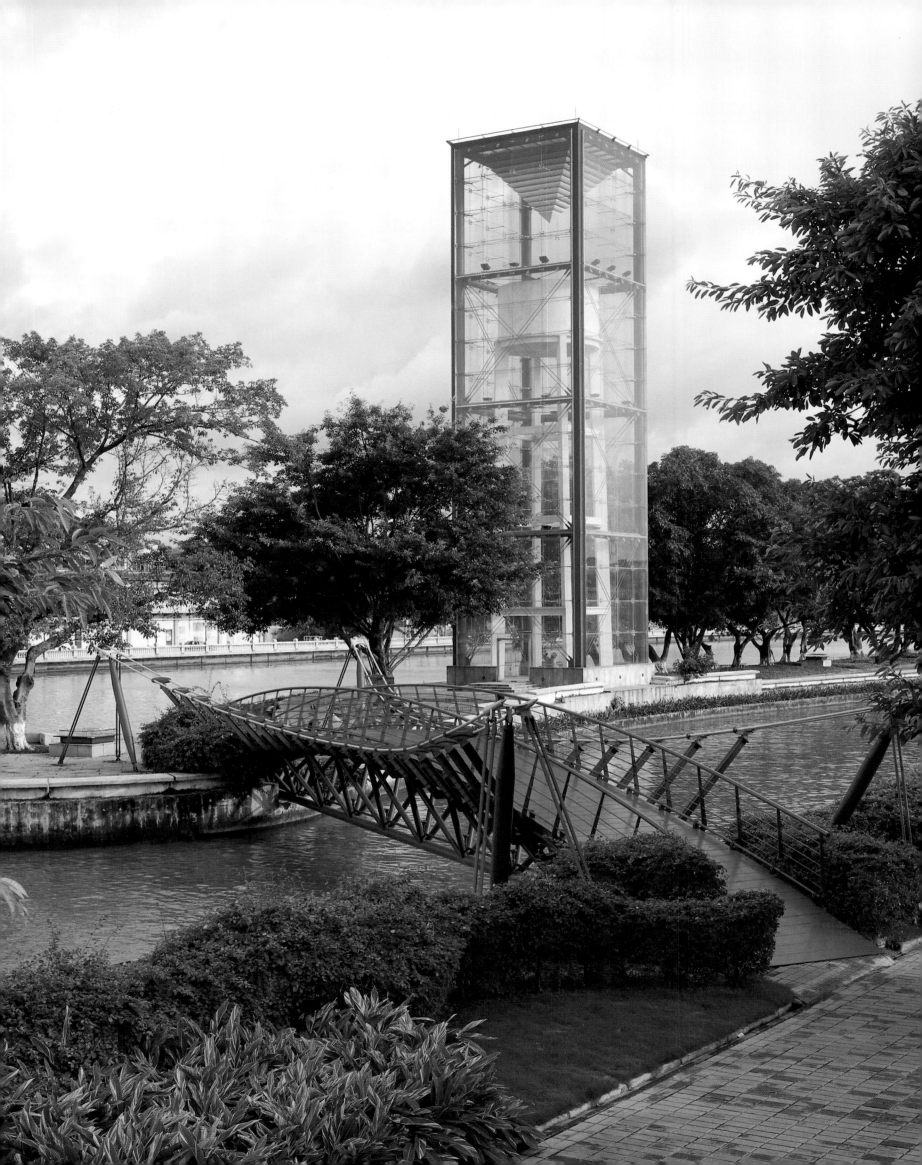

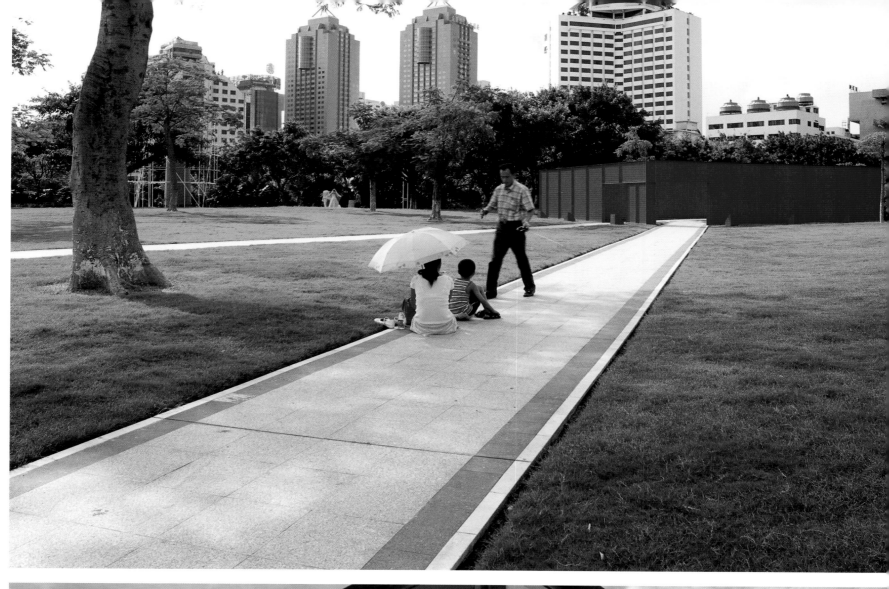
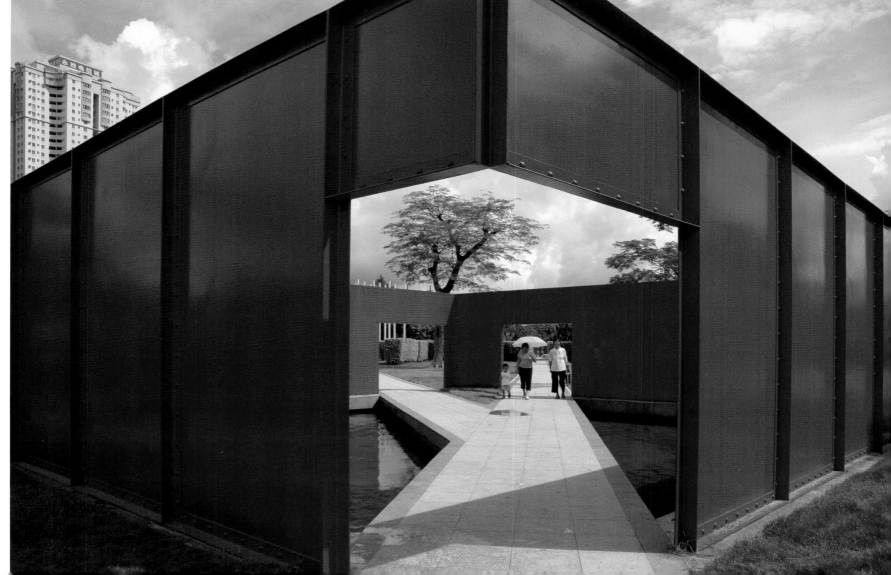

Shipyard Park's main design ethos was to convert a damaged, polluted site into a primary example of urban renovation whilst reflecting the remarkable fifty year history of socialist China.

Die Idee hinter dem Design des Shipyard Parks bestand darin, eine verschmutzte Brache in ein herausragendes Beispiel für Stadtsanierung umzuwandeln und gleichzeitig die außerordentliche, fünfzigjährige Geschichte des sozialistischen Chinas widerzuspiegeln.

L'idée de génie à la base de la conception du Shipyard Park était de convertir un site délabré et pollué en un brillant exemple de réhabilitation urbaine à même de refléter cinquante remarquables années de l'histoire de la Chine socialiste.

El principal lema de diseño del Shipyard Park era transformar un entorno dañado y contaminado en un ejemplo de renovación urbana que reflejara los extraordinarios cincuenta años de historia de la China socialista.

L'idea alla base del progetto dello Shipyard Park era convertire un sito fortemente danneggiato ed inquinato in un fine esempio di rinnovamento urbano, e allo stesso tempo riflettere gli straordinari cinquant'anni di storia della Cina socialista.

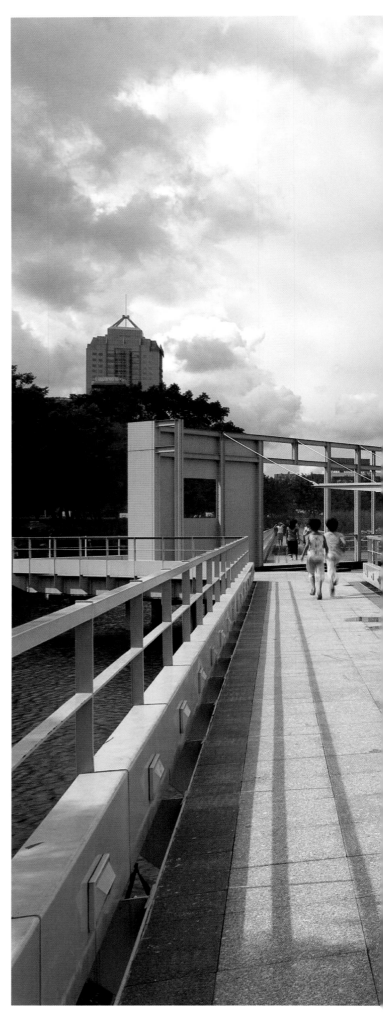

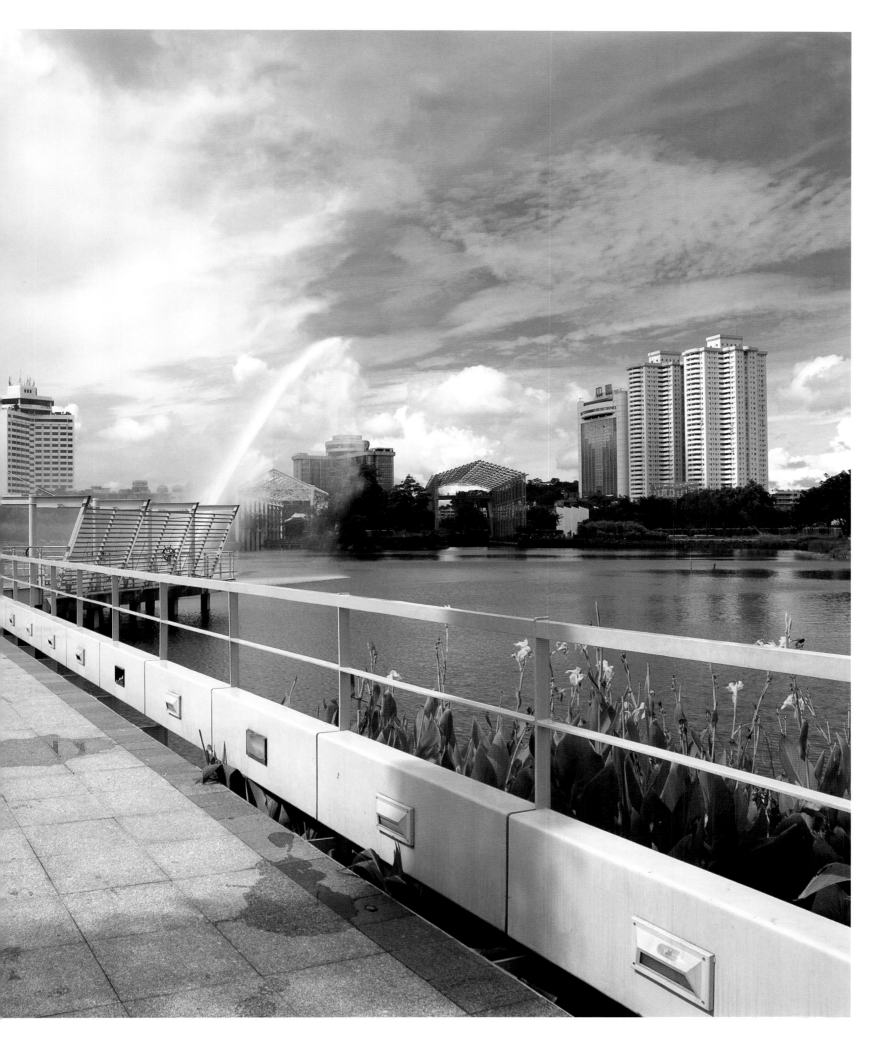

Benaroya Hall
Garden of Remembrance
Seattle, USA

Serving Seattle as both a vibrant urban plaza and a war memorial for the State of Washington, the garden is built over a parking garage and a bus tunnel. Utilising elegant plants, waterfalls and engraved granite slabs the site integrates Symphony Hall, Seattle Art Museum and University Street. As a result, the plaza is often filled with people socializing, having coffee or simply paying their respects to those who lost their lives in American wars since 1941.

Der Garten wurde oberhalb eines Parkhauses und eines Bustunnels erbaut und dient Seattle gleichzeitig als lebhafter öffentlicher Platz und Gedenkstätte des Staates Washington für den Krieg. Neben eleganten Pflanzen, Wasserfällen und gravierten Granitplatten befinden sich auf dem Gelände die Symphony Hall, das Seattle Art Museum und die Universitätsstraße. Deshalb ist der Platz oft mit Menschen bevölkert, die sich hier treffen, Kaffee trinken oder einfach jenen Ehre erweisen wollen, die in amerikanischen Kriegen seit 1941 ihr Leben verloren haben.

Étant utilisé par Seattle à la fois comme une vibrante place urbaine et un monument aux morts pour l'État de Washington, le jardin est construit au-dessus d'un parking et d'un tunnel fréquenté par les autobus. Le site, où cohabitent d'élégantes plantes avec des chutes d'eau et une série de blocs de granit gravé, intègre le Symphony Hall, le Seattle Art Museum et et la rue de l'Université. Le résultat fait de cette place un lieu très social où beaucoup de gens viennent prendre un café ou rendre hommage à tous ceux ayant perdu la vie dans les guerres auxquelles les États-Unis ont participées depuis 1941.

El jardín, que está construido sobre un aparcamiento subterráneo y un túnel para autobuses, proporciona a Seattle una vibrante plaza para uso público y un monumento conmemorativo de los soldados muertos del estado de Washington. En el lugar se integran el Symphony Hall, el Seattle Art Museum y la calle de la Universidad mediante plantas de porte elegante, cascadas y losas de granito con inscripciones. El resultado es una plaza a menudo llena de gente paseando, tomando un café o simplemente presentando sus respetos a los soldados estadounidenses que han perdido sus vidas desde 1941.

Fungendo sia da vivace piazza della città di Seattle che da monumento alla memoria dei caduti dello Stato di Washington, questo giardino è costruito sopra un parco macchine e un tunnel riservato agli autobus. Facendo uso di piante, cascate e lastre di granito incise, il sito si estende fino ad integrare anche il Symphony Hall, il Seattle Art Museum e la via dell'Università. Il risultato è una piazza sempre molto attiva, frequentata da persone che socializzano, che gustano un caffè o che si fermano semplicemente a commemorare chi perse la vita nelle guerre Americane dal 1941.

1998
Murase Associates
www.murase.com

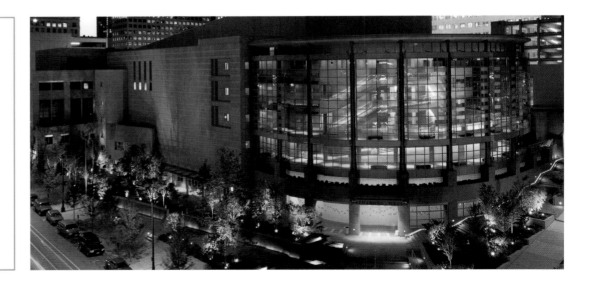

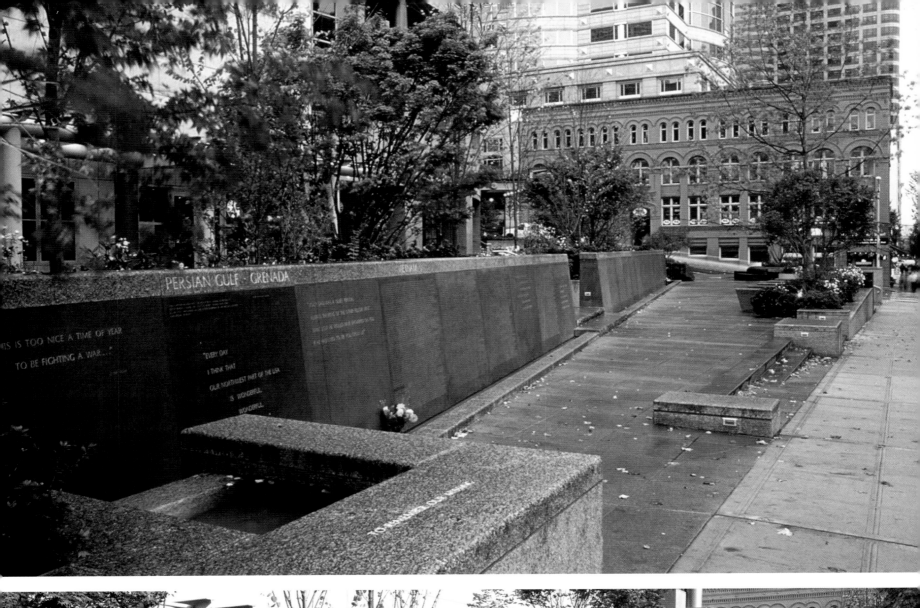

Chess Park

Glendale, USA

This project transformed a city passageway into a thriving community oriented chess park. Inspired by Isamu Noguchi's famous lamps, the designers created chesspiece light towers from recycled materials. The light towers emit a warm glow and are strategically placed around the park. While the towers bring an iconic presence, they also provide significant lighting to help solve the park's functional needs. The park contains borders with lush, low-maintenance shrubbery and white-flowering perennials. Cypress trees provide a buffer to the alley.

Dieses Projekt verwandelte einen innerstädtischen Durchgangsweg in einen belebten öffentlichen Schachpark. Inspiriert von Isamu Noguchis berühmten Lampen, schuf der Designer leuchtende Türme in der Form von Schachfiguren aus Recyclingmaterialien. Diese Lichttürme sind an strategischen Punkten im ganzen Park verteilt und tauchen diesen in ein warmes Licht. Die Türme schaffen eine ikonenhafte Präsenz, erfüllen aber natürlich ebenso die Beleuchtungserfordernisse des Parks. Pflegeleichte Sträucher und weißblühende Stauden begrenzen den Park; Zypressenbäume schirmen ihn zur Straße hin ab.

Ce projet a transformé un passage de la ville en un parc de jeu d'échec pensé pour une communauté de joueurs en essor. Inspirés par les célèbres lampes d'Isamu Noguchi, les concepteurs ont créé des pièces d'échec à partir de matériaux recyclés en leur donnant la forme de tours lumineuses. Celles-ci, émettant une lueur chaude, sont distribuées de manière stratégique autour du parc. Elles amènent à la fois une présence iconique et fournissent une illumination suffisante pour résoudre les besoins fonctionnels du parc. Les bordures de ce dernier, composées de massifs d'arbustes et de plantes vivaces de couleur blanche, sont luxuriantes. Une allée de cyprès crée une zone intermédiaire.

Este proyecto transformó un pasaje de la ciudad en un parque ajedrecístico orientado a la comunidad. Inspirándose en las famosas lámparas de Isamu Noguchi, los diseñadores crearon unas torres de luz con forma de piezas de ajedrez y realizadas a base de materiales reciclados. Las torres de luz emiten una luz suave y están colocadas de forma estratégica en el parque. No solo aportan una fuerte presencia icónica, sino que también constituyen una fuente significativa de iluminación para ayudar a solucionar las necesidades funcionales del parque. El parque cuenta con parterres de exuberantes arbustos que necesitan muy poco mantenimiento y plantas perennes de flor blanca, además de unos cipreses que actúan como cobertura del pasaje.

Questo progetto ha trasformato una comune via di passaggio cittadina in uno stimolante parco per gli scacchi orientato all'interazione con la comunità. Ispirato dalle famose lampade di Isamu Noguchi, gli architetti hanno creato delle torrette luminose a forma di pezzi di scacchi utilizzando materiali di riciclo. Le torrette emettono una luce calda e sono tutte poste in luoghi particolarmente strategici. Oltre ad essere molto suggestive, suppliscono anche alle necessità funzionali del parco fornendo un'abbondante quantità di luce. All'interno, il parco è bordato da lussureggianti cespugli e piante perenni dai fiori bianchi. Alberi di cipresso rinfrescano il viale.

2004
Rios Clementi Hale Studios
www.rchstudios.com

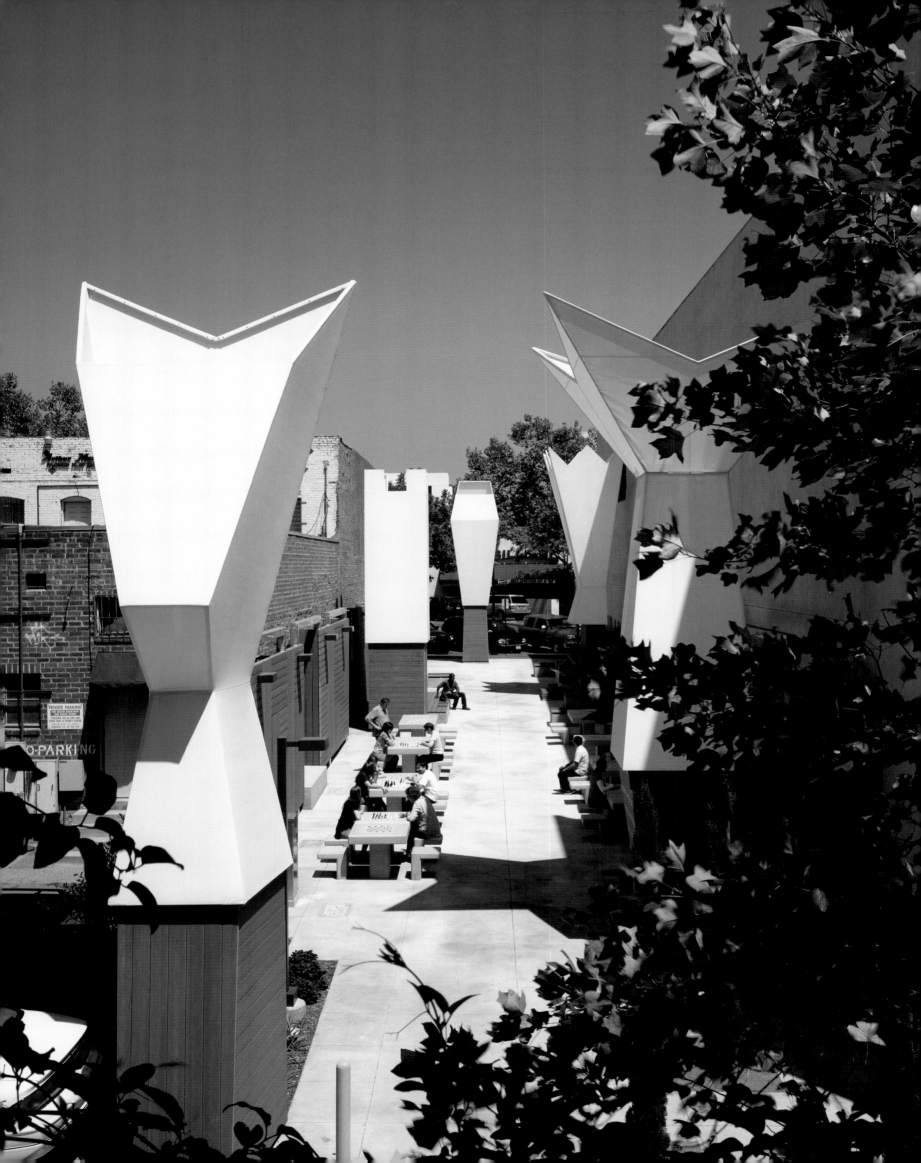

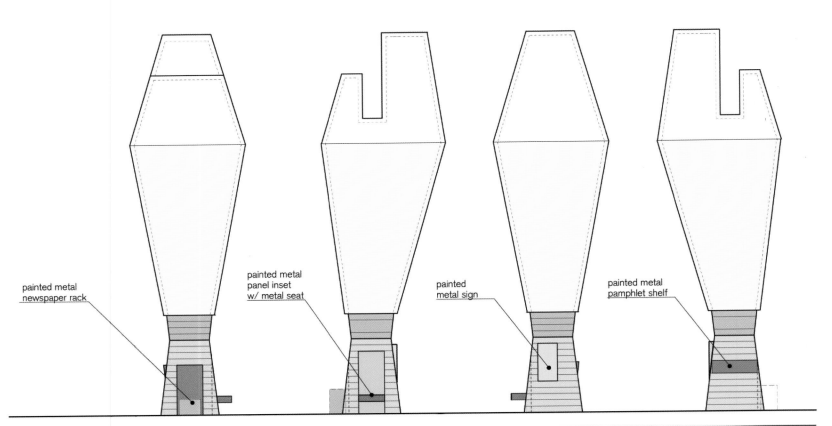

painted metal
newspaper rack

painted metal
panel inset
w/ metal seat

painted
metal sign

painted metal
pamphlet shelf

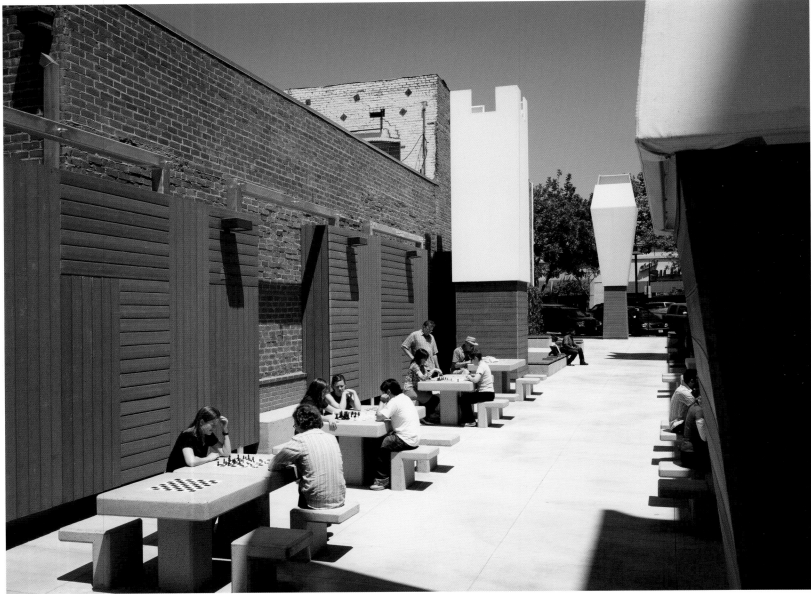

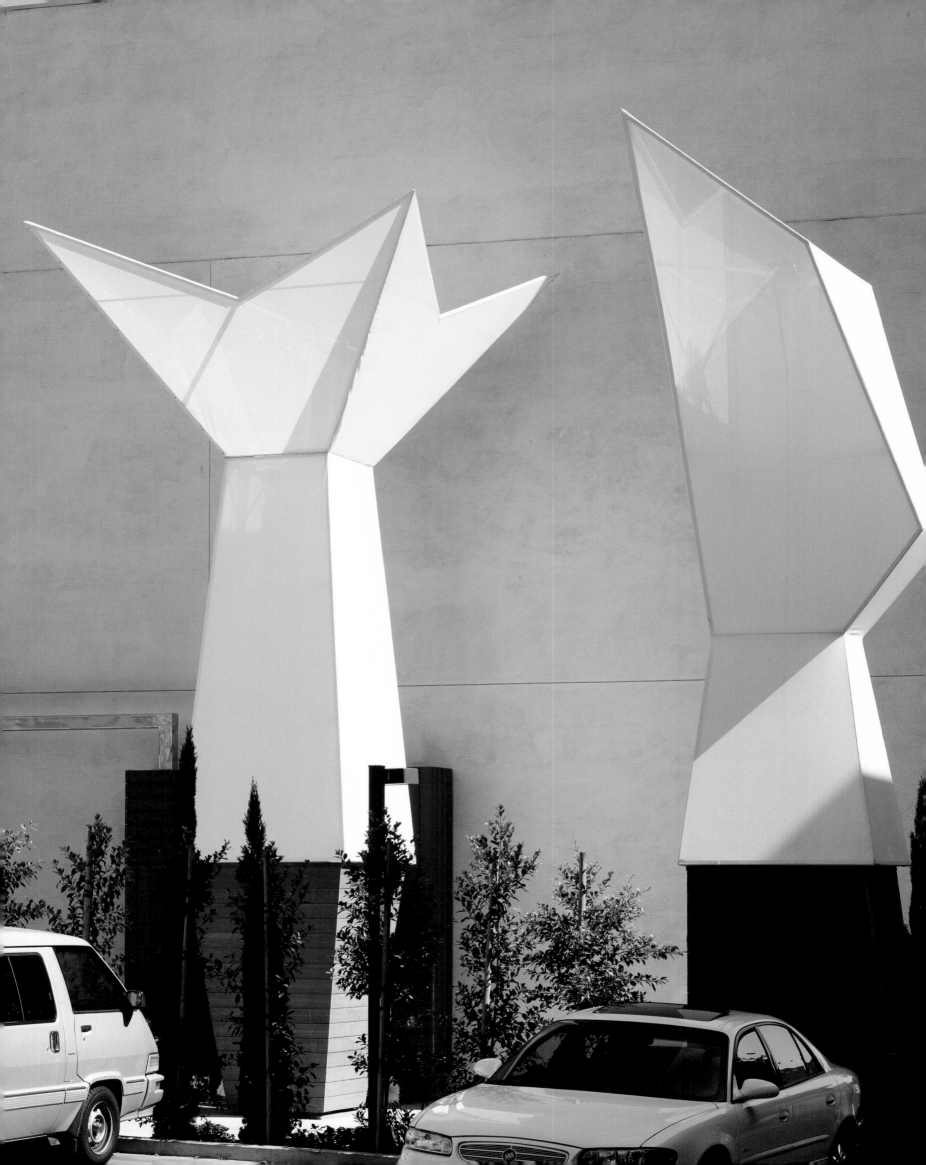

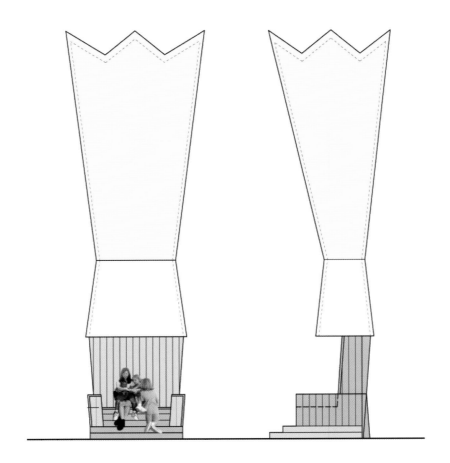

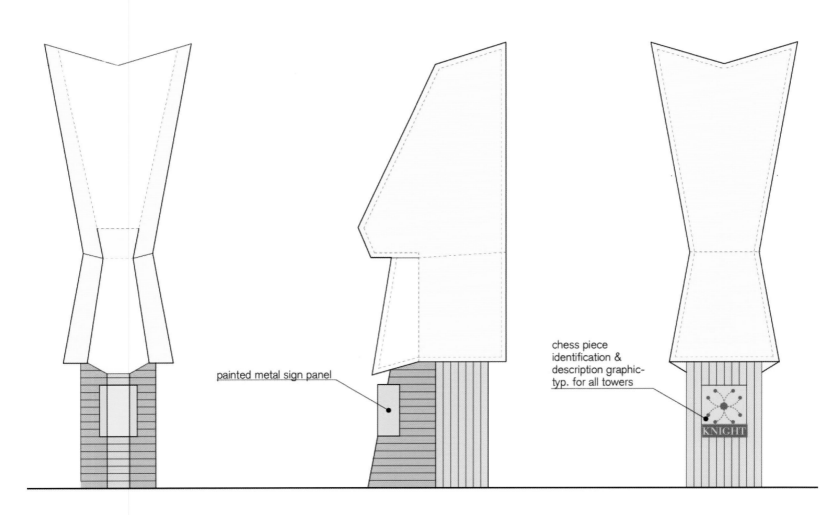

painted metal sign panel

chess piece
identification &
description graphic-
typ. for all towers

KNIGHT

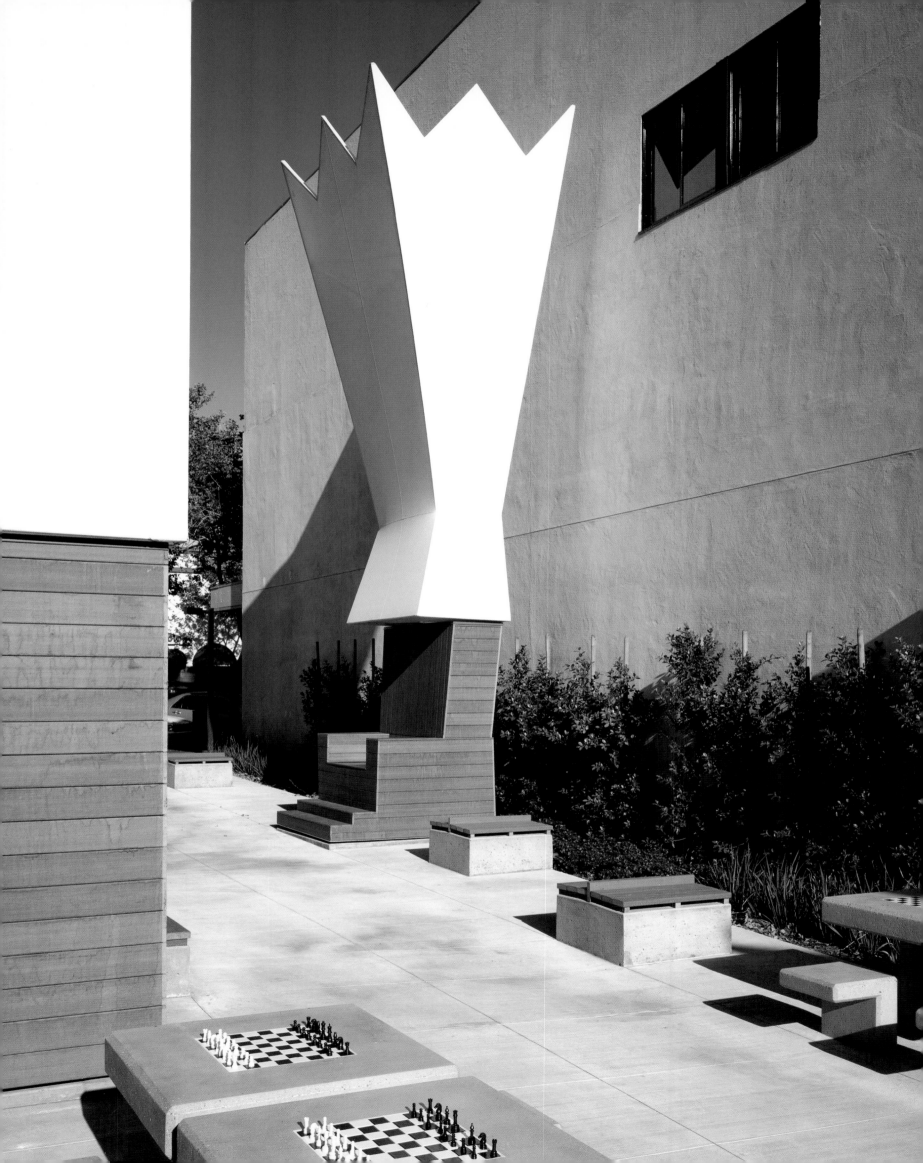

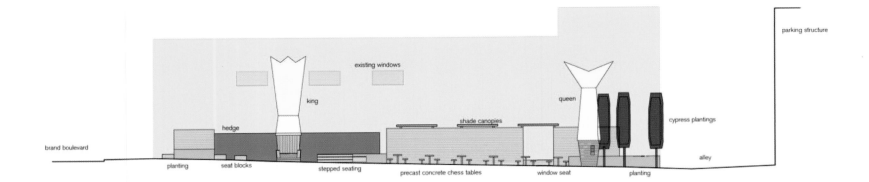

The King Tower sits as a giant story-telling throne. Across the throne is a platform where musicians, actors and artists can gather together and showcase their talents. A gray TREX wall folds up behind the platform to create a backdrop for performances. The powerful Queen Tower presides over the gaming zone and stands as a symbol for the Glendale Chess Club.

Der Königsturm thront als gigantischer Sitz des Geschichtenerzählens. Jenseits des Throns befindet sich eine Plattform, auf der Musiker, Schauspieler und Künstler zusammenfinden und ihre Fähigkeiten präsentieren können. Eine graue TREX-Wand kann hinter der Plattform ausgefaltet werden, um einen Hintergrund für Vorstellungen zu erhalten. Der kraftvolle Königinnenturm herrscht über die Spielzone und steht als ein Symbol für den Glendale Schachclub.

La Tour du Roi semble être le trône d'un géant en train de raconter une histoire. Une plate-forme entoure la tour. Elle peut être utilisée pour que musiciens, acteurs et artistes en tout genre puissent se rassembler et faire preuve de leurs talents respectifs. Un mur gris de type TREX peut être déplié derrière la plate-forme afin de créer une toile de fond pour les représentations. L'imposante Tour de la Reine préside la zone de jeu et se dresse tel un symbole du club d'échecs de Glendale.

La Torre del Rey está emplazada cual trono gigante de cuentacuentos, y enfrente de ella se ha colocado una plataforma para que músicos, actores y artistas muestren al público su talento. El muro gris de TREX que se ha dispuesto tras la plataforma sirve de telón de fondo para las actuaciones. La poderosa Torre de la Reina preside la zona de juego y sirve de símbolo al club de ajedrez de Glendale.

La Torre del Re si propone come un enorme trono cantastorie. Di fronte al trono, un palco dove musicisti, attori e artisti possono dare sfoggio dei loro talenti. Un muro grigio TREX circonda il palco per creare uno sfondo per gli spettacoli. La possente Torre della Regina veglia sull'area di gioco e rappresenta il simbolo del club di scacchi di Glendale.

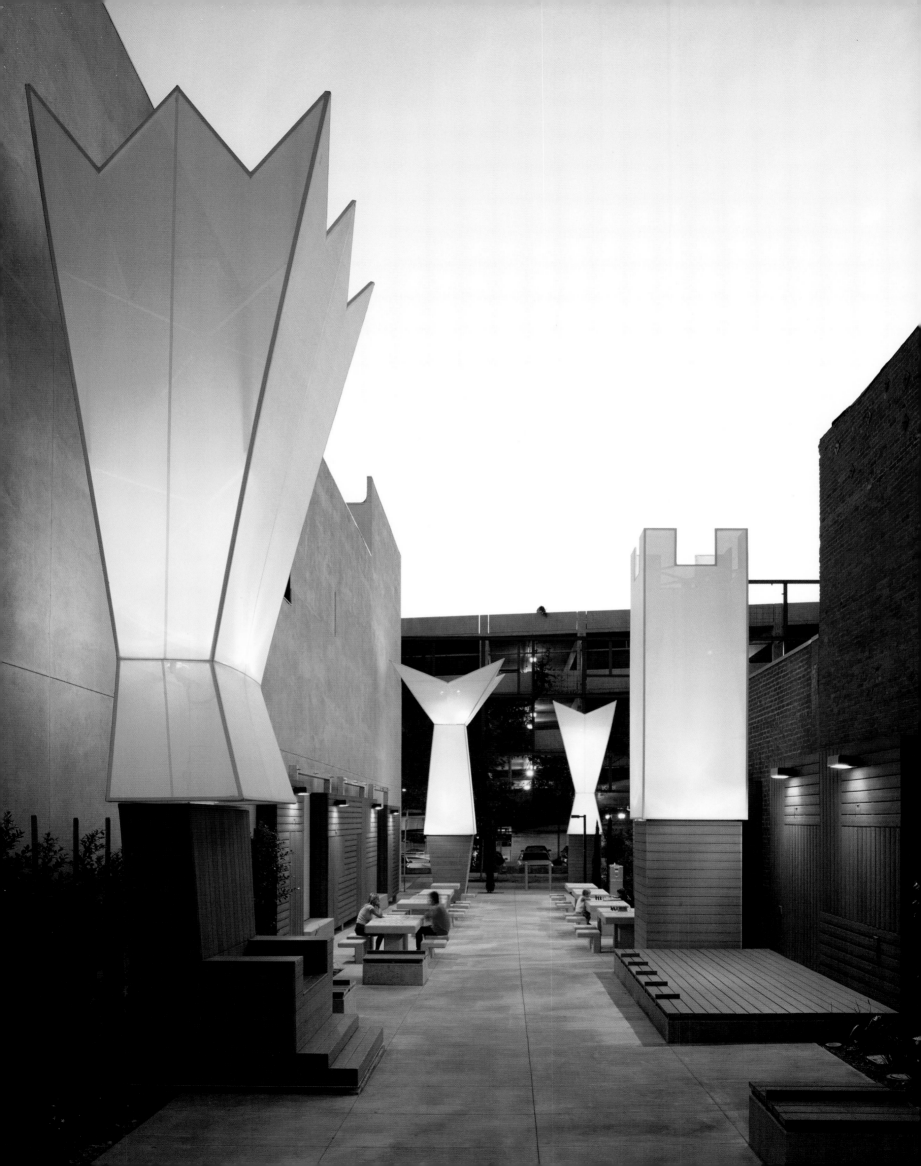

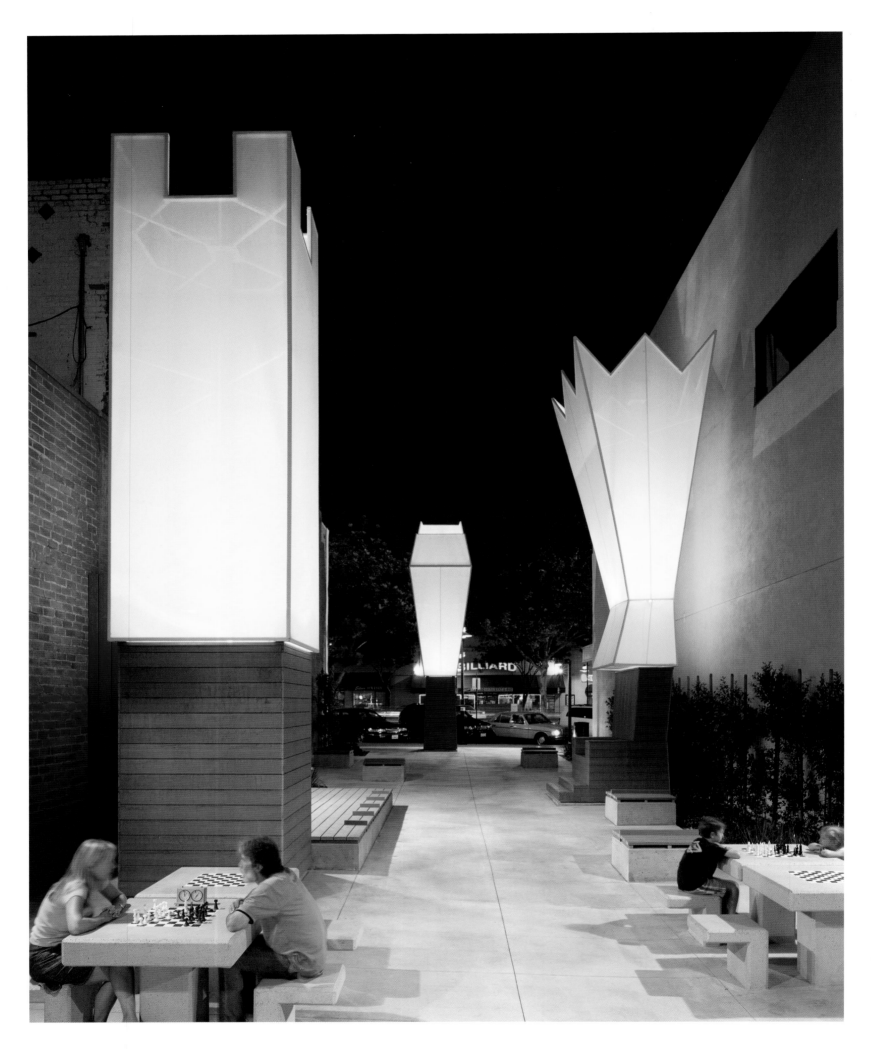

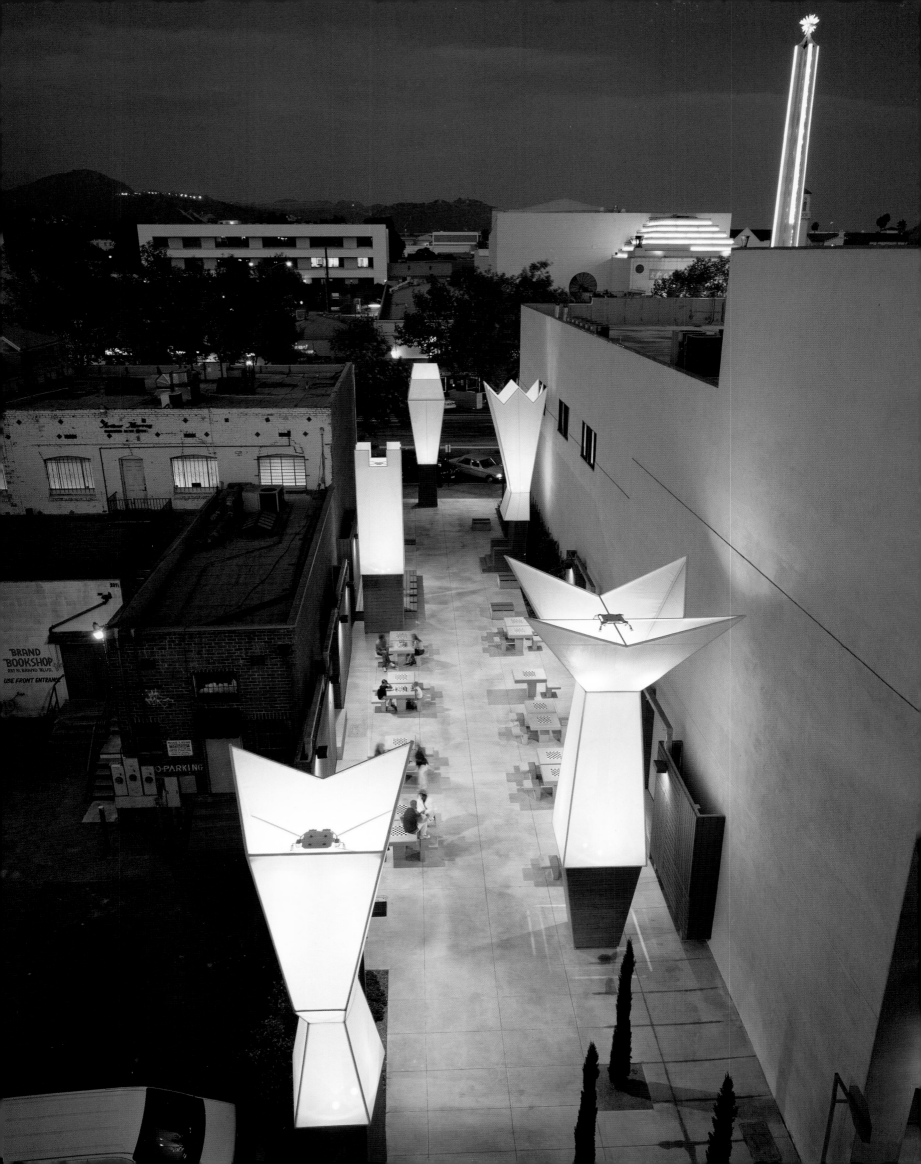

Courthouse Square
Toronto, Canada

The transformation of a dilapidated space behind Toronto's original courthouse combined different elements of urban landscape design. Public amenity, streetscapes, a water feature and the site's historical context were all integrated into the scheme. The educational and historic references are evident in the planting of native species, medicinal herbs, perennials and rose gardens. Flowering vines are supported with wrought iron pergolas in keeping with the courthouse architecture. An element of theater is brought to the square by the black granite outdoor stage.

Die Umwandlung eines baufälligen Platzes hinter Torontos altem Gerichtsgebäude verband verschiedene Elemente städtischer Landschaftsarchitektur. Öffentliche Einrichtungen, Straßenbilder, ein Wasserspiel und der historische Zusammenhang wurden alle in die Szenerie integriert. Geschichtliche und erzieherische Referenzen zeigen sich in den gepflanzten einheimischen Kulturen, Medizinkräutern, Stauden und Rosengärten. Blühender Wein wächst an gusseisernen Pergolen, die im Einklang mit der Architektur des Gerichtsgebäudes stehen. Die Freiluftbühne aus schwarzem Granit fügt dem Platz ein Theaterelement hinzu.

La transformation de l'espace délabré derrière le tout premier palais de justice de Toronto s'est basée sur la combinaison de différents éléments issus du design du paysage urbain. Les distractions pour le public, les éléments issus du remodelage urbanistique, l'eau comme élément vedette et le contexte historique du site sont les paramètres qui ont été intégrés dans le projet. Les références éducatives et historiques ont évidemment été prises en compte au moment de planter les plantes médicinales et vivaces autochtones et les parterres de roses. Des vignes en pleine croissance sont supportées par des pergolas en fer forgé qui rappellent l'architecture du palais de justice. La scène extérieure, fabriquée en granit noir, amène un élément de théâtralité au square du palais de justice.

La transformación de un espacio infrautilizado situado detrás de los primeros juzgados de Toronto implicó el uso combinado de varios elementos de paisajismo urbano; en este proyecto se integraron una instalación pública, paisajes urbanos, un elemento acuático y el contexto histórico del emplazamiento. Las referencias educativas e históricas son evidentes en las plantas autóctonas, hierbas medicinales, plantas perennes y jardines de rosas que se han plantado. Las enredaderas en flor se apoyan en pérgolas de hierro forjado que guardan el estilo del edificio del juzgado. El escenario de granito negro allí situado dota a la plaza de un elemento dramático.

La trasformazione di un'area in decadimento dietro al vecchio tribunale di Toronto ha visto combinare diversi elementi di progettazione urbanistica. Servizi pubblici, paesaggio urbano, una fontana e il contesto storico del luogo, tutti questi elementi sono stati integrati all'interno dello scenario. I riferimenti educativi e storici sono accentuati dalle rigogliose piantumazioni di vegetazione tipica locale, erbe officinali, piante perenni e giardini di rose. Rampicanti fioriti vengono supportati da pergolati in ferro battuto, per mantenere lo stile architettonico. Elemento di grandissimo effetto è costituito dal grande palco esterno in granito nero.

1997
Janet Rosenberg + Associates
www.jrala.ca

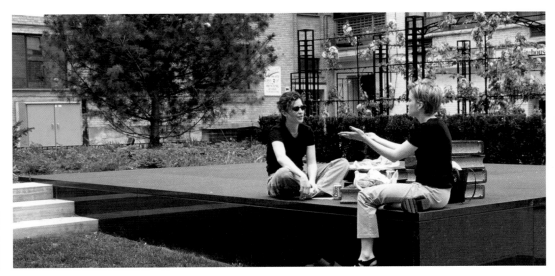

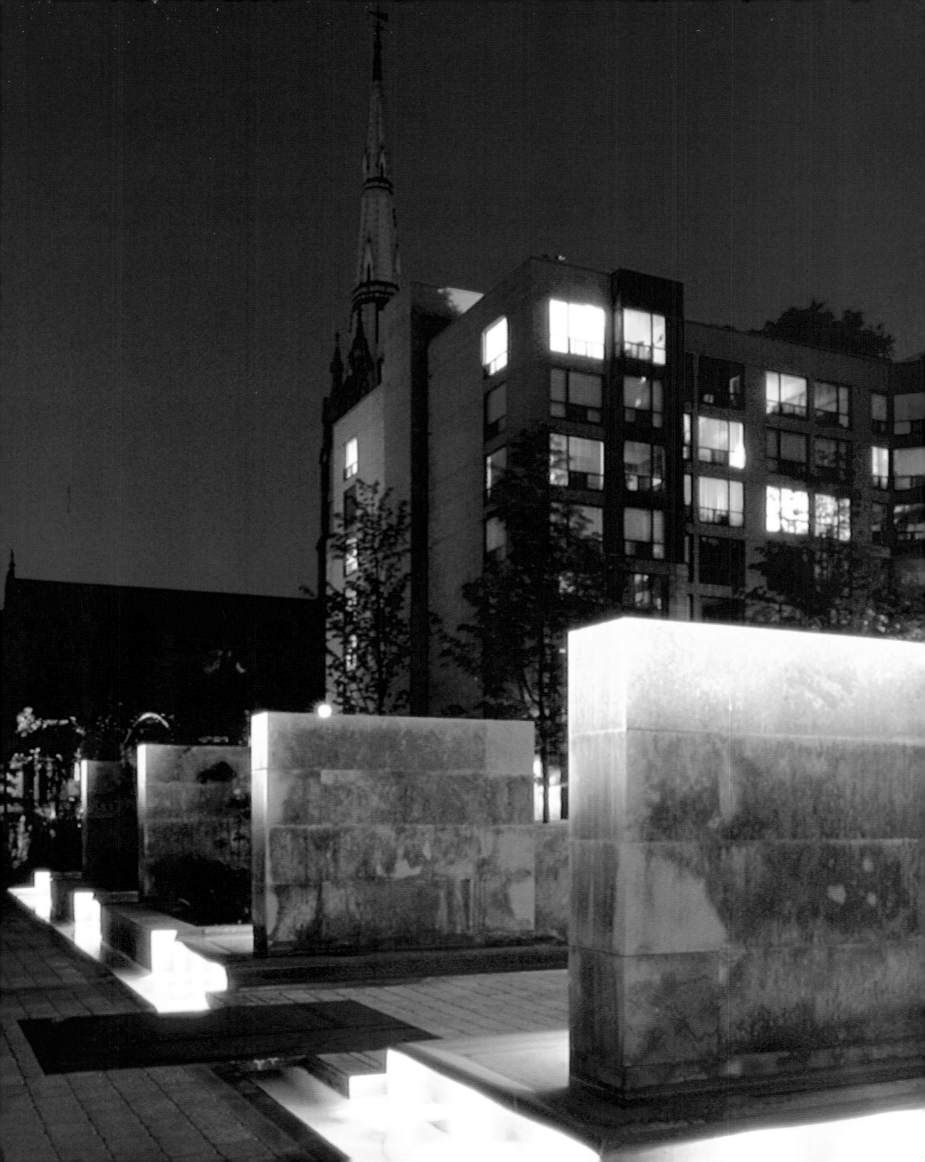

Courthouse Square, ironically, once used as a prison is now transformed into a spectacular public open space, creating a sense of freedom within the heart of the city. The ornate water fountain provides a restive quality in both sound and vision.

Der Platz des Gerichtshofs, ironischerweise früher ein Gefängnis, wurde in einen aufsehenerregenden öffentlichen Platz umgeformt, der ein Gefühl von Freiheit im Herzen der Stadt vermittelt. Die kunstvolle Wasserfontäne stellt ein unruhiges Element dar, sowohl hinsichtlich der Geräuschkulisse als auch des optischen Eindrucks.

Ce dernier – ironie du sort – fut utilisé comme prison. Depuis, il a été transformé en un spectaculaire espace ouvert au public qui a permis d'amener une sensation de liberté au centre urbain. Une sorte d'agitation aussi bien auditive que visuelle se dégage de la fontaine ornée.

Irónicamente, la plaza de los juzgados que fue utilizada en su día como cárcel ahora se ve transformada en un espectacular espacio abierto y público, que brinda una sensación de libertad al corazón de la ciudad. La fuente ornamental aporta un contrapunto al equilibrio del conjunto, tanto a la vista como al oído.

Per ironia della sorte, un tempo la piazza del tribunale veniva utilizzata come prigione, mentre ora è stata trasformata in uno spettacolare spazio aperto che diffonde un bellissimo senso di libertà proprio nel cuore della città. La fontana ornamentale aggiunge qualità distensive sia dal profilo visivo che auditivo.

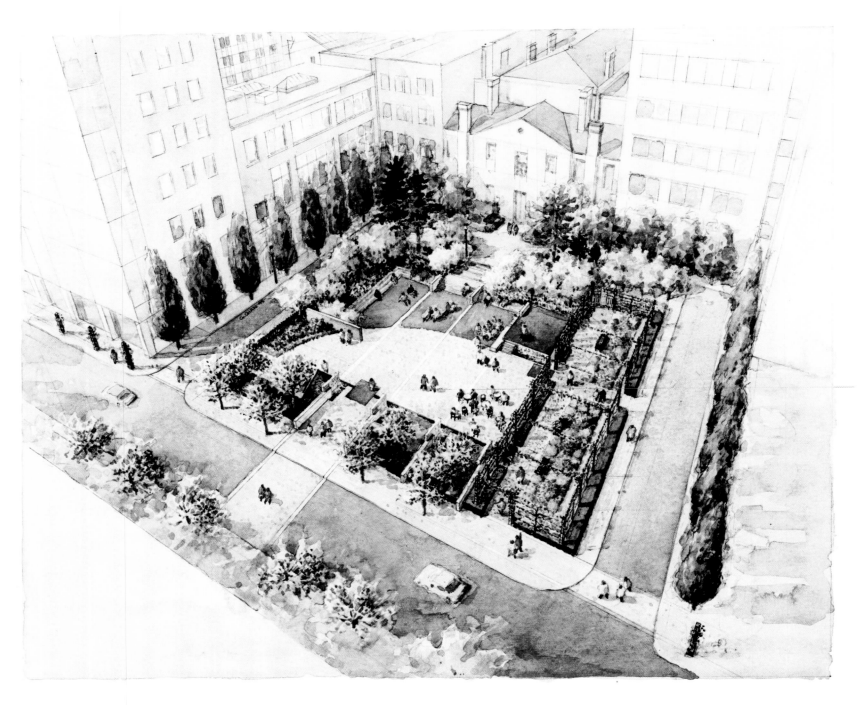

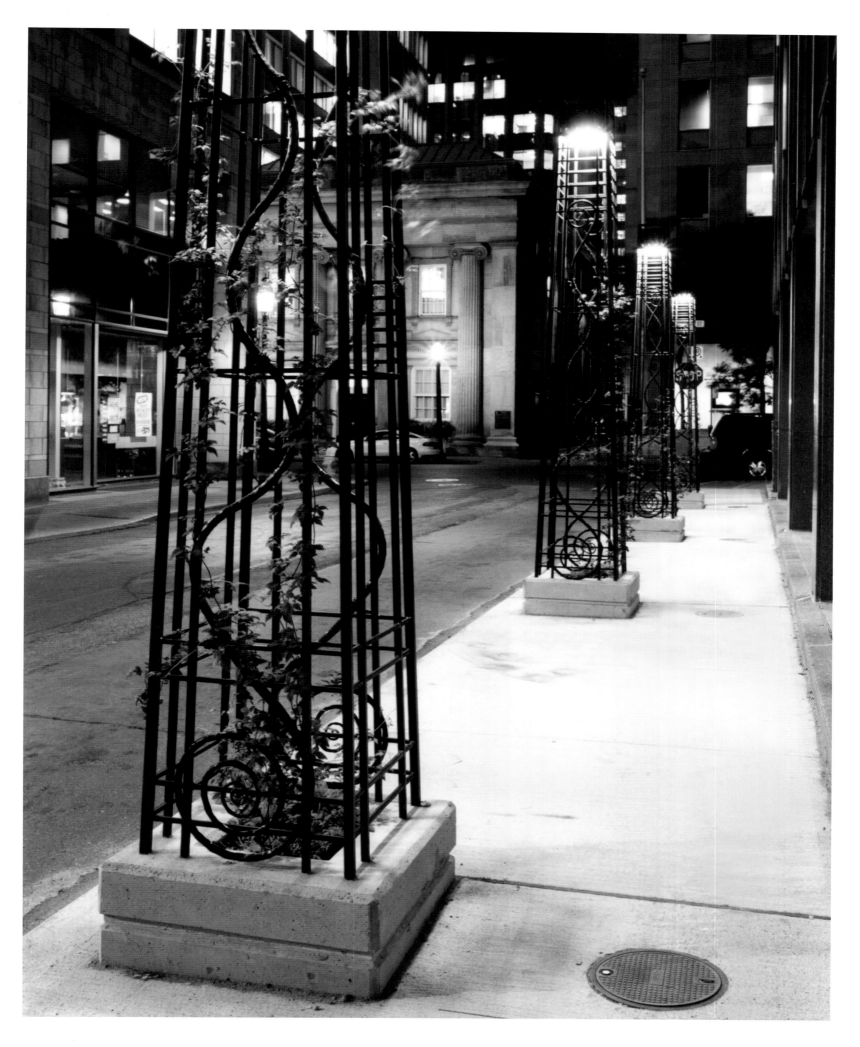

The square's margins are generously planted with Carolinian forest species, while within the square espaliered crab apple trees provide blossom in the spring.

Die Begrenzungen des Platzes sind großzügig mit Waldpflanzen aus Carolina bepflanzt, während im Frühling innerhalb des Platzes Spaliere von Johannisapfelbäumen blühen.

Des espèces d'arbres issus de la forêt Carolinienne ont été généreusement plantées sur les bords du square. Les zones intérieures présument quant à elles de pommiers sauvages florissant au printemps plantés en espalier.

En los márgenes de la plaza se ha plantado un gran número de especies americanas de hoja caduca, mientras que en el interior de la plaza florecen en primavera los manzanos silvestres en espaldera.

Il perimetro della piazza è piantumato con abbondanti specie tipiche della vicina Carolina foresta mentre, all'interno della piazza, alberi di melo selvatico donano colorate fioriture primaverili.

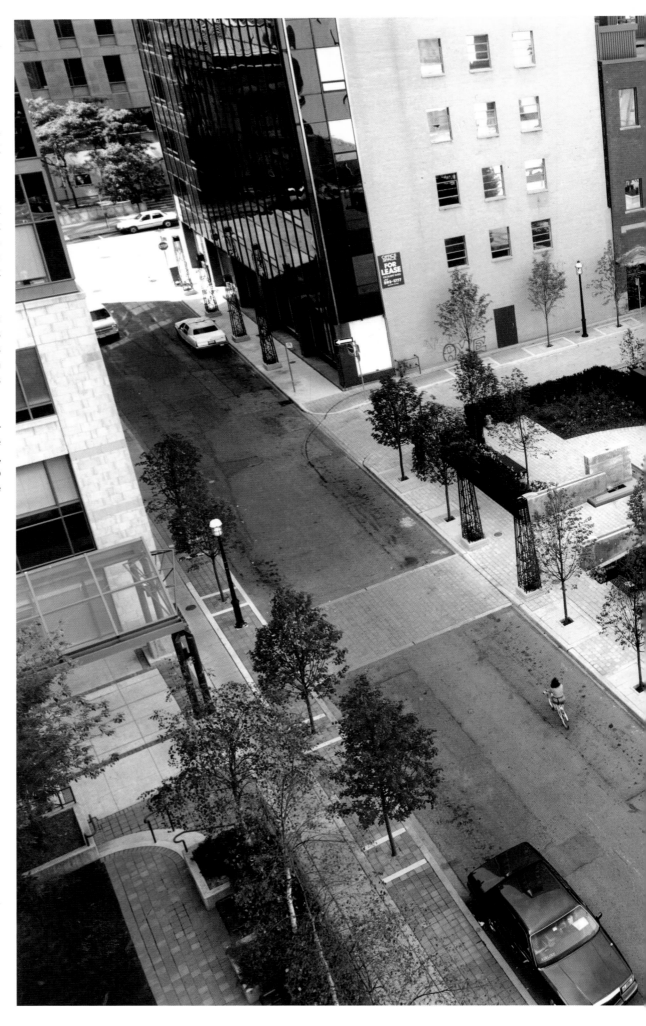

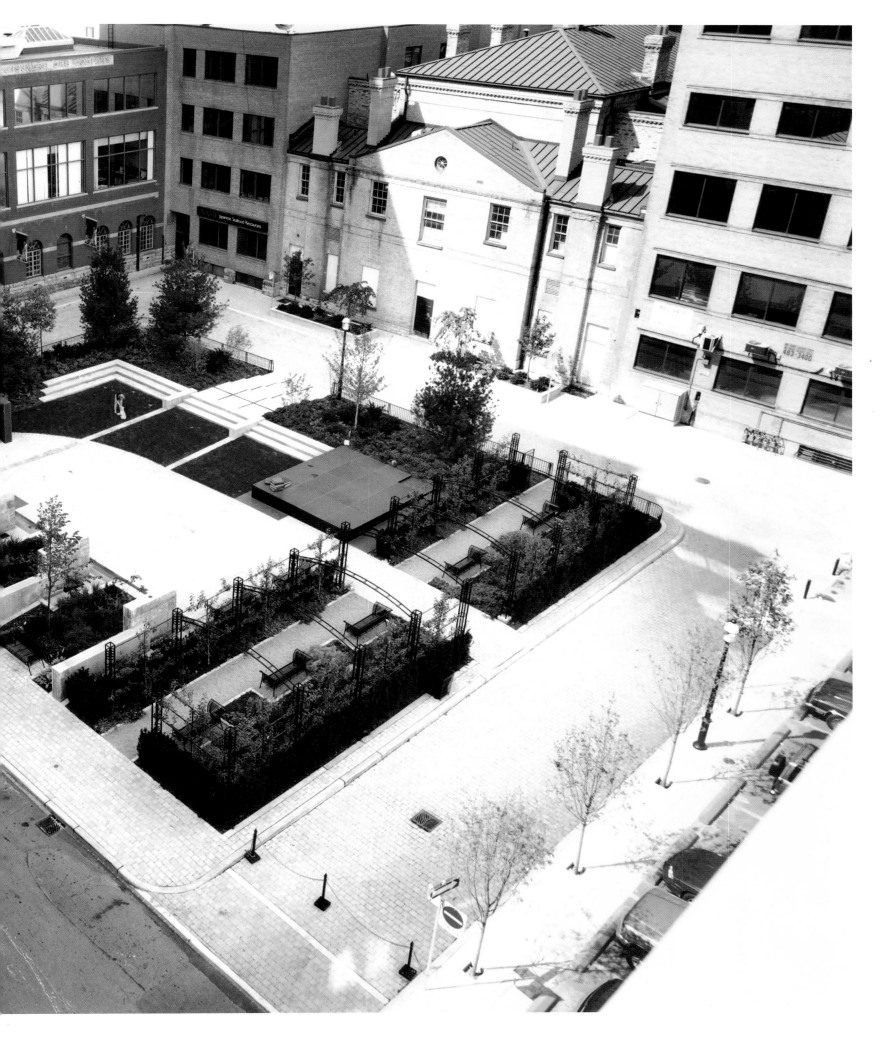

Federation Square

Melbourne, Australia

The project incorporates a new civic plaza with cultural and commercial buildings in a Melbourne city precinct covering 8.9 acres. Facilities totaling 474,000 square feet include the National Gallery of Victoria, the Australian Centre for the Moving Image, broadcast media studios and numerous restaurants and cafés. The 35,000-square-feet atrium is a passively cooled covered public space of forecourts and streets designed to compliment the stunning 81,000-square-feet open plaza. This outdoor amphitheater can accommodate up to 35,000 people for major public events such as New Year celebrations.

Das Projekt umfasst einen neuen städtischen Platz mit Gebäuden für Kultur und Kommerz in einem Stadtbezirk von Melbourne, der sich über 3,6 Hektar erstreckt. Zu den baulichen Anlagen von insgesamt 44.000 Quadratmetern gehören die Nationalgalerie von Victoria, das australische Filmzentrum, Rundfunk- und Medienstudios sowie zahlreiche Restaurants und Cafés. Das 3.250 Quadratmeter große Atrium ist ein passiv gekühlter, überdachter öffentlicher Bereich von Vorplätzen und Straßen, die gestaltet wurden, um die 7.500 Quadratmeter große, offene Piazza zu ergänzen. Dieses Freiluftamphitheater kann bei wichtigen öffentlichen Veranstaltungen, wie zum Beispiel Neujahrsfeiern, bis zu 35.000 Menschen aufnehmen.

Le projet comprend une nouvelle place municipale composée de bâtiments culturels et commerciaux faisant partie d'une zone de Melbourne s'étendant sur 3,6 hectares. Les aménagements, répartis sur une surface de 44.000 mètres carrés, incluent la National Gallery of Victoria, l'Australian Centre for the Moving Image, des studios de diffusion média et de nombreux restaurants et cafés. L'atrium de 3.250 mètres carrés est un espace public couvert et refroidi passivement. Composé d'avant-cours et de rues, il est conçu pour s'intégrer au cœur de l'extraordinaire place ouverte de 7.500 mètres carrés. Cet amphithéâtre extérieur peut, pour les besoins d'évènements majeurs tels les célébrations du Nouvel An, accueillir jusqu'à 35.000 personnes.

El proyecto incorpora un nuevo centro urbano de reunión con edificios comerciales y culturales y está situado en una zona del centro de Melbourne con una extensión de 3,6 hectáreas. Los edificios, que suman una superficie de 44.000 metros cuadrados, incluyen la National Gallery of Victoria, el Australian Centre for the Moving Image, estudios de transmisión de medios de comunicación y un buen número de restaurantes y cafés. El atrio de 3.250 metros cuadrados es un espacio público cubierto de patios y calles dotado de refrigeración pasiva y diseñado para complementar la impresionante plaza abierta de 7.500 metros cuadrados. Este anfiteatro exterior puede albergar hasta 35.000 personas en el caso de grandes actos públicos, como las celebraciones de Año Nuevo.

Federation Square incorpora il progetto di nuova piazza cittadina alla costruzione di attività culturali e commerciali in un distretto della città di Melbourne vasto circa 3,6 ettari. 44.000 metri quadrati di terreno dedicati a strutture come la National Gallery of Victoria, l'Australian Centre for the Moving Image e gli studi televisivi, più numerosi ristoranti e bar. Nei 3.250 metri quadrati di atrio coperto, rinfrescato passivamente, si trovano arcate e strade progettate per dare risalto alla bellissima piazza scoperta di 7.500 metri quadrati. Questo anfiteatro a cielo aperto può ospitare fino a 35.000 persone nei principali eventi pubblici, come ad esempio i festeggiamenti del Capodanno.

2002
LAB Architecture Studios + Bates Smart
Karres en Brands
www.labarchitecture.com

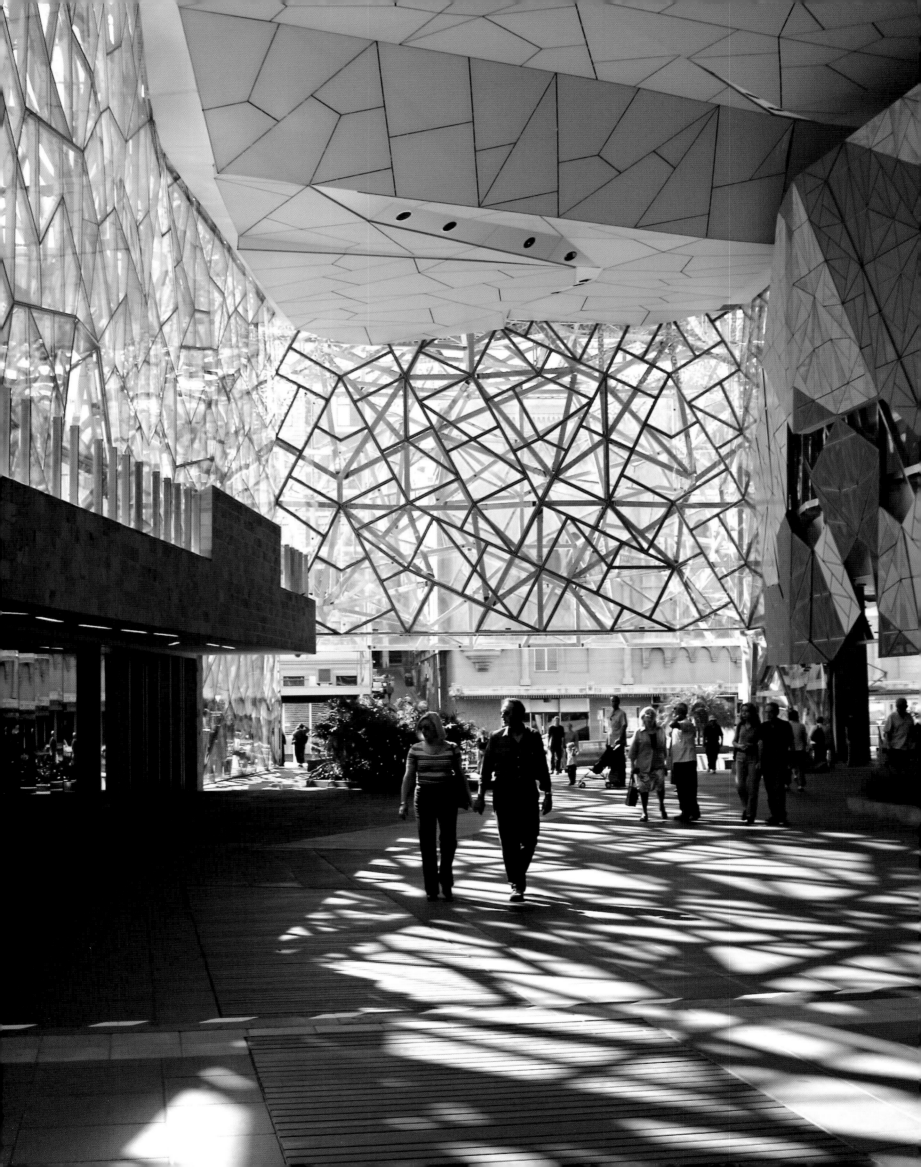

Federation Square is distinguished from the city's existing pavements by using colored Kimberley cobblestones. The variety of stone colors is arranged to form a subtly differentiating pattern across the entire plaza surface.

Der Federation Square unterscheidet sich von den vorhandenen Laufflächen der Stadt durch die Nutzung farbiger Kimberley-Pflastersteine. Die vielfältigen Farben der Steine wurden so geordnet, dass ein geschickt differenziertes Muster über die gesamte Oberfläche des Platzes entstanden ist.

Le recours aux pavés colorés de type Kimberley pour couvrir la Federation Square a permis de distinguer chaussée de celle préexistante. Les pierres aux couleurs variées sont combinées entre elles sur toute la surface de la place de manière à former un ensemble aux différences subtiles.

A diferencia del resto de los pavimentos de la ciudad, en Federation Square se han usado adoquines de piedra de Kimberley. La variedad de colores de la piedra se ha dispuesto de tal forma que dota a toda la superficie de la plaza de unas sutiles diferencias en su diseño.

Federation Square si differenzia dalla pavimentazione cittadina esistente grazie all'impiego di ciottolato colorato Kimberley. Le diverse tonalità di colore sono disposte in modo da formare raffinati disegni lungo la superficie della piazza.

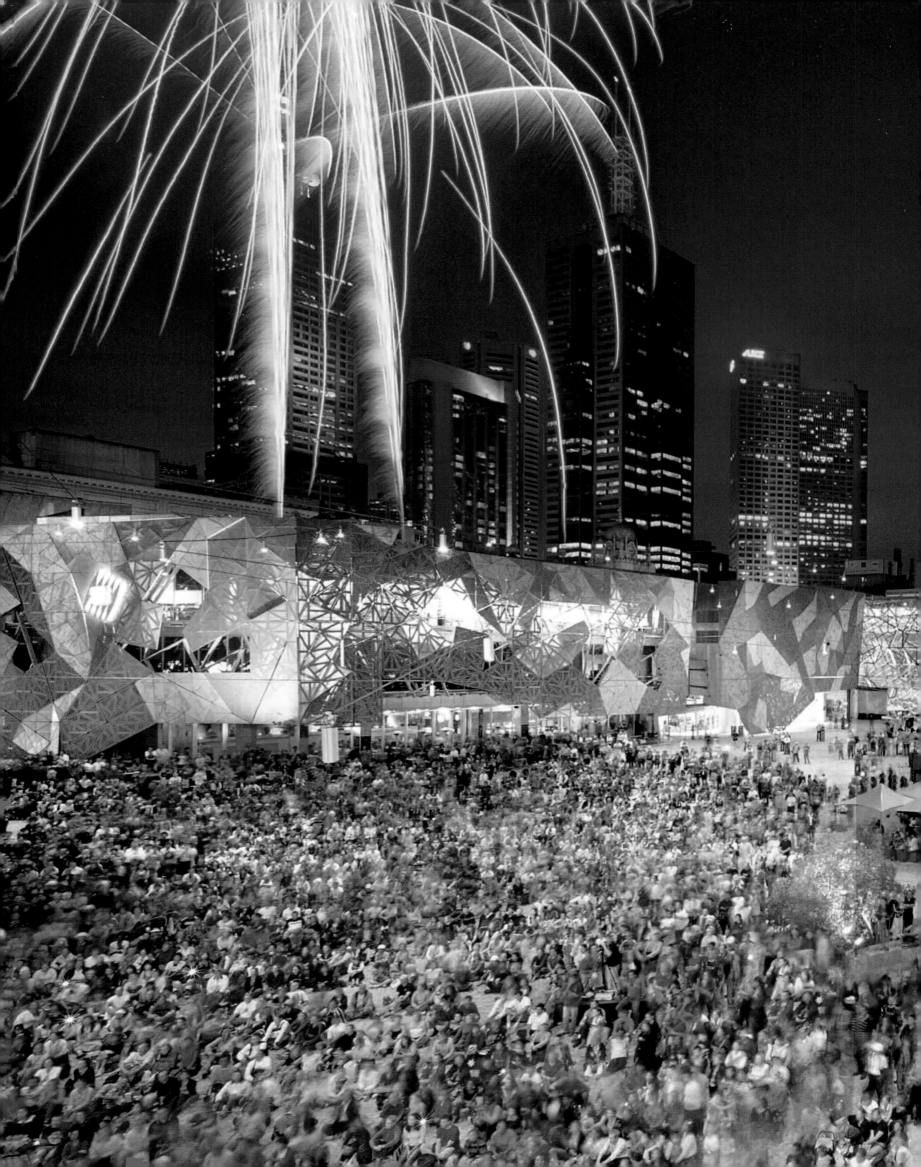

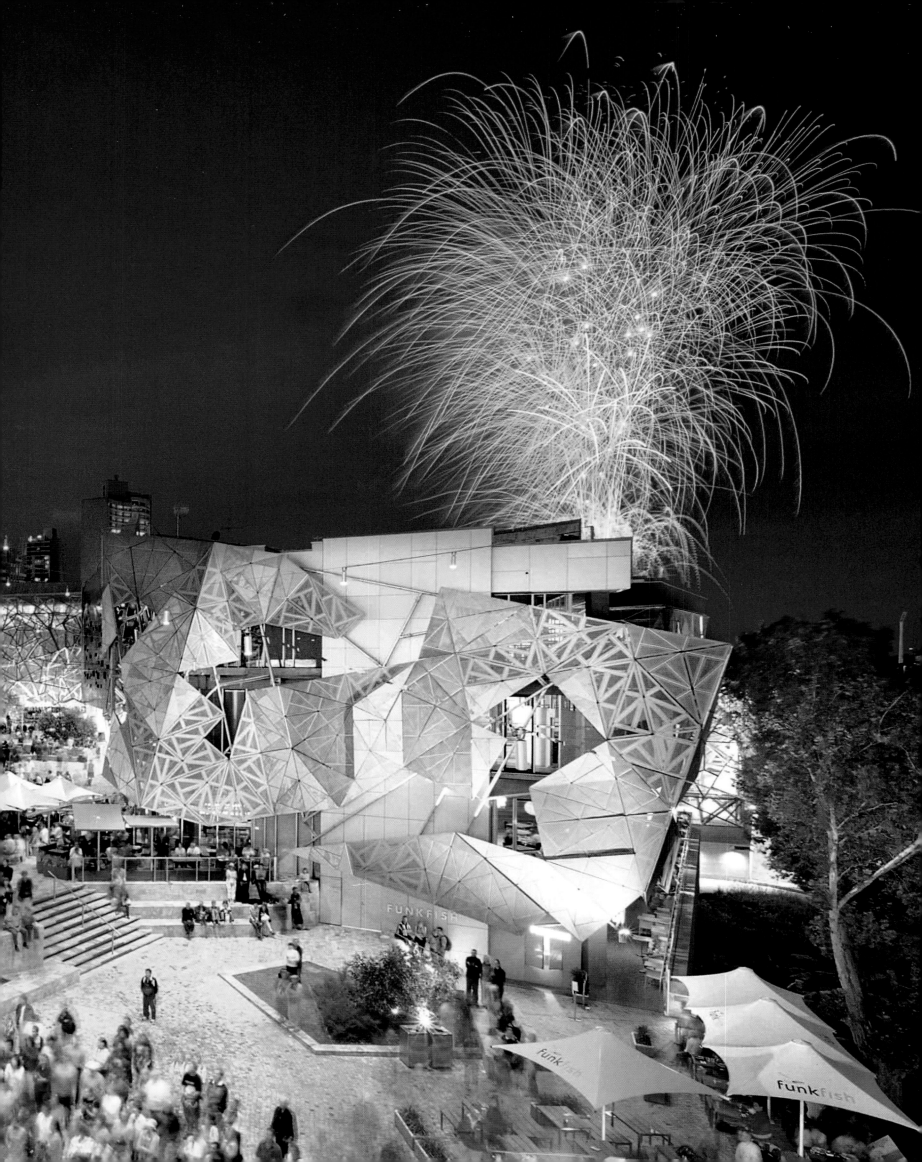

Grand Avenue Streetscape

Los Angeles, USA

The principal design concept was to transform Grand Avenue into a more welcoming pedestrian environment. By increasing the width of the sidewalks the architects have created a spacious urban garden promenade 20 to 40 feet wide. The walkways are enhanced with sporadic planting and seating areas. The new streetscape is lined with drought resistant trees and plants which are unique to Los Angeles. As a result of these improvements Grand Avenue has become the civic and cultural heart of the downtown area.

Das vorherrschende Designkonzept war, die Grand Avenue in einen einladenderen Fußgängerbereich zu verwandeln. Durch Verbreiterung der Bürgersteige haben die Architekten eine großzügige städtische Gartenpromenade mit 6 bis 12 Metern Breite geschaffen. Die Fußgängerwege wurden mit sporadischer Bepflanzung und Sitzbereichen erweitert. Das neue Straßenbild ist durch Reihen dürrebeständiger Bäume und Pflanzen geprägt, die in Los Angeles einmalig sind. Als ein Resultat dieser Erweiterungen ist die Grand Avenue zum kulturellen Zentrum der Innenstadt geworden.

Le concept principal du projet était de transformer la Grande Avenue en une zone piétonne plus accueillante. En augmentant la largeur des trottoirs, les architectes ont créé une spacieuse promenade urbaine de 6 à 12 mètres de large. Les allées ont été mises en valeur par de sporadiques espaces jardinés et de zones pour s'assoir. Le nouveau design du paysage urbain a eu recours à des allées d'arbres et de plantes résistantes à la sécheresse propres à Los Angeles. Le résultat de ces améliorations a permis de faire de la Grande Avenue le cœur civique et culturel du centre ville.

El principal concepto de diseño consistía en transformar la Grand Avenue en un entorno más acogedor para los peatones. Gracias al aumento de la anchura de las aceras, los arquitectos han creado un espacioso paseo urbano ajardinado con una anchura de 6 a 12 metros. Las aceras se han mejorado dotándolas de zonas ajardinadas y asientos aislados. El nuevo paisaje urbano está flanqueado por plantas y árboles de gran resistencia a la sequía que son endémicos de Los Ángeles. Como resultado de todas estas mejoras, la Grand Avenue se ha convertido en el corazón cultural y ciudadano del centro de la ciudad.

L'idea principale alla base del progetto di Grand Avenue era di trasformare questa zona in un'area pedonale più invitante. Aumentando l'ampiezza del marciapiede, gli architetti hanno creato una spaziosa passeggiata giardino ampia dai 6 ai 12 metri. Lungo il percorso sono state posizionate in modo sporadico piante e panchine. La nuova immagine della strada si delinea con alberi resistenti al clima secco ed esemplari di piante unici a Los Angeles. Il risultato di queste migliorie è stata la completa trasformazione di Grand Avenue nel cuore civico e culturale della città.

2003
Rios Clementi Hale Studios
www.rchstudios.com

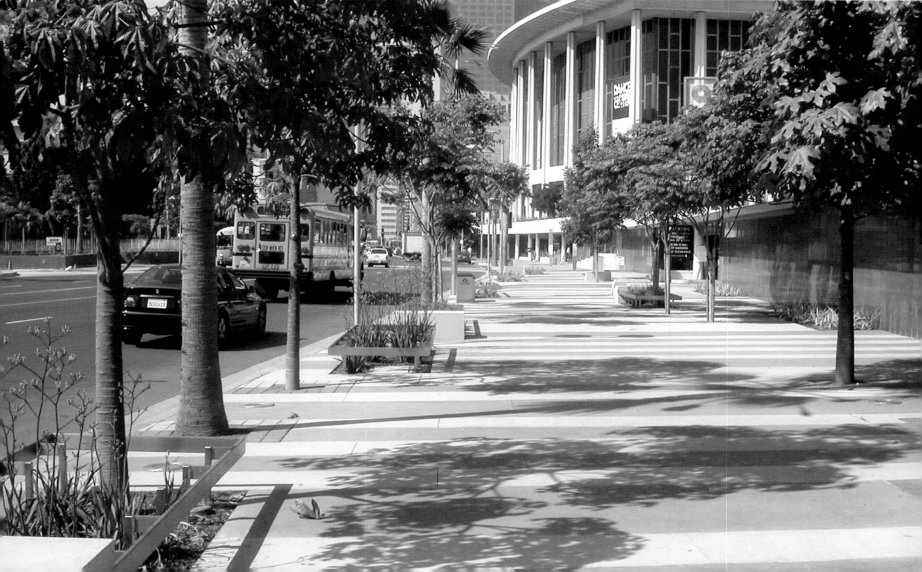

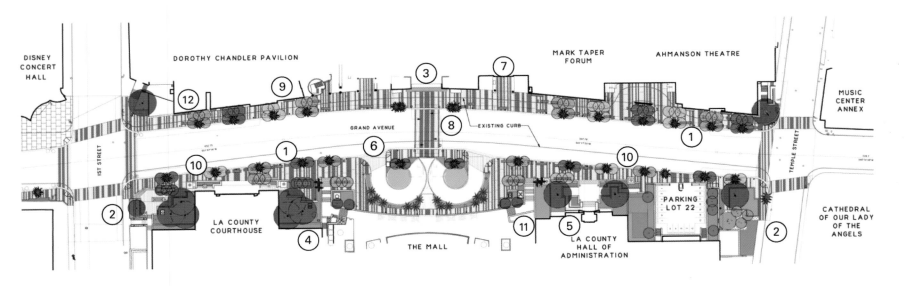

1 urban garden promenade
2 corner garden
3 widened stair
4 pocket park
5 building entry
6 new landscape at existing parking ramps
7 parking entry
8 new crosswalk
9 outdoor dining
10 bus shelter
11 new stairs and elevator
12 screened service drive

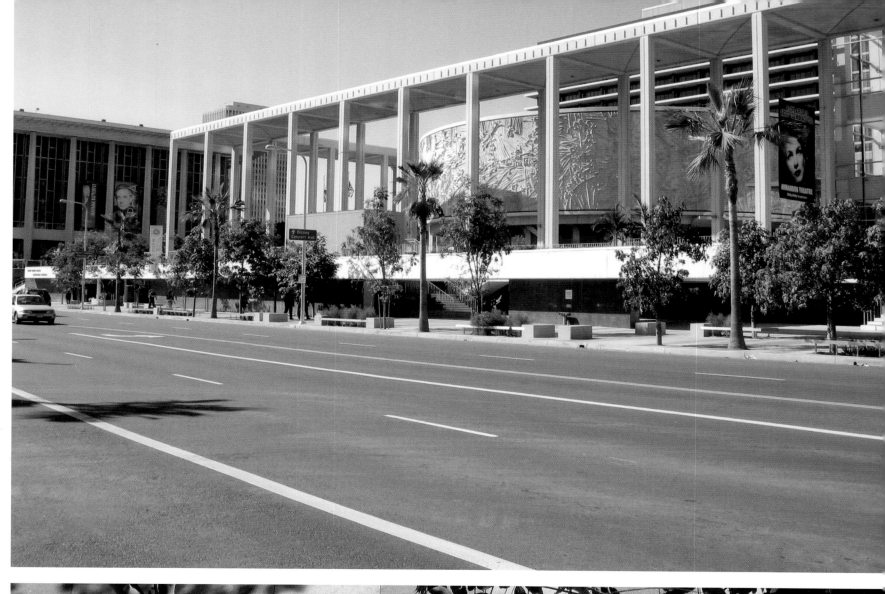

Jacaranda Square
The Everyday Stadium
Sydney, Australia

Located in Sydney's Olympic Park, this new urban open space is intended to create a vibrant, communal center for the town. The site's proximity to the former Homebush brick pit inspired the liberal use of colored and recycled brick in the grounded elements of the scheme. A large lawned central area is defined by integral perimeter walls and seating. Shade is provided naturally by trees and structurally by a colorful steel-framed canopy. Recycled water is used for irrigation, thus completing the green credentials of this sustainable scheme.

Dieser neue innerstädtische Freiraum im Olympic Park von Sydney ist darauf ausgelegt, einen lebensfrohen, gemeinsamen Fokus für die Stadt zu bieten. Die Nähe des Standorts zum ehemaligen Homebush-Ziegelwerk inspirierte zur weitläufigen Nutzung farbiger und wiederverwerteter Ziegel bei den erdverbundenen Elementen. Eine großzügige zentrale Grünfläche wird von integrierten Umfassungsmauern und Sitzgelegenheiten abgegrenzt. Bäume spenden natürlichen Schatten und eine farbenfrohe, mit Stahlrahmen verstärkte Überdachung bietet zusätzlichen Schutz vor den Elementen. Als Abrundung dieses umweltfreundlichen und zukunftsfähigen Projekts erfolgt die Bewässerung der Anlage durch rezykliertes Wasser.

Situé dans l'Olympic Park de Sydney, ce nouvel espace urbain ouvert a été conçu dans le but d'offrir à la ville un centre communautaire plein de vie. La proximité du site avec l'ancienne mine de brique d'Homebush a suscité l'utilisation généreuse de briques colorées et recyclées pour les éléments destinés, dans le projet, aux surfaces au sol. Un grand espace central couvert de pelouse est délimité par des murs d'enceinte intégraux et des sièges. L'ombre est procurée à la fois de manière naturelle par les arbres et de manière structurelle par un feuillage aux couleurs vives grimpant sur une monture d'acier. Le fait que l'eau recyclée soit utilisée pour l'irrigation est une caractéristique qui complète la qualification écologique de ce projet durable.

Situado en el Olympic Park de Sídney, este nuevo espacio urbano ha sido concebido para proporcionar un vibrante centro social a la ciudad. La proximidad del lugar a los antiguos hornos de ladrillos de Homebush ha servido de inspiración para el uso de ladrillos reciclados y coloreados en los elementos que se apoyan en el suelo del proyecto. Las paredes perimetrales y la zona de asientos definen una gran zona central dotada de césped. La sombra natural de los árboles se suma a aquella que proporciona la cubierta de vivos colores y estructura de acero. El uso de agua reciclada para el riego resume la identidad medioambiental de este proyecto sostenible.

Situato all'interno dell'Olympic Park di Sydney, questo nuovo spazio aperto urbano è stato pensato per creare un vibrante centro pubblico cittadino. La vicinanza del sito all'ex Homebush Brick Pit ha ispirato il libero uso di mattoni colorati riciclati per la pavimentazione dello schema. Un'ampia area verde centrale è circondata da un lungo perimetro in muratura che funge anche da posto a sedere. All'ombra naturale degli alberi si aggiunge quella fornita da parasole colorati in struttura d'acciaio. Inoltre, l'acqua è interamente riciclata ed utilizzata per l'irrigazione, vero e proprio tocco finale ad un quadro di autentico intervento sostenibile.

2008
ASPECT Studios Pty Ltd, McGregor Westlake
Architects, Deuce Design
www.aspect.net.au

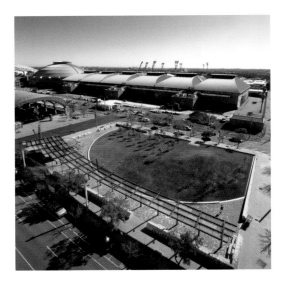

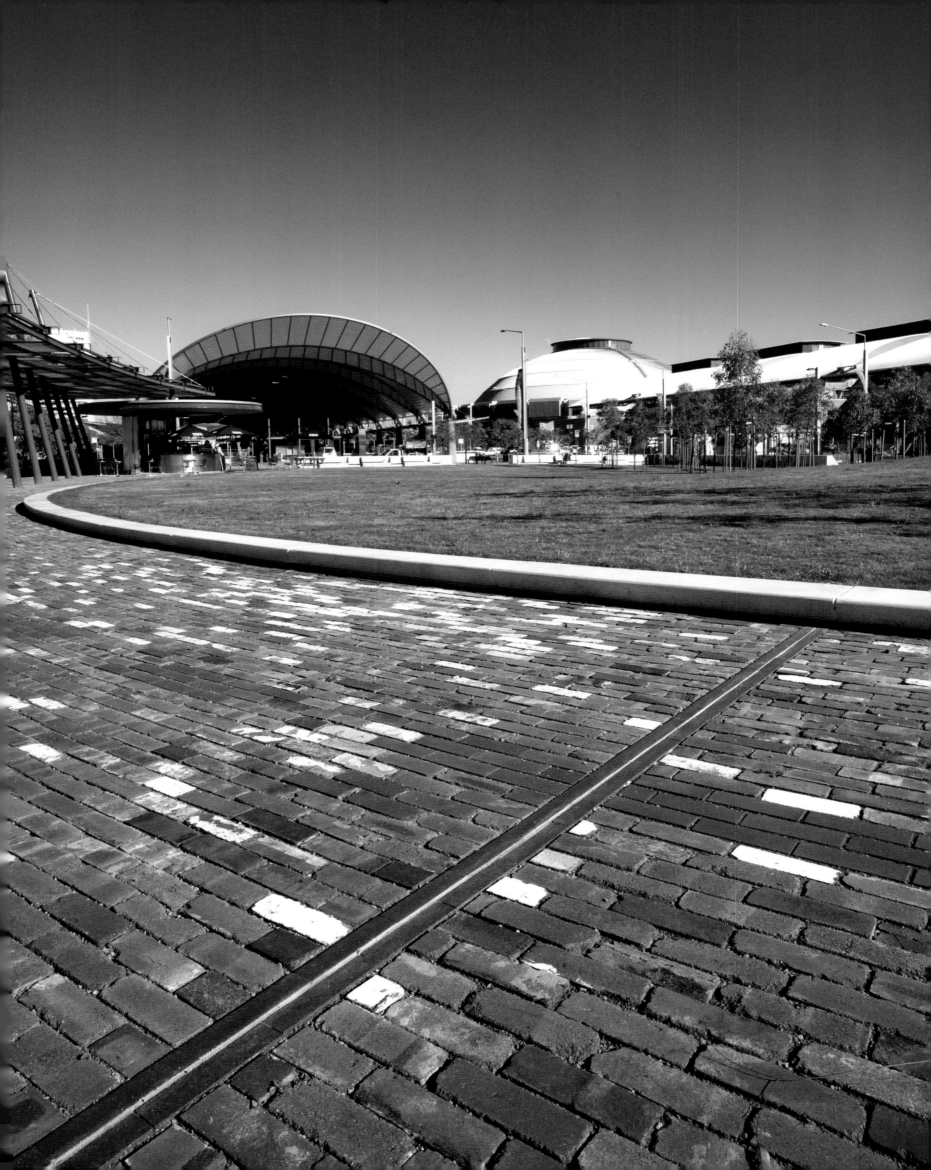

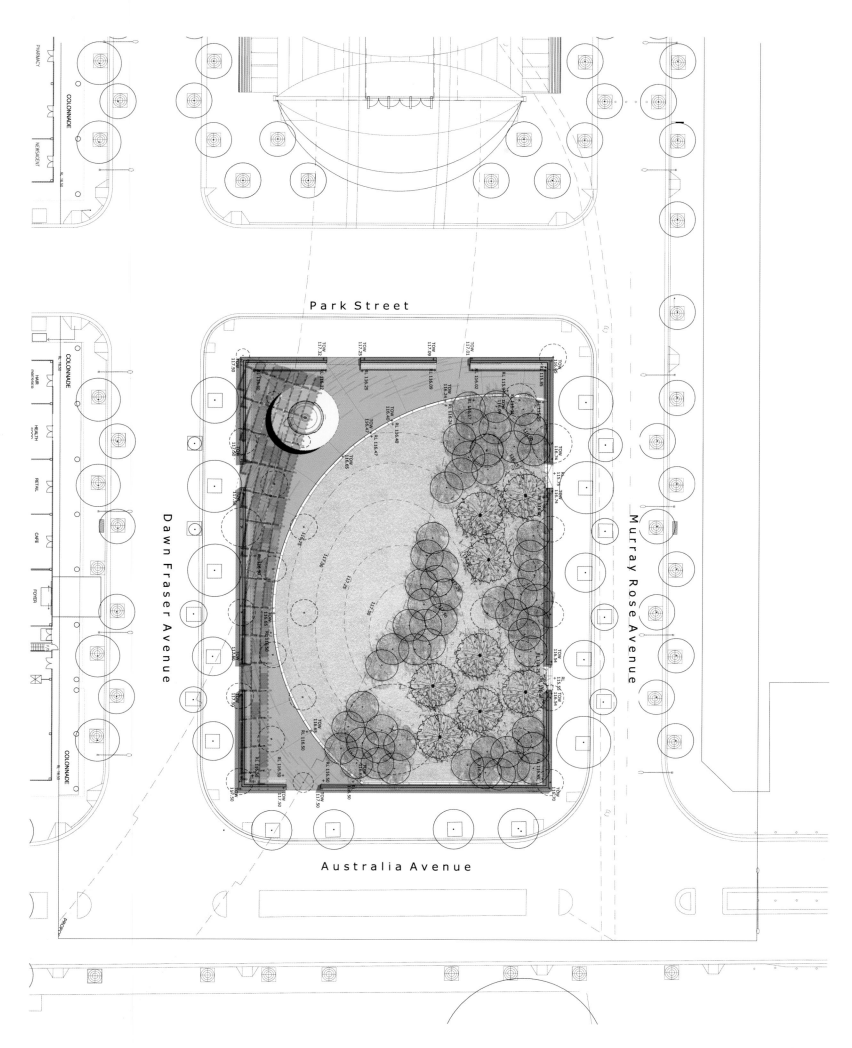

Park Street

Australia Avenue

Dawn Fraser Avenue

Murray Rose Avenue

Jacaranda Square, The Everyday Stadium | Sydney | Australia

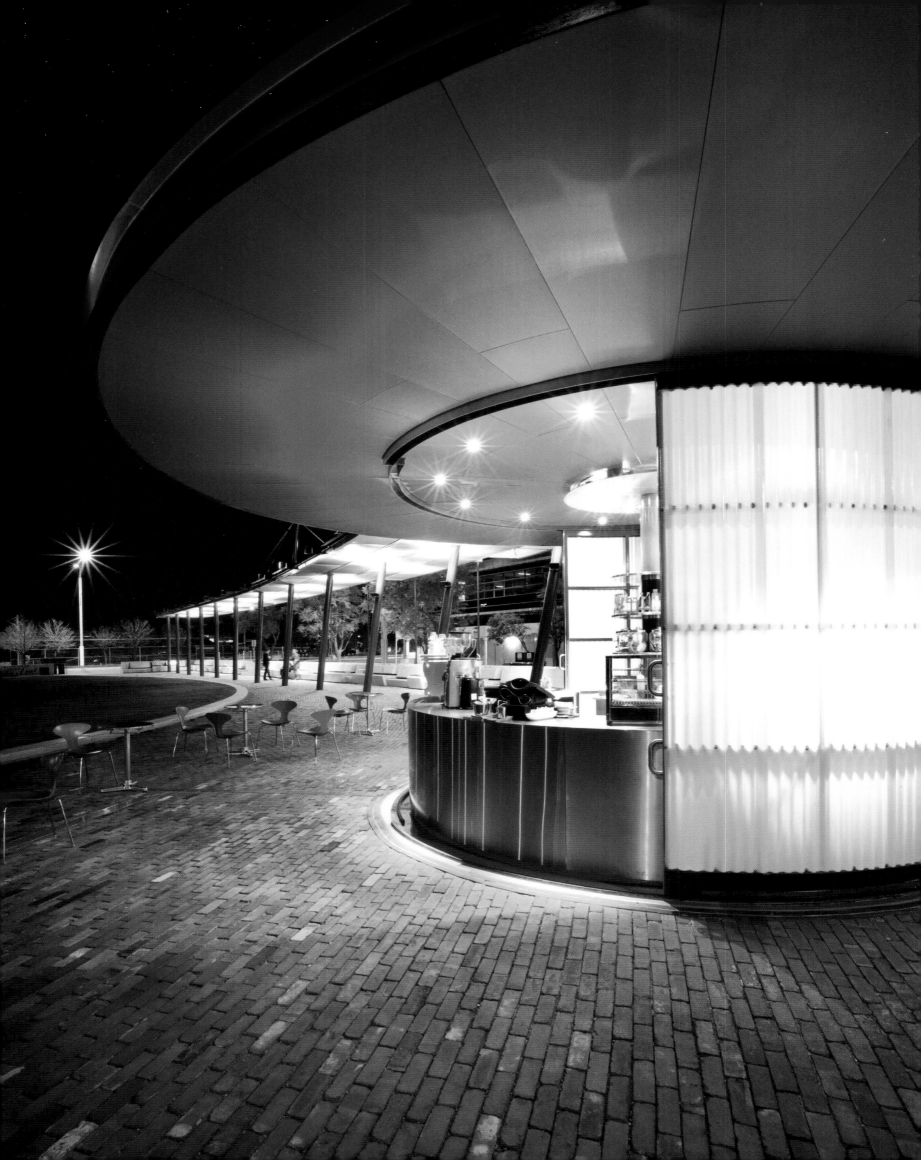

Memphis Performing Arts Center Plaza

Memphis, USA

This visually striking structure designed by New York artist Vito Acconci serves as a multi-functional canopy for the performing arts plaza in Memphis, Tennessee. The canopy's structural columns and framing are clad in "mirrored," perforated stainless steel. The funnel forms afford circular views of the sky and cast appropriately dramatic spotlights of sun onto the plaza, inviting performance in the variable space. Seating is provided in the canopy. When outside the structure the viewer is surrounded by reflections and becomes wrapped inside a room of sky.

Diese auffällige Bauskulptur des New Yorker Künstlers Vito Acconci dient als ein multifunktioneller Baldachin für den Platz der darstellenden Künste in Memphis, Tennessee. Die tragenden Stützen und das Rahmenwerk sind mit spiegelndem, perforiertem und rostfreiem Stahl verkleidet. Die Trichterform erlaubt kreisrunde Aussichten in den Himmel und wirft umgekehrt dramatische Lichtpunkte des Sonnenlichts auf die Piazza und lädt geradezu zu Performances auf dem variablen Platz ein. Unter dem Baldachin finden sich zudem Sitzgelegenheiten. Außerhalb der Bauskulptur wird der Betrachter von Reflektionen umgeben und in einen „Himmelsraum" eingewickelt.

La structure à l'aspect visuel saisissant conçue par l'artiste new-yorkais Vito Acconci sert de feuillage multifonctionnel pour que la place, mise à disposition par la ville de Memphis, Tennessee, puisse accueillir des performances artistiques. Les colonnes structurelles du feuillage et les bardages sont habillés d'acier inoxydable perforé ayant une fonction de « miroir ». La forme du tunnel procure des vues circulaire du ciel et, captant de manière appropriée le dramatisme des rayons de soleil sur la place, permet de percevoir la performance dans un espace en variation. Il est aussi possible de s'asseoir dans le feuillage. Une fois à l'extérieur de la structure, le spectateur est entouré par les reflets et se sent comme absorbé à l'intérieur d'une partie du ciel.

Esta estructura de gran atractivo visual diseñada por el artista neoyorquino Vito Acconci sirve de cubierta exterior multifuncional en la plaza del Center for the Performing Arts, en Memphis, Tennessee. Las columnas y viguería estructurales de la cubierta están recubiertas de acero inoxidable perforado y tratado como un espejo. Sus formas de embudo proporcionan imágenes circulares del cielo y arrojan unos dramáticos puntos de luz sobre la plaza, que invitan a celebrar actuaciones en un espacio tan variable. La propia cubierta ofrece también unos asientos. Si se coloca fuera de la estructura, el espectador se ve rodeado de reflejos y se ve atrapado en el interior de una prolongación del cielo.

Questa imponente struttura, progettata dall'artista newyorkese Vito Acconci, serve come cupola multifuzionale per il centro di arti creative di Memphis, Tennessee. Le colonne e i pannelli che compongono la struttura della cupola sono placcati in acciaio inossidabile perforato e "specchiato". La forma ad imbuto offre viste circolari davvero emozionanti del cielo e riflette colpi di luce verso la piazza, creando degli incredibili giochi di luce. Dei posti a sedere sono disponibili sotto la volta. Mentre attorno alla struttura lo spettatore è circondato da riflessi e viene come risucchiato in una stanza fatta solo di cielo.

2001-2003
Acconci Studios
www.acconci.com

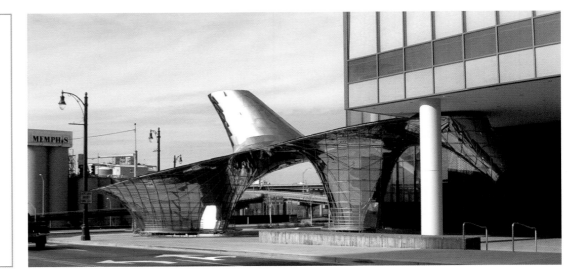

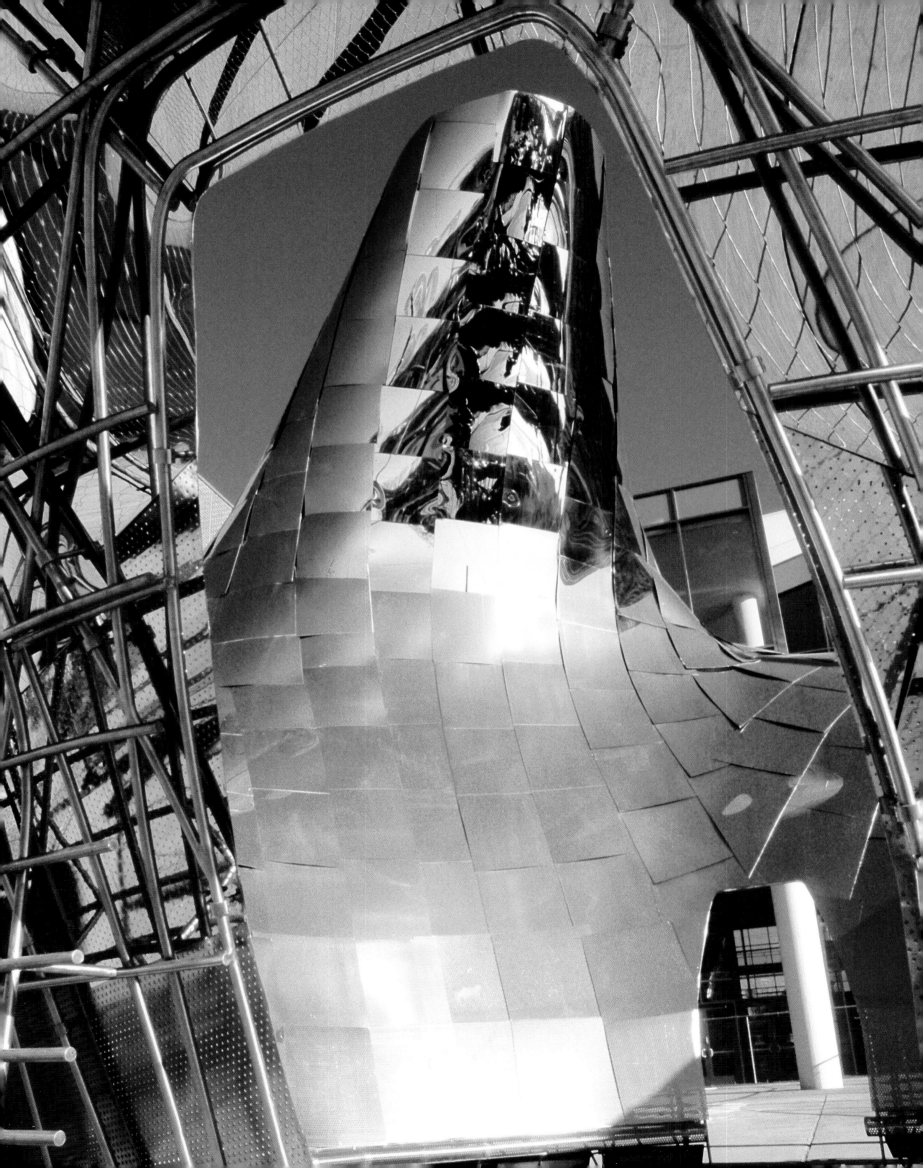

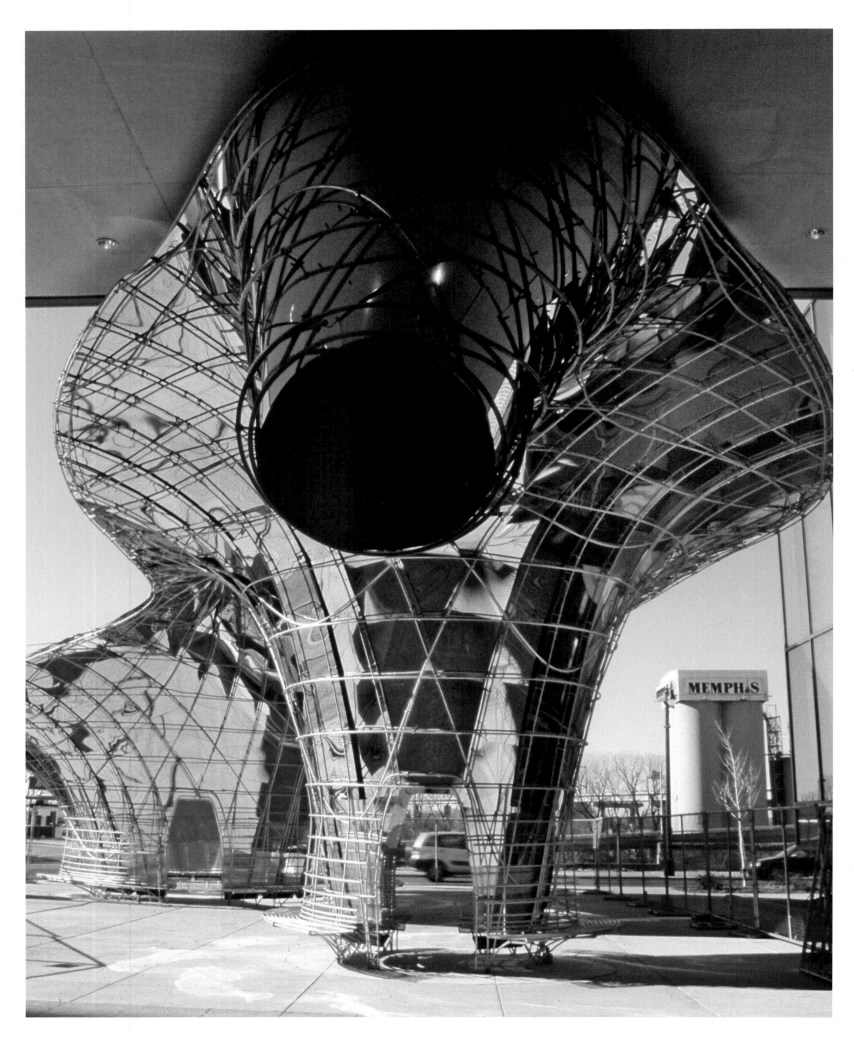

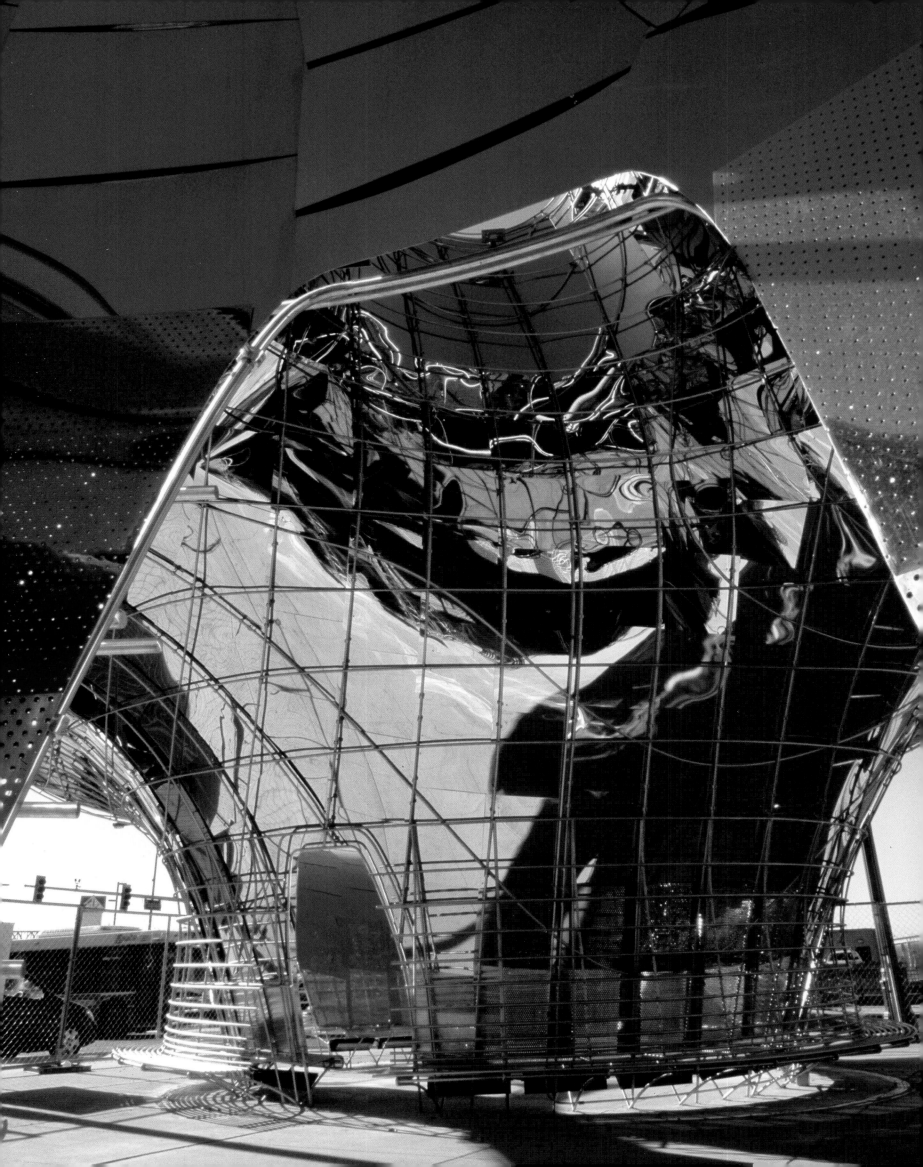

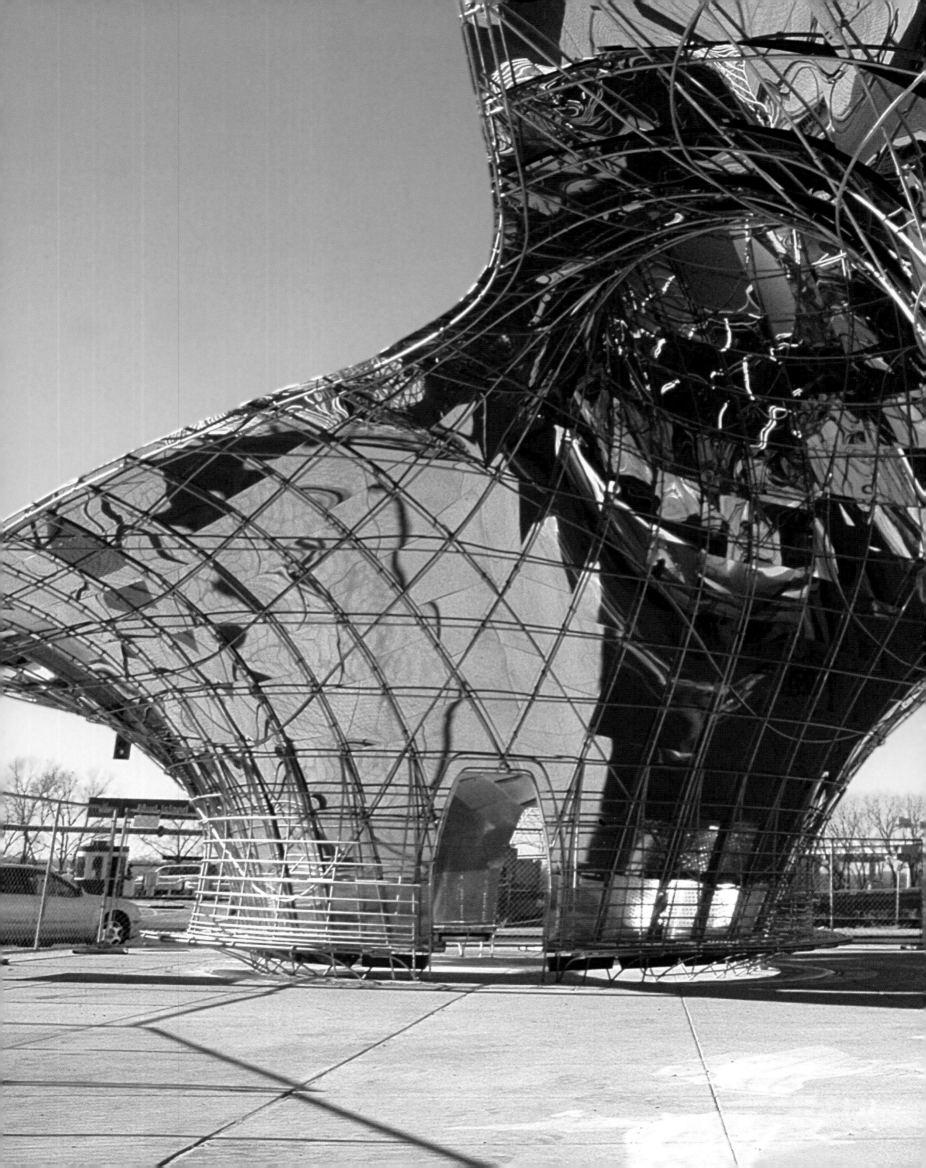

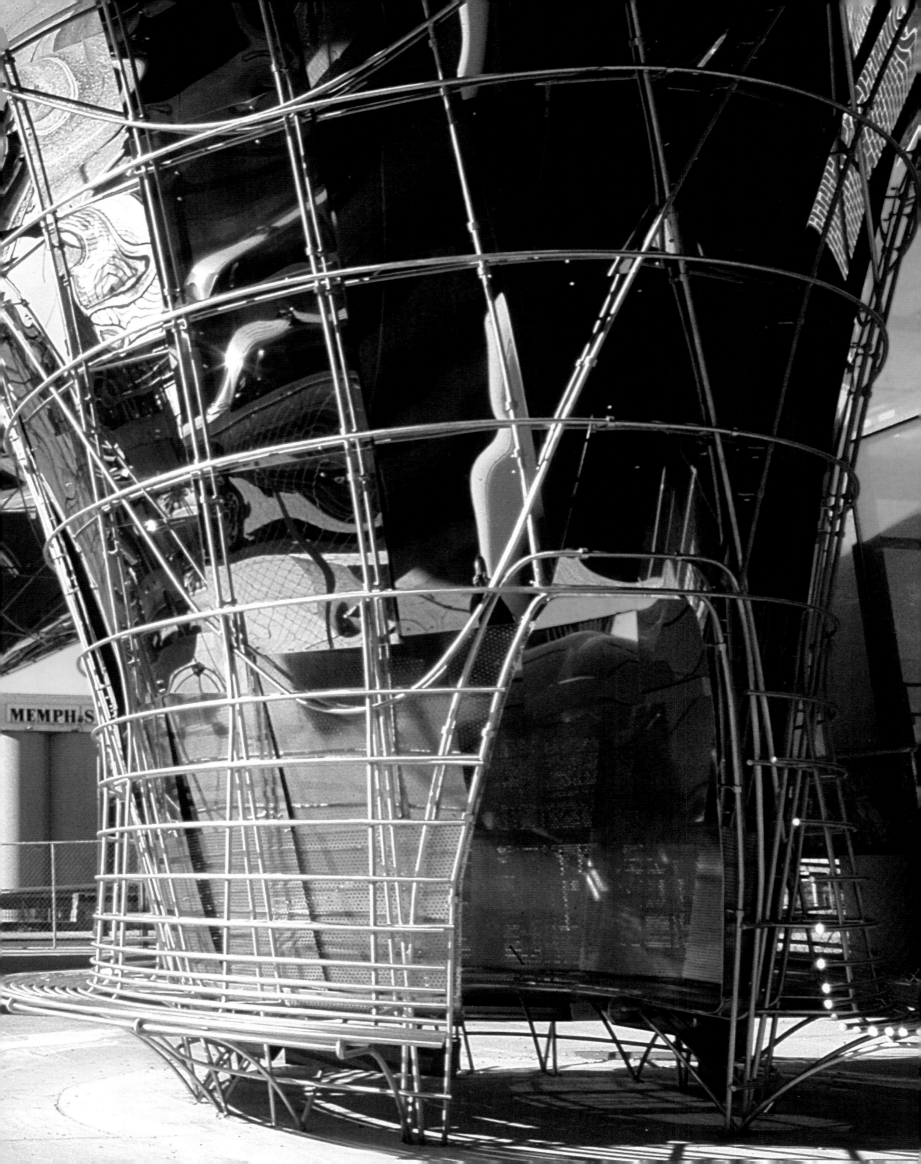

Old Market Square

Nottingham, England

The City of Nottingham Market Square has existed for over 800 years and is the second largest in the United Kingdom after Trafalgar Square. The regeneration of the 124,000-square-feet space replaced a 1929 design by T. C. Howitt. The new design by Gustafson Porter now provides unhindered access for all including those of impaired mobility. The use of high-quality paving materials, new water features, soft landscaping and integrated street furniture attracts pedestrians into the square. Greatly improved lighting encourages 24-hour use of the facilities.

Der alte Marktplatz von Nottingham besteht seit über 800 Jahren und ist im Vereinigten Königreich der zweitgrößte Platz nach dem Trafalgar Square. Die Wiederherstellung des 11.500 Quadratmeter großen Platzes ersetzte die Gestaltung von T. C. Howitt aus dem Jahre 1929. Das neue Design von Gustafson Porter erlaubt nun allen den ungehinderten Zugang, einschließlich jener mit eingeschränkter Mobilität. Die Nutzung qualitativ hochwertiger Straßenmaterialien, neuer Wasserspiele, weicher Landschaftsgestaltung und integrierter Straßenmöbel zieht Fußgänger auf den Platz. Die großzügige Beleuchtung unterstützt die Nutzung der Anlage rund um die Uhr.

La place du marché de Nottingham existe depuis à peu près 800 ans et est la plus grande du Royaume-Uni après celle de Trafalgar Square. La régénération de l'espace de 11.500 mètres carrés est venue remplacer un projet datant de 1929 mis au point à l'époque par T. C. Howitt. La nouvelle conception de la place, fruit du travail de Gustafson Porter, permet à toutes les personnes, dont celles à la mobilité réduite, d'y avoir accès sans qu'aucune entrave ne vienne les en empêcher. L'union de matériaux de pavage de grande qualité, les nouvelles installations d'eau, l'un aménagement paysager discret et le mobilier urbain intégré attirent les piétons vers la place. Une illumination notablement améliorée permet d'utiliser les installations 24h/24.

La Old Market Square de Nottingham tiene más de 800 años y es la segunda más grande del Reino Unido tras Trafalgar Square. La regeneración de este espacio de 11.500 metros cuadrados sustituye un diseño de 1929, obra de T. C. Howitt. El nuevo diseño a cargo de Gustafson Porter proporciona un acceso sin obstáculos a todas las personas, incluidas aquellas de movilidad reducida. El uso de materiales de alta calidad en los pavimentos, nuevos elementos acuáticos, plantas y mobiliario urbano integrado atraen a los peatones a la plaza, además de que la gran mejora que ha experimentado la iluminación fomenta el uso ininterrumpido de sus instalaciones.

La Old Market Square di Nottingham esiste da più 800 anni ed è la seconda piazza per grandezza del Regno Unito dopo Trafalgar Square. La rigenerazione degli 11.500 metri quadrati di spazio è andata a rimpiazzare un progetto del 1929 ad opera di T. C. Howitt. Il nuovo progetto di Gustafson Porter permette un accesso più ampio alla piazza, anche ai disabili. L'impiego di materiali di altissima qualità per la pavimentazione, di nuove strutture d'acqua, di arredi sinuosi e perfettamente integrati con il paesaggio, la rendono molto più appetibile agli occhi dei pedoni. Un incremento dell'illuminazione, inoltre, la rende fruibile 24 ore su 24.

2007
Gustafson Porter
www.gustafson-porter.com

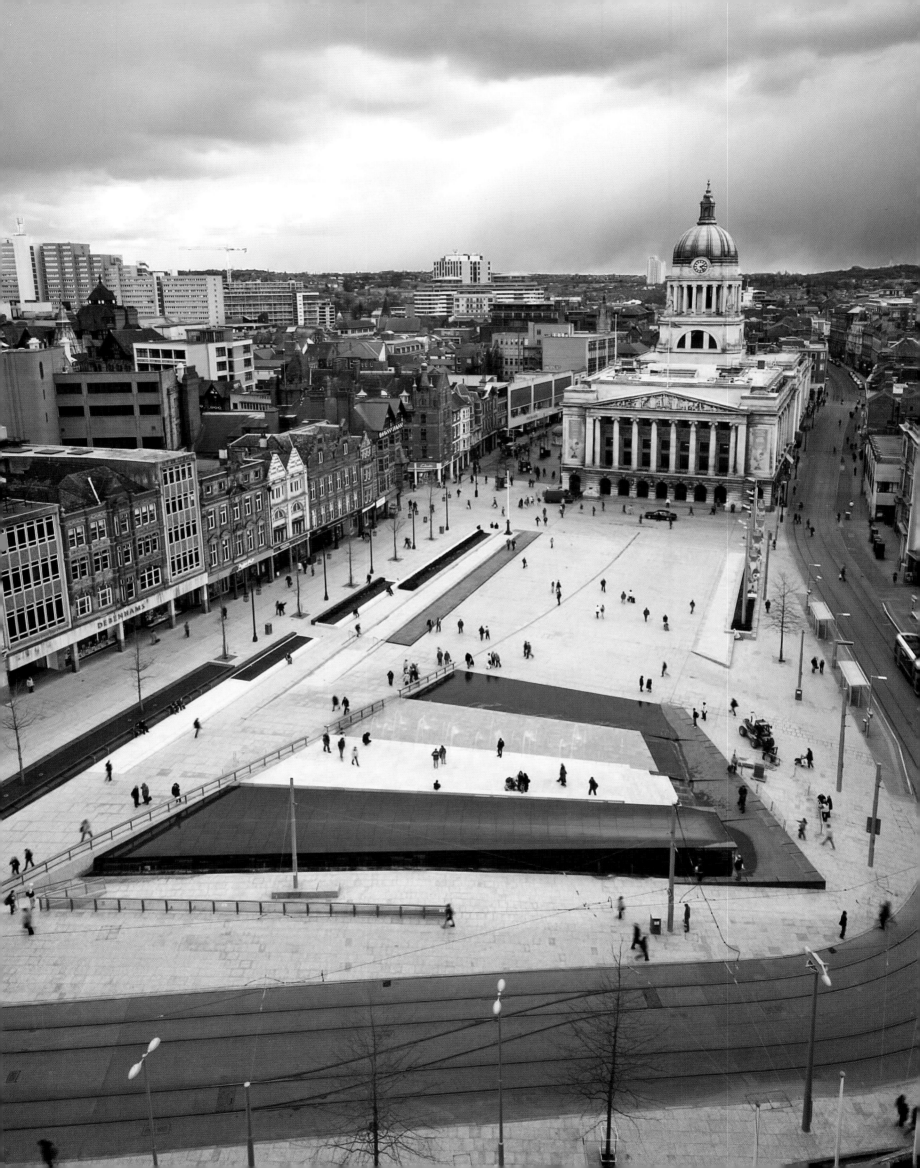

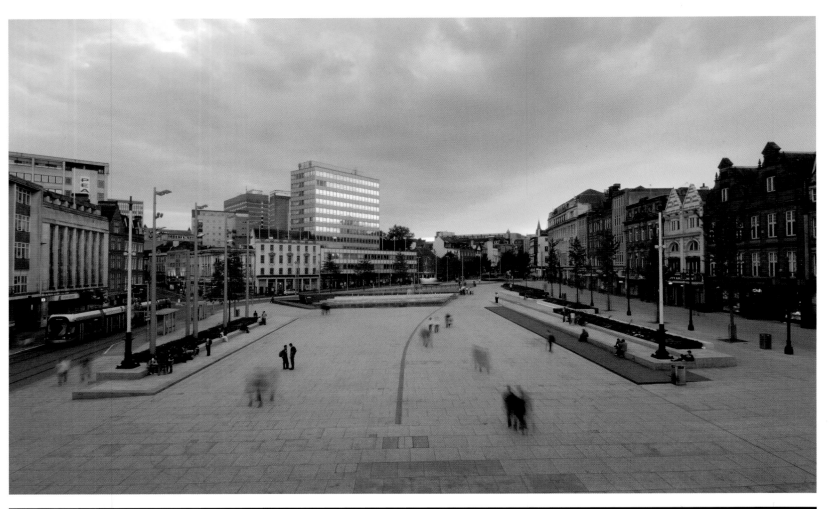

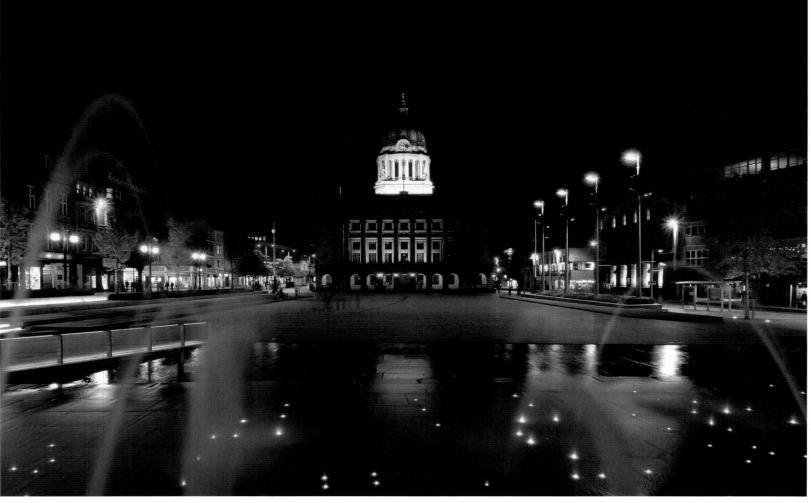

Place d'Youville
Montreal, Canada

The refurbished Place d'Youville is an important gateway to Montreal's waterfront and old port. The project's design references are the layers of archaeological data for the site. Sidewalks were constructed from a diverse palette of materials including wood, granite, limestone and concrete thus creating a walk through time. Montreal's offices, restaurants and city museum are linked by the sidewalks. The square's central path tracks the route of an ancient creek. Abundant greenery, benches and the soft lighting from adjacent buildings complete the restive atmosphere.

Der neugestaltete Place d'Youville ist ein wichtiges Tor zu Montreals Küste und dem alten Hafen. Archäologische Spuren wurden bei der Platzgestaltung berücksichtigt. Für die Bürgersteige wurden unterschiedliche Materialien gewählt, unter anderem Holz, Granit, Kalkstein und Beton, die die verschiedenen Zeitabschnitte erfahrbar machen. Montreals Büros, Restaurants und Stadtmuseen sind durch Seitenwege verbunden. Der zentrale Weg des Platzes folgt der Route eines alten Baches. Reichlich Grün, Bänke und das sanfte Licht der angrenzenden Gebäude vervollständigen die abwechslungsreiche Atmosphäre.

Située près du front d'eau et du vieux port, la place d'Youville rénovée est une porte d'entrée importante de Montréal. Les références utilisées lors de la conception du projet sont issues des couches de données archéologiques trouvées sur le site. Les trottoirs ont été construits à partir d'une palette de matériaux divers incluant le bois, le granit, le calcaire et le béton. Ils donnent ainsi l'impression d'être des chemins à travers le temps tout en permettant de relier les bureaux, restaurants et musées municipaux de Montréal. L'allée centrale de la place suit la trajectoire d'un ancien ruisseau. Une abondante verdure, la présence de bancs et le jeu de lumière discret émanant des bâtiments adjacents complètent l'ambiance se dégageant du site.

La renovada Place d'Youville es una importante puerta de acceso al frente marítimo de Montreal y al antiguo puerto. Las referencias de diseño del proyecto son los estratos arqueológicos del lugar. Las aceras se han elaborado con una gran diversidad de materiales, desde la madera y el granito a la piedra caliza y el hormigón, creando así una sensación de viaje en el tiempo. Esas aceras comunican las oficinas, restaurantes y el museo de la ciudad de Montreal. El camino situado en el centro de la plaza sigue el recorrido de un antiguo arroyo. Completan la relajante atmósfera de la plaza una abundante vegetación, bancos y la suave iluminación procedente de los edificios adyacentes.

La rinnovata Place d'Youville rappresenta un punto d'accesso molto importante verso il litorale di Montreal e il vecchio porto. Il progetto si richiama agli strati archeologici del luogo. I marciapiedi sono stati costruiti utilizzando diversi materiali come legno, granito, calcare e cemento per dare il senso di una passeggiata nel tempo. A Montreal, uffici, ristoranti e Il museo cittadino sono tutti collegati dai marciapiedi. Il sentiero centrale della piazza segna il percorso di un vecchio torrente. L'abbondanza di zone verdeggianti, di panchine e le luci soffuse provenienti dai vicini edifici, completano quest'atmosfera rilassante.

2002
Claude Cormier Architectes Paysagistes
www.claudecormier.com

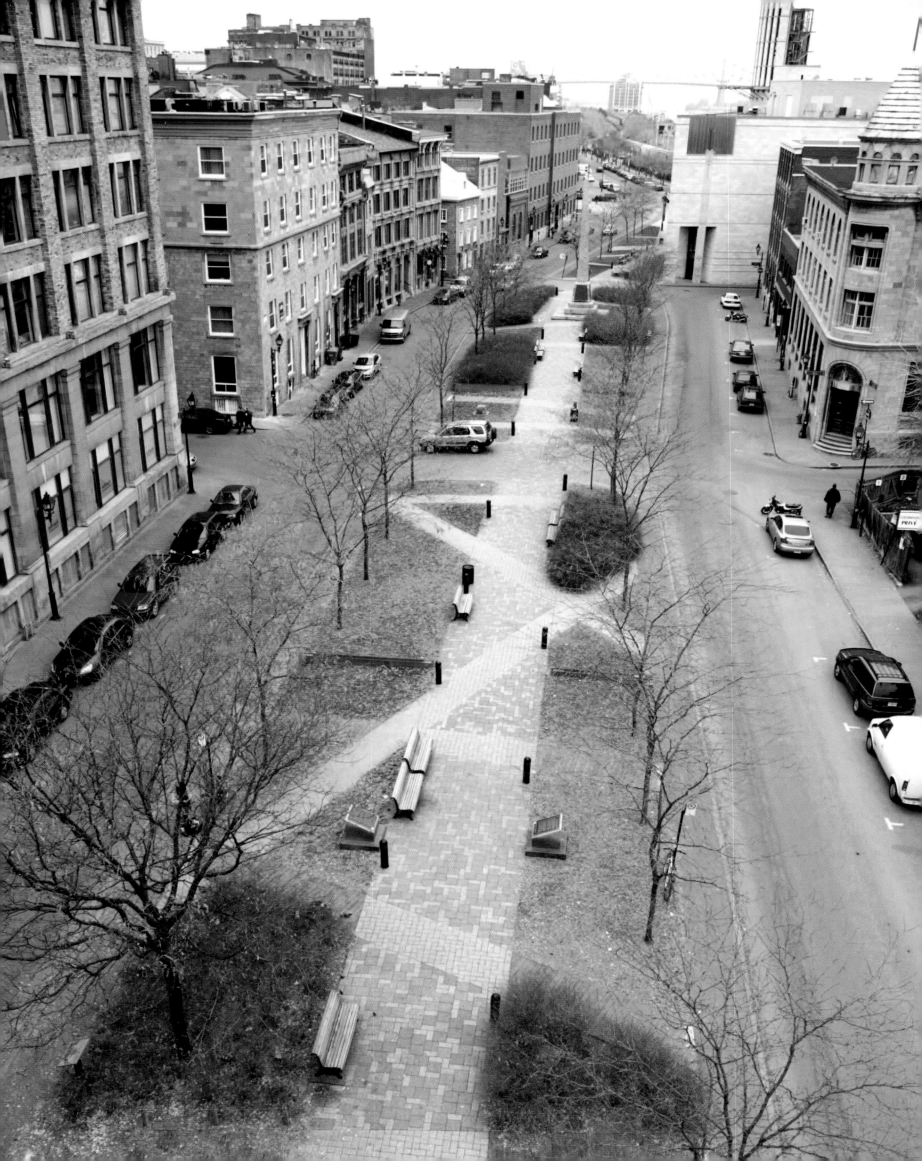

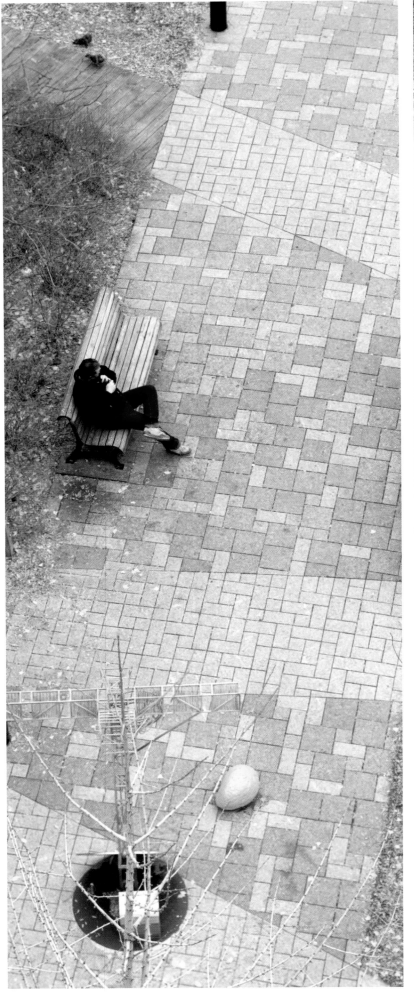

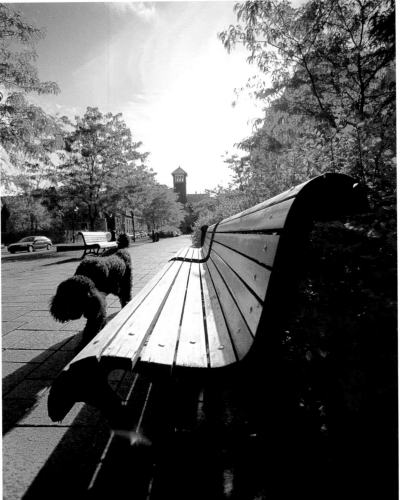

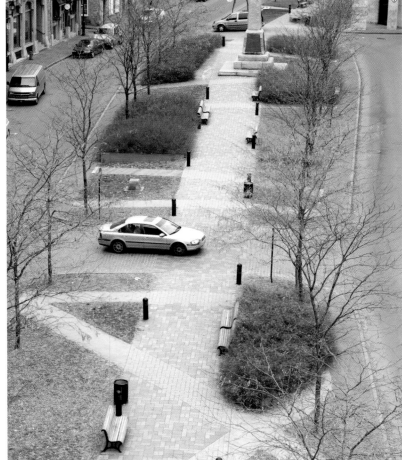

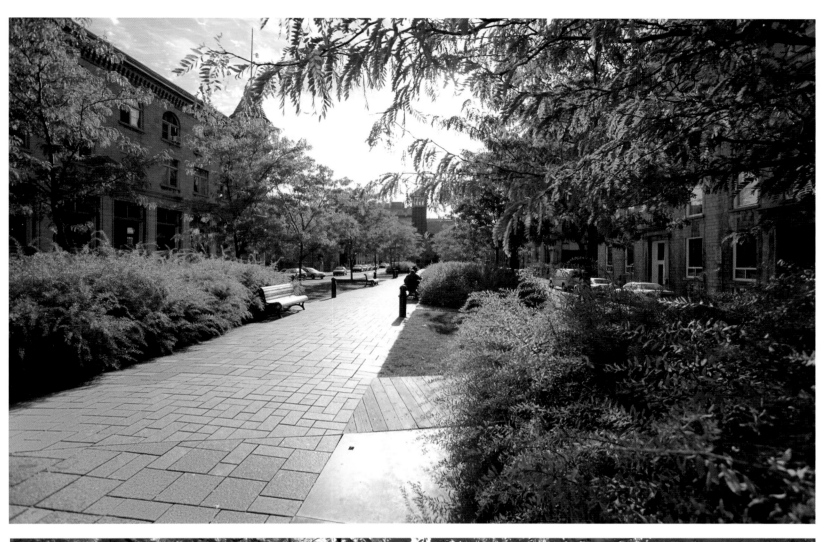

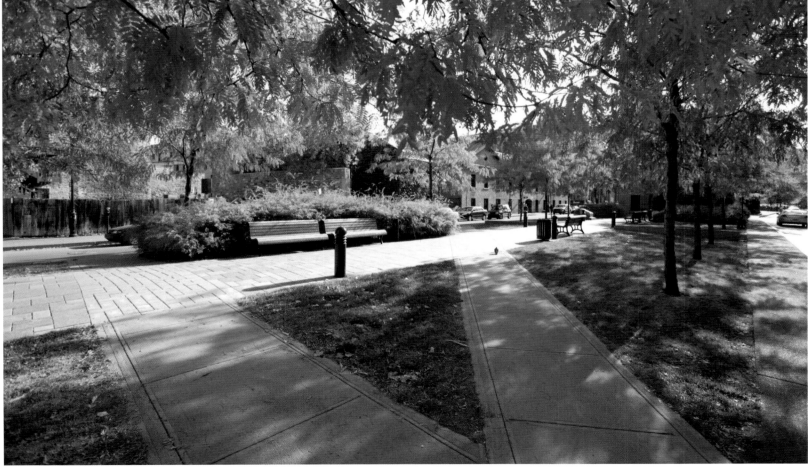

Theater Square

Nordhorn, Germany

Nordhorn concert and theater square was re-designed to form a plaza where theater-goers can meet up before and after performances. To enhance the theater's impressive natural stone facade, the designers used a single element concrete paving material for the new plaza. Existing trees were re-sited into square enclosures framed on one side by monolithic concrete elements which can be used as seating. At nightfall these monoliths appear to float as they are illuminated by hidden neon lamps located behind perforated metal covers.

Der Konzert- und Theaterplatz von Nordhorn wurde umgestaltet in einen Platz, auf dem sich Theatergänger vor und nach Vorführungen treffen können. Zur Betonung der beeindruckenden Steinfassade des Theaters nutzten die Designer als einziges Element Betonstraßenbelag für den gesamten neuen Platz. Bereits vorhandene Bäume wurden in viereckige Einfriedungen umgesetzt, die an einer Seite durch monolithische Betonelemente abgegrenzt werden, die auch als Sitzgelegenheiten genutzt werden können. Beim Dunkelwerden scheinen diese Monolithen zu schweben, da sie durch versteckte Neonlampen beleuchtet werden, die sich hinter perforierten Metallabdeckungen befinden.

La place de concert et de théâtre de Nordhorn a été reconçue dans le but de former un espace où les spectateurs puissent se rencontrer avant et après les spectacles. Afin de mettre en valeur l'impressionnante façade en pierre naturelle de la nouvelle place, les concepteurs ont eu recours à un élément unique composé d'un matériau de dallage en béton. Les arbres existants ont été replantés dans les enceintes du parc, encadré sur un côté par des éléments monolithiques en béton qui peuvent être utilisés pour s'assoir. Une fois la nuit tombée, les lampes à néons dissimulées derrière des plaques de métal perforées émettent une lumière qui donne l'impression que les monolithes flottent dans l'espace.

La plaza de teatro y conciertos de Nordhorn fue rediseñada para formar una plaza donde los asistentes al teatro pudieran reunirse antes y después de las actuaciones. Para potenciar la impresionante fachada de piedra natural del teatro, los diseñadores utilizaron el mismo material de hormigón para pavimentar toda la nueva plaza. Los árboles existentes fueron reubicados en alcorques cuadrados enmarcados en uno de sus lados por elementos monolíticos de hormigón que pueden utilizarse como asientos. De noche estos monolitos parecen flotar cuando los iluminan unas lámparas ocultas de neón situadas tras cubiertas de metal perforadas.

La piazza per concerti e spettacoli teatrali di Nordhorn fu ridisegnata per creare uno spazio in cui gli amanti del teatro potessero incontrarsi prima e dopo gli spettacoli. Per dare risalto all'incredibile facciata in pietra naturale, gli architetti hanno utilizzato una pavimentazione in cemento. Gli alberi presenti sono stati ricollocati all'interno della piazza, accostati, da un lato, da elementi in cemento che fungono da panchine. A notte fonda questi monoliti sembrano fluttuare mentre sono illuminati dalle lampade al neon situate dietro a maschere in metallo perforato.

2007
hutterreimann + cejka
Landschaftsarchitektur
www.hr-c.net

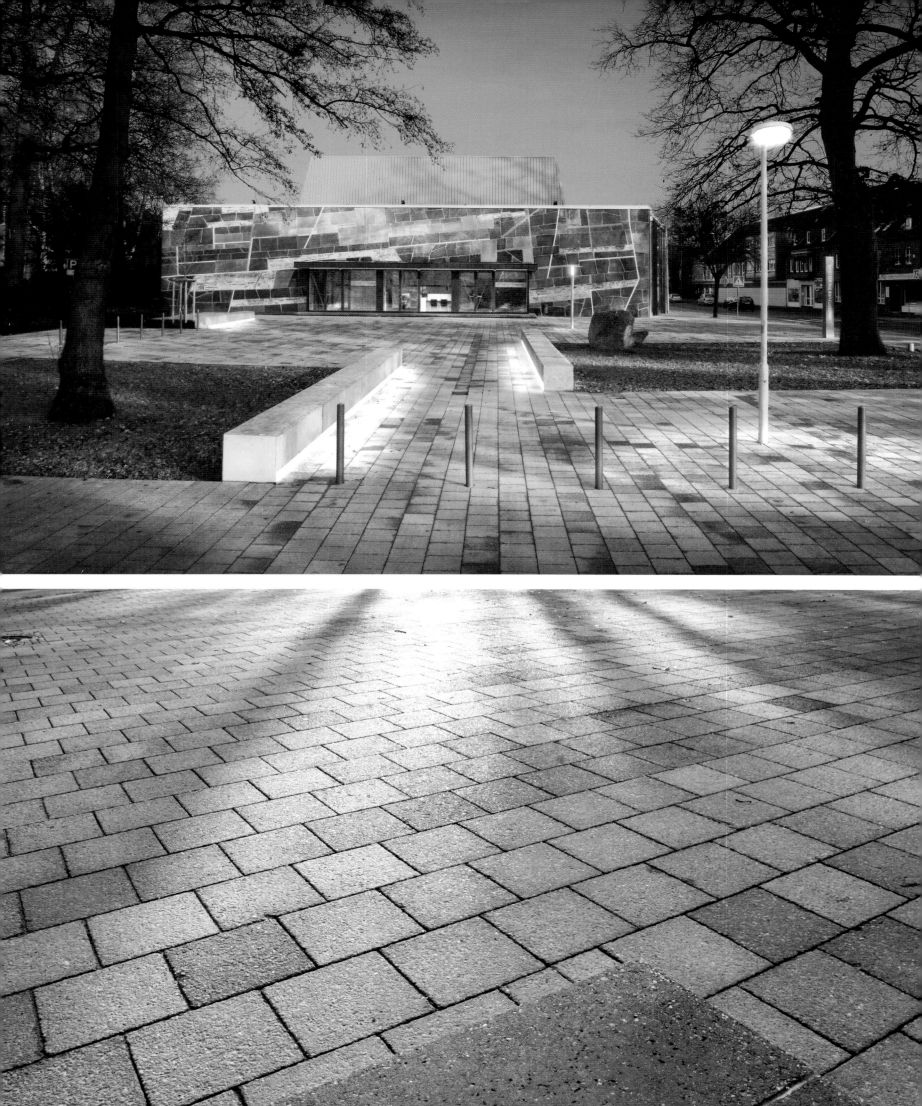

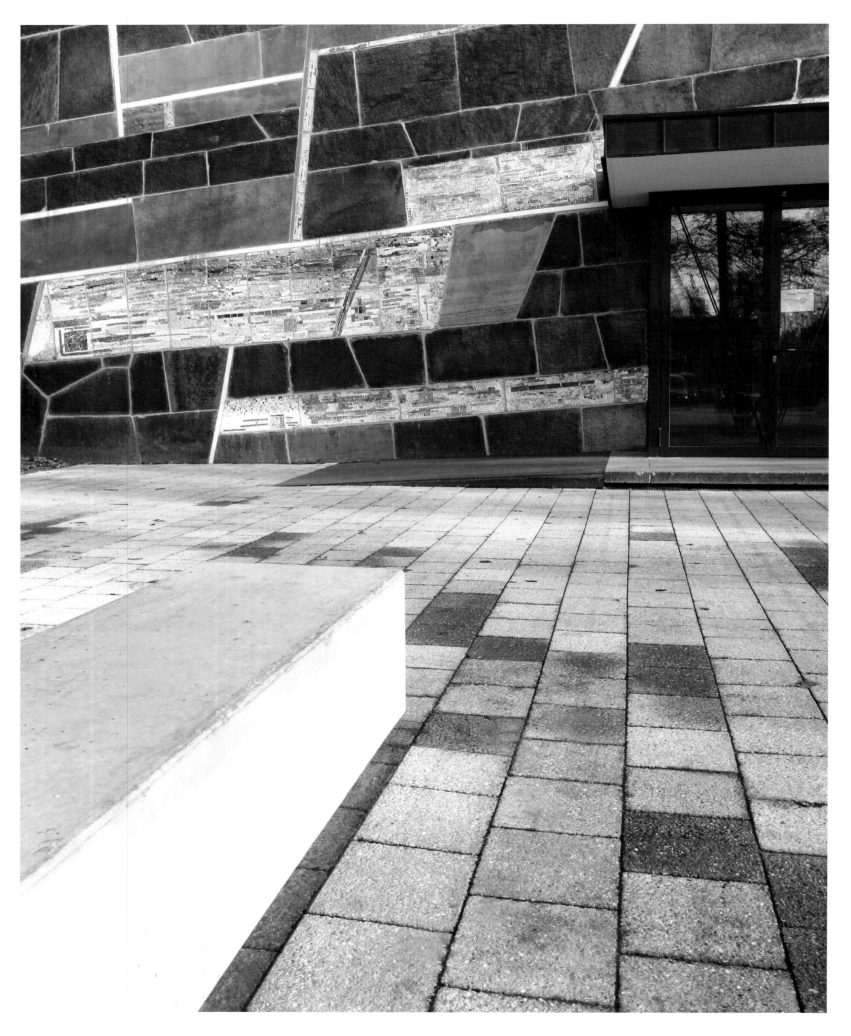

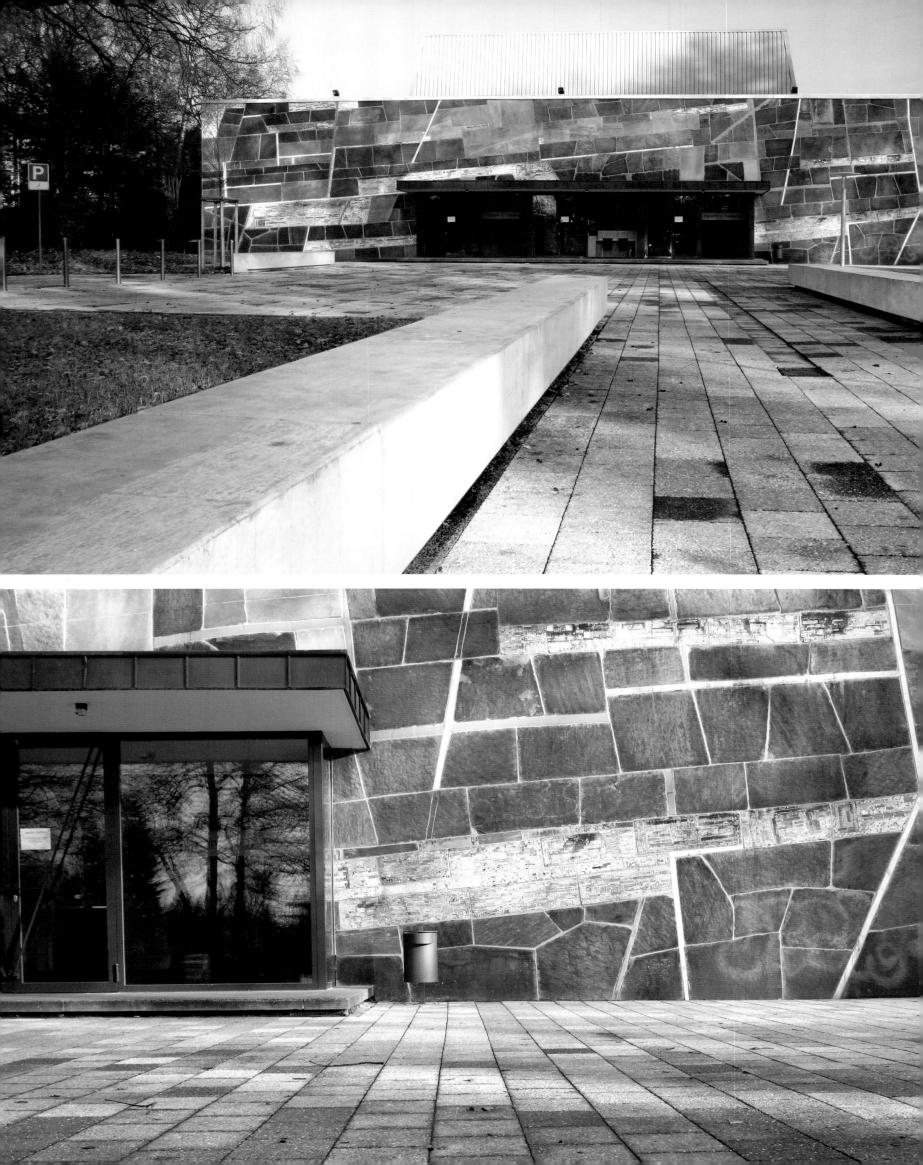

Town Hall Square

Toronto, Canada

Bordered by Yorkville Public Library and overlooked by a new condominium building, Town Hall Square follows a connected geometric layout. Varied vibrant green planting of yew hedging, periwinkle ground cover, boxwood and Gingko trees provide a textural quality to the vegetation. Furniture is functional and multi-purpose with concrete discs providing both tree protection and occasional seating. A sculpture entitled "Piercing a Cloud" by Canadian artist Jean Pierre Moran provides a dramatic focal point to this successful urban space.

Begrenzt durch die öffentliche Bibliothek von Yorkville und überragt durch ein neues Gebäude mit Eigentumswohnungen, folgt der Rathausplatz einer verbundenen geometrischen Ordnung. Die Anpflanzung abwechslungsreicher, kräftiger grüner Eibenhecken, immergrüner Bodendecker und von Buchs- und Gingkobäumen stellt Vegetation mit struktureller Qualität zur Verfügung. Die Möbel sind funktionell und vielseitig mit Betonplatten, die die Bäume schützen sollen und gleichzeitig Sitzgelegenheiten bieten. Eine Skulptur mit dem Namen „Piercing a Cloud" des kanadischen Künstlers Jean Pierre Moran bietet einen dramatischen Brennpunkt für diesen erfolgreichen städtischen Platz.

Bordé par la Yorkville Public Library et surplombé par un nouvel immeuble d'appartements, le Town Hall Square est conçu sur la base d'un agencement géométrique connecté. Une éclatante et luxuriante plantation de haies d'ifs, un sol recouvert de pervenches, des buis et des arbres de Gingko donnent à la végétation une magnifique texture. Le mobilier, fonctionnel et multi-usage, est composé de plaques de béton qui peuvent à la fois protéger les arbres et être utilisées pour s'assoir. Une sculpture appelée « Piercing a Cloud », fruit du travail de l'artiste Canadien Jean Pierre Moran, est le point de convergence spectaculaire de cet espace urbain.

Rodeada por la biblioteca pública de Yorkville y presidida por un nuevo edificio de apartamentos, la plaza del ayuntamiento sigue un esquema geométrico interconectado. Se ha recurrido a setos de tejo, vincapervinca, boj y ginkgos para proporcionar una textura variada de vibrantes tonos verdes a la vegetación que se ha plantado. El mobiliario es funcional y cumple diferentes objetivos, como los discos de hormigón que brindan protección a los árboles y sirven de asiento. Una escultura titulada "Piercing a Cloud" del artista canadiense Jean Pierre Moran brinda un dramático centro de atención a este satisfactorio espacio urbano.

Situata accanto alla Yorkville Public Library e ai nuovi complessi residenziali, Town Hall Square segue uno schema molto geometrico. Una variegata e rigogliosa piantumazione di Tasso, Pervinca, Bosso e Ginko crea una dimensione di accuratezza e qualità. L'arredamento è funzionale e si adatta a numerosi scopi, composto in dischi di cemento che, oltre a proteggere gli alberi, fanno anche da posti a sedere. Una scultura chiamata "Piercing a Cloud" dell'artista canadese Jean Pierre Moran, fa da punto focale di questo magnifico spazio urbano.

2005
Janet Rosenberg + Associates
www.jrala.ca

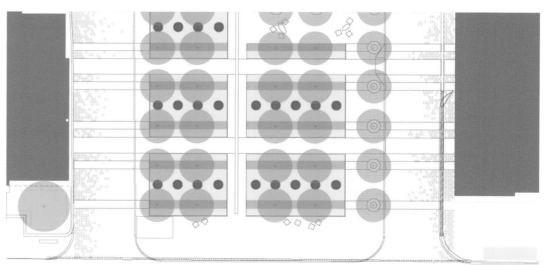

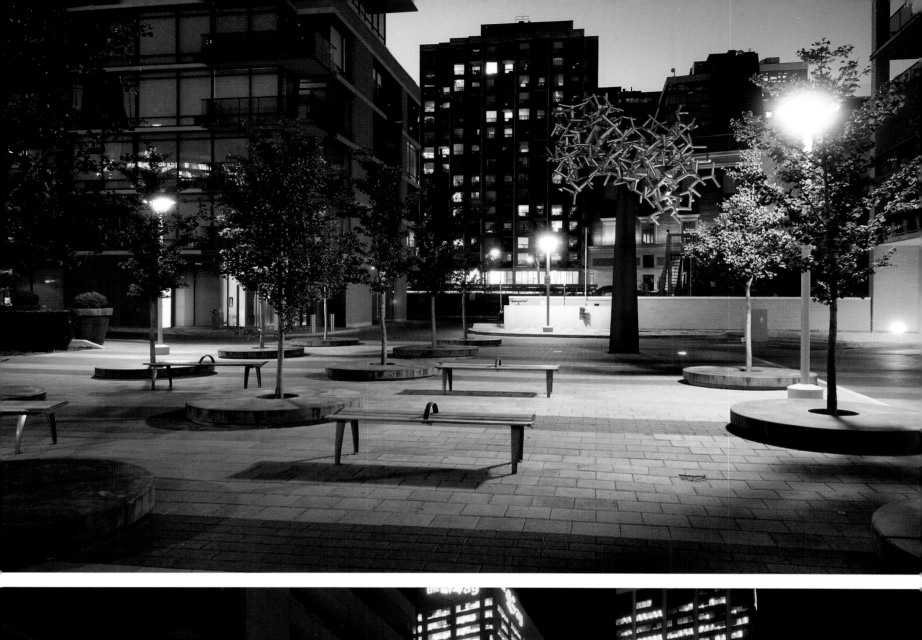
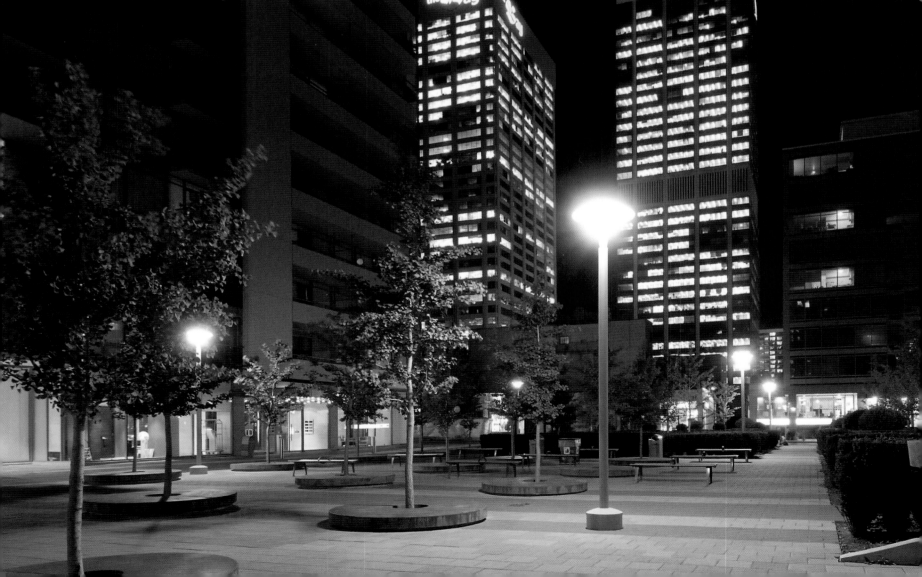

Planting was carried out in continuous pits with structural soils to ensure maximum growth. Both trees and shrubs were specifically selected for their durability due to the harsh urban conditions. The park's irrigation system records rainfall and automatically compensates when precipitation levels fall.

Die Bepflanzung wurde in Reihen von Vertiefungen ausgeführt, deren nährstoffreiches Erdreich maximales Wachstum garantiert. Bäume wie auch Büsche wurden mit Hinsicht auf die rauen städtischen Bedingungen spezifisch aufgrund ihrer Langlebigkeit ausgewählt. Das Bewässerungssystem des Parks misst die Niederschlagsmenge und gleicht einen Wassermangel automatisch aus.

Une plantation a été mise en forme dans une fosse continue contenant des sols structurels, garants d'une croissance maximale. Les arbres et buissons ont été choisis spécifiquement en fonction de leur durabilité face aux conditions de vie sévères imposées par le cadre urbain. Le système d'irrigation du parc enregistre le niveau des précipitations et le compense de manière automatique.

Las plantas se han dispuesto en trincheras continuas con suelos estructurales para garantizar el máximo crecimiento. Tanto los árboles como los arbustos han sido seleccionados por su resistencia a las difíciles condiciones de un entorno urbano. El sistema de riego del parque registra la lluvia caída y compensa automáticamente el descenso de las precipitaciones.

La piantumazione è stata realizzata in scavi consequenziali su suoli strutturali per garantire la massima crescita. Sia gli alberi che i cespugli sono stati selezionati appositamente per la loro resistenza a causa delle dure condizioni del terreno. L'irrigazione del parco registra le precipitazioni e compensa automaticamente la quantità d'acqua somministrata qualora il livello non fosse sufficiente.

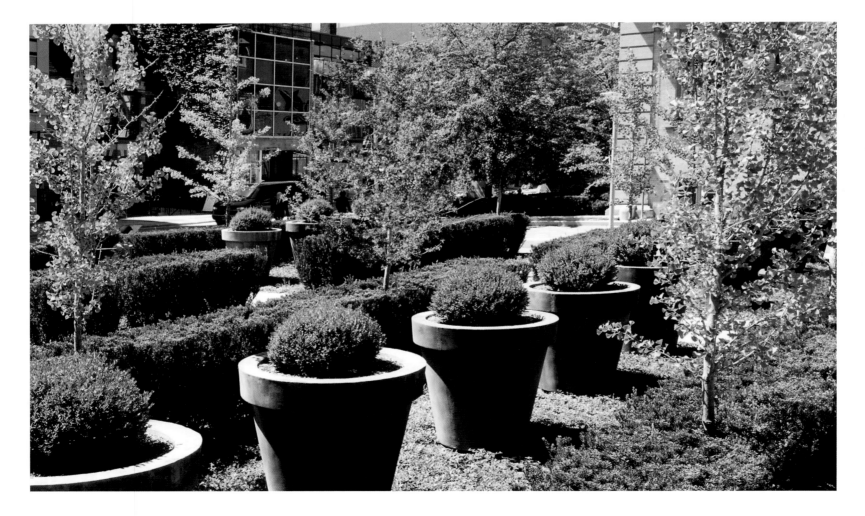

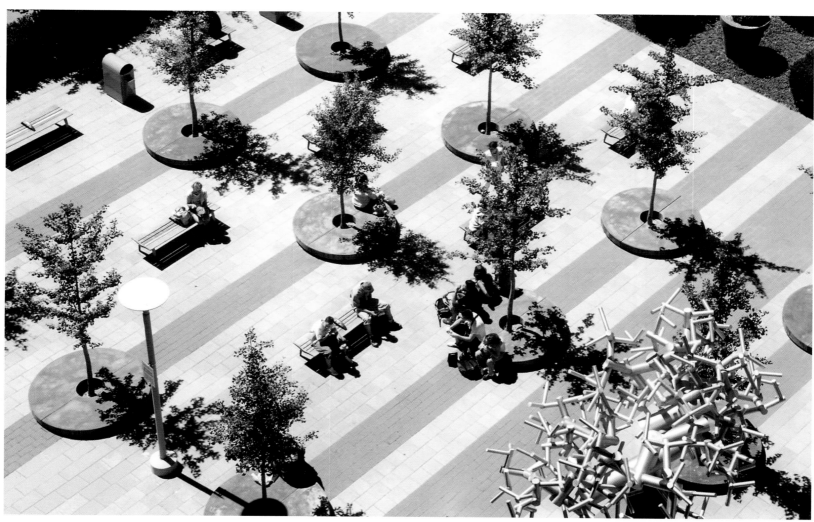

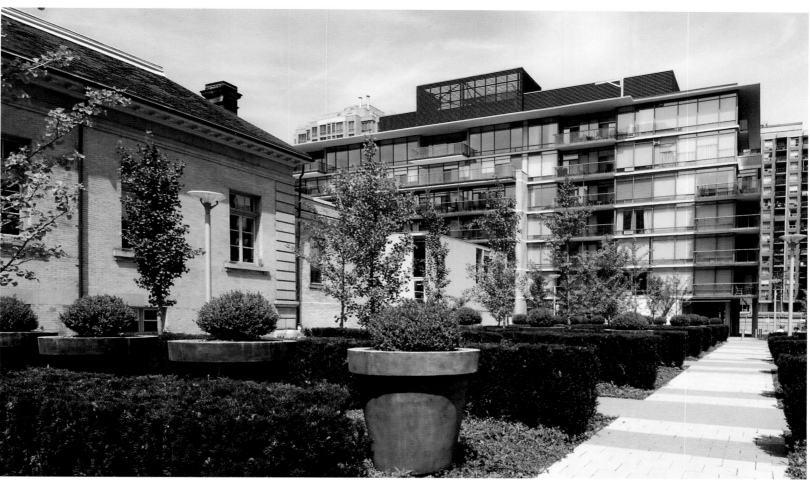

PHOTO CREDITS

Public Open Space

Shores, Quays and Riversides

Boulevards, Streets and Squares

Editors and texts: John A. Flannery, Karen M. Smith

Layout & pre-press: Boston Spa Media, Leeds, U.K.

Translations: 101Translations

Produced by: Boston Spa Media, Leeds, U.K.
www.bostonspamedia.com

Published by teNeues Publishing Group

teNeues Verlag GmbH + Co. KG
Am Selder 37, 47906 Kempen, Germany
Tel.: 0049-(0)2152-916-0, Fax: 0049-(0)2152-916-111
E-mail: books@teneues.de

Press department: arehn@teneues.de
Tel.: 0049-(0)2152-916-202

teNeues Publishing Company
16 West 22nd Street, New York, NY 10010, USA
Tel.: 001-212-627-9090, Fax: 001-212-627-9511

teNeues Publishing UK Ltd.
P.O. Box 402, West Byfleet
KT14 7ZF, Great Britain
Tel: 0044-1932-403509, Fax: 0044-1932-403514

teNeues France S.A.R.L.
93, rue Bannier, 45000 Orléans, France
Tel.: 0033-2-3854-1071, Fax: 0033-2-3862-5340

www.teneues.com

ISBN: 978-3-8327-9275-6

© 2008 teNeues Verlag GmbH + Co. KG, Kempen

Printed in Italy

Bibliographic information published by the Deutsche
Nationalbibliothek. The Deutsche Nationalbibliothek
lists this publication in the Deutsche Nationalbibliografie;
detailed bibliographic data are available in the Internet
at http://dnb.d-nb.de.